THE AGE OF PATRONAGE

THE AGE OF
PATRONAGE

THE ARTS IN SOCIETY
1660-1750

BY

MICHAEL FOSS

HAMISH HAMILTON
LONDON

First Published in Great Britain
by Hamish Hamilton Ltd 1971
90 Great Russell Street London W.C.1

© *1971 by Michael Foss*

SBN 241 01971 0

PRINTED IN GREAT BRITAIN
BY EBENEZER BAYLIS & SON LIMITED
THE TRINITY PRESS, WORCESTER, AND LONDON

Contents

List of Illustrations

between pages 38–39

between pages 70–71

Acknowledgement

I would like to thank my friend Maurice Cochrane for photographing many of the illustrations especially for this book.

<div align="right">M.F.</div>

with usura

no picture is made to endure nor to live with
but it is made to sell and sell quickly
with usura, sin against nature
 EZRA POUND, *Canto XLV*

The wretched State of the Arts in this Country & in
Europe, originating in the wretched State of Political
Science, which is the Science of Sciences, Demands a
firm & determinate conduct on the part of Artists to
Resist the Contemptible Counter Arts Establish'd by
such contemptible Politicians as Louis XIV & originally
set on foot by Venetian Picture traders, Music traders,
& Rhime traders, to the destruction of all true art as it
is this Day.
 WILLIAM BLAKE, *Public Address*

CHAPTER I

PROLOGUE

OBSERVERS OF social and political changes, aware of the sanctity of their mysteries, often demand that art should follow life: a country in turmoil puts art into confusion. The Civil Wars of the seventeenth century, so full of what Clarendon called 'prosperous wickedness', may be expected to stop or turn aside the ordinary course of artistic production. And the opinions of the victorious Puritans seemed to bear hard against the arts. The arts, however, refused to be intimidated. The quiet hand still attended to the loom; the tapestry grew out of isolation and experience though the country beyond the gate was noisy with gunfire.

The misfortunes of war overtook all ranks of society. True religion and proper government were the concern of all, and the artist, as a citizen, was liable to take his part in the struggle between King and Parliament. He incurred the usual penalties of warfare. A few, such as William Lawes, were killed in action. Denham, Inigo Jones and several others less famous had their property sequestrated. Many were imprisoned, including Cleveland, Davenant, Denham, Lovelace and Waller. And a minor host of Royalists went into exile, or were banished from the realm, among whom were Nicholas Lanier, Master of the King's Musick, the painter John Hayls, and the poets Cowley, Crashaw, Davenant, Denham and Waller.

Life and property were threatened, for most artists had an inclination towards the King's party. Even the quiet men who had no wish to be drawn into the fighting found some dangers to their artistic lives in the upset and re-organization of society under the Commonwealth. An artist's living has always been securely tied to the structure of society. And although an artist can easily fit himself into most governmental arrangements, adaptation to political changes is a worrying and tiresome business, taking energies more happily devoted to art. The Puritans made a number of pious sallies on the unholy carnival of contemporary life and their efforts put many out of work, especially actors and musicians. On September 2, 1642, Parliament closed the public playhouses. The ingenuity of the disreputable but lively theatrical profession soon found a way round the ban, but the years of the interregnum were difficult for playwrights, and even more hazardous for players. The Puritans also

had a great dislike for church organs and organists: the one they destroyed, the other they turned out. Well-known musicians, like Christopher Gibbons, organist of Winchester Cathedral, were soon without posts. The Anglican clergy, too, were obvious candidates for attack, and since the priesthood had always been one of the soundest careers open to literary men, several clergymen-writers were deprived of their livings. Gentle Henry King, Bishop of Chichester, was 'most barbarously treated' when Chichester surrendered in 1643, and had his library seized 'contrary to the condicion and contracte of the Generall and Counsell of warre'.[1] Robert Herrick was ejected from the comforts of Dean Prior in 1647 and went to try his luck in London where, it is said, he 'subsisted by Charity until the Restoration'.[2]

The artists who fared worst from the Wars were the very many who enjoyed the patronage of the King. Charles I was good to the arts. His enthusiasm and his generosity—often capricious but often forthcoming— encouraged music, architecture and painting. For a surprising length of time after the beginning of the troubles Charles managed to keep a remnant of his artistic followers together; they were still with him at Oxford in 1646. But at the King's final defeat the positions in the royal gift were abolished. Charles had maintained an establishment of eighty-eight musicians: between 1644 and 1660 not one entry relating to music or musicians can be found in state records.[3] The positions of Inigo Jones and John Webb, Surveyor and deputy in the Office of Works, came to an end with the ordinance of September 20, 1643, seizing 'all His Majesty's, the Queen's and Prince's Houses, Manors, lands etc'. The Serjeant-Painter, John Decritz, possibly went abroad at the start of the Civil Wars. He died in 1644 and his post went unfilled until the Restoration.

The arts became unfocused. The court was disbanded and its artistic retainers forced to look for other employment. The loyal aristocracy was sorely tried by fines and impositions. The great houses, which had formerly served as centres of friendship and enquiry, were now very often put under another kind of siege—bombarded by cannons not questions. For these houses were often the dominating points of the countryside. In peacetime they attracted the civilized and the cultivated; in war they became the rallying places for armies. Chipping Campden was blown up by the Royalists, and Basing House was torn down by the Roundheads. Basing House, Lord Winchester's property in Hampshire, held out against the Parliamentary forces for over two years. When it fell on the morning of October 14, 1645, it placed a good haul of talented men in the hands of Cromwell's soldiers. They captured Hollar and Faithorne,

both engravers, the actor Robinson, killed for taunting the conquerors, and Inigo Jones, contemptuously referred to by the triumphant *Mercurius Britannicus* as 'Contriver of Scenes for the Queen's Dancing-Barne', carried away in the dawn wrapped in a blanket and without his clothes.

From these discomforts and dangers men of the arts emerged shaken but still ready to work. A few, a very few, declined after the flight of the court and could find no inspiration to continue under the sober Commonwealth. They were those whose art was most distinctly cavalier and courtly, whose genius withered when the aristocratic streams went dry. Afterwards, they showed the familiar marks of despair, mournful, drunken or reckless, and came to no good end at a young age. William Dobson, 'the most courtly portrait painter, the most chivalrous romantic England has perhaps produced',[4] in spite of a flourishing practice landed in debtors' prison, and died at thirty-six. Richard Lovelace, gallant poet and energetic soldier, after a precipitous and slightly unbalanced career had his lands sold under the Commonwealth and grew, said Anthony Wood, 'very melancholy (which brought him at length into a consumption), became poor in body and purse, was the object of charity'.[5] Wood is not the most reliable guide, but certainly Lovelace died in 1658, aged forty. These however were the exceptions; most artists accepted the new polity quietly enough, and set about restoring their fortunes.

The amount of work done in the difficult years of the Wars and the Commonwealth is an impressive monument to the application of artists; it shows too that their minds were relatively easy however hard their bodily circumstances. There were complaints, of course. Loud moans made it appear as if hands were idle and inspiration dead. Abraham Cowley, preparing his works for the press in 1667, the year of his death, groaned over the past and the poet's hard lot:

> And if in quiet and flourishing times they meet with so small encouragement, what are they to expect in rough and troubled ones? if *Wit* be such a *Plant*, that it scarce receives heat enough to preserve it alive even in the *Summer* of our cold *Clymate*, how can it choose but wither in a long and a sharp *winter*? a warlike, various, and a tragical age is best to *write of*, but worst to *write in*.[6]

But his activity during these dreadful years belied his laments. The love poems of *The Mistress* appeared in 1647. Nine years later, still well before the Restoration, *The Mistress*, the *Pindarique Odes* and the *Davideis* were brought together in a folio volume notable for the number, variety and experimental nature of the verses. Nor was Cowley's the only active pen. Between 1642 and 1660, there came from the press poems by Denham, Milton, Waller, Crashaw, Shirley, Suckling, Vaughan, Cleveland,

Lovelace, Herrick, Herbert, Marvell and Dryden; among the prose works were volumes from Fuller, Browne, Henry More, Hooker, Herbert of Cherbury, Taylor, Wotton, Walton and Evelyn. The press in these years provided the age with an unusually rich selection of the very best writings, both poetry and prose.

The writer, needing few props, can continue his work under the worst conditions; so Davenant, who according to Aubrey barely escaped the death sentence for his Royalist activities, devoted his years of imprisonment, first at Cowes Castle and then in the Tower, to *Gondibert*. But painters, architects, musicians and players, being more subject to outside influences, are more endangered by unsettled times. Yet though the court no longer employed painters and musicians; though buildings were as liable to be knocked down as to be put up; and though the theatres were officially closed, the arts all continued in a surprisingly lively way.

Painters were as busy as ever; gentlemen of both parties still sat for the fashionable portraiture. Dobson, before his early death in 1646, found many clients among the King's men at Oxford. His imprisonment for debt was caused by despairing extravagance, not lack of work. The painting family of Decritz seemed as prosperous as ever. Emannuel Decritz bought heavily at the sale of Charles's collection. Indeed, many a painter profited from the King's defeat, and purchased good bargains from among the royal paintings, sold by Parliamentary order between 1649 and 1653. George Vertue listed Decritz, Lely, Wright, Gaspar and Van Leemput as buyers. Lely was the leading painter in England after Dobson's death, and he was undisturbed by political shifts. He had begun his career under royal patronage. In 1647 he visited Hampton Court where his old master was held under house-arrest, and painted the well-known double portrait of *Charles I and the Duke of York*; four years later the Waynwright letters mention a portrait of Cromwell by Lely; and in October 1654 Waynwright wrote to Bradshaw in Copenhagen about a picture commissioned from 'Mr. Lilly, the best artist in England who hath undertaken to do it rarely'.[7] By 1658, when Sanderson published his *Art of Painting*, English painting was flourishing and esteemed throughout Europe. Sanderson listed the following masters at work: Walker, Soest, Wright, Lely, Hayls and Sheppard. Hayls had left at the start of the Wars, but returned to take his place among Sanderson's masters.

The closing of the Office of Works in 1643 brought an end to royal building, and severed the connection between the royal patronage and Inigo Jones, which had been so fortunate for English architecture. But

official building did not cease. Parliament instituted its own department of works and placed Edward Carter, a former deputy of Jones's, in charge. Even Jones, though now over seventy and in some trouble with Parliament, still advised on various projects. Aubrey relates that when the Earl of Pembroke began to rebuild Wilton House after the fire of 1647, he did so 'with the advice of Inigo Jones; but he being then very old, could not be there in person, but left it to Mr. Webb'.[8] The great man was apparently occupied right up to his death in 1652. Sir Roger Pratt very likely consulted him about the design of Coleshill, and Jones perhaps had a hand in designing the front at Lees Court, begun in the year of his death.[9] John Webb, Inigo's kinsman and deputy and an ardent follower of the royal cause, later found sufficient work under the Commonwealth. Between 1649 and 1660 Webb worked on Wilton House for Lord Pembroke, Lamport Hall for Sir Justinian Isham, Drayton House for Lord Peterborough, The Vyne for Mr. Speaker Chute, and Gunnersbury House for Serjeant Maynard. In 1650 the aristocratic Sir Roger Pratt began to build Coleshill, one of the most beautiful of all English houses. Away from the great houses, building went on at a quiet but steady pace. Church-building was almost at a standstill, though the strange Gothic structure at Staunton Harold intruded into the sober age of 1653, a kind of insult from the Laudian past. The destruction in the cities was rebuilt, and the universities continued to commission work in a settled Gothic style.

The Puritans looked askance at poetry and said little about architecture; but against music and plays there had been a number of splenetic outbursts from such as Gosson, Stubbes and Prynne; and no doubt musicians felt a great uneasiness at the start of the Commonwealth. The break up of the King's Musick, which put at least eighty-eight leading men out of work, seemed to confirm their fears. Their memories of Puritan writings could only depress them further. Stephen Gosson thought music part of that unlicensed liberty destined to take the unwary 'from pleasure to sloth, from sloth to sleep, from sleep to sin, from sin to death, from death to the Devil'.[10] Philip Stubbes took the same gloomy view:

> So sweete musicke at the first delighteth the eares, but afterward corrupteth and depraveth the minde, Making it weake and quasie, and inclined to all licenciousnesse of life whatsoever.[11]

Prynne thought music itself was good, but most performances unlawful:

> Effeminate accurate lust-provoking Musicke, (especially in *publike meetings, feasts and Enterludes . . .*) must undoubtedly bee utterly unlawfull to Christians, in regard of the fore-named lewde effects which issue from it.[12]

Music certainly suffered. In 1657 a Committee for the Advancement of Music petitioned the government to alleviate the general hardship:

> That by reason of the late dissolucion of the Quires in the Cathedralls where the study and practice of the Science of Musick was especially cherished, Many of the skilfull Professors of the said Science have during the late Warrs and troubles dyed in want, aḥd there being now noe preferrment or Encouragement in the way of Musick, noe man will breed his child in it, so that it must needes bee, that the Science itselfe, must dye in this Nacion.[13]

But the picture painted here is altogether too black. The Puritan animosity was against the King's servants, the church musicians, and the church organs. Once the offending musicians were turned out and some of the offending organs destroyed, music was left to go on with its ordinary business. For the Puritan polemicists did not voice the opinion of the ordinary citizen living under the Commonwealth, nor even the opinion of the government. In spite of the statement in the 1657 petition, music was far from dying in the nation; and many musicians rode out the troubles quite successfully. Gibbons and Henry Cooke joined the royalist forces and their martial efforts did them no harm. Cooke proudly retained his army rank of captain. After the Wars both men are in the list of teachers given in Playford's *Musicall Banquet* of 1651, and in 1654 Evelyn heard Gibbons perform on the organ at Magdalen College.[14] So much for the Puritan hate of organs and organists. Aged Tomkins was still organist of Worcester Cathedral when he retired in 1646. William Child went farming but still continued to compose. Other church musicians became teachers and are to be found in Playford's list. Teaching was also the best recourse for the men from the royal service. Playford mentions Henry Lawes, Coleman, Hudson, Mell and Hingston as active in London. Some others spent time with private patrons; John Wilson was employed by Sir William Walter, and John Jenkins by Lord North.[15]

There are further indications that music did not suffer too severely at this time. The Commonwealth years saw the appearance of the first specialist music publisher in England. John Playford's *The English Dancing Master* came out in 1651, and from then on the enterprising publisher was hard put to meet the demands for his volumes. In 1651 he also brought out *Orlando Gibbon's three-part Fantazies*, *Musick and Mirth*, and *A Musicall Banquet*; in the following year he published *A Banquet of Musick*, *Select Musical Ayres and Dialogues*, *Musick's Recreation* and *Catch that Catch can*; thereafter each year had its share of notable publications of secular music—in 1653 more *Ayres and Dialogues*, in 1655 *An Introduction to the Skill of Musick*, in 1656 *Mr. Matthew Locke, his Little*

Consort, and in 1659 *The Division Violist*.[16] And many of these works went into several editions. Obviously the public was eager for these publications, and according to the diaries of the period put them to good use. At Oxford in Anthony Wood's time at least three weekly music clubs flourished. Ellis, late organist of St. John's, earned an income by holding a club in his house; Marsh at Exeter College and Janes at Magdalen held meetings in their rooms.[17] Francis North found good music at Cambridge in 1653:

> and there he began his use of Musick, learning to play on the base violl . . . and became one of the neatest violinists of his time.[18]

London also had a prosperous musical life. Playford, in the *Musicall Banquet*, pointed out how fortunate Londoners were to have so many good teachers. He gave eighteen teachers for 'Voyce or Viole' and nine for the 'Organ or Virginall', ending each list with the note '*cum multis aliis*'. Many casual passages in Evelyn refer to the musical events of the age. At one time he visits Carew, the Welsh harper; at another time Mr. Clark, 'the most incomparable player on the Irish harp' visits him. He mentions Davis Mell, the English violinists, and also Baltzar, the great virtuoso from Lübeck. He is entertained with 'voice and theorbo' by Captain Cooke.[19] Music, driven out of palaces by the Civil Wars, descended into the home and took root there most strongly. Roger North described this happy state of affairs in his own dry way:

> and when most other good arts languished Musick held up her head, not at Court nor (in the cant of those times) profane Theaters, but in private society, for many chose rather to fidle at home, than to goe out, and be knockt on the head abroad.[20]

The ordinary citizen, practising music in the home, was following the highest authority; for Oliver Cromwell was a great lover of music, and maintained a small body of domestic players. John Hingston was in charge of the band and taught music to Cromwell's daughters. The group also included Davis Mell, six other men, and two boys to sing the Latin motets of Deering, the Protector's favourite music. The marriage of Cromwell's daughter, Frances, in November 1657 was the occasion for a courtly entertainment in the grand style—music from forty-eight violins and fifty trumpets, and 'mixt dancing (a thing heretofore accounted profane) till 5 of the clock yesterday morning'.[21]

Of all the arts, the theatre had the most to fear, and suffered most, under the Puritans. By the beginning of the Civil Wars the theatre was not in good order. In the decade before 1642 the plague had closed the

playhouses for lengthy periods. The great playwrights were dead or silent; the remaining writers, nearly all lesser men, failed to attract. James Shirley lamented the small audiences and the lack of enthusiasm. Puritan controversialists bombarded the stage with angry pamphlets; and in this matter, unlike the attacks on music, the righteous had the support of respectable citizens. They objected to private theatres, such as the Blackfriars, because of the traffic, noise and inconvenience to house-holders; and they objected to public theatres, such as the Red Bull, because of the rowdiness and criminal tendencies of the audience, and the questionable artistry and morality of the troupes. The theatre, too, as the most public and outspoken of the arts, had meddled unwisely in politics— perhaps to help out a waning inspiration, perhaps to tempt a fickle audience. The passions leading to the Civil Wars were easy to exploit, and the players were not the men to resist this temptation. At the Fortune in 1638 Davenant's *Britannia Triumphans* was virulently anti-Puritan, and Massinger's *The King and the Subject* was more cautiously against Charles.[22] Neither pleased the government. Davenant, playwright and theatrical manager, dabbled so eagerly in politics, he was forced to flee the country in 1641 after taking part in the Army Plot. The order of Parliament which closed the theatres on September 2, 1642 complained with some justice that the playhouses did not 'well agree with publike Calamities'.

The history of the theatres after 1642 is understandably obscure, though it is certain that a number of surreptitious performances were given within a very short time. The favourite stages for these plays appeared to be the Fortune, the Red Bull and the Salisbury Court.[23] There was a danger in illegal performance and the government ensured that the players had a lively time. Raids were common and often successful. A letter assigned to 1643 (though printed much later) gives the familiar picture:

> The Souldiers have routed the Players. They have *beaten* them out of their *Cock-pit, baited* them at the *Bull*, and *overthrown their Fortune*. For these exploits, the Alderman (the Anagram of whose name makes *A Stink*) [Atkins] moved in the House, that the Souldiers might have the Players cloaths given them.[24]

The open defiance of the players called forth stronger government measures. An order of February 9, 1648 declared that all players were to be treated as 'Rogues', and commanded all public playhouses to be pulled down. The Red Bull alone escaped, and celebrated this good fortune with more performances. Further raids are mentioned in the newsbooks—1655 being a particularly difficult year—but still the Red Bull staggered on

towards the Restoration, ever open despite having players wounded and imprisoned and its properties confiscated and destroyed. The Red Bull demonstrated the stubbornness of a vulgar and popular institution against any government attempt to regulate the people's pleasures. It had also helped to keep the theatrical profession alive and fighting through the difficult years, if only to outwit regulations and avoid imprisonment.

Active resistance was no longer necessary after 1656. The irrepressible Sir William Davenant, fresh from two years in the Tower, once more took the artistic direction of the theatre into his own hands. With the encouragement of some cultivated men in Cromwell's government, men like Bulstrode Whitelocke and John Maynard, he proposed a new type of dramatic performance imported from the Continent, an 'Opera' with declamation and music, preserving 'all decency, seemliness and without rudeness and profaneness'.

> This *Italian Opera* began in Rutland-house in *Charterhouse-yard*, and was afterward translated to the *Cock-pit* in *Drewry-lane*, and delighting the eye and ear extreamly well, was much frequented for several years.[25]

Milton acknowledged the busyness of 'pens and heads' in these years, but spoke of 'a Nation so pliant and so prone to seek after knowledge'[26] as if all mental and artistic efforts were merely reflections of the doctrinal and political squabbles of the age. Certainly the propagandists and pamphleteers (among whom Milton held forth himself from time to time) produced enough heavy matter to fill several catalogues. But, avoiding the controversialists, one also sees peaceful men following their own inquiries, not much fretted by the disorders in government and society. Lovelace, dedicating the poems of *Lucasta* to Anne Lovelace in 1649, asked her to accept '(With Devotion) these Toyes'. Herrick's *Hesperides*, published in 1648, takes for the 'Argument of his Book' the small, intimate events of the countryside, enduring, hopeful and beautiful:

> I sing of Brooks, of Blossomes, Birds, and Bowers:
> Of April, May, of June, and July-Flowers.
> I sing of May-poles, Hock-carts, Wassails, Wakes,
> Of Bride-grooms, Brides, and their Bridall-cakes.
> I write of Youth, of Love, and have Accesse
> By these, to sing of cleanly-Wantonnesse.

Henry Vaughan, too, ignored the shifting elements of social revolution and fixed his eyes on more steadfast and higher matters. The second edition of *Silex Scintillans*, which came out in 1655, was dedicated to 'Jesus Christ, The Son of the Living God, And the Sacred Virgin Mary'. 'Dear Lord, 'tis finished!' the poet sighed with touching relief:

and now he
That copied it, presents it thee.
'Twas thine first, and to thee returns
From thee it shin'd, though here it burns.

Are these contradictions to the temper of a severe age worried about social reconstruction, anxious to free the land from the manacles of arbitrary rule and superstitious religion? Then all the arts gave examples that seemed to go against the Puritan spirit. No apartment in England is more magnificently decorated than the Double Cube room at Wilton, completed by Jones and Webb around 1650. The wealth of the plaster-work and the gilt, the huge Corinthian door-case, the marble chimney supported by Bacchus and Pomona (those anti-Puritan deities), the portraits by Vandyck and the painted ceiling by Edward Pierce, and the central oval by Emannuel Decritz making the room appear open to the sky, all produce an impression of luxurious elegance. The Single Cube room, hardly less splendid, has panels painted by Thomas Decritz with scenes from Sidney's *Arcadia*, and the sense of Sidney's aristocratic refinement pervades the house far more than the worthy plainness of the Common-wealth. Coleshill, too, the most lovely house of the age, showed in every lineament a tradition—whether drawn from Rubens or from Italy—quite contrary to Puritan severity.

In music, light airs and poplar tunes overwhelm the graver pieces among Playford's publications. Characteristic titles were *The Dancing Master*, *Musick and Mirth* and *A Banquet of Musick* in three books, 'the second Ayres and Jiggs for the Violin, the third Rounds and Catches'. Catches, what Burney called 'this species of humorous and convivial effusions', were the rage; and the best known were provided by John Hilton, first organist and then parish clerk at St. Margaret's, Westminster, Parliament's own church. 'These times,' wrote Hilton in his famous collection, *Catch that Catch can*, 'Catches and Catchers were never so in request.'[27] Parliament's parish clerk became one of the most popular musicians in England. When he died in 1657, his fellow musicians, prevented by order of Parliament from singing him to his grave, 'sang the Anthem in the House over the corps before it went to the church, and kept time on his coffin'.[28]

In painting, Lely serenely carried on with his portraits. His pictures from the Commonwealth years are toned down and more severe than his earlier romantic manner. The portraits of Lady Bedel and Sir Simon Fanshaw have a touch of Puritan austerity and responsibility. But a surprising light breaks out occasionally, as in the *Little Girl in a Green Dress*, painted about 1655.

In the mid-century, men of the arts were perfectly capable of dividing their time and allegiance. Many of them fought for one side or the other, but they felt no duty to compel their inspiration in the cause of politics. Though they might from time to time lend their talents to arguments and controversy, they preserved the right to withdraw and develop their work according to its own rules, far away from the dictates of the state. Alexander Pope, writing somewhat critically of Crashaw, said:

> I take this Poet to have writ like a Gentleman, that is, at leisure hours, and more, to keep out of idleness, than to establish a reputation; so that nothing regular or just can be expected from him.[29]

This inept judgment was based on a misunderstanding. Nothing could be further from the gentlemenly trifles of idle moments than Crashaw's passionate outburst to Saint Teresa:

> O sweet incendiary! show here thy art,
> Upon this carcass of a hard, cold, heart,
> Let all thy scatter'd shafts of light, that play
> Among the leaves of thy large books of day,
> Combin'd against this breast at once break in
> And take away from me myself and sin.[30]

This is poetry drawn from the heart after hard battles and much suffering. But Pope had a different notion of the uses of poetry. For him, regularity, sobriety and social consciousness led to 'reputation', the professional standing that the Augustans wished for so ardently. The writer of Pope's time hoped to be a man of weight and opinions; his concern was, have I fulfilled my social duty? In the earlier age of Crashaw other considerations were more important. The arts still had the freedom to be personal, obscure, idiosyncratic, and even uncertain. Sir Thomas Browne, a fine example of the earlier seventeenth-century artistic intelligence, expressed the typical attitude in a well-known passage:

> The world that I regard is my self; it is the Microcosm of my own frame that I cast mine eye on; for the other (*i.e.* the Macrocosm), I use it but like my Globe, and turn it round sometimes for my recreation.[31]

The license which the artists allowed themselves reflected the quixotic judgments of the age. Even in the anti-royalist party the variety of opinion was astonishing. At the start of the Wars, the Presbyterian Thomas Edwards wrote a book called *Gangraena*, in which he tried to list all the various sects—Arians, Anabaptists, Baptists, Shakers, Quakers, Levellers, Diggers, Fifth Monachy men, and so on. By the time the first edition came out the sects had multiplied enough for a second volume, and then a third; at this point Edwards called a halt, recognizing that he could never keep

up with this miraculous division. Aristocrats, too, were equally in-
dependent and by no means all of them were for the King. Lord Pembroke,
Lord Brooke and Denzil Holles, son of the Earl of Clare, were active for
Parliament. Yet their support was a personal matter and nothing about
them could be taken for granted. Pembroke never disguised his contempt
for the party he served, and Holles, though a Member of Parliament,
grew tired of fighting and was impeached by the army in 1648. Divided
allegiances were quite common. John Webb, the fervent Royalist who had
'sent to the King at Oxford his designs of all the fortifications about
London' and even 'carried his majesty's jewellery in his waistcoat through
all the enemy's quarters unto Beverley in Yorkshire',[32] still accepted work
at Wilton from Lord Pembroke, the Parliamentarian. And later he built
for Serjeant Maynard and Chaloner Chute, Speaker of the House under
Richard Cromwell. An artist made his own bargains with society and
conformity to some political programme was no necessary part of the
contract. The poet John Cleveland had fought for the King and been
imprisoned by Parliament, and remained an unrepentant Royalist,
writing elegies on Charles, Laud and Strafford. In 1657 he addressed to
Cromwell a noble justification for his conduct:

> For the service of his *Majesty* (if it be objected) I am so far from excusing it,
> that I am ready to alledge it in my vindication: I cannot conceive that my
> fidelity to my Prince should taint me in your opinion; I should rather expect it
> should recommend me to your favour; Had not we been faithfull to our *King*,
> we could not have given our selves to be so to your *Highness*; you had then
> trusted us *gratis*, whereas now we have our former Loyalty to vouch for us.[33]

Perhaps later opinion would not regard this point of view as respectable,
but it has its own excellent logic. Integrity lies in the man not the cause.
John Hingston passed calmly from the royal service in Cromwell's
domestic band and then back to the King's Musick at the Restoration; he
was merely attending to his art. Architects like Webb and Pratt, painters
like Lely and Hayls, and even the sorely pressed playwrights Shirley and
Davenant, refused to be driven from their arts by the dogs of politics.[34]
Milton was a good Parliament man, but he was certain that the artist's
work went beyond the functions of the state, and in the *Areopagitica* he
gave the artist his charter of independence from the state:

> The State shall be my governours, but not my criticks; they may be mistak'n in
> the choice of a licencer, as easily as this licencer may be mistak'n in an author:
> This is some common stuffe; and he might adde from Sir *Francis Bacon*, That
> *such authoriz'd books are but the language of the times.* For though a licencer
> should happ'n to be judicious more than ordinary, which will be a great jeopardy
> of the next succession, yet his very office, and his commission enjoyns him to let
> passe nothing but what is vulgarly receiv'd already.[35]

The ease with which the Restoration happened is a sign that the years of Puritan government had hardly altered the structure of society. The arts were able to develop quietly because the livelihood of artists was not endangered by changes in patronage and demand. Patronage under the Commonwealth was similar to that in the days of Charles I, with the great exception that the fountainhead of munificence from the court was temporarily stopped up. For the rest, Commonwealth men of position and taste acted very much like their predecessors in the days of the first Stuarts; and the rich or aristocratic Royalists did not cease to love the arts just because the country was in upheaval. Men on both sides still found the time and money to make their bargains with artists. Milton had declared, and others had felt, that the cultivation of their talent was a private affair; no doubt they moved naturally towards this opinion because the agreement between artist and patron was still very private, not much influenced by public demand or political attitudes. When John Webb began work on Lord Pembroke's house in Wilton in 1649, it was not very important that the earl was a Parliamentarian and his architect a strong Royalist. The important thing was the house itself. Webb's master, Inigo Jones, had been connected with Wilton for the best part of fifty years, and now that the fabric needed rebuilding after the fire of 1647, Webb naturally took up the work of his ageing master and brought the care of so many years to a grand conclusion.

The clear division between public political life and private artistic life can be seen very well in the career of Thomas Fuller, author of the famous *Worthies*. Fuller was a genial, unfanatical fellow. He was, however, a Royalist, an Anglican clergyman, and the nephew of a bishop, and thus had some grounds to expect Parliament's displeasure. Instead, protected by cultivated men on both sides, his career moved serenely forward with only a few anxious moments. During the Wars he was first army chaplain to Sir Ralph Hopton, and then chaplain to Princess Henrietta at Exeter— an undemanding job as the Princess was an infant. At the defeat of the King's forces he retired to London in good order, and lived above his bookseller. Soon friends were at hand to help a needy author. The Parliamentarian Lord Montague of Boughton took Fuller to Boughton House and gave him money and encouragement. Help, in the form of an annual payment, came also from Sir John Danvers, the regicide. The friendship between the Royalist priest and the regicide lasted until Danver's death in 1655. Then in the year of the King's execution, Fuller received from the Earl of Carlisle, another Parliament man, the perpetual curacy of Waltham Abbey and became the earl's chaplain. Life was now

very pleasant. He worked on his *Church History*; he received from the Earl of Middlesex the library of the earl's father; every Wednesday he lectured at St. Clement's, Eastcheap; in 1651, he married the younger sister of a Viscount. Even when his relations brought him into trouble with Parliament, he knew the right approach. 'Sir,' he said to Cromwell's domestic chaplain, 'you may observe that I am a pretty corpulent man, and I am to go through a passage that is very straight; I beg you would be so good as to give me a shove, and help me through.' And the trick was done. As a crown for his labours, he received in 1658 from Lord Berkeley the living of Cranford in Middlesex. Two years later he accompanied this patron to the Hague with a 'Loyal Panegyrick' for the restored King.[36]

No doubt Fuller was a confirmed sycophant; his clerical opponents Haylyn and Robert South derided his eager search for patrons. South pictured him running round with a big book under one arm and a little wife under the other, looking for dinner invitations. But all the while Fuller's work went on: *The Holy and Profane State* came out in 1642; then appeared some small devotional works, the *Pisgah-Sight of Palestine* in 1650, and the great *Church History* in 1656; from then until his death he was at work on the *Worthies*. The generous help he received from nobles of both parties was a tribute to his ability as a writer, and to his devotion to his craft. Appreciation of artistry took precedence over political considerations.

It may seem that in this kind of patronage the artist had a low and servile place. A judicious man was careful not to question too closely the taste of his patron. In the letters between Webb and Sir Justinian Isham concerning the building of Lamport, the architect pays respectful attention to his patron's suggestions. But the relations between the two were sincere and quite close; indeed rather closer than was usual between a commoner and a knight of the time. Webb's letters are addressed 'Sir' or 'Honoured Sir', and he signed himself 'your assured friend to serve you'. Sargenson, the building contractor for Lamport, though he boasted a coat-of-arms, addressed Sir Isham as 'Your Worship, in all humble and dutiful service'.[37]

Whatever social difficulties he faced, the artist's financial rewards under seventeenth-century patronage were often very respectable. Inigo Jones died a rich man. It is true that he accumulated most of his wealth in the time of the early Stuarts, but the Wars failed to impoverish him. When hostilities began he had cautiously buried his ready money in Scotland Yard.[38] At Beverley in 1642 he was able to make the King a loan of £500, and when he died on June 21, 1652 he bequeathed legacies amounting to

£4,150.[39] Jones was not alone in his prosperity. Peter Lely increased his custom, and also his fees, throughout the interregnum. Around 1650 he charged £5 for a *ritratto* and £10 for a half-length; by 1670 he was charging £15 for a head and £25 for a half-length.[40] Other painters appeared to do equally well. Both Michael Wright and Decritz had the funds to buy at the sale of the King's collection. Robert Walker had a strong line of business painting the Puritan gentry, and was particularly successful. He also made a speciality of copying, for which he was well paid. He asked £50 to copy Titian's *Naked Women and a Man playing an Organ*. His portraits were as expensive as Lely's—£10 for 'Mr. Thomas Knightley's wife's picture to the knees', and £10 for 'A Philosopher he did from poor old men'. Only the best was good enough for Walker; he painted on 'best fine cloth' that did not crack when rolled up.[41]

Musicians could not command the grand fees of the painters, but they kept going well enough with the modest gains from teaching. The flourishing private music-making noted by Roger North and the great number of Playford's publications showed a strong public desire to learn and to play. Parliament, for all its supposed dislike of music, kept a kind eye on the fortunes of musicians. When the royal band was broken up in the Wars, Clement Lanier, a recorder and sackbut player, found his pay in arrears. This was a well-known hazard of royal service. Yet in 1651 Parliament agreed to make up the arrears, and in the next year paid Lanier a sum on account.[42] In 1657, Parliament listened sympathetically to the petition got up by Cromwell's domestic musicians and appointed a committee for the Advancement of Musick, the members of which included the Earl of Mulgrave, the Lord Deputy and Lord Lambert. The absence of the court was not a disaster for the arts. Even Whitehall, which was a project very close to the royal heart, seemed endowed with an artistic life of its own and went forward without the King. In 1647–8, Webb was quietly preparing a batch of drawings for the palace;[43] three years later the jack-of-all-arts, Balthazar Gerbier, joined with two other foreigners, Geldorp and Lely, and suggested to Parliament a scheme for decorating Whitehall with a series of large murals. Nothing came of this ambitious plan.[44]

The arts were active, but where they were going no one could quite see. The old styles were wearing out. The Civil Wars and the Puritan years, though they did not stop men working, had their effect. The grounds of art were slowly re-examined in the light of the social and political experiments of the time. Puritan government failed (though it hardly tried) to control or to impose on the arts; but the questionings of the artists

themselves began a new and uncertain development that became important years later when the Commonwealth was long gone. Very few of the Jacobean masters lived long enough to help steady the arts in this period. Of the poets, Donne died in 1631, George Herbert in 1633, and Ben Jonson in 1637; among the playwrights, Shakespeare, Jonson, Beaumont and Fletcher, Dekker, Tourneur, Middleton, Webster, Marston and Ford were all dead by the start of the Wars. Massinger lasted until 1648; then only the inconsiderable Shirley and Davenant were left to bridge the years before the Restoration. The great and all-dominating architect Inigo Jones died in 1652. The losses to music were even greater. Byrd and Weelkes died in 1623, Orlando Gibbons in 1625, Dowland in 1626, Bull in 1628, and Wilbye in 1638. Painting alone was fortunate. Peter Lely arrived in England in 1641 and began in the manner that Vandyck and Dobson had made popular. He worked steadily all through the forties and the fifties, and his development continued until well into the reign of Charles II.

The death of the old masters left an emptiness into which new ideas and new methods could slip quite easily. England's commercial and political standing, especially under Cromwell, caused Europeans to revise their estimates of English civilization. Seeing that the land was not wholly barbarous, they came to enjoy English tolerance and wealth. And Englishmen were open to the theories of art that came in with the foreigners. In many of these theories notions of discipline, propriety and conformity took a high place. The keen interest in seventeenth-century science also encouraged the belief in a set of 'rules' by which both art and life were governed. At a time of diminishing creative force theories and rules are always attractive. Questions such as the proper subject of an 'heroic poem', a topic that had drifted around Europe since the days of Petrarch, suddenly assumed great importance to English writers. Milton, Cowley and Dryden were among those who worried themselves on this matter. Milton's deliberations came to a triumphant conclusion in *Paradise Lost*; but it is doubtful whether other poets stood to gain much from this expense of time and thought. Cowley was a representative of the unsure middle period between the Jacobean and the Restoration writers. In his zeal to make rules for a worthy heroic poem he condemned his predecessors for scattering their riches without any thought for propriety:

> It is not without grief and indignation that I behold that *Divine Science* employing all her inexhaustible riches of *Wit* and *Eloquence*, either in the wicked and beggarly *Flattery* of great persons, or the unmanly *Idolizing* of *Foolish Women*, or the wretched affectation of scurril *Laughter*, or at best on the confused antiquated *Dreams* of senseless *Fables* and *Metamorphoses*.[45]

But conformity leads to dogmatism, dogmatism to instruction, and that to propaganda. The artist having gone that far is likely to find that he has enrolled himself in the service of the state; for the state needs above all dogmatism, instruction and propaganda.

While the artist was binding himself in the cause of worthy and dignified service, the state was preparing to accept, even to demand, service from all the talents of society. Disturbed by anarchy and Civil War, Thomas Hobbes placed his great influence on the side of authority, the Leviathan. Man's natural appetites drove him towards power and gain: 'to consider them behind is glory: to consider them before is humility: . . . continually to outgo the next before is felicity: and to forsake the course is to die.'[46] These ravening propensities would only be civilized by men entering into the Social Contract, and one of the obligations of the contract was to support by all means the supreme authority of the Leviathan, the state. And this arduous work asked from each the use of his characteristic talent. Previously, the writer had been able to separate his life as a citizen from his life as an artist. In the future this would be more difficult; for did not the writer have the greatest task of all, that of drawing up the terms of the contract itself? The power of words was well recognized. Who could say whether Hobbes's work owed more to his argument, or to his strong, brutal and despairing prose? When Addison and Steele, Swift and Pope took up the direction of society, they did so not as the best men or the greatest thinkers, but according to their right as the clearest and most forceful expounders.

In other respects, too, the private world of the artist, innocent of social and political significance, was sinking away. The old system of courtly and aristocratic patronage was not as rewarding as it had been. The arts were forced to follow wealth, now more widely distributed through the community. Moreover, politics was gradually becoming the new aristocratic rage. Those who had before spent to keep amused, soon began to spend to keep in office. The last great occasion of the old patronage took place on January 21, 1640. The King already had intimations of rebellion; in the first days of the year the Council had agreed to raise an army of thirty thousand foot and three thousand horse. But at the Queen's Dancing Barn, built by Inigo Jones, the old architect and William Davenant were ready to receive the King, the Queen, the Queen's mother, the ambassadors and the courtiers for a performance of *Salmacida Spolia*, the last masque. Charles, grave in blue doublet bespattered with silver and slashed blue padded breaches, played his part as Philogenes. Amazing inventions of the old maestro Inigo Jones, Davenant's

appropriate words, and Richard's discreet music worked their spell; all were caught up in the world of illusion. Art sought to create order, and assured the worried King:

> All that are harsh, all that are rude,
> Are by your harmony subdued,
> Yet so into obedience wrought
> As if not forced to it, but taught.[47]

Despite the expense, the ingenuity, and the artistry, the magic did not last. The delicate and private world failed to conceal or reconcile the protests of the people. The money would have been more wisely spent on another regiment.

COURT CULTURE

In courts and palaces he also reigns,
And in luxurious cities, where the noise
Of riot ascends above their loftiest towers,
And injury and outrage; and when night
Darkens the streets, then wander forth the sons
Of Belial, flown with insolence and wine.

Milton, *Paradise Lost*, I, 497–502.

ENGLAND ENTERED the Restoration like a fever-patient waking from a long delirium who takes up his life with a sense of infinite relief, all terrors forgotten. But the cheerful aspect covered a weakened constitution; the memories of the ravaging interim silently attended the joys of the present.

The moment, however, demanded the return of the King. In February, 1660, cautious General Monk, testing the air before he leaped, took note of the violent mood of the London mob and, says Aubrey, promised these 'importunate children' a free Parliament. The people set the bells ringing and feasted by the light of bonfires until 'the whole citie looked as if it had been in a flame':

> Healths to the king, Charles II, were drunke in the streets by the bonfires, even on their knees; and this humor ran by the next night to Salisbury, where there was the like joy; so to Chalke, where they made a great bonfire on the top of the hill; from hence to Blandford and Shaftesbury, and so to the Lands-end: and perhaps it was so over all England.[1]

The country stirred under enormous expectations. The superheated euphoria of Robert Wild, which so excited the brokers at the Exchange that they missed their bargains through reading it,[2] seemed merely the breath of prophecy:

> But what will London do? I doubt Old Paul
> With bowing to his Sovereign will fall;
> The royal lions from the Tower shall roar,
> And though they see him not, yet shall adore;
> The conduits will be ravish'd and combine
> To turn their very water into wine.[3]

The bad taste of a bad poet was strangely justified by events: when Charles entered London on May 29 the public fountains did run with wine.[4] The King, genial, easy and dignified, received the homage of the

city at Whitehall; and when that was done he crossed the river to spend the night with Barbara Villiers, his mistress. To the sound of loud music and dubious numbers, amid hysteria and excess, with a touch of the ludicrous and some cynicism, this rather exceptional man set his reign off on its variable course.

With the return of the King and the court the prospect for the arts seemed good. As to the King's own taste, people could not be quite sure. He was, it is true, a sophisticate and pre-eminently a man of wit; but some doubted whether he had the endurance to pass from rapture to discernment. 'The reason why Men of Wit,' commented Lord Halifax, 'are often the laziest in their Enquiries is, that their heat carrieth their Thoughts so fast, that they are apt to be tired, and they faint in the drudgery of a continued Application.'[5] There were some good signs. At the Restoration Pepys had the duty of transporting the royal guitar to London. 'The King is a little musicall,' Pepys noted later, 'and kept good time with his hand all along the anthem.' Charles's ear was good enough for him to sing duets with pleasant Tom D'Urfey, and he cut an attractive figure on the dance-floor, far more so than his solemn brother James.[6] With typical Stuart enthusiasm, the King was also known to be 'a great lover of good painting'.[7] Severer critics, however, considered the royal taste to be either corrupted or dilettante; the King had the attributes of a gentleman without the instincts of a connoisseur. Roger North admitted that Charles was 'a professed lover of musick', but remarked that he liked the French kind only 'and had an utter detestation of Fancys'.[8] And Halifax could not give much credit to the King's reading:

> He had but little Reading, and that tending to his Pleasures more than to his Instruction. In the Library of a young Prince, the solemn Folios are not much rumpled, Books of a lighter Digestion have the Dog's Ears.[9]

But Charles had spent some impressionable years in France, and had learnt from the court of Louis XIV the parts required of a royal despot. Though he himself only touched the surface, he knew that he had a duty towards the arts. He agreed with Colbert, who directed for Louis the most resplendent court in Europe, that the court should be a font of beauty.

Artists, then, expected to be made happy. The joyful lines of Dryden on the coronation would serve equally well to celebrate the re-establishment of the court patronage—'Now our sad ruines are remov'd from sight, The Season too comes fraught with new delight.'[10] Familiar royalist faces began to re-appear at court. Sir William Davenant took up the laureateship which had originally come to him on the death of Ben Jonson in 1637. Old Nicholas Lanier returned, once more Master of the King's

Musick. Under him was assembled a full company of performers—
twenty-four violins, assorted instrumentalists, including a bagpiper, a
harper, harpsichordists, organists, lutenists, fifers, trumpeters, drummers
and sackbut players; there were also singers and composers. Former
companions in the King's service, such as Henry Lawes, Hudson, Mell
and Hingston, took up their musical duties at court almost as if the
Commonwealth had never intervened.[11] At the royal Office of Works there
was less sense of continuity. Hardly an official remained from the old
times. Inigo Jones was dead; the Comptroller, the Master Mason, the
Master Carpenter and the Paymaster were likewise all gone. Only John
Webb remained, and he had every expectation of the Surveyorship. But
Charles had many debts of gratitude to pay from the time of his exile,
so the deserving and competent Webb had to make way for Sir John
Denham, a poet and a gentleman but merely an amateur with 'some
knowledge of the theory of architecture' and 'none of the practice'.[12] The
position of Serjeant-Painter, vacant since the death of John Decritz, went
to Sir Robert Howard, another gentleman of slender professional qualifica-
tions; but fortunately within a couple of years Howard passed on to more
profitable sinecures, and Robert Streeter, a real painter, succeeded him.

 Artists who had built excessive hopes on the return of Charles were
quickly warned that the golden age had not come back. The court was no
resting-place for artistic talent. It felt, as usual, the contrary tugs of
politics, influence and favour; it went about its work with a familiar
capriciousness and neglect. Many found to their cost that neither their
genius nor their service qualified them to pass into the enhanced realm.
Cowley had faithfully served the royal cause. He had been imprisoned
and exiled. He had worked for the Queen Mother in France, and had not
forgotten to write a pindaric *Ode upon His Majesties Restauration and
Return*. He had been promised the post of Director of the Savoy, yet even
that small and pleasant sinecure was denied him. The court also had good
reason to thank Samuel Butler. When Lord Buckhurst introduced the
first part of *Hudibras* to the delighted courtiers in 1663, the rout of the
Puritan remnant was complete. 'Did not the celebrated Author of
Hudibras,' wrote Cibber, 'bring the king's enemies into a lower contempt
with the sharpnesse of his wit, than all the terrors of his administration
could reduce them to? Was not his book always in the pocket of his
Prince?'[13] The second part of *Hudibras* came out in 1664 to more general
praise; but somehow the solid rewards for Butler's wit did not materialize.
'He died,' Cibber went on, 'with the highest esteem of the Court—in a
garret!' Butler's poverty has perhaps been romantically overstated. He had

for a while the patronage of the Duke of Buckingham, and even the tardy recognition of the King. In 1677, fourteen years after the first appearance of his poem, Butler received from Charles a gift of £100 and a pension of £100 a year. A year later this payment was already in arrears.[14]

If loyal poets were treated like this, what hope was there for the opposition? Milton's *Defensio Populi* was burnt by the public hangman in 1660, and he retired to complete a lonely poet's work 'in darkness, and with dangers compassed round, and solitude'.[15] Bunyan endured twelve years in Bedford gaol. Only Andrew Marvell prospered, and he because he was a politician as well as an author. When Charles sent Lord Danby to Marvell with a thousand guineas, it was not for love of Marvell's poetry. He hoped to buy the conscience of a Member of Parliament, and silence that truculent and contemptuous satiric voice. But Marvell was well supported by his constituency and was able to send back the royal bribe.

The court as a vale of tears is a constant theme of history. Charles's court, muddled and venal, disappointed too. But it came in with high hopes and gaiety. It carried at the start a certain elegance, a certain tone which answered almost exactly the mood of a country growing quietly richer and impatient with the austerity of the spirit recommended by the Commonwealth. Davenant, some years before the Restoration, had perceived that new desires were stirring. He had urged the government to permit some relaxation 'to entertaine a new generation of youth uningaged in the late differences, of which there is a numerous growth since the warre'.[16] In its first days the Restoration court mirrored the temper of the people; if the court was light-headed, so too was the country. 'With the restoration of the king,' wrote Burnet with disapproval, 'a spirit of extravagant joy spread over the nation;' and he continued:

> All ended in entertainments and drunkenness, which overran the three kingdoms to such a degree that it very much corrupted all their morals. Under the colour of drinking the king's health, there were great disorders and much riot everywhere.[17]

Others found the new spirit less objectionable. The worldly Frenchmen Cominges, the ambassador, and Gramont, the playboy, registered something between surprise and appreciation; the wit and the sprightly naughtiness of English life was very cheering to exiled Parisians. 'Accustomed as he was to the grandeur of the Court of France,' Gramont reflected, 'he was surprised at the politeness and splendour of that of England.'[18] The King was decidedly distinguished, and his brother James was not without parts, though what these were—besides courage—was perhaps a little hard to say. Then there were the ladies. Never, it was true

to say, had an English King been surrounded by a bevy of such various talent. At the top of this spirited hierarchy came the royal mistresses, the most important being Lady Castlemaine and the Duchess of Portsmouth; then the stars of the aristocracy, Lady Chesterfield and Lady Shrewsbury; and last the gentlewomen of more modest social rank, but no less beautiful and no less immoral—Mrs. Middleton and Mrs. Roberts, Miss Stewart, Miss Price, Miss Brooks and Miss Hamilton, all caught forever in the appreciative pages of the Count de Gramont.

With the ladies in the ascendant, pleasure was the main business at court. 'There is a ball and a comedy every other day,' Cominges reported back to Paris; 'the rest of the days are spent at play, either at the Queen's or at the Lady Castlemaine's, where the company does not fail to be treated to a good supper.'[19] Everything but gallantry fatigued, and that was pursued with formidable energy. Suddenly all would rise like migrating birds, 'leaving one of the greatest towns in the world turned into a solitude', and take the waters at Tunbridge—'*les eaux de scandale*, for they nearly ruined the good name of the maids and of the ladies.'[20] Returning to London, they follow their desires in Hyde Park, St. James's and Spring Garden until well into the night. The ladies 'are so many Atalantas' but 'fast as they run, they stay there so long as if they wanted not time to finish the race'. The thickets were full of wicked sounds, and afterwards there was the refreshment of a collation of 'tarts, neat's tongues, salacious meats, and bad Rhenish'.[21] A lustful life and an idle one, but perhaps also idyllic and not without grace. In the summer, when the heat and the dust made the park unpleasant, the court took to the river, and to the sound of music the boats spread out round the royal barge like fireflies in the dusk, and then the fireworks added their pattern of light in the night sky.[22]

The court took its tone from its prince; the lightness and pleasantry fitted very well with Charles's character. At first, he impressed all observers with his qualities, his charm, his ease; then a certain underlying casualness and instability began to be noted so that later in his reign the voices of praise turned sour with condemnation. His very virtues were dangerous. The sly wisdom of Halifax soon found out the perils in the King's talents:

> The Thing called *Wit*, a Prince may taste, but it is dangerous for him to take too much of it; it hath Allurements which by refining his Thoughts, take off from their *dignity*, in applying them less to the governing part. There is a charm in Wit, which a Prince must resist: and that to him was no easy matter; it was contesting with Nature upon Terms of Disadvantage.[23]

Good humour and a love of ease are admirable qualities; but a prince needs sterner equipment to meet the importunities of his subjects:

2

The thing called *Sauntering*, is a stronger Temptation to Princes than it is to others. The being galled with Importunities, pursued from one Room to another with asking Faces; the dismal Sound of unreasonable Complaints, and ill-grounded Pretences; the Deformity of Fraud ill-disguised; all these would make any Man run away from them; and I used to think it was the Motive for making him walk so fast. So it was more properly taking Sanctuary.[24]

The King was tolerant, kind, and wonderfully self-indulgent. Cominges noted the pains the King went to to avoid trouble: he wished 'that each and all might have only cause to be pleased and none to complain'.[25] And Halifax less kindly wrote that Charles held the fundamental maxim 'of not purchasing anything at the price of a difficulty'.[26]

The flaws in the royal character later worked their mischief in the state. But his agreeable points had an effect too. The court over which he presided, following his notable example, was a Court of Love, not only in the obvious and lewd sense, but also in the better sense that it encouraged friendship and intellectual curiosity. The presence of women, even though they may be cynical and depraved, is a great civilizer. The high art of the Middle Ages cannot be understood without some reference to *frauendienst*, that strange doctrine of adultery and blasphemy; and the lesser art of the Restoration drew from and was encouraged by the debased Courtly Love of the time. Where an apt reply is the measure of virtue and dullness is the ultimate sin, a gentleman will be keen to polish his intellectual and artistic accomplishments. Ability in the arts displaced moral considerations when it came to judging men. Perhaps for this reason, the art of the Restoration gives an unusually exact portrait of the age. The greatest happiness was to be the subject of art; so long as the representation was witty and elegant, no one minded if it occasionally showed a shallow, conceited or lascivious subject. 'The beauties of Windsor are the court of Paphos,' wrote Horace Walpole about Lely's famous portraits: 'They please as much more as they evidently meant to please; he caught the reigning character, and

> on animated canvas stole
> The sleepy eye that spoke the melting soul.'[27]

Others glimpsed sweeter aspects of the 'reigning character'; and as Lely caught the dangerous luxuriance of the court, Dryden in his *Essay of Dramatic Poesy* caught the friendly spirit of enquiry of the age; in the finest prose of the Restoration he portrayed the finest manifestation of the Restoration mind. Lord Buckhurst, Sir Robert Howard, Sir Charles Sedley and Dryden, on that summer day at the height of the Dutch War, take to the river in search of peace and reflection:

and then, every one favouring his own curiosity with a strict silence, it was not long ere they perceived the air break about them like the noise of distant thunder, or of swallows in a chimney: those little undulations of sound, though almost vanishing before they reached them, yet still seeming to retain somewhat of their first horror, which they had betwixt the fleets.[28]

Civilized men, they leave behind the noise and horror of temporal ambition, and embark upon the rational discussion of inquisitive minds. This pleasant and easy scene was naturally heightened by Dryden's great talent, but it gives a true picture of the arts in action; for Dryden's critical opinions were slowly tempered and refined through his lifetime by a process of extended conversation with his artistic friends: so the Dedication to *The Rival Ladies*, in 1664, was addressed to the Earl of Orrery and admitted the influence of his lordship's practice; Sir Robert Howard, the Crites of the *Essay of Dramatic Poesy* and the poet's brother-in-law, was the friend and disputant of the important series of essays which began with the Preface to *Annus Mirabilis* in 1667 and ended in the next year with the *Defence of an Essay of Dramatic Poesy*; and the last of Dryden's critical works, the Preface to *The Fables* printed in the year of his death, was addressed to the Duke of Ormond.

For a poet to perfect his art with the critical help of friends was nothing new. A century before Edmund Spenser and Gabriel Harvey had discussed poetic theory and made experiments in versification in many a heavy letter. And several later groups as varied as the dark 'School of Night' of Raleigh and Chapman, and Jonson's bibulous 'Sons of Ben' had applied their attitudes to the mysteries of art. What was new in the case of Dryden and his contemporaries was the extent to which a common interest in art bound together people from differing walks of life and rank of society. One cannot pretend that Dryden was a social intimate of Lord Buckhurst, or the Duke of Ormond. But he was allowed some artistic equality; without this their lordships would have passed him blindly in the street. At the Restoration the arts helped towards social cohesion, and were all the stronger for doing this. Charles, of course, partly secured this common ground by his genuine interest in the arts. Any man of talent who could insinuate himself through the hedges of etiquette and privilege, and then catch the King in an interval between his energetic sauntering, was almost sure of an easy welcome. The course was not always simple, as Dryden himself found out; the difficulties of court intrigue were manifold and spectacular, and the aspiring poet often needed to plan a cunning campaign to attract the royal attention. Dryden, who was more assiduous than most in these matters, first prepared an assault on the outworks of influence. A work could not be dedicated to the King without permission,

so Dryden began in the farther reaches of the royal family with a dedication of *The Indian Emperor* to the Duchess of Monmouth, in 1665; then he mined towards the royal favour with further dedications to the Duke of Monmouth in 1668, and the Duke of York in 1669, and to tie up the business even more surely he did not forget to throw in a poem to Lady Castlemaine and another to the Duchess of Portsmouth.[29] The campaign was successful. In 1668 Dryden followed Davenant as Poet Laureate and two years later added Historiographer Royal to his official title, the salary from these two positions coming to £200 a year.

Not everyone received money as a reward for the King's attention. But once Charles's eye was caught, he was likely to give the new talent a considerate interest. Sir Samuel Tuke and John Crowne followed the King's advice in their choice of plots; Dryden was pleased to incorporate some royal alterations into his play *Aurengzebe*, and even more pleased when his majesty took *The Maiden Queen* under his special protection and designated it 'His play'.[30] Charles was so often in easy conversation with writers, painters, philosophers and men of taste that these occurences became the commonplaces of the diaries of the times. We see him discoursing with Evelyn on English houses and gardens;[31] or passing the time with Lely whose talk was 'as agreeable as his pencil';[32] or sitting for his portrait at the house of Samuel Cooper, 'the prince of limners of this last age', where after a while Thomas Hobbes came in to divert the company:

> Here his majestie's favours were reintegrated to him [Hobbes], and order was given that he should have free accesse to his majestie, who has always much delighted in his wit and repartees.[33]

No wonder that when Evelyn, in 1671, found an obscure young man called Grinling Gibbons working alone in a thatched cottage in the middle of a Deptford field, he should hasten to bring this young paragon, whose 'curiosity of handlinge, drawing and studious exactness, I had never before seen in all my travels', to the notice of the King:

> Of this young artist, and the manner of finding him out, I acquainted the King, and begged that he would give me leave to bring him and his worke to Whitehall, for that I would adventure my reputation with his Majesty, that he had never seen any thing approach it; and that he would be exceedingly pleased, and employ him. The King said he would himselfe go to see him. This was the first notice he had of Mr. Gibbons.[34]

But the King's interest was only part of the reason for the lively community of the arts in the Restoration. The enthusiasm which the King fostered had, like many another social manifestation, begun in the age of the Commonwealth. The revulsion from the Wars, the democratic

learnings of the Puritans, the seventeenth-century rise in scientific curiosity, the emulation of France and Italy—all had to some degree encouraged a banding together of like-minds in pursuit of knowledge and gentle arts. As early as 1646 Robert Boyle had written of an 'invisible college'; by 1649 the loose beginnings of the Royal Society were in evidence at Oxford where 'the principall reviver of experimentall philosophy', John Wilkins of Wadham, had 'weekly an experimental philosophicall clubb'.[35] Soon the fraternity spread to London where they met at the Bull's Head Tavern in Cheapside, and later at Gresham College. By the end of 1660 the club had swelled to fifty-five members, each paying a subscription of a shilling a week. Charles, as one might expect, smiled on this enterprise; on July 15, 1662, the Royal Society received a charter of incorporation.

The first work of the Royal Society was the advancement of experimental science, and the founding members—including such eminent figures as Wilkins, Seth Ward, William Petty, Laurence Rooke and Christopher Wren—were all to some extent scientists. But the boundaries of science were not very well marked, and the Royal Society became a pen which collected notable intellectual specimens from all sides of life. The membership climbed quickly over the two hundred mark, as representative a sampling of English talent as one was likely to find; Dryden, Evelyn and Aubrey mixed quite easily with their more strictly scientific brethren. Naturally, Samuel Pepys was also a member.

The creation of the Royal Society did not go entirely unopposed; even Samuel Butler had a mild satiric blast at it. But what with the quality of its members and the royal approval its example was noted and its methods imitated. 'My whole discourse was sceptical,' wrote Dryden in the *Defence of an Essay of Dramatic Poesy*, 'according to that way of reasoning which was used by Socrates, Plato and all the Academics of old, which Tully and the best of the Ancients followed, and which is imitated by the modest inquisitions of the Royal Society.'[36] Braced by this very respectable lineage, men of taste turned themselves into peripatetic disputants, taking their friendly arguments into private homes and coffee-houses with an unwearying enthusiasm so clearly shown in the cheerful pages of Pepys.

The temper of the arts at the Restoration was, in the best sense, amateur. Mere physical conditions—the intimacy of the court, the attention of the King, the congregations of learned men—helped to make this so. Also, much of what carried over from the traditions of the last age was courtly and amateur. Poets in 1660 were enrolled, as Dryden recalled, under the elegant banner of Mr. Waller.[37] The most grand buildings in London were

those Inigo Jones had put up for the first Stuarts, and the most original architect left at the Restoration was Sir Roger Pratt, an aristocratic gentleman soon to be at work on Lord Clarendon's magnificent house in Piccadilly. Music had been supported through the Commonwealth largely by private and amateur performance and this did not stop with the Restoration. The theatre, the most professional of the arts, did not rely on amateur enthusiasm; but even it received an onslaught after 1660 from the aristocratic wits. Gentlemanly ideals, and a true interest, demanded that a person show some proficiency in the arts. Even the wits 'talk of Philosophy, History, Poetry, as if they came into company to study'.[38] And the occasions of social life in a court so devoted to pleasure gave opportunities for the talented to shine, a chance they were quick to take. Charles's partiality for the guitar, said the Count de Gramont, 'brought the instrument so much into vogue, that everyone played upon it, well or ill; and you were as sure to see a guitar on a lady's toilette, as rouge or patches'. The Duke of York played the instrument pretty well, and the Earl of Arran like the master Francesco Corbetta himself. Gramont goes on to relate one of his spicy stories of intrigue, immorality and jealousy involving the notorious Lord and Lady Chesterfield, the Duke of York and Lord Arran, all to the soft background music of a guitar saraband. While the accomplished fingers of Arran performed their magic, his sister Lady Chesterfield had designs on the duke while her husband stood by and fumed:

> A thousand suspicions blacker than ink took possession of his imagination, and were continually increasing; for whilst the brother played upon the guitar, the sister ogled the duke, as if there had been no enemy to observe them. This saraband was repeated more than twenty times, the duke declaring that it was played to perfection. Lady Chesterfield marvelled at the composition; but her husband, who clearly perceived that he was the person played upon, thought it a most detestable piece.[39]

Had the arts ever been so much in demand, and so intermixed? It seemed as if the rage for music swept London as thoroughly as the Great Fire itself. No event appeared complete without musical accompaniment. 'Sometimes,' wrote Hamilton of Gramont, 'he had complete concerts of vocal and instrumental music, privately sending to Paris for the performers, who struck up on a sudden in the midst of these water parties.'[40] Sir Robert Carr courting Mrs. Bennet also gave an entertainment on the water, and Evelyn was there to remark the music and the banquet at Mortlake.[41] Pepys, at Windsor, was in the company he loved so much— 'young ladies and gentlemen, who played on the guitar, and mighty merry.'[42] No business, no affair, was so important that it could not give way to music. The great Duke of Buckingham kept a private band, 'the beste

in towne';[43] Lord Sandwich, wrote Pepys, went not 'one day through all his different scenes of life at land and sea' without 'the actual solace' of music—his lordship even had an organ set up in his dining room.[44] Blind Sir Samuel Moreland performed psalms on his theorbo; Sir Roger L'Estrange, the king's pamphleteer, was an accomplished hand on the viol; Sir Edward Sutton played excellently on the Irish harp, and Sir Francis Prujean performed on the polyphone, 'a sweete instrument, by none known in England'.[45] There was music, too, when Evelyn dined with Sir Robert Reading and with Lord Falkland.[46] The family of the Norths were fanatics, almost more musicians than lawyers. Francis, Lord Keeper Guilford, published in 1677 *A Philosophical Essay on Musick*, and invited Purcell home to perform with him. Roger and Charles North were both skilful players, accustomed from childhood to read music at sight.[47] And as for Samuel Pepys, proficient on several instruments, composer and employer of a musical serving-man, he wrote 'musique is the thing of the world that I love most'.[48]

The best music, of course, was heard in the rich households, though not all the important people were fond of it; Lord Lauderdale for one hated 'the lute most, and next to that, the bagpipe', and claimed 'that he had rather hear a cat mew, than the best musique in the world'.[49] But the appreciation of music, as one might have expected from Commonwealth times, extended well below the highest ranks of society. In the flight from the Great Fire Pepys saw 'hardly one lighter or boat in three, that had the goods of a house in it, but there was a pair of Virginalls in it'.[50] Much of the education of the time seemed to include some musical training. The boys at Christ's Hospital sang well enough, and so too did those at Eton.[51] The musicians Banister and Hart kept a boarding school for boys and girls at Chelsea. Purcell set *Celestial Music did the Gods Inspire* for the students at Maidwell's school, where it was performed in 1689; and the young at Josias Priest's Academy were advanced enough to perform Purcell's *Dido and Aeneas*.[52] There are also some other indications of a fairly wide-spread knowledge of music. Purcell's songs published in the *Gentleman's Journal* took for granted an ability to accompany from a figured bass.[53] And Dryden, in *The Kind Keeper*, portrays a maid able to sing at sight. Dryden himself, the complete artistic man of the age, did not neglect music. His excursions into dramatic opera naturally threw him in with composers, Draghi and Purcell for example. And although Dryden did not seem to have a finely-tuned ear—when preparing the songs for *King Arthur* the poet and Purcell fell out over that hoary old question, the relative value of words and music—at least he had the sense to recognize

musical genius. He had saluted the rising Purcell in the Dedication to
Amphitryon; in the Dedication to *King Arthur* he recognized the mature
master: 'There is nothing better than what I intended but the musick,
which has since arrived to a greater perfection in England than ever
formerly; especially passing through the artful hands of Mr. Purcell, who
has composed it with so great a genius, that he has nothing to fear but an
ignorant, ill-judging audience.' He had such an opinion of the young
composer's ability that to help the subscription edition of the instrumental
music to *The Prophetess* he wrote a preface which he allowed to be
printed under Purcell's name.[54]

Music was not the only artistic passion of polite society. The taste to
enjoy painting, and even perhaps an inclination to dabble, was considered
a good part of a gentleman's equipment. Men like Evelyn prided them-
selves on their connoisseurship. Evelyn was for ever in and out of studios
and did not hesitate to give judgment on the merits of contemporary
painters. Lely he hardly mentioned; apparently he had no great opinion of
him. Cooper, Verrio and Michael Wright—who signed himself 'pictor
Regius'—received more praise. Indefatigible Pepys could not be kept
from any fashionable venue, so he too was frequently among artists.
Unlike Evelyn, Pepys often mentions Lely, but his good sense found the
pretensions of the painter ludicrous but irresistible: 'Went to Lely, the
great painter,' he noted, 'and then to see in what pomp his table was laid
for himself to go to dinner.'[55] Pepys, in his small way, was also a patron of
painters, and had his wife's portrait done by both Hayls and Cooper.
Simon Varelst showed the diarist a drawing of a 'little flower-pot'—'the
finest thing I ever saw in my life'—for which Pepys tried to knock the
price down from £70 to £20.[56] Cooper was also a friend of John Aubrey who
had many acquaintances among artists and sculptors—Wenceslas Hollar,
David Loggan from Danzig, Edward and William Marshall, Bushnell and
Caius Cibber (father of Colley Cibber).[57] The Norths, for all their devotion
to music, had time left for painting. Lord Guilford was a good friend of
Lely, and Roger North was the painter's executor. Painting and poetry
was a popular a mixture as music and poetry. Robert Streeter, the
Serjeant-Painter, in 1671 produced new scenes at the Theatre Royal for
Dryden's *Conquest of Granada*. When Evelyn saw Part I of the play in
February, he commented very favourably on the 'very glorious scenes and
perspectives, the work of Mr. Streeter, who well understands it'.[58] Dryden,
of course, had his opinions on painting; in 1694 he also translated Du
Fresnoy's *Art of Painting*, thus earning the gratitude of Kneller and
Clostermann. And to show that scientists were not behind hand in

appreciation, Robert Hooke was for a time a pupil to Lely. Some even attempted to combine equal ability in two arts. Dryden celebrated Mrs. Anne Killigrew, who died in 1685 'to the unspeakable reluctancy of her relations' aged twenty-five, for her double talent in poetry and painting.

> Her pencil drew whate'er her soul designed,
> And oft the happy draught surpass'd the image of her mind

the poet laureate wrote unconvincingly in his ode which Dr. Johnson called 'undoubtedly the noblest that our language has produced'.[59] And Thomas Flatman went one better than Anne Killigrew, being lawyer, poet and painter.

If music and painting were often invaded by amateurs, architecture seemed to be entirely in the possession of amateurs. At the time of the Restoration, John Webb was perhaps the only professional architect in England, though masons such as Mills and Marshall were quite capable of designing buildings. The other architects of the time were mostly self-educated gentlemen who had studied the correct classical authorities, and had done the rounds of famous buildings in France and Italy. They had sufficient self-confidence to see their ideas put into practice. Architecture in England had always been under the particular patronage of the court, so the emergence of these gentlemanly architects was not surprising; to courtiers the notion of professionalism is not attractive. At the Restoration, the Office of Works was put in the hands of two of these learned amateurs —Sir John Denham, poet, became the Surveyor and Hugh May, virtuoso and friend of Evelyn, Roger North and Lely, was the Paymaster. Neither of them was completely incompetent at building. Denham, it is true, was not very distinguished; but May had several quite notable houses to his credit including Eltham Lodge, Berkeley House in Piccadilly and Cassiobury. He also remodelled Windsor Castle for the King. The tradition which these men represented may have been unfair on poor professionals like Webb, but out of this tradition came the most spectacular achievements of English architecture. For Christopher Wren, Savilian Professor of Astronomy at Oxford, was bred to architecture in much the same way as Sir Roger Pratt, or Hugh May. As a man of various and brilliant scientific achievement, Wren had turned almost casually to architecture. The model for the Sheldonian Theatre which Wren presented to the Royal Society in 1663 was merely the clothing round an interesting engineering problem. The Sheldonian was to demonstrate his method of carrying a ceiling over a large span by means of a trussed roof. Having shown his hand, and considering his well-known mechanical ingenuity, Wren was soon swept into the business of building and design.

2*

When the problem of what to do about the collapsing fabric of Old St. Paul's came up, the artful Dr. Wren was a natural person to turn to. Denham, Pratt and Wren presented three different remedies for the old building. On September 11, 1666, a mere six days after the flames of the Great Fire were under control, Wren was ready with a sketch for the new St. Paul's. Other plans were submitted by John Evelyn and Robert Hooke, Gresham Professor of Geometry. On September 13, a royal proclamation announced six commissioners for the rebuilding of the City. The three King's men were May, Pratt and Wren, and the three City representatives were Hooke, Jerman and Peter Mills.[60] Of these six men, the first four were gentlemen practitioners, though all four had designed buildings and two—Pratt and Wren—were exceptionally talented. It was, however, a triumph of amateurism.

As the passion to be an amateur of the arts was so wide-spread throughout society, the young aristocrats of the Restoration court, men with money and leisure, took to the arts with the greatest enthusiasm. These were the men who felt that they constituted the society of the Wits. At first, no doubt, recalling the respectable traditions of their forebears under the early Stuarts, they saw themselves as handmaids, intermediaries between deserving talent and the fountainhead of money and favour at the court. Slowly they progressed to become arbiters of taste, and finally entered the productive ranks of artist themselves. They became both patron and practitioner. On New Year's Day 1662, Dryden had addressed to Lord Clarendon a poem begging the Chancellor to use his influence with the King for the benefit of poets.[61] Within a few years Dryden's plays were competing on the stage with the works of aristocrats like Buckingham, Orrery, Newcastle, Sir Robert Howard and Sir Charles Sedley. This was a competition which the professional man of letters could well have done without. The relation between the aristocratic wits and the poor writer who had to struggle for a living was strangely undefined. This breed of aristocrat has passed out of existence. In our century of the common man, who can understand them, or know what was in their minds? Sometimes wit and poet seemed to share a real friendship based on a common respect for the writer's craft. In 1673, Dryden dedicated *Marriage à la Mode* to Rochester, acknowledging the Earl's 'ties of friendship' and 'practice of generosity'; Rochester's conversation, he said, had been the model for comic writers of the age. And in the same year, dedicating *The Assignation, or Love in a Nunnery* to Sir Charles Sedley, he spoke of his 'genial nights' with the wits:

 Where our discourse is neither too serious, nor too light; but always pleasant,

and for the most part instructive: the raillery neither too sharp upon the present, nor too censorious on the absent; and the cups only such as will raise the conversation of the night, without disturbing the business of the morrow.

But occasions for intimacy were rare. At other times, Dryden, who abased himself in many an abject dedication, knew his place. He was not to presume, and to take the handouts with gratitude and the criticisms with humility. Perhaps patrons in the past had been more gentle to the talent they supported. But then they could afford to be, for their reputation depended on their generosity not on their wit. Now patron and client were harnessed in the same race, both striving for the golden apples of fame. 'Your Lordship has but another step to make,' wrote Dryden to Rochester, 'and from the patron of wit you may become its tyrant, and oppress our little reputations with more ease than you now protect them.'[62] How right poor Dryden was! Aristocrats did not like to be out-run in the stakes for reputation.

The contribution of the wits to the artistic life of the country was, like their personality, equivocal. Sometimes they oppressed and domineered through arrogance and jealous. But some of them, and in particular Rochester, were men of great talent whose works stand up with the best of the age. And most of them had real taste and appreciation; they wished to encourage, and when they could forget their pride, their reputations and their quarrels they gave money and time generously to the deserving. The patrons of the Restoration are best known for their services to literature, and writing was the art that needed their generosity most. The other arts were still to some extent in the royal service—the King's Musick and the Chapels Royal for musicians, the Office of Works for architects, and the Office of Works too for painters who were also much in demand by the court for portraits and wall decoration—and the prosperity of these arts depended much on the strength of the royal department. None the less, men like Sandwich, Brouncker and Guilford were very good to musicians. Painters, too, though fairly independent, valued their aristocratic contacts. Walpole reports that Lely was embittered in his old age not only by his jealousy of the rising Kneller, but also because people like Buckingham and the Duchess of Portsmouth were now showing favour to other painters.[63] The Duke of Buckingham over a number of years maintained a magnificent establishment. At one time or another he had included in his retinue Hugh May, the architect, Samuel Butler, the poet, and a band of fiddlers almost rivalling the King's. But literature was the passion of the wits; hardly a writer of the age failed to get some help—and some brick-bats too—from the aristocratic galaxy—the Duke of Buckingham, the

Earl of Rochester, the Earl of Mulgrave, the Earl of Dorset, Sir Charles Sedley to name only the best known.

Of these, the most remarkable patron was without doubt Charles Sackville, Lord Buckhurst and, after 1677, Earl of Dorset. Buckhurst, in his youth, had done the fashionable round of debauchery, but unlike Rochester he had remained genial and unembittered. By the time he put on the responsibilities of the Earldom he was a long way towards wiping out the indiscretions of youth by his kind attention to writers. At the end of the century, when relations between poet and patron were unhappy and disillusioned, Matthew Prior exempted Dorset alone from his anathemas on the perfidious race of patrons:

> All my Endeavours, all my Hopes depend
> On you the Orphans, and the Muses Friend;
> The only great good Man, who will declare
> Virtue and Verse the object of his Care;
> And prove a Patron in the worst of Times.[64]

Had Prior said anything else he would have been extremely ungrateful, for Dorset had discovered the young poet serving in his uncle's Rhenish Wine House, in Cannon Row. There, in 1674, Dorset had gone to meet his drinking companion, Fleetwood Shepherd, and there he found the young Prior construing Latin: 'and the Earl of Dorset from that moment determined that Mr. Prior should pass from the station he was then in, to one more suitable to his promising abilities.'[65] Prior went to Westminster School and Dorset paid part of the expense. This kindness was typical of Dorset who was always on the look-out for talent. John Oldham, an usher at Croydon School and an aspiring poet, was surprised one day in 1678 to find Dorset, Rochester and Sedley outside the door waiting to visit him.[66] The results of this visit are not known, but soon Oldham passed on to a more profitable position, becoming tutor to the grandsons of a judge and meeting Dryden and all the other names in the enchanted circle of the wits.

> It seems by your obliging kindness to the Poets, and your great example in writing, as if you were design'd by Heaven, among many other great uses, for the sustaining of declining Poetry.

So wrote Shadwell to Dorset in the Dedication to *The Miser*, and to many poets, great and small, it must have seemed like the only truth. All the needy, from hard luck, idleness, desperation or want of talent, were sooner or later likely to turn to the good Earl of Dorset. And hardly anyone was sent away. Shadwell had Dorset to thank for the laureateship when Dryden went into disgrace; Nahum Tate who followed Shadwell

had the gift from the same hand. All kinds of other lame spirits came
limping. Tom D'Urfey, whom Prior caught so exactly—

> And all Retreats except *New-Hall* refuse
> To shelter *Durfey*, and his Jocky Muse;
> There to the Butler, and his Grace's Maid,
> He turns, like Homer, Sonneteer for Bread;
> Knows his just Bounds, nor ever durst aspire
> Beyond the swearing Groom, and Kitchin fire.[67]

besides his place in Albemarle's kitchen at New Hall, had also his own
room above Dorset's dairy at Knole. In a *Scene in the Steward's Room at
Knole*, van der Gucht has painted D'Urfey at ease among those he knew
best—the steward and the servants.[68] Sir Richard Blackmore, tedious epic
poet, and Richard Flecknoe, epitome of dullness, complimented Dorset.
Dim playwrights—Brady, Higden, Medbourne, Fane—sued for Dorset's
attention; the critics Rymer and Dennis prepared their weighty dedica-
tions. Nor did the ladies forget him. Sixteen-year-old Catherine Trotter
sent her play, *Agnes de Castro*—'This little Off-spring of my early Muse.'
'To you alone,' wrote Susannah Centlivre, 'the muses pay their grateful
tribute;' and for the redoubtable Aphra Behn, Dorset was 'a Hero more
than half a God'.[69] The Earl was the magnet that drew all the dull metal of
literature. Even Tom Brown and his riotous companions petitioned for
funds to keep them in drink:

> My Lord, we are Four or Five, some say Honest, others Foolish, but all say
> Drunken Fellows, now drinking Your Lordships Health at the Tavern; and our
> Poetical Inclinations are all attended with Poetical Pockets. Some of us have
> Six-pence and Eight Farthings, some neither Eight Farthings nor a Sixpence;
> so that the chiefest of our dependance is upon the strength of this Dedication.
> And since the Majority of Us are too dirty for Your Levee, we have pick'd out
> the nicest Spark of us All, to make this present by.[70]

All hands were in his pocket, but amiable Dorset was no fool. Two
incidents testify to his taste and general culture. First, in the words of
Jonathan Richardson, the eighteenth-century painter:

> *Dr. T. Robinson* told me that it was my *L. Dorset* that made *P. Lost* [Paradise
> Lost] first taken notice of: that he light upon it by Chance in Little Brittain,
> reading a few lines was so pleas'd with it that he bought it for a Trifle, for it was
> then but waste Paper & when He came home read it many over, & sent it to
> Dryden to know his opinion of it. *Dryden* had never seen it before, but brought
> it back to Him, & told Him *that Poet had cutt us all out*.[71]

In 1688 Dorset was one of the subscribers to Tonson's lavish edition of
Paradise Lost. Secondly, when Tate edited Davies's *Nosce Teipsum* in
1697, he admitted he had never seen the poem until Dorset gave him a

copy. Though pestered by small fry, a man of Dorset's learning and distinction was bound to attract the great talents as well. At his two houses, Knole and Copt Hall, he entertained with an easy style. In the Poet's Parlour at Knole hang the portraits of the men Dorset admired—Dryden, Congreve and Wycherley all painted by Kneller; Prior, Garth, Rochester, Flatman, Cowley, Jonson, Waller, Milton, Otway and Butler by other painters. There, too, are the pictures of Newton, Locke and the actors Betterton and Mohun. Some of these were respected names from the past, but of the rest, many were Dorset's acquaintances and some were indebted to him. From Ratisbon, George Etherege, a lonely and bored envoy of the government, recalled 'the content you enjoy at Copt Hall now', remembering perhaps the occasions when Dorset sat as Maecenas to his feasting friends and distributed his largesse sometimes with tact though always with wit. John Dryden was often a guest, receiving one Christmas Day a £100 note under his plate, and another time a promissory note for £500.[72] Dorset was the most faithful of Dryden's patrons, ever ready with money and advice. Even when politics and religion forced them officially apart, and in 1689 Dorset as Lord Chamberlain removed Dryden from his position of poet laureate, Dorset still gave his private support.[73] The gifts of money continued, the hospitality was waiting at Knole. All this the poet repaid with his gratitude, his genius, and outrageous flattery.

Thomas Otway was another who felt he owed a large part of 'his well being' to Dorset, and dedicated to him two plays—*Alcibiades* in 1675 and *Friendship in Fashion* three years later. Otway's sad career was full of misfortune, and he later complained of his hard lot. Not all deserted him. Perhaps Dorset's hand can be seen in his appointment to tutor Nell Gwynne's royal bastard; for Nell's steward was Fleetwood Shepherd, one of the company of the wits and Dorset's bosom companion. Dorset also commissioned from Gerard Soest the portrait of Otway that now hangs at Knole.[74] If Otway in his disappointments was forgetful of Dorset's attentions, William Congreve knew well to whom a poet's thanks were due. His elegant dedication to *Love for Love* is the best expression of Dorset's high place in the arts:

> Whoever is King, is also the Father of his Country; and as no Body can dispute Your Lordship'd *Monarchy* in *Poetry*; so all that are concerned, ought to acknowledge Your Universal Patronage:

In the first years of the Restoration Dorset had introduced *Hudibras* at court, thirteen years later he made himself responsible for the success of Wycherley's *Plain Dealer*. He was indeed the universal patron.

Bishop Burnet, a rather solemn man, felt one might have affection for Dorset, but could hardly approve of him:

> He is bountiful to run himself into difficulties and charitable to a fault, for he commonly gives all he has about him, when he meets an object that moves him. But he was so lazy that, though the King seemed to court him for a favourite, he would not give himself the trouble that belonged to that post.[75]

A man who lacks moral endeavour and high seriousness is inclined to rate somewhat low in a bishop's book. But Dorset was the star of another little world, and that world had a curious and spirited vitality of its own:

> The most ingenious Persons of their Nation, meet either in Places of promiscuous Company, as *Coffee-houses*, or in *Private Clubs*, in *Taverns*. Among the first *Will's* Coffee-house in *Covent* Garden, holds the first Rank, as being consecrated to the honour of *Apollo*, by the first-rate Wits that flourish'd in King *Charles* II's Reign, such as the late Earl of *Rochester*, the Marquis of *Normanby*, the Earl of *Dorset*, Sir *Charles Sidley*, the Earl of *Roscommon*, Sir *George Etherege*, Mr. *Dryden*, Mr. *Wycherly*, and some few others; and tho' this Place has lost most of its illustrious Founders, yet it has ever since been supported by Men of great Worth . . . being accounted the Temple of the *Muses*, where all *Poets* and *Wits* are to be initiated.[76]

For another view of the wits at work, we see them making their light-hearted patterns in George Etherege's effervescent play, *The Man of Mode*.

The world of the wits reflected the ideals of Charles's court. It had much to be said for it—friendship, curiosity, stimulation, mutual help and reverence for artistic accomplishments. 'The Court,' wrote Dryden, 'is the best and surest judge of writing;'[77] the reign of Charles II was the last occasion in England for anything like a court-art. In such a considerate air, the arts should have flourished. But the results were strangely mixed, and the works which drew their inspiration from the world of the court are the most disappointing. At the time of the Restoration, the artistic fashions were in general those of the past age. The stream ran unbroken from Charles I to Charles II, though agitated a little by the shoals and rocks of the Commonwealth. In architecture, Roger Pratt developed the genius that had first appeared in Coleshill and which culminated in Clarendon House, begun for the Lord Chancellor in the early years of the Restoration. Hugh May helped to promote the Dutch style which Gerbier and others had touched on in former years. And John Webb, building the new block at Greenwich Palace in 1665, continued as if the ghost of Inigo Jones had personally approved the plans. In painting, the lengthy series of Stuart portraiture continued, now more lively and less proper, but in the line of true descent from Vandyck. Music was in a state of expectation; the old masters were dead and the new wonder,

Henry Purcell, was only a year old at the Restoration. Even so, when Purcell began his career in the last years of Charles's reign, Burney judged him to be quite at home in the old, elaborate style of Byrd, Tallis and Gibbons. In literature, lyric poets were under the tutelage of Edmund Waller and Sir John Denham, whose *Cooper's Hill* was 'the exact standard of good writing'.[78] Davenant's *Siege of Rhodes* had set the heroic play on its way, and comedy acknowledged Ben Jonson as the master.

This was the state of art inherited by the Restoration. It was a fair inheritance and one which pleased the court society well enough. And, considering the delight of the court in art, one would expect art to develop very much under court auspices. Development there was indeed, but not much of it was inspired by the court.

Two extraordinary events—the destructions of the Great Fire and the all-dominating genius of Christopher Wren—made architecture a special case. On the death of Denham in 1669 Wren became Surveyor, and the rebuilding of St. Paul's may be seen as part of the royal patronage. But Wren, perhaps because he was so exceptional, did not stand in the main line of development. Clarendon House was the most imitated house of the age and its architect, Sir Roger Pratt, never had any connection with the royal Office of Works. And though Wren, the Surveyor, redesigned the burnt City churches, his employer then was the City. The three Commissioners nominated by the Rebuilding Act of 1670 were the Archbishop of Canterbury, the Bishop of London and the Lord Mayor. In spite of Wren's achievements the declining influence of the Office of Works first peeped out about this time. When speculators like Nicholas Barbon started to reconstruct London after the Fire, their buildings showed a varied Dutch and English Influence, but not much evidence of Wren and his colleagues. And after Wren the major architects had less and less to do with the royal Works. Hawksmoor, Wren's great assistant, never rose above humble rank in the Works; and Vanbrugh, though suddenly elevated to Comptroller by a piece of transcendent political jobbery, never became Surveyor.

Nor was painting helped by court attitudes. The fashion for portraits continued unabated, almost to the exclusion of any other type of picture. A master like Lely developed his technique, but not his ideas: he was bound by the attitudes of his sitters. The task which the court had allotted to him was 'to paint blatantly alluring sex',[79] and the *Windsor Beauties* are proof that he did his duty. As a celebratory painter he had more success with the *Flagmen* at Greenwich. In this series of the sailors who took part in the Dutch War, Lely had a nobler theme to praise, and the

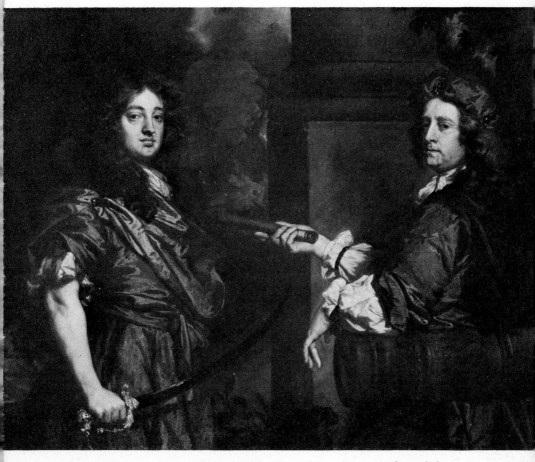

Lely was particularly successful in his portraits of English
sailors

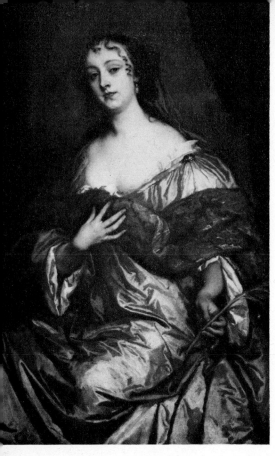

One of Lely's *Windsor Beauties* from the licentious court of Charles II, and one of Kneller's *Hampton Court Beauties* from the staider time of William and Mary

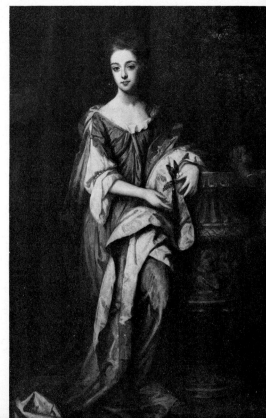

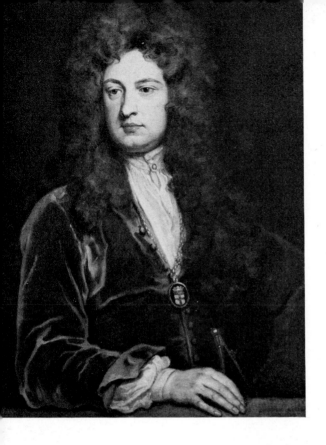

Two of the Kit-Cat portraits,
painted between 1702 and 1717

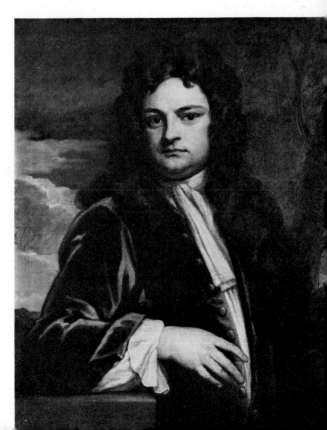

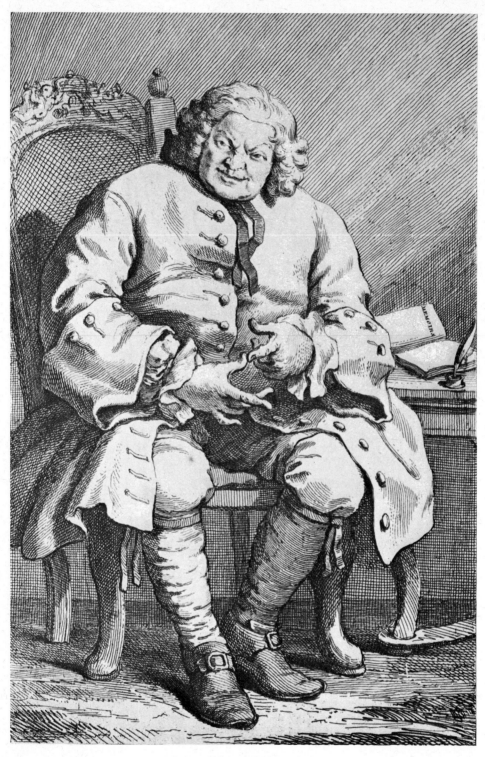

In 1746 Hogarth went to St. Albans especially to sketch Lovat,
later executed for his part in the Forty-five uprising

uncompromising strength of these admirals appealed to his serious mind. But at other times he catered to the unpleasing foibles of his courtly sitters quite unabashed. In 1664, he presented Barbara Villiers and her royal bastard as the Madonna and Child. And Vertue records that he gave another royal mistress, the Duchess of Portsmouth, and her bastard the same honour. He also at the King's request painted Nell Gwynne naked, often while the appreciative Charles looked on. Besides portraits, the only other type of painting encouraged by Charles's court was wall and ceiling painting. The Neapolitan, Antonio Verrio, who arrived in England about 1670, was the most successful of this type, doing much work for the King at Windsor Castle. Walpole found his efforts unattractive:

> an excellent painter for the sort of subjects on which he was employed; that is, without much invention, and with less taste, his exuberant pencil was ready at pouring out gods, goddesses, kings, emperors and triumphs, over those public surfaces on which the eye never rests long enough to critise, and where one would be sorry to place the works of abetter master: I mean ceilings and staircases.[80]

Verrio at least has a sense of humour, for he placed Shaftesbury on one of his ceilings as Faction dispersing libels; and he borrowed the ugly face of his housekeeper, with whom he had quarrelled, for one of his Furies. But the cause of painting was not much advanced by the court's patronage of Verrio and his like.

As to music, the years of the Restoration court did neither much good nor much harm. Music, being the purest of the arts, usually has slower and longer lines of development than most, less troubled by politics and ambition. Events in Italy and France had set music on a certain course and the most Charles could do was salute it as it went by. His tastes, however, seem to have been in touch with the prevailing taste. Tudway wrote of him:

> His Majesty, who was a brisk and airy Prince, coming to the Crown in the flow'r and vigour of his Age, was soon, if I may so say, tyred with the grave and solemn way, and ordered the Composers of his Chappell to add Symphonys, &c., with Instruments to their Anthems....[81]

The best course for the King was to employ as many musicians as possible, and this to some extent he did, filling out the complement in the King's Musick and the Chapels Royal. He also, said Tudway, encouraged the compositions of Pelham Humfrey and John Blow. But other events were affecting music too. There had been some technical changes at the Restoration. Since many organs had been destroyed under the Commonwealth, there was a need for new ones. The builders—particularly

Renatus Harris and 'Father' Smith—took the opportunity to improve the instrument. When Smith provided the new organ for the Temple he added two quarter-tones to each octave—Ab and D♯—thus bringing into service four more keys.[82] The new organs helped the advance of church music which was popular anyway, if only because it had suffered such a set-back in Parliamentary times. 'Here I heard very good music,' wrote Pepys after a visit to the Chapel Royal in 1660, 'the first time that ever I remember to have heard the organs and singing men in surplices in my life.'[83] Violins, too, were suddenly everywhere. Not long before, even so keen a musician as Anthony Wood had to be advised that the fiddle, unlike the viol, was tuned in fifths, so uncommon was the instrument. After the Restoration, the King had twenty-four fiddlers, Buckingham had his own string band, and the violin, much to the disgust of Evelyn,[84] was even taking the place of the cornet in the instrumental sections of the anthem. This natural evolution of music was not much influenced by the King and court. Even the type of music provided by the royal musicians was circumscribed by tradition: they played sacred music in the Chapels Royal, and 'private musick'—odes, songs, instrumental interludes and accompaniments—for the court entertainments. Opera, dramatic music, concerts of instrumental music and the like received their chief impulse from sources beyond the court.

Of all the arts under the court, the omens seemed best for literature. Yet in spite of the love and learning shown by the members of polite society, the patronage of the court took literature a few staggering steps only. The greatest work of the age, the labours of blind Milton's last years—*Paradise Lost*, *Paradise Regained* and *Samson Agonistes*—of course owed nothing at all to the court culture; and other poets' work owed little more. In 1660, under the example of Waller and Denham, the signs seemed hopeful for lyric poetry, a type especially native to the English genius and usually much encouraged by courtly surroundings. But the singing voice somewhere caught a chill, became silent or made rude noises at romance. Waller, Denham, Cowley, Marvell and even Dryden either stopped writing lyrics or turned their major efforts to other forms. In the plays of the time there is a host of lyrics, but it is not the best work. The occasional lyrics of the poetasters about the court do not impress either. The lyric poetry of the Commonwealth, written under a severe Puritan government, far outweighs that of the pleasure-loving Restoration. Rapture at the King's return called forth the conventional eulogies; by 1665 the infatuation had worn out. Waller's *Instructions to a Painter*, a laborious paean in praise of the Duke of York's victory over the

Dutch, became an easy mark for parody. Even Dryden faltered. He was the first poet of the new age, a royalist and poet laureate; he had most cause to celebrate all the court stood for; yet how very few of his better poems sing of the courtly life. He naturally welcomed Charles in 1660 with *Astraea Redux*; he celebrated the coronation in 1661 and presented a poem *To My Lord Chancellor* in the next year. 'The year of wonder, 1666' inspired *Annus Mirabilis* commemorating the victory of London—and England—over the Dutch, the Plague and the Fire. Then he found little to commemorate until *Threnodia Augustalis* marked Charles's death in 1685:

> Thus long my Grief has kept me dumb:
> Sure there's a Lethargy in mighty woe,
> Tears stand congeal'd, and cannot flow;

Was it grief, too, at the conduct of the King and the sad decline of a courtly age which kept him from celebrating it? Even the court poets themselves, like Rochester, seemed possessed by the very antithesis of courtly tradition, determined to show the foul face of all mankind.

The theatre alone had happy results to show from court attention. The heroic play developed on the public stage, but it was a product of court circles. The first authors were men like Davenant, Orrery, Howard and Dryden, and it played very much to a court audience. All were welcomed by theatrical managers, but many outside the court found the invitation offensive:

> The City neither likes us nor our wit,
> They say their Wives learn *ogling* in the pit:[85]

The stage also boasted an even greater triumph from the court. Restoration comedy, the great and original theatre of the age, was born in the society of the wits and refined by the genius of Etherege and Wycherley, two gentlemanly adjuncts to that society, who with the practice of Ben Jonson to guide them fashioned their plays out of the life and conversation of their companions.

Outside causes partly explain why the arts did not develop very well under court patronage. Foreign influence exerted strong pressures; public patronage increased; wealth and better education diffused the arts through the country, away from the court. But also the Restoration which seemed so kind to artists—this society which appeared so interested and so amused—was in its actions hard and ruthless to the arts, destroying the roots while it tended the blooms.

At the Restoration, while the returning court was showing an un-inhibited licence, the legislators were preparing a code which supported intolerance, conformity, vigilance and discipline. A Treason Act was the

first ordinance of the Cavalier Parliament. In the next five years the Acts of the Clarendon Code stamped on England the Anglican state religion, attempted to put down all religious controversy and in doing so fettered dissent and freedom of argument. By the Five Mile Act of 1665, no clergyman or schoolmaster was allowed within five miles of city or town unless he promised not to 'endeavour any alteration of Government either in Church or State'. The press, of course, was not overlooked. The Treason Act condemned 'all printing, writing, preaching, or malicious and advised speaking calculated to compass or devise the death, destruction, injury, or restraint of the sovereign, or to deprive him of his style, honour, or kingly name'. In 1662, the Licensing Act introduced a censorship directed against, among other matters, all contrary 'to the doctrine of government or of governours in Church or State'. The provisions of the Clarendon Code and the Licensing Act were strongly enforced. Armed with the royal powers of search and seizure, Sir Roger L'Estrange, the King's bloodhound, sniffed out sedition. In 1677, L'Estrange managed to extend the definition of 'libels' to include not just printed material, but manuscripts as well. L'Estrange was an eager watchdog and those who were caught suffered severely. 'Elephant' Smith, an indefatigable printer of suspect pieces, was constantly in trouble. In 1661 he went to gaol for two years. In 1667, he fell foul of Arlington, the Secretary of State, over the satirical *Advices to a Painter* which followed Waller's *Instructions*. In 1670, he was up at the Middlesex Sessions for selling 'scandalous pamphlets'. And in 1684, Smith came before Judge Jeffreys who fined him £500 and ordered him

> to stand in the pillory at the Palace yard at Westminster, at the Temple, and at the Royal Exchange, and the libel to be burnt by the common hangman, and to have a paper set on him signifying his crime, and to find sureties for his good behaviour for life, and to be committed till all was done.[86]

Smith's offence was that he had published *The Raree Show*, a lampoon that had helped its author, Stephen College, to the scaffold on a charge of treason. Judge Jeffreys condemned to death the Whig politician, Algernon Sidney, for merely possessing a lampoon in manuscript.

Conformity usually stems from uncertainty. The arts about the time of the Restoration were in a naturally uncertain state. The giant vitality and achievement of the Elizabethan and Jacobean ages had come to an end some time before. After some quiet years the arts were making small beginnings in new directions, and needed most of all some freedom of action and sympathy. Instead, the slight, developing buds were shaken by the cruel and changeable winds of the state. The disasters of Charles's

reign followed each other remorselessly—the sale of Dunkirk in 1662, the Plague in '65, the Great Fire in '66, the fall of Clarendon in '67, the secret Treaty of Dover in '70 and after 1678, most horrible of all, Charles's last years corrupted by the poison of Titus Oates. No wonder a cloud of gloom descended over much of the population. Right from the start men spoke of prophecies and dire omens. A series of pamphlets sharing the title *Annus Mirabilis* told of prodigies, monstrous births, weird events all hinting at God's displeasure with the nation. The administration was perturbed and called up Dryden, the laureate, to give the correct official interpretation of disastrous events. His *Annus Mirabilis* asserted that God was merely putting his people on trial.[87] The people were not convinced. Even Tillotson, a future Archbishop of Canterbury, concluded in a sermon preached in 1667 that God's judgment was upon England.

Clarendon, too, noted a falling away in the nation:

> The tenderness of the bowels, which is the quintessence of justice and com-
> passion, the very mention of good nature was laughed at and looked upon as the
> mark and character of a fool; and a roughness of manners, or hard-heartedness
> and cruelty was affected.[88]

These were the sad reflections of an old conservative driven into exile, but other sources agree that there was a pernicious spirit abroad. The court, with no function but to exercise itself on a tread-mill of pleasure, set the worst of examples. 'Rude, rough, whoremongers,' Anthony Wood called its members, 'vain, empty, carelesse.' That they were as lustful as rutting horses could perhaps be overlooked; but soon they began to fill their empty days with spite, envy and malice:

> There are a middling sort of courtiers, who become happy by their want of wit;
> but they supply that by an excess of malice to those who have it. And there is no
> persecution as that of fools; ... they are safe only in their obscurity, and grow
> mischievous to witty men by the great diligence of their envy ... they are
> forced to live on the offals of their wit whom they decry. . . .[89]

The pages of Gramont, at first sight so amusing and sparkling, cover the basilisk stare of a man indifferent to pitiable humans. Old Sir John Denham, who deserved some reverence as a fine poet, was only a comic object unfortunate enough to be jealous of a pretty wife: 'his wife was young and handsome, whilst he was old and disgusting.' And the heartless Gramont added, 'What reason, then had he to flatter himself that heaven would exempt him from the fate of husbands of his age and appearance?'[90]

The looseness of the age has become a byword, for the best of reasons. Charles, once more, set the example, as Rochester proclaimed in the outspoken lampoon for which he was banished from court:

Whate'er religion or his laws say on't,
He'll break through all to come at any c——t.
Restless he rolls about from whore to whore,
A merry Monarch, scandalous and poor.[91]

So lascivious and suspect were fashionable ladies, Sir Henry Blount
thought it 'far cheaper and safer to lye with common wenches'.[92] Whores
became modest lights of society. 'Lady' Bennet, madam of a brothel in
Milford Lane, was a Restoration personality. Dorset wrote an indecent
poem about her;[93] Dryden mentioned her in *Sir Martin Mar-All*, and
Wycherley made wicked fun whilst dedicating the *Plain Dealer* to her.
The conduct of the wits was generally intemperate, but sometimes with
an audacity more amiable than shocking. Sedley, Dorset (then Lord
Buckhurst) and Sir Thomas Ogle in 1663 appeared naked on the balcony
of the Cock Tavern in Bow Street where Sedley delivered a ribald sermon
to the crowd below. In 1668 Buckhurst and Sedley were again seen to go
'up and down all night with their arses bare'.[94] Rochester had a fine time
gulling the citizens of London in his impersonation of a mountebank, one
Alexander Bendo. And in 1674, Rochester and the rest of the crew,
finding themselves in the royal garden at Whitehall, dashed to pieces the
dials which the learned Jesuit Linus had constructed for the King. But
always behind the society pranks there was a hint of uncontrolled violence.
There were too many dangerous incidents. Dorset and his companions
had killed a man in a muddle over a highway robbery. Sedley arranged to
have the actor Kynaston beaten in St. James's Park, much to the indig-
nation of the King. Then there was the curious case of Sir John Coventry
who made caustic remarks about Charles's mistresses on the floor of the
Commons, and had his nose slit for his trouble. Rochester and friends had
a fracas with watchmen at Epsom as a result of which a Mr. Downs was
killed. No member of society seemed safe from this violence. Even
Dryden, always so ready to please, was attacked. On December 18, 1679,
on his way home from Will's coffee-house he was waylaid and beaten in
Rose Alley by three men who were never identified.[95] What with the
dangers of life and the uncertainty of art, it is not surprising that some
artists took the downward road to debauchery and early death. Walpole
relates the sad story of John Greenhill, 'the most promising of Lely's
scholars':

> At first he was very laborious, but becoming acquainted with the players, he
> fell into a debauched course of life, and coming home late one night from the
> Vine tavern, he tumbled into a kennel in Longacre, and being carried to Parrey
> Walton's, the painter in Lincoln's-inn-fields, where he lodged, died in his bed
> that night in the flower of his age.[96]

Cynicism, malice, violence, even the unwelcome attentions of Sir Roger L'Estrange, might have been tolerated if the financial rewards from the court had been great. Much was promised in the early days, and the salaries of the royal officials were, by the standards of the day, adequate. But throughout his reign Charles never ceased battling for funds which were apportioned out to him by Parliament with a mean hand; payments for artists were usually in arrears and often not paid at all. Inefficiency and corrupt administration added to the general woe. Money to support the work of men outside the artistic departments of the court was rarely available and erratically spent.

Some artists did well, the most prosperous group, on the whole, being the painters. And of these Peter Lely was by far the richest. Throughout his career, no matter what the political climate, Lely's charges had steadily risen. He began at £5 for a head and £15 for a half-length; by the time of his death he was asking £20 for a quarter length, £40 for a half, and £80 for a full length figure.[97] When he died, in 1680, he left extensive property in Lincolnshire, a legacy of £3,000 to his daughter Anne, and £2,000 to his sister Katherina Maria; he also gave £50 towards the building of St. Paul's.[98] The auction of his magnificent picture collection, including twenty-six Vandycks, raised the enormous sum of £26,000. Lely was so rich he was even drawn into the financial tangles of the impecunious King. Lely certainly loaned the King £500 in 1668, and later claimed that he was owed £1,200 which he commuted for a pension of £200 a year.[99] Needless to say, it was generally unpaid and he had the greatest difficulty collecting it. But Charles, for all his poverty, had a weakness for painting. Antonio Verrio made a small fortune out of the decorations for Windsor. The full account is set out in Walpole, and the amount paid to Verrio was £5,545. 8s. 4d. Nor was that all; he had, too, from the King a gold chain worth £200. 'He was expensive,' wrote Walpole, 'and kept a great table, and often pressed the King for money with a freedom which his Majesty's own frankness indulged.' Their prosperity made both Lely and Verrio extremely proud. Lely refused to paint two judges because they would not attend on him; Michael Wright took the job and still made £60 on each portrait. Riches were perhaps as bad for painting as poverty was for writing. The pickings were so extremely easy. Walpole lists about seventy painters at work in the reign of Charles II, and most of them were portrait painters. There was no desire for change because too much money was being made from the fashion of the moment, Walpole's editor was severe on the fashion, calling it 'gaudy, corrupt, and meretricious';[100] it was certainly static and unadventurous.

The artists officially employed by the King in the Office of Works and in the King's Musick were far less fortunate than the painters. Of the two, the Office of Works seemed to have better treatment; no doubt this was because buildings are large and expensive undertakings which require planning and constant supervision. The level of expenditure by the Works in Charles's reign was high, and the officials appear to have been paid. The chief officers were gentlemen and so not entirely dependent on their salaries; but as gentlemen they were inclined to squabble for prestige, and as Charles could not accommodate the ambitions of all, he tried to compensate the unsuccessful with pensions and special fees. John Webb, done out of the Surveyorship in 1660, was made architect at Greenwich Palace with a salary of £200 a year. In 1669, when Buckingham preferred Wren to the Surveyorship instead of Hugh May, he at least obtained from the King a pension of £300 a year for May.[101] In 1670, May also became Inspector of Gardeners at the royal palaces at a further £200 a year.

Of all artists, musicians were the most vulnerable to the King's poverty. They counted as 'his Majesty's servants abovestairs', and came under the direct control of the Lord Chamberlain. Most of them were men without means, coming perhaps from families which had supplied musicians to the court for several generations. They depended very much on their salaries. In an age devoted to music, musicians were respected men, and the court, so long as it was in funds, dealt with its musicians kindly. John Jenkins, for example, was excused attendance at court because he was getting old and feeble. But the funds were not easily available for long, and then the musicians suffered. The financial affairs of the Musick and the Chapel Royal were rather complicated. Each member had a fixed salary which was augmented by various allowances and 'gifts'. The Master drew the quite princely sum of £200, others received very much less. In 1663, when Banister was ordered to form a select band of twelve violins out of the twenty-four at court, he was granted an extra £600 to spread amongst them because of 'the smallnesse of their wages already settled'.[102] When Purcell, in 1684, followed Hingston as the keeper of all wind instruments his salary was £60. The Gentlemen—adult singers—in the Chapel Royal received £70 each, and the children £30 plus 'diett, lodging, washing, and teaching'. Since the salaries were rather low, musicians were very ardent pluralists and many of them held a bewildering number of positions. A musician usually held his place for life and when he died his position could be bid for by one of his former companions; so Thomas, uncle of Henry Purcell, collected the 'places' of Henry Lawes, George

Hudson and John Wilson;[103] he was also Groom of the Robes, a singer in the Chapel Royal, and director of music at Windsor. An entry of 1679 shows the various elements of his salary for that year—£16. 2s. 6d. for livery, £46. 10s. 10d. as a member of the violins, £42. 15s. as composer for the violins, £46. 10s. 10d. and £36. 2s. 6d. as a member of the private music.[104] He also received £60 as Groom of the Robes. Even when all these were added up the sum was not very large.

Musicians also received fees for the various tasks they had to perform, each separate piece of business being carefully itemized. For the year 1675, Staggins was paid various sums for 'penns, inke, ruled paper and chamber rent', for 'fayre writing', for 'drawing the musick into severall parts', even for fire and candles: for all these tasks he received £93 2s.[105] An allowance was given for each journey out of London. These payments made up a good part of the yearly income. In 1668 Louis Grabu, the Master after Lanier, collected £165 9s. 6d. for—

> fayre writing severall dances, aires and other musick, and for drawing the said musick into severall parts, for penns, ink and paper, for chamber rent and for the prickers dyett [food for the copyist], and for fire and candles and for other necessaryes, from 4 November, 1666 to 25 March, 1668.[106]

The Serjeant-Trumpeter was allowed £27 for a fanfare at a launching.

If the salary and all his fees had been paid regularly a musician would have had a modest but comfortable living. Instead, as a lowly member of the King's retinue he waited for payments that were often years in arrears. Grabu, a Catholic, fell on hard times and petitioned for the £627 9s. 6d. owed him. When James came to the throne, Staggins was owed livery for five years, Child for eight, Blow and Clements for ten, and there was hardly a musician without some fees outstanding.[107] 'Many of the musique are ready to starve,' Hingston told Pepys in 1666:

> nay, Evans, the famous man upon the Harp, having not his equal in the world, did the other day die for mere want, and was fain to be buried at the alms of the parish, and carried to his grave in the dark at night without one linke, but that Mr. Hingston met it by chance, and did give 12d. to buy two or three links.[108]

Although musicians had some outside sources of income, the King's Musick was the chief and largest establishment of musicians in England, and the centre of all music-making. The decay of this establishment had the direst consequences for English music, consequences which were felt until the beginning of this century. And the decay of the King's Musick began in the reign of Charles II.

The author's lot was almost as bleak as the musician's. A man such as Dryden should have been well beyond the reach of poverty. He had a

small private income, and many rich friends and relations; he was the
Laureate and Historiographer Royal; he was a shareholder in, and
resident playwright to, the King's Company at the Theatre Royal; he was
versatile, hard-working and productive; moreover, he had genius,
though that is often a questionable asset when it comes to earning a
living. He was the complete literary man of the age. Yet all his life he went
from crisis to financial crisis, worried always about money. He lived quite
fashionably, had three children and a wife, Lady Elizabeth, used to the
best, and moved in spend-thrift company. But as he himself was cautious,
all this should have been within his means. From his court positions he
received £200. As usual, it is paid at very infrequent intervals. Three
years after his appointment he had great trouble collecting the £500
outstanding on his salary. In the same year, 1671, the £500 which he had
loaned to the King in 1667 was not repaid.[109] Clifford had put a stop on
the Exchequer. Never, said Evelyn, did the King's affairs prosper after-
wards. Dryden's loan was not repaid until June 1673. As Charles's financial
affairs went downhill, so the King's servants waited even longer for their
salaries. Dryden was among those who suffered. Luckily he also received
income from sources other than the court and the gifts of the patrons,
which were usually handed out with a good deal of condescension. Like so
many authors of the time, he looked to the theatre to keep him from want.
And like most he received more pains than profit from the stage. His
contract with the King's Company tied him to the incredible labour of
three full-length, five-act plays a year for which he might expect perhaps
£350 as his share. The expectations of neither side were realized. Dryden
failed to produce his quota of plays, and the value of his share was only
about £160. Malone calculated that Dryden's receipts over a fifteen-year
period did not exceed £100 a year.[110] The most he earned for one play—
the author was entitled to profits from the third performance—was also
less than £100, and that included the money from the dedication and the
sale of the manuscript to a bookseller.[111] Of the other authors in the court
circle, the aristocrats, of course, were not writers for money, a few like
Waller were rich men anyway, but some gentlemen of modest means—
notably Etherege and Wycherley—were in a very awkward state. They
were supposed to maintain the pretensions of a wit and a gentleman
without descending to the mean labour of a hack author. Both hit on the
happy solution of a rich wife, an expedient that saved Etherege from
bankruptcy:

> E'en gentle *George* (flux'd both in tongue and purse)
> Shunning one Snare, yet fell into a worse.

A man may be reliev'd once in his Life,
But who can be reliev'd that has a Wife?[112]

Wycherley's handsome looks promoted him to a place among the Duchess of Cleveland's lovers, and he followed up this advantage by marrying the Countess of Drogheda. However, when she died his fortunes sank; he spent some years in debtor's prison until the King remembered and rescued him.

The stage was the great hope of most Restoration authors. In the theatre they expected to win both fame and fortune. Unhappily, they came up against a very precarious enterprise. There was work enough; managers were desperate for new ideas and new talents. But the attempt to please the whims of a careless court audience almost guaranteed a heavy financial loss. Davenant, the greatest manager of the Restoration, died bankrupt. The expense of the productions was huge; and so as not to fatigue the fashionable playgoers they were changed with lightning rapidity. The new passion, imported from France, was for scenery, machinery and magnificent effects:

Then came Machines, brought from a Neighbour Nation;
Oh how we suffered under Decoration![113]

all of which was extremely costly. The decorations for Shadwell's *Psyche* cost more than £800.[114] Yet a play might only run for a few days, though the most popular could expect to be revived. The only payment the author received was the profit from the third performance—£70 was exceptional, Otway thought £50 a fair return and D'Urfey was content to get £20.[115] So little reward for such hard labour. No wonder Shadwell sighed wearily in the dedication to *The Virtuoso*:

That there are a great many faults in the conduct of this Play, I am not ignorant. But I (having no pension but from the Theatre, which is either unwilling, or unable, to reward a Man sufficiently for so much pains as correct Comedies require) cannot allot my whole time to the writing of Plays, but am forced to mind some other business of Advantage.

The hopeful theatre, blighted by the touch of the court, turned into a cruel taskmaster for authors. John Dryden, who did best of all, won nothing more than an uncertain and irregular living from the stage. Lesser men were not only impoverished, but broken by their struggles:

Otway can hardly Guts from Gaol preserve,
And, tho he's very fat, he's like to starve:
And Sing-song Durfey (plac'd beneath abuses)
Lives by his impudence, and not the Muses:
Poor Crown too has his third days mix'd with Gall,
He lives so ill, he hardly lives at all.

Shadwell and Settle both with Rhimes are fraught,
But can't between them muster up a groat:
Nay, Lee in *Beth'lem* now sees better days,
Than when applauded for his bombast Plays;
He knows no Care, nor feels sharp want no more,
And that is what he ne'er could say before:[116]

The King and court failed to foster and develop the arts because they no longer had real power in the country. The plans for a Stuart despotism were no more successful than the designs of Stuart patronage. As the King and court lost control of the country, they lost their hold on the imagination of artists. The King became less and less able to pay for the arts from a Privy Purse which was always lean and very often completely empty; and as the King's policies brought violence and the threat of civil war, the needs and expectations of poor artists ranked very low in the royal list of priorities. For the arts, the grand promises of the Restoration were shown to be mostly illusions. Events caused the artist to turn away from the court and take his inspiration and money from other sources. But from where? The public was one possibility, and some steps had been made in that direction. But the public domain, as we shall see, was not yet a promised land. With the grounds of his art uncertain, and his living threatened, the artist saw desperate times at hand.

TRIMMING

The obligation of subjects to the sovereign is understood to last as long, and no longer, than the power lasteth, by which he is able to protect them.

Hobbes, *Leviathan*, 2, 21.

EDMUND WALLER, a great master of abasement, spent a poetic life sending flattering shafts from a humble subject to the susceptible vanities of the powerful. Rulers, legitimate and suspect alike, had his commendation. The young poet tried his hand with some pleasant words on Charles I's navy in 1627; the middle-aged writer in 1654 saluted Cromwell in *A Panegyric to My Lord Protector*; the mature equivocator was unashamedly ready with a poem *Upon His Majesty's Happy Return* at the Restoration of Charles II. John Dryden, a younger poet but with little to learn in his handling of the fawning line, rang out the old, rang in the new with equal poetic style. His *Heroic Stanzas* expressed inconsolable grief at Cromwell's death; less than two years later his *Astraea Redux* proclaimed insupportable joy at Charles's return. Waller and Dryden were not alone; the sighs and the plaudits of others were as nicely tuned.

This adaptibility has not gone unreproved. Dr. Johnson, as one may expect, had some hard things to say. Of Waller he wrote:

> It is not possible to read, without some contempt and indignation, poems of the same author, ascribing the highest degree of power and piety to Charles the First, then transferring the same power and piety to Oliver Cromwell; now inviting Oliver to take the Crown, and then congratulating Charles the Second on his recovered right.[1]

And on Dryden he was even more severe:

> in the meanness and servility of hyperbolical adulation, I know not whether, since the days in which the Roman emperors were deified, he has even been equalled. ... When once he has undertaken the task of praise, he no longer retains shame in himself, nor supposes it in his patron.[2]

Doubtless these criticisms were well-founded; the poets were on the make, and hoped with smooth compliments to ease their way forward. Dryden, put the poet's case, with perhaps a touch of unconscious irony, in the *Heroic Stanzas* in memory of Cromwell:

> Yet 'tis our Duty and our Interest too,
> Such Monuments as we can build, to raise

But Johnson's strictures, though affecting testimony to the good heart of the Doctor, failed to recognize something in the poetic purpose of the 'encomiastick homage' he despised so much. Writing in the middle of the eighteenth century, Johnson thought that poetry should be the expression of the whole man, the words integrated with the conduct. He saw the lackey in the character of Waller and of Dryden, and thought their lines merely the glosses of menial spirits. The upright man of sound moral conviction would write in a similar sense, for that was the way things were done in the rational eighteenth century. Between the two ages— that of the early Dryden and that of the mature Johnson—there was a misunderstanding as to what constituted 'poetic truth'. Dr. Johnson put the rational position every clearly:

> Poets, indeed, profess fiction; but the legitimate end of fiction is the conveyance of truth; and he that has flattery ready for all whom the vicissitudes of the world happen to exalt, must be scorned as a prostituted mind, that may retain the glitter of wit, but has lost the dignity of virtue.[3]

Earlier poets did not see matters quite in this light. They, indeed, found a kind of truth in that very 'wit' which Johnson contrasted so unfavourably with 'virtue'. The subject of their extravagant homage was merely a peg on which to hang the rich garment of the poet's fancy and wit. The poet played with the pure patterns of invention and did not feel bound by the laws of morality, or even of probability. Sometimes, behind the minor or ugly figures they praise, poets had a glimpse of an exemplar. So Donne, when Ben Jonson objected that the *Anniversaries* addressed to young Elizabeth Drury 'were profane and full of blasphemies', replied 'that he described the Idea of a Woman, and not as she was'.[4] The mind of the poet was not to be bound by the literal sense; the play of the imagination was all-important. Dryden was 'very certain' that 'even folly itself, well represented, is wit in a larger signification'.[5]

The chief end of 'encomiastick homage' was to praise not man, but power. When government is autocratic, power lies in a few individuals and particularly in the prince. So to praise the prince was also to call attention to the virtues and achievements of England. The young Waller, congratulating Charles I on his navy, really has in mind the benefits conferred on England by the presence of the navy:

> Now shall the ocean, as they Thames, be free
> From both those fates, of storms and piracy.

The older Waller, in his panegyric on Cromwell, has his eye fixed on 'the chief, the governor, the defender of England's honour, and the enlarger of her dominion'.[6] Dryden, welcoming the Restoration, dwells on the

advantages of peace, and the good that will come to England from established order:

> Our nation, with united Int'rest blest,
> Not now content to poize, shall sway, the rest.
> Abroad your Empire shall no Limits know,
> But like the Sea in boundless Circles flow.[7]

Since power was their theme, and England's glory, poets were natural Hobbesians, supporters of *de facto* government. Indeed, it was asserted against Hobbes that he wrote *Leviathan* with motives as suspect as the place-hunting expectations of Waller and Dryden. Hobbes, said Dr. Wallis, wished to return from France and wrote *Leviathan* 'in defence of Oliver's title, or whoever, by whatsoever means, can get to be upmost; placing the whole right of government merely in strength'.[8] As long as England's glory did depend on the autocratic rule of a pre-eminent man, such as Cromwell, there was a true poetic reason, beyond gross flattery, for the art of praise as it was practised by Waller and the early Dryden. But as the power of government inevitably passed, despite the attempts of the later Stuarts to establish an absolute monarchy, from the King to Parliament, the praise of the prince was no longer an exaltation of England, for the prince no longer represented the interests of England. With the decline of autocracy, the poetry of homage no longer 'conveyed truth'— to use Johnson's phrase; no wonder, then, that the honest Doctor could find nothing in it but 'meanness and servility'. The rise of democratic institutions put an end to a kind of artistic production.

Artists may be forgiven if they are slow to see the drift of politics. Yet the signs were surely there for the wise to note. Even immediately after the Restoration, a time of monarchal triumph, the peculiar nature of English government impressed itself on the mind of Cominges, the French ambassador. When Cominges sailed for England, his master, Louis XIV, had warned him to note particularly that strange institution, the English Parliament. And the extraordinary nature of that assembly had penetrated Cominges's old-fashioned head, even though he spoke not a word of English. Aristotle himself, the ambassador wrote to Louis, would have been puzzled to define the English government. 'It has a monarchical appearance, as there is a King, but at bottom it is very far from being a Monarchy.' And Cominges wondered whether this was caused 'by the fundamental laws of the kingdom, or by the carelessness of the King'.[9] With the help of authorities such as the prophet Daniel, the Medes and the Persians, and William the Conqueror, he set out diligently to unravel the mystery of English government; his researches

failed to make everything clear. But he did note that Englishmen, tutored by the events of the Civil Wars, were well-versed in politics:

> For in this country everybody thinks it is his right to speak of the affairs of State, and the very boatmen want the *mylords* to talk to them about such topics while they row them to Parliament.[10]

And further, the English had a strange freedom of action. Members of Parliament 'are not only allowed to speak their mind freely, but also to do a number of surprising, extraordinary things, and even to call the highest people to the bar!' The Earl of Bristol had accused the King's Chancellor of treason, yet there he was, free and indubitably healthy:

> It seems to me, every moment, I have been transferred to the antipodes, when I see a private gentleman walking the streets, sitting as a judge in Parliament, receiving the visits of his political friends, and leading no less pleasant a life than usual, when he has accused of capital crimes the first officer of the State, a dignitary on the best terms with his master, supported by the Queen-mother, and father-in-law to the heir of the crown.

Such scandal would not be allowed in France; Cominges's correspondent affirmed that in Louis's well-ordered absolutism there would be no competition to marry into the house of an Earl of Bristol.[11]

The force of parliamentary rule, which appeared to Cominges almost as an offence against nature, grew stronger and stronger after the rapture of the King's return wore off, and when it was seen that King and country had different plans for England. But artists, mostly political innocents, still supported in their work the fictions of autocracy. The structure of patronage changes more slowly than the pattern of government (though inevitably the former is determined by the latter), and artists still felt that they greatly depended on the support of the King and his courtiers for their living. The notes of praise still sounded, though now ringing rather hollow as artists perceived that King and court were no more able to support the arts than they were able to govern effectively.

So writers, and other artists too, were gradually forced to examine their relations with the ruling power, for their prosperity depended on it; they began to recognize the political reality. Waller's *Instructions to a Painter* of 1665, while still a panegryic to the Duke of York in the old laudatory manner, is also an account of the progress of the Second Dutch War from the point of view of the King's party. It cannot quite be called a factional piece of work, for panegyric still predominates over propaganda. But it showed the way the arts were going. And Andrew Marvell's various *Advices to a Painter*, in answer to Waller, boldly confirmed the direction towards politics. Marvell, of course, was an outspoken parliamentarian

and a keen critic of royal policy; yet even he made a slow march towards the ranks of committed political partisan. Much of the fun in his immediate reply to Waller, the *Second Advice* of 1666, is in the satire at Waller's expense, the guying of the convention, the imitation of wretched and absurd similes. And though Marvell had hard things to say about the war, he carefully distinguished between the conduct of the King and that of his despicable ministers:

> Imperial Prince, King of the seas and isles,
> Dear object of our joys and Heaven's smiles:
> What boots it that thy light does gild our days
> And we lie basking in they milder rays,
> While swarms of insects, from thy warmth begun,
> Our land devour and intercept our sun?[12]

Others were less careful to mark the distinction. On December 14, 1666, Pepys received 'the lampoon, or Mock Advice to a Painter, abusing the Duke of York and my Lord Sandwich, Penn, and everybody and the King himself'. In the further *Advices* from Marvell's pen the King's name is progressively brought into the condemnations; the fun is less playful, the criticism more severe. The *Last Instruction* of 1667, a long, brilliant and particular examination of the sins of government, gives full savage treatment to the hated names—York and the Duchess, Clarendon and Arlington; but the King, too, is admonished:

> Kings in the country oft have gone astray
> Nor of a peasant scorn'd to learn the way.[13]

Then in the *Further Advice* of 1671, with Nell Gwynne and the affair of Sir John Coventry's nose fresh in mind, Marvell tilts at the King as before at his ministers:

> Thus whilst the King of France with powerful arms
> Frightens all Christendom with fresh alarms,
> We in our glorious bacchanals dispose
> The humble fate of a plebeian nose.[14]

The party lines, soon to be known as Whig and Tory, were now well-drawn, and the poets recruited for the fight.

For the task of uniting politics with poetry the techniques was already at hand. An age of strong hatreds, such as the time of the Commonwealth, was a rich forcing-ground for satire; and Butler's *Hudibras*, published in the early years of the Restoration, had shown what triumphs the genre could rise to. The renewed interest in the rhymed couplet was helpful to the composition of long narrative satires; and the couplet, as it developed especially in the hands of Dryden, with its balance and antithesis, was a sharp weapon for inflicting the stings of satire.

3

This satiric poetry was now well in touch with political reality. The old fictions of the sanctity and pre-eminence of the royal authority were no longer advanced with the old abandon; even writers of the royal party, like Dryden, learnt that their best course was to take the argument *ad hominem*, and sink the opposition with ridicule. Poetry was paying close attention to the facts of political life, and so no doubt coming nearer to Dr. Johnson's 'legitimate end' of poetry, which was the 'conveyance of truth'.[15] Whatever truth it carried, it was extremely popular. Johnson had from his father an account of the success of Dryden's *Absalom and Achitophel*, in 1681:

> Of this poem, in which personal satire was applied to the support of publick principles, and in which therefore every mind was interested, the reception was eager, and the sale so large, that my father, an old bookseller, told me, he had not known it equalled but by *Sacheverell's* trial.[16]

The danger of this 'personal satire' was that its strength lay in portraits; these flashes most often made the poem. Dryden's poem, the greatest of all political satires, in the story of David and Absalom had a most fitting biblical parallel to contemporary events, and one moreover that had been frequently commented on and was much in the public mind;[17] even so, the most memorable parts of the poem are the portraits—Monmouth as Absalom, Shaftesbury as Achitophel, Titus Oates as Corah, Buckingham as Zimri and so on. In lesser poets, what was supposed to be political satire degenerated into mere personal abuse and vituperation. And this poetic mud, hurled around with such enthusiasm, stuck to all types of verse and tainted with angry rancour much of the poetry of the day.

Political affairs, ecclesiastical affairs, literary affairs, even love affairs were afflicted with an ill-bred humour and smothered with a rash of splenetic outbursts. All this can be seen in the various collections of *Poems on Affairs of State*. Literary affairs, which at one time, for all the differences, had been handled with a certain courtesy, now showed the greatest spite and ill-feeling. *The Sessions of the Poets*, which summon all to judgment, allow hardly anyone to escape without a bad word. Buckhurst compared Edward Howard's brain to a filbert where 'Maggots survive when all the kernel's gone';[18] and another anonymous critic thought the same brain nourished 'with stinking fish, Ox-cheek, tripe, garbage'.[19] Rochester saw Mulgrave as 'My Lord All-Pride':

> Bursting with pride the loath'd impostume swells;
> Prick him, he sheds his venom straight and smells:[20]

And in another bitter poem has Mulgrave speak as follows:

Must none but civet cats have leave to shit?
In all I write should sense and wit and rhyme
Fail me at once, yet something so sublime
Shall stamp my poem that the world may see
It could have been produc'd by none but me.[21]

Dryden's rhymes, wrote Rochester, 'Were stol'n, unequal, nay dull, many times';[22] while at this onslaught Mulgrave and Dryden together reply:

Rochester I despise for his mere want of wit
(Though thought to have a tail and cloven feet)[23]

To Sir Carr Scroop, Rochester is a 'vex'd toad', while to the earl the knight is 'Poet Ninny'. Shaftesbury, with the tap let into his side to drain the poisons from his corrupted body, is cruelly mocked by Otway in *Venice Preserved*, and by Dryden in *Albion and Albanius*. These writings form a pageant of spite.

To some extent, poets were victims to their own techniques. Concentration on satiric portraits, so effective and popular, led them to be as outrageous and vituperative as possible. The restraint of a master was needed to stop satire curdling into malevolence; even Dryden sometimes fell to a petty meanness. But the chief cause of all this hatred was the factionalism of politics. The struggle between the Whig and Tory parties infected the whole life of England, and art, and all else from religion to philosophy, was drawn into the dissensions of power politics. Writers were indeed reading the political signs well; and they were becoming realists in another sense, too: they now looked to the aristocrats of the new political parties for the patronage which the court, bankrupt and at bay, could no longer provide. But the new patrons demanded something more than flattery and entertainment; they wanted propaganda for their programme as well. Perhaps for the first time in England, the arts were pressed into political partisanship in a systematic way. Writers became part of political organization. At the Whig Green Ribbon Club, which operated under the fretful genius of Shaftesbury from the King's Head in Chancery Lane, writers like Shadwell and Tate found a place in Whig plans. The Tory, or King's party, was strongly placed to reply, for the stage was under royal patronage and so a natural forum for Tory plays. Successions of plays with titles like *Sir Barnaby Whigg*, *The City Heiress*, *The Royalist*, *The Loyal Brother*, *Venice Preserved* (subtitled *A Plot Discovered*) and *City Politiques* showed that the Whigs were receiving a hard drubbing on the stage.[24]

A professional artist, concerned for his income, could hardly avoid a

descent into the political fogs. 'I am no Politician,' wrote Settle to Shaftes-
bury, explaining why, as a playwright, he could not afford to go against
the Tories; 'for that Scribler must have no prospect to his Interest, who
dares affront so numerous a Party, that are so powerful a Support of the
Stage.'[25] Dryden found the mature years of his poetic life complicated,
and perhaps darkened, by his work as laureate and the political necessities
of his allegiance to the King. In 1683 he wrote:

> I know but four men, in their whole [Whig] party, to whom I have spoken for
> above this year last past; and with them, neither, but casually and cursorily. We
> have been acquaintance of long standing, many years before this accursed Plot
> divided men into several parties.[26]

Political satire led him to compose some of his most powerful verse—
MacFlecknoe, *Absalom and Achitophel*, and *The Medal*; but to have to
compose political pamphlets, such as *His Majesties Declaration Defended*
justifying the King after the Oxford Parliament, in 1681, was a weary
task. Political sentiment entered into his other work, with bad results. Of
Amboyna, a play against the Dutch written in 1673 to benefit from the
martial mood induced by the Dutch War, Dryden himself said it would
'scarcely bear a serious Perusal, it being contriv'd and written in a Month,
the Subject barren, the Persons low'. *The Spanish Fryar* and *The Duke
of Guise* which rehearse in disguise various aspects of the English con-
stitutional problem are not much better. The opera *Albion and Albanius*,
written in 1684 as a glorification of the Stuarts, is called by Professor
Dent 'a monument of stupidity'; it is hard to know which is worse,
Dryden's words or Grabu's music.

The political struggles in the late Stuart years produced more victims
than gainers. And the arts were among the former. The Popish Plot was
the image of a corrupted State; a fictional plot promoted with cruelty and
cynicism by the Whigs as a means to power, and permitted to run its evil
course by a callous and conscienceless King. The miasma of pollution
crept into the heads of all the community, from King to apprentice.
Rochester gave the character of the age:

> The general heads under which this whole island may be considered are spies,
> beggars, and rebels. The transpositions and mixtures of these make an agreeable
> variety; busy fools and cautious knaves are bred out of 'em and set off wonder-
> fully, though of this latter sort we have fewer now than ever: hypocrisy being
> the only vice in decay amongst us, few men here dissemble their being rascals,
> and no woman disowns being a whore. Mr. O[ates] was tried two days ago for
> buggery and cleared; the next day he brought his action to the King's Bench
> against his accuser, being attended by the Earl of Shaftesbury and other peers
> to the number of seven, for the honour of the Protestant cause.[27]

T. S. Eliot, a critical wizard peeping into the obscure, has spoken of a 'dissociation of sensibility' which occurred about the time of the Civil Wars. In the arts, the paramountcy of the imagination was disputed; sensibility was reintegrated, no longer under the order of imagination, but now under the order of reason. The Restoration brought rationality in with the returning King, and the great work of the age of reason was to impose upon the King in England a rational system of government free from the arbitrary power of the monarch and the whimsicality of the royal prerogative. After the Glorious Revolution of 1688, the dearest wishes of reasonable men were triumphantly realized. Addison could look back with his notorious smug satisfaction on a world well-ordered; the stars in their appointed places, the crown shackled, freedom secured, and 'Christianity not Mysterious' (to use Toland's famous title). The Cambridge Platonists and later the Deists had between them combined to take, as it were, the sting of the unknown out of religion. 'No *Christian*,' wrote Toland, 'says *Reason* and the *Gospel* are contrary to one another.'[28] And John Locke, who tied all together and provided a handbook for inquirers after a rational universe, wrote on the old paradox of religion:

> *Credo quia impossibile est*: 'I believe because it is impossible', might, in a good man, pass for a sally of zeal, but would prove a very ill rule for men to choose their opinions or religion by.[29]

There was nothing in man's experience that could not be brought under the guidance of reason. Tyranny and arbitrary government were merely impediments which are banished when rational men, 'by nature all free, equal and independent', contract together and put on the bonds of civil society; for no one can be 'subjected to the political power of another without his consent'.[30] The victory of 'free' men came—or so many thought—when the bad Stuarts were expelled in 1688, and William and Mary were invited to accept a kingdom under proper Parliamentary control. And what were the aims of this rational society? Why, said Locke, 'The great and chief end of men's uniting into commonwealths and putting themselves under government is the preservation of their property'.[31] Though 'property' for Locke included 'lives, liberties and estates', this was the justification for the politics of the land-owning Whig oligarchy; here spoke the quintessential Whig.

The advantages of the age of reason have been forcefully stated. When the great succession of Whig historians have given their admiring approval, no more praise is needed. It was not strange for a philosopher to reflect the social and political state of the country. Blake wrote with truth that 'King James was Bacon's primum mobile'; Hobbes would

have countered the anarchy of the Civil Wars with the authority of the
Leviathan; and Locke wrote to justify the accession of William and Mary.
But reason was more than a principle of empirical philosophy; it was an
enthusiasm shared by many throughout society, and led to some curious
effects. The politics that toppled James were carried out in the name
of reason. It was, too, the beacon the Anglican Church attempted to
steer by, keeping the middle way between the rich mystery of the Catholics
and the strong individualism of the non-conformists, and without the
passion of either. The arts as well were touched by its influence. To be
'reasonable' was to avoid the lyrical, the metaphysical, the mysterious
inner voice, and to lend one's talent to those aspects of art that are service-
able and useful—argument, narrative, description and the didactic. The
personal vision was at a discount, the public view won. Responsibility
was beginning to tyrannize over imagination. That same *credo quia
impossibile est* which Locke had rejected so firmly in the name of reason,
had before been happily accepted by Sir Thomas Browne under the spell
of the imagination.' I love to lose myself in a mystery, to pursue my
Reason to an *O altitudo*!' he wrote. 'I can answer all the Objections of
Satan and my rebellious reason with that odd resolution I learned of
Tertullian, *Certum est quia impossibile est.*'[32]

Rationalism, full of logic and zeal for improvement, did not quite
conquer all. A stubborn crowd of anti-rationalists still produced their
subversive squibs and went their way secure in the evidence of experience
that the world is a highly irrational place. Bernard Mandeville put the
essence of their case in his usual bold way:

> All Human Creatures are sway'd and wholly govern'd by their Passions, what-
> ever fine Notions we may flatter our Selves with; even those who act suitably
> to their knowledge, and strictly follow the Dictates of their Reason, are not less
> compell'd so to do by some Passion or other, that sets them to Work, than
> others, who bid Defiance and act contrary to Both, and whom we call Slaves
> to their Passions.[33]

Among those who felt the force of this way of thinking were many
artists. Rationalism attempted to control the flights of the imagination in
the name of good sense and propriety; and though an artist, as a man in the
age of reason, might feel some sympathy for the respectable ends of a
rational art, his aesthetic sense might warn him of the dangers. Artists
are not expected to philosophize, but if they had formulated their thoughts
many would surely have inclined to the opinions of a long line of sceptical
thought, from Erasmus to Pierre Bayle. For the sceptics held that the
powers of reason were uncertain, and its view of the world incomplete;

the mysteries, especially the mystery of religion, were left unshaken; and among them, in that higher realm, the artist could seek his exemplars and his perfection. A rational art aimed to follow nature; but to the sceptical mind, tinged with the apprehension of the unknown, 'Nature is an impenetrable Abyss, and its springs are known to none, but to the Maker and Director of them';[34] that dark is only penetrated by the light of the imagination.

At the Restoration, the conflict between rationalism and anti-rationalism in the arts began to emerge. A few men, whose development had started well back in the middle years of the century, continued unconcerned by the new intellectual fashion. Lely, for example, remained infinitely adaptable to the vanity of his sitters, painting not the truth of nature, but the perfection 'correcting Nature' which Dryden thought a painter should find in his subject.[35] And the *Windsor Beauties* express perfectly the idea of lasciviousness. That the later rational age did not consider lasciviousness a 'perfection' is neither here nor there; the earlier imagination was not bound by these rational notions of propriety.

Other men, younger than Lely, felt the contrary pulls very strongly. Dryden, once again the best example of a Restoration type, was a reluctant rationalist. As a busy literary man, he naturally followed to some extent the taste of the age; his commitment to the stage, his post of laureate, and his support for the King's policies set him to work in fashionable modes. His early tragedies, with 'many passages of strength and elegance, and many of empty noise and ridiculous turbulence',[36] embellished a fatuous image of the hero which delighted the contemporary world. His verse satire, his polemics against sedition, his later plays, such as *Amboyna*, of a faintly political hue, all show him attempting to produce fiction which conveyed the kind of truth the rationalists approved. But his heart was not in the business and he remained secretly a partisan of the opposite camp. His life, his criticism, and at last his poetry finally display the true anti-rationalist tendency of his outlook.

In his life, he moved very gradually from the faith of an English rationalist—which is no faith at all but merely some polite expressions of piety such as might become a gentleman—towards that most horrid and anti-rational persuasion of all, the Catholic Church. At the end of 1685, soon after the death of his admired Charles II, Dryden became a Catholic. His enemies, led by Macaulay, have sneered knowingly: another of Dryden's typical sordid manœuvres. But Professor Bredvold has dealt firmly with that calumny. Considering the poet's temporizing nature, one might think that James's Catholicism was the final incentive for Dryden

to declare his own faith; but Bredvold has shown how consistent and logical Dryden's development was. For once, Dryden did not have his eye on patronage or preferment. When Charles died, the arrears on the poet's salary amounted to £1,075; there was no likelihood that an embattled and equally impecunious James could make up this sum. What James could give, Dryden already had; and laureateship had been confirmed by James even before Dryden changed religion. And the final clinching argument for Dryden's sincerity is that for the rest of his life he remained steadfastly Catholic, even though his religion caused him to be deprived of his official posts after the accession of William and Mary, and the last twelve years of his life were spent without the patronage he had relied on for a large part of his income. Dryden's conversion was first a triumph which only faith can produce in a weak man. Then it was, too, an affirmation in support of imagination over reason, a blow at the rationalist world.

The anti-rationalist practice of his life was what could be expected from the expression of his criticism. He never liked the rules of a 'sensible' art which so many of his colleagues tried to impose. In the early *Essay of Dramatic Poesy* he had defended the irregular fancy of the English plays against the neat formality of the rational French: 'what,' he wrote, 'is more easy than to write a regular French play, or more difficult than write an irregular English one, like those of Fletcher, or of Shakespeare?' In the *Apology for Heroic Poetry and Poetic Licence* he turned once more on the advocates of reasonable art, protesting against 'a narrow and trivial misuse of Common Sense to the detriment of Imagination'.[37] He was still sufficiently in touch with the integrated sensibility of the Elizabethans and Jacobeans to recognize that the essential cause of glory in English poetry was the unbounded imagination. 'This is,' he wrote, 'that birthright which is derived to us from our great forefathers, even from Homer down to Ben [Jonson].'[38]

The evidence of Dryden's anti-rationalism, taken from life and criticism, is confirmed by the most powerful argument of all—the example of his work. As a young poet, he began in imagination's service, though respectful to the discipline and order introduced into poetry by Waller and Cowley; in his middle years, pressed by policy and his patrons, he lent his talent for a while to the community, and produced useful argument and propaganda; as he grew older he withdrew from the madness of politics and worked once more at the poet's business as he had first thought of it—the mind at play among its own patterns. He dropped satire and controversy and became lyrical. He wrote panegyrics again,

investing the inconsiderable Anne Killigrew with the same kind of
majesty and mystery that Donne had expended on the equally unexcep-
tional Elizabeth Drury. He wrote songs and odes, and took his lyrical
inspiration from the world of music. For the St. Cecilia Festival in 1687
he produced *The Song for St. Cecilia's Day* which Draghi set very grandly
for five-part chorus, string band, flutes and trumpets. Ten years later
the St Cecilia Stewards again approached Dryden, who then wrote
Alexander's Feast, this time set by Jeremiah Clarke. The death of Henry
Purcell was appropriately marked by another Dryden panegyric. In his
late years he took to expounding his faith in verse, and marked the steps
to Catholicism, through the *media via* of Anglicanism in *Religio Laici* to
the full Romanism of *The Hind and the Panther* in 1687. In a daring, but
not very successful flight, Dryden had the Roman Church as the milk-
white hind, and the English Church as the panther, beautiful but spotted.
'A fable which exhibits two beasts talking Theology, appears at once full
of absurdity,' pronounced Johnson, in the voice of reason; and in the
satiric *City Mouse and Country Mouse* of Prior and Montague, the
sensible rationalists had their laugh at this preposterous device of an old
gothic imagination.

The case of Dryden suggests that the arts—literature in particular,
as the most articulate—were driven towards rationalism, not just by
contemporary fashions in thought, but also by politics and the need to
earn a living; and this was surely true. At the Restoration, when political
and social questions became a common pre-occupation for all society,
artistic views were inevitably coloured by political attitudes. Anti-
rationalism, of course, did not die; it is as impossible to kill scepticism in
philosophy as it is to kill imagination in art. Since politics and reason went
together, the art that paid least attention to reason was developed by those
who had least interest in politics. The comedy of manners of the court
wits is the Restoration monument to anti-rationalism.

The comedies are the reflection of the wits' life, and as that life was
unreasonable, so the plays were unreasonable. What need for plans,
policy and crusading zeal, for mutability reigns: 'Do not vow,' cries
Emilia in *The Man of Mode*. 'Our love is frail as is our life, and full as
little in our power; and are you sure you shall out-live this day?'[39] The
unsure moments are best crowned with a little pleasure—'Well, Franck,
what is to be done to day?' asks Courtall in *She Wou'd if She Cou'd*; and
the answer comes, 'Faith, I think we must e'ne follow the old trade,; eat
well, and prepare our selves with a Bottle or two of good Burgundy, that
our old acquaintance may look lovely in our Eyes; for, for ought as I see,

3*

there is no hopes of news.'[40] Effort and business were infinite boredom, and art shone best in doing very little—'Writing, Madam, 's a Mechanick part of Witt! A Gentleman should never go beyond a Song or a Billet.'[41] Etherege's Dorimant, said the perceptive Dennis, 'is an admirable Picture of a Courtier in the Court of King *Charles* the Second.'[42] Playwrights are not to blame, says Wycherley's Dorilant, 'they must follow their Copy, the Ages'.[43] The comedy of manners is only the life of the wits transmuted into art.

The censorious age of reason was doubly shocked by Etherege and Wycherley. Not only were their plays irrational and immoral, pictures of a decadent society which reason abhorred; but the authors also had the gall, or the courage, to live according to the sentiments in their plays, as if rational designs for political improvement did not even exist! Wycherley aspired to a rich wife, and then declined to a debtors' prison; but he was a gentleman, and nothing would make him work—a small dabble in the arts was as far as he could go. 'You have noe share in that noble Laziness of the minde,' Etherege wrote to Dryden, 'which all I write make out my just title to.'[44] Etherege, it is true, did enter government service, being between 1685 and 1689 Resident in Ratisbon. But this responsibility quite failed to change him. 'Nature,' he wrote in the same letter to Dryden, 'no more intended me for a Polititian than she did you for a Courtier.' And Etherege's embassy was no credit at all to his government. He spoke no German and refused to learn any (his sympathies were French not German, and French he spoke and wrote with ease); he would not attend to business; he lost scandalous sums in gambling; he kept the town awake with fiddling, piping and dancing 'till 2, 3 & 4 a clock in the morning'; and worst of all, he took as a mistress an actress, a certain Julia, which would have been an ordinary occurrence in London, but was very shocking in staid Ratisbon. He would have been a disaster except that his natural intelligence and quickness enabled him to sort out with ease the minor matters that came the way of the rather unimportant Residency in a European backwater.

The Restoration comedy of manners, with its easy acceptance of privilege, idleness and immorality, was an insult to the Whigs, whose rational programme aimed at doing away with all these horrors. Anti-rationalism became an element in politics; after the triumph of the Whigs, it became a danger to the state. Movements were instituted straightaway, and with success, to reform this evil thinking. Throughout the age of reason, anti-rationalist works retained this wicked image, and when one appeared, like Mandeville's *Fable of the Bees* which stressed the importance of

luxury and vice in the make up of society, it was received as a sin against nature; and attacked as being not only against true art, but also against sound policy. One result was unforeseen: to fight anti-rationalism one had to set the mind against the rights of the imagination. When the movement of reform, began by Collier and others towards the end of the seventeenth century, succeeded, imagination had been made to retreat by policy. The new artists were rationalist because it was not socially or politically respectable to be anything else; to earn a living and reputation a man had to be a devotee of reason. So the new artist of the early eighteenth century turned himself into the expounder and moralist, a propagandist of the society he lived in rather than a servant of the muse.

John Dryden, caught between the old and the new, artist of the old imagination and reluctant servant of new policy, died on May 1, 1700. In spite of a sceptical and imaginative turn of mind much in sympathy with the older sensibility, he had not managed to prevent the confusion between art and the political order; in fact, in his concern for his profession, his eagerness to follow the shifts of patronage, and his support for the Stuarts, he had helped the confusion to arise. At the end, divested of political attachments and his old lyric self more once, he looked back and saw an age spoilt. In almost his last piece of writing, *The Secular Masque*, completed a few weeks before his death, he consigns the past to forgetfulness. Love and War have both had their moment, and both have come to nothing:

> All, all of a piece throughout:
> Thy Chase had a beast in View;
> Thy Wars brought nothing about;
> Thy Lovers were all untrue.
> 'Tis well an Old Age is out,
> And time to begin a New.

The new 'secular age' of reason was waiting quietly in the wings to obey the summons. Whether John Dryden would have approved its course is another matter.

THE PUBLIC

It must be more than an ordinary provocation that can tempt a man to write
in an age overrun with scribblers as Egypt was with flies and locusts.

Halifax, *Character of a Trimmer*, Preface.

THE SIZE AND wealth of a city exert their own influence; the growth of
population has effects both obvious and mysterious. In the seventeenth
century, that incoherent mass of equivocal potency, the people, began to
assume the form and firmness of an intervening hand in all English
affairs, including the arts. Throughout the century, whatever the mis-
fortunes of war and politics, London supported people in greater and
greater quantities. In the sixty years before the Restoration the popula-
tion of the capital had almost doubled; intelligent guesses set the number
in 1660 at nearly half a million. After 1660 the influx still continued; in
the sixties, commented the ingenious Sir William Petty, London swelled
with place-hunters and courtiers, and the seventies saw an immigration
of plotters and politicians.[1] The Plague and the Fire slowed down the
rate of growth; even so, by 1700 the population of London was close to
550,000. Petty, the father of statistics, proved to his own satisfaction that
London was as large as Rouen, Paris and Rome combined. It had become
the greatest city in Europe, and it was also the richest. The French
ambassador, Cominges, who had learnt from his master Louis XIV that
ostentation and expense are a large part of temporal glory, gave the
material crown to London—'without comparison, the place in the world
where expenses are largest, and where money is most freely squandered.'[2]

Given over as it was to the pursuit of wealth, London was not every-
where unattractive. Certainly it had notorious slums, streets full of mire
and excrement, dark, twisting canyons between the jutting house-fronts
through which swirled the smoky polluted air that Evelyn inveighed
against in his *Fumifugium*. But even the critical Evelyn did not despair;
wealth brings refinement as well as slums, and London was favourable
material to work on, so pleasantly situated 'upon a sweet and most agree-
able eminency of ground, at the North-side of a goodly and well-con-
ditioned river, with a soil universally gravel, richly irrigated and visited
with Waters which christalize as Fountains in every Street'.[3]

The consistent policy of the early Stuarts, and of Cromwell too, had attempted to prevent the spread of London. But when a city becomes large enough it gathers a momentum that no legislature can withstand. People need homes, whatever the policy of the government. By the start of the Civil Wars a fashionable quarter had developed around Covent Garden, and the liberties outside the City walls were extending eastwards to Stepney. Later, Lord Southampton had permission from Cromwell to build on his estate in Holborn. As the aristocracy, with their parcels of hereditary land handily placed within reach of the City, became aware of the profits in building, it became increasingly harder for the Crown to prevent development. In 1662 the Earl of St. Albans negotiated a lease for Pall Mall Fields and planned to erect houses 'fit for the dwellings of noblemen and gentlemen of quality'. He began to build St. James's Square. At about the same time Sir Roger Pratt started for the Lord Chancellor a house in Piccadilly. Clarendon House, the most magnificent and admired house of the age, was so grand and so expensive (the estimated cost was about £50,000), it helped to bring about the fall of its owner. Marvell, never slow to upbraid the administration, produced a satiric *Clarendon's House Warming*:

> Behold, in the depth of our Plague and our Wars,
> He built him a Palace that outbraves the Stars.

But the fashionable world hurried west to join the extravagant Lord Chancellor; and gentlemanly speculators like St. Albans, Arlington and Colonel Panton busily developed St. James's, Piccadilly and Mayfair to receive them.

To build outside the City walls was far simpler than to reform the late mediaeval and Elizabethan huddle within the City, and planners might have despaired of this area had it not been for the fortuitous tragedy of the Great Fire. On September 1, 1666, Pepys was awakened in Seething Lane at three in the morning by his maid, who saw a glimmer of fire over the housetops 'on the backside of Mark Lane at the farthest; but being unused to such fires as followed, I thought it far enough off; and so went to bed again, and to sleep'. City officials viewed the early flames with the same easy negligence. 'Pish,' said Sir Thomas Bludworth, the Lord Mayor, at his first sight of the fire, 'a woman might piss it out.'[4] His confidence was misplaced; it took four days to bring the flames under control, and by then 13,000 houses and 87 churches had been destroyed.

Official casualness had helped the fire to spread; the work of rebuilding began with an impressive sense of civic responsibility. The legislation for the new City was quickly set out in the Rebuilding Act of 1667. The

inevitable and incredible legal complications were boldly minimized by referring all questions to a court of equity, the Fire Judges' Court which, under Sir Matthew Hale, a man of quite remarkable good-sense and probity, 'removed a multitude of grave impediments'. The public-spiritied virtuosoes within the Royal Society—Wren, Evelyn and Hooke—rushed out their plans. Even the King acted against his own financial interest. He committed to gaol a certain Valentine Knight who had proposed a cunning rebuilding scheme calculated to raise for the King immediately the sum of £372,670, and to provide an annual income for the Crown of £223,517; 'as if his Majesty,' said the *Gazette*, 'would draw a benefit to himself from so public a calamity of his people, of which his Majesty is known to have so deep sense.'[5]

After the inevitable dejection—'the City less and less likely to be built again,' noted a gloomy Pepys, 'everybody settling elsewhere, and nobody encouraged to trade'[6]—the advantages of a new London began to appear. Mandeville, the mocker of conventional attitudes, remarked on the odd paradox:

> The Fire of *London* was a Great Calamity, but if Carpenters, Bricklayers, Smiths, and all, not only that are employed in Building but likewise those that made and dealt in the same Manufactures and other Merchandizes that were burnt, and other Trades again that got by them when they were in full Employ, were to Vote against those who lost by the Fire; the Rejoicings would equal if not exceed the Complaints.[7]

The problems of the gigantic task, and the difficulties of finance, made the rebuilding seem painfully slow; but there was always work in hand, and all craftsmen benefited. The mason, Samuel Fulkes, worked for 2s. 6d. a day in 1664; in the seventies he started taking small contracts; in the eighties the contracts became larger—£1,946, £3,204 and then £3,335; finally he became principal masonry contractor for St. Paul's.[8] The impetus begun by the fire in London seemed to encourage building everywhere. Speculation was never so profitable; private patrons discovered a new zest for building.

There emerged, as a result of these ferments, a phenomenon called Nicholas Barbon, the archetype of the unprincipled speculator so well known in all subsequent ages including our own. Barbon was as various-sided as any member of the Royal Society—a doctor, an economic theorist, the proposer of a Land Bank and the father of Fire Insurance; but building speculation was his chief interest. 'All his aim,' wrote Roger North, 'was profit.' He was, like most of his kind, a wizard in financial dealings, notoriously pliant and extremely able; not all his work stayed up (there

were some unfortunate collapses in the Minories), but at least he conjured forth houses in imaginative style. Roger North, who had professional dealings with him over some rebuilding in the Temple, gave a picture of him at work:

> He was the inventor of the new method of building, by casting of ground with streets and small houses, and to augment their number with as little front as possible, and selling the ground to workmen at so much per foot front, and what he could not sell, build himself. Thus he made ground rents high for the sake of mortgagers, and others following his steps have refined and improved upon it and made a superfoetation of houses about London.[9]

Though unscrupulous, Barbon and his kind were to a degree necessary. Of the 13,000 city houses destroyed in the fire, only 9,000 were replaced. With the population continuously expanding, London needed some 'superfoetation' of houses.

Barbon's interests were not extensive within the City, for there the land was well tied up. He began with a share in St. Albans's development in Pall Mall Fields. Then he became well known for his work south of the Strand. With the westward movement of the fashionable, the old river palaces in this area lost their popularity; the aristocratic owners discovered that their large houses could be pulled down and the ground filled with very profitable development. Barbon was close at hand to assist them. In 1674, he began with Essex House, and then the Duke of Buckingham's York House went the same way. Later, Barbon set out more extensive estates in Red Lion Fields, and in Bloomsbury. Where Barbon led others soon followed. Lord Salisbury developed his property in the Strand. Lord Southampton built in Holborn and Bloomsbury; Great Russell Street came into being and included among its occupiers Wren and Sir Godfrey Kneller. St. Giles's was built over. The exodus from the City continued. Richard Frith expanded in Soho; St. Anne's, Soho, to serve the new parish, was consecrated in March 1686. Westminster was by now joined to the City, and was itself overflowing. The bizarre practice of touching for the King's Evil strained the Westminster accommodation; between 1667 and 1684 Westminster reluctantly housed no less than 68,506 scrofulous people who came for the royal touch. The pressure was eased after 1688 when King William, no claimant of divine right, tried to discontinue this practice.[10]

As the rebuilding of the City and the expansion of the suburbs in the late seventeenth century was the work of many men, so the architecture was equally varied. None of the grand, unifying plans presented just after the Fire came to anything; the problems of reconciling all the interests

were too great. In the first enthusiasm of replanning Wren was appointed 'Surveyor-General and Principal Architect for rebuilding the whole City, the Cathedral Church of St. Paul, and all the principal churches, with other structures'.[11] In fact, he was wholly responsible for St. Paul's, chiefly responsible for the fifty-one City churches to replace the eighty-seven destroyed, and hardly responsible for anything else in the rebuilding.

In 1685, Nicholas Barbon, attempting to justify his work as a builder, wrote the following:

> The Artists of this Age have already made the City of London the Metropolis of Europe, and if it be compared for the number of good houses, for its many and large Piazzas, for its richness of inhabitants, it must be the largest, the best built and the richest City in the world.[12]

The case for the pre-eminence of the architecture may be doubtful, but at least it is arguable. Such architectural plan and uniformity as existed was not so much imposed by the builders as insisted on by the new regulations. For the Rebuilding Act set out for the first time a standard building practice which was soon effective all over England. The houses were to be brick-built and one of four different types, either two-, three- or four-storied. The Acts specified no particular style; but for speculators after profit the simplest style was best. The town-houses of an earlier age, for example those built before the Civil Wars in Lincoln's Inn Fields and Great Queen Street, were ambitious houses constructed for rich and fashionable occupants. Their architecture, under the influence of Inigo Jones, was classical, elegant and impressive. Houses built for artisans at that time were still gothic, timbered and gabled. The new brick houses in the rebuilt London were for artisans and men of moderate means, and therefore plain and without frills. Their dignity and their architectural value came from the uniformity of the streets and the proportions of the squares. Each development was built to slightly different plans, producing a local character on each estate which still fitted harmoniously into the whole city. This feeling for local variety and a smaller scale was brilliantly realized by Wren in his fifty-one City churches. The contrast between their architecture and the great and imperious plan of St. Paul's is very marked. The rather cavalier handling of classical forms and the variety of contrivance in the City churches show Wren responding to a particular patronage. St. Paul's was the work of the King's Surveyor, a monument for all England. Each City church expressed the sense of individuality in each parish, though taken together the churches

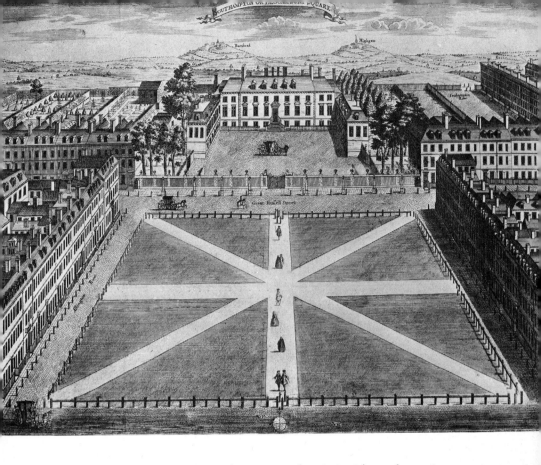

Contrasts in town and country planning: Bloomsbury Square,
laid out by the Earl of Southampton in 1661, and Claremont,
designed by Vanbrugh for the Duke of Newcastle around 1712

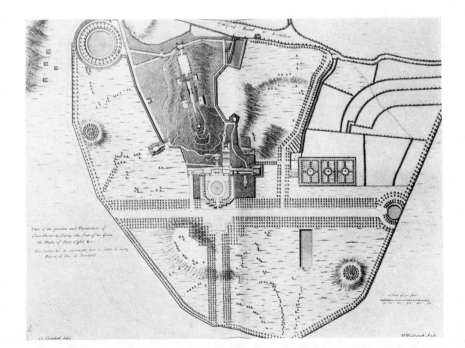

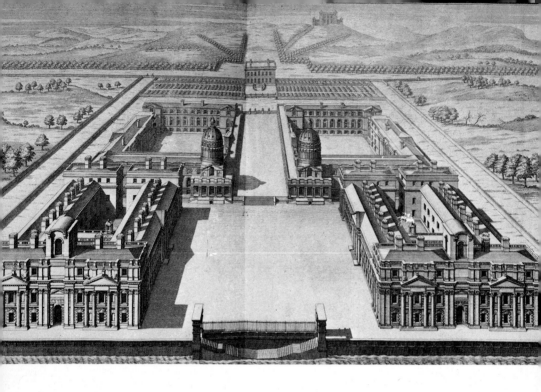

Greenwich Hospital (1665-1735) and (below) Hampton Court
(1689-94): two of the chief buildings from the Royal Works,
designed during the period of Wren's Surveyorship

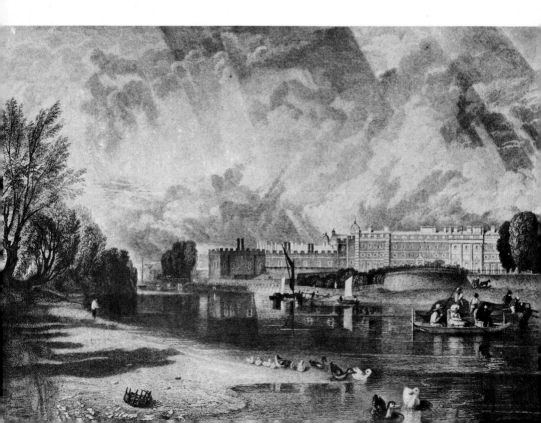

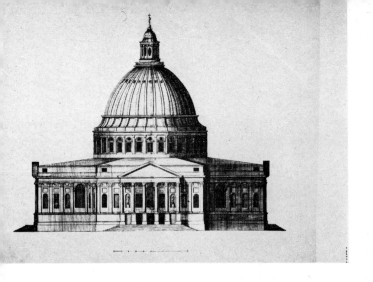

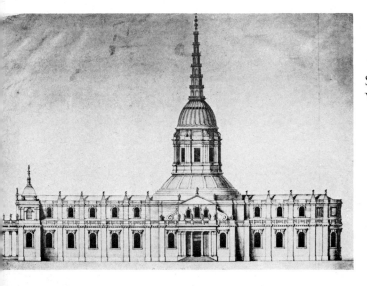

Studies in the evolution of a
Wren building

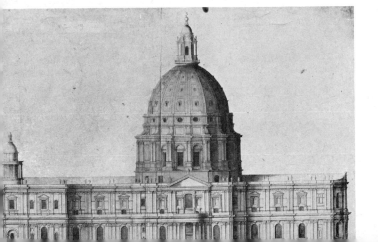

Old and new domestic architecture in eighteenth-century London. Uxbridge (originally Queensberry) House, designed by Leoni in 1721, was the first Palladian town house

had sufficient similarities to prevent them being incongruous;[13] they reflected a local, not a national, spirit.

In London, the effect of great buildings put up by architects under royal or aristocratic patronage became gradually less striking. The nobles continued to be enthusiastic builders, and work on fine houses still went on; Clarendon House arose in Piccadilly, and Southampton, Thanet and Montague Houses dignified the new estates in Bloomsbury. But there began to appear also a pleasant over-all harmony of streets and squares, enlivened by modest local variations. This was caused by the response of builders and developers to a pressing population, and this speculation was kept in check by some sensible and uniform building regulations introduced as a result of the Great Fire. For the first time, the town's beauty did not only depend on the resplendent showpieces of a private or court patronage; now great buildings were set off by town-houses of simple dignity produced by a public need.

There were signs, too, in the years after the Restoration, that painting, which is always liable to be a plaything of the rich, was becoming, if not quite in touch with the public, at least aware of subject matter more popular than the interminable portraiture. The indications were slight, for portrait painting was still very much in the ascendant. The opinion of Kneller, who took over the mantle of Lely, was probably common enough. 'Painters of history,' he said, 'make the dead live, and do not begin to live themselves until they are dead. I paint the living, and they make me live.'[14] To work in a secure tradition and to make a good deal of money is no sin; and the seventeenth-century English portraiture was a fine achievement. In the next century, Jonathan Richardson, testifying to the amount and quality of English portraiture, placed the achievement very high indeed. England, he wrote:

> being well stor'd with the Works of the greatest Masters, whether Paintings, or Drawings, Here being moreover the finest Living Models, as well as the greatest Encouragement, This may justly be esteem'd as a Complete, and the Best School for Face-Painting Now in the World; and would probably have been yet Better, had *Van-Dyck*'s Model been follow'd.[15]

But, as Richardson also admitted, a 'false taste' was everywhere apparent towards the end, and it was time for English painting to try other modes.

The construction of so many great houses throughout the Stuart years gave one opportunity to painters. In 1629, Rubens had come to London to decorate for the King the ceilings of Whitehall; in the last years of the century wall and ceiling painting became almost a necessity

in any building of the least pretensions. Robert Streeter, the versatile Serjeant-Painter of the Restoration, began the fashion; Verrio, Laguerre, Pelligrini and Thornhill continued it. Streeter—'a very civil little man, and lame'[16]—was much admired in his time, and mixed freely with the virtuosos such as Wren, Evelyn and Pepys. His fame, in fact, considerably outran his accomplishments, and one enthusiast very unwisely wrote:

> That future ages must confess they owe
> To Streater more than Michael Angelo.[17]

He was, however, competent and adaptable (he painted, says Walpole, 'all the scenes at the old playhouse'),[18] and a fit man to undertake the ceiling decoration for Wren's Sheldonian Theatre. He received £400 for this work, thus setting a profitable and successful precedent. He later decorated the chapel at All Souls, Oxford, some ceilings at Whitehall, and did a *Moses and Aaron* for St. Michael's, Cornhill.

Once the English preference for wall painting was known, European artists quickly arrived to put their training and tradition to the English service. And they discovered for themselves a very good business. Verrio grew extremely rich at the expense of Charles II and James II. As a Catholic, he fell out with William, and only in his last years deigned to return to the royal service, to paint the great staircase at Hampton Court. Verrio's reputation and wealth made him quite independent from the royal patronage. When James fled, Verrio was snapped up by Lord Exeter to work at Burleigh, and afterwards he painted at Chatsworth and Lowther Hall. Nearly every large house now demanded its share of wall decoration, and the fashion continued into the eighteenth century. Louis Laguerre, who arrived in 1683 and began as Verrio's assistant, soon became a master in his own right on walls, ceilings and stairways. His work was to be seen at Burleigh, at Devonshire, Buckingham and Marlborough Houses in London, at Petworth, and finally at Hampton Court and Blenheim. He was also chosen to paint the inside of the cupola at St. Paul's, but was then set aside for Thornhill. He did a staircase at Whitton for Kneller, and a bacchanalian rout on a tavern wall for a club that met there. By the end of the century, the fees paid out by some owners of noble houses were extraordinarily high. The Duke of Montague required the very best for his new house in Bloomsbury. He therefore summoned from the continent Rousseau and de la Fosse, agreeing to pay Rousseau £1,500 and de la Fosse £2,000. In contrast, Thornhill, though a notable painter with work to his credit at Hampton Court, Blenheim, Greenwich and Moor Park, received only sixty shillings a square yard for

the dome of St. Paul's, twenty shillings for the walls of St. Paul's, and twenty-five shillings at Blenheim.[19] Official patronage of painting was no longer the exhilaratingly profitable business Verrio had discovered in the high days of Charles II.

This house decoration was not the greatest art. Walpole observed that 'Painted ceilings, at best, are but awkward ornaments, not only as it is impossible to examine them without pain, but also as the foreshortening of the figures, which is absolutely necessary to give them any kind of effect, is so contrary to what we see in common life, that it is disgusting'.[20] But this sort of art had its value since it helped to break the monotony of portraiture. It paid painters well and encouraged them to diversify and try other subjects. The decoration, too, so much of the work being in churches, drew the public eye towards painting, and helped the public to become accustomed and to form opinions.

Wall painting was art in the grand manner which only the rich could afford. Some painters, however, turned aside from grandeur to try their hand at less heroic subjects—sporting scenes, landscapes, battlepieces and the like. Most of this was quiet work, often by minor figures, and not richly rewarded. Francis Barlow, whose long life spanned from Charles I to Anne, was the founder to the English school of animal and sporting pictures, producing illustrations for Aesop's *Fables*, and several large paintings which capture wonderfully the sportsman and his prey in their English setting. Barlow's work was popular in his own age; many of his pieces were engraved by Hollar and Faithorne. He also had a reputation on the continent—rather rare for an English artist. In 1714, more than a hundred of his etchings were published in Holland. Barlow was followed by such men as Vanson, who painted birds in water-colours for the Earl of Radnor, and, more notably, John Wyck, a lively painter of hunting and hawking. Landscape had its share of practitioners, among them being the busy Robert Streeter, Thomas, the father of John Wyck, and Henry van der Straaten who, according to Walpole, could only paint when completely broke. Historical scenes and battles were also painted, but not in great numbers. Perhaps the experiences of the Civil Wars followed by the varying misfortunes of the Dutch Wars left the country with little martial appetite. At the Restoration, Isaac Fuller pictured the King's escape at Worcester in five very large paintings. These were soon decently buried in the Irish Parliament. John Wyck produced some pieces on subjects from King William's campaigns—the battle of the Boyne, the Sieges of Narden and of Namur. A more profitable subject-matter was found in seascapes. William van de Velde was employed by Holland to

portray the sea-battles of the Dutch Wars. With a fine disinterest, and disregard for danger, he took a boat between the fleets of Monk and De Ruyter, to observe the action better. He came to England in 1675 rightly famous as a sea-painter, and his son, William the younger, following the father within a few years, raised this particular art even higher. The tradition was carried on by Peter Monamy.

The education of the public eye is always a problematic business. It is not easy to provide opportunities to see paintings; arraying them in galleries makes picture-viewing a kind of cultural pilgrimage which the public often finds pretentious or repugnant. And, in the late seventeenth century, apart from the houses of the rich, there were no galleries. Nor have ordinary citizens ever been great patrons of painting. A few exceptional men like Pepys have raised the rather exorbitant fees that successful painters usually ask, but in general the public has been pleased to leave painting as a private, intimate affair between the artist and the rich. The painter, therefore, realizing his part of the bargain, was content to preserve the illusions of the rich, that theirs was the power and the glory. Yet the press of affairs, wider education and greater wealth did make people more aware of graphic art. Engravers like Hollar and Faithorne multiplied the unique image of a painting, and their reproductions became popular. Newspapers, pamphlets, broadsheets and books all had a part in placing these designs before a wider public. Those who strolled in King Charles's picture gallery at Whitehall, though they came to amaze themselves with the excesses of the fashionable world, perhaps took away a minute portion of Charles's own enthusiasm for painting. The new style of decoration on walls and ceilings in churches and great buildings was sometimes homiletic, sometimes didactic and sometimes merely grandiloquent, but all served a vague public purpose. Awareness among the public was undoubtedly growing. Auctions and sales were common enough after the Restoration. The industrious editor of Walpole claimed that 'the first regular sale of a miscellaneous collection' took place at the King's Arms Tavern, in the Strand, in June 1682. This marked 'the first era of the diffusion of vertu among the public at large'.[21] After 1688, Dutch picture-dealers found it profitable to bring their collections to be auctioned in London.

If painting is an art for the rich, music has always been the art for everyman—'our Common Prayer,' says W. H. Auden, 'whose greatest comfort is music.' For two centuries before the Restoration, England had made music as beautiful and accomplished as any in Europe. Now times were changing; the generation of Jacobean composers had passed. But

England still had numerous and eager musicians, reflecting the organization and vitality that come from a successful tradition. King Charles employed most; then the City had its waits and trumpeters, Westminster had waits, St. Paul's and the Abbey had bands of choristers; the Inns of Court and the City guilds employed musicians, and great lords had private bands. Some musicians were pluralists, working for as many masters as they could find, and most spent part of their time teaching. These were the professionals, belonging to one of the two Corporations. There were besides the itinerant performers much in demand at fairs, weddings, taverns and domestic celebrations.

The austerities of Puritan times had driven music-making into the home. With the return of the King, music was officially permitted outdoors again, and welcomed at all public events. The coronation of Charles, in April 1661, the first great ceremony of the new age planned to banish all remnants of Puritan gloom, was a resounding musical occasion. On the day before, the King's progress through the City was punctuated with bursts of music. At Aldgate, six waits performed from a balcony; Cornhill had trumpeters and 'eight nymphs', before the Exchange were three singers dressed as sailors; Cheapside had wind music and more nymphs, and at Wood Street the King was serenaded by Love and Truth. At Paternoster Row he was handed over to drum and fife, and went with martial accompaniment down to Ludgate and over the Fleet.[22] The next day, in the Abbey, Pepys expressed 'a great pleasure' to see musicians looking so well and elegant, and Evelyn noted the contribution that 'Lutes, Viols, Trumpets, Organs, Voices &c.' made to the service. From this time, ceremonies, processions and celebrations seemed incomplete without music. The Lord Mayor had his yearly pageant; ambassadors were received and flattered to soft airs; victories were proclaimed to music. The burgesses in City livery companies from time to time forgot their pre-occupation with the market-place and disported themselves with 'garlands about their heads, and musique playing before them'.[23] When the music was missing, there was concern at the loss. 'I expected music,' wrote Pepys after a Lord Mayor's banquet, 'but there was none but only trumpets and drums, which displeased me.'[24]

As there was a general joy in music, any event garnished with music became that much more attractive. Sometimes the musical performance itself became the occasion, and the event that gave rise to it sank out of sight. In 1655 a group called the Sons of the Clergy came together to provide charity for the needy clergymen and their families. Each year, to publicize their cause, they held a choral service with an

exhortatory sermon, first in a City church and eventually in St. Paul's. In the process of time the choral service received an orchestral accompaniment, and by the end of the century London had one of its annual musical events. Purcell's *Te Deum* and *Jubilate* in D became a regular part of the programme. Other notable annual performances were under the direction of the genial groups of friends known as the Gentlemen of Kent and the Yorkshire Gentry. The latter group had their own ode composed by Purcell—his *Yorkshire Feast Song*—which was performed after a banquet of some magnificence 'with a very splendid Entertainment of all sorts of Vocal and Instrumental Musick'.[25] The revels of the lawyers, too, were accompanied with music. The connection between law and music was not accidental. Some ability on an instrument was part of the accomplishment of a gentleman, and the Inns of Court were pre-eminently abodes for gentlemen. And to keep them up to the mark, there was John Playford, Clerk of the Temple Church, running his musical publishing business from the Inner Temple. His successors, Henry Playford and Richard Carr, established their music shop at Middle Temple Gate.

Best known of the annual musical feasts was the appropriate celebration on November 22 for St. Cecilia, the patron saint of music. This occasion began obscurely soon after the Restoration, was in full vigour by 1683 and continued into the next century. A special ode was composed; after a service in St. Bride's there was an evening concert in Stationers' Hall. The fame of the occasion is now remembered largely because the Stewards had the good sense to ask for contributions from Dryden and Purcell.

Although there was much music-making under the Commonwealth, most of it had taken place in the intimacy of the home. In King Charles's day a new spirit reigned. Under the influence of an inquisitive, amusing and sauntering monarch, there was much going out, much drinking, conversation and conviviality. A people used to music in the home now came to expect it in the town. The societies—of Yorkshiremen, Temple lawyers and the like—provided music for some, but these were coteries, or privileged audiences. When the ordinary man felt the need for the indispensable harmony of music he took himself to the tavern. 'A musician is a merry Fellow,' wrote Samuel Persons, 'for he is much for strong drink.' Then, as now, affable musicians in certain kindly taverns made a double welcome with ale and song. 'He is a conjurer in the circle of the ear,' Persons added, 'When the heart sinks down (as it were) into the Earth, and would be buried there, yea, when it is almost dead, he with the breath of his musick resuscitates it again.'[26] At the Blue Bell in London Wall and the Blue Balls in Covent Garden, at the King's Head in Greenwich

and the King's Head in Stepney, at the Mitre in Wapping and the Mitre by St. Paul's, at the Cock, the Dolphin, the Dog and many another, a special room was set aside for music, with tables and chairs or seats in rows, and the performers behind a rail or in a kind of curtained box at one end.[27] No charge was made for the music, the customer being expected to lay out his money assiduously for food and drink. Consequently the level of alcohol often submerged the performance. Ned Ward, visiting the Mitre at Wapping in his character as *The London Spy*, thought that had 'the harmonious grunting of a hog' been added 'as the bass to a ravishing concert of caterwauling performers in the height of their ecstasy, the unusualness of the sound could not have rendered it, to a nice ear, more engaging'.[28] However, when heads were clearer many taverns achieved a respectable standard. The organist, Arundell, gave Pepys 'a fine voluntary or two' at the King's Head in Greenwich, and on other occasions Pepys was accompanied to musical taverns by lights of the musical establishment such as Matthew Locke, Hingston and Banister.[29]

Pepys, whose favourite pastimes included chatter and music, was a grand patron of these taverns, and left many pleasant accounts of his harmonious evenings, sometimes a listener and sometimes in full musical flight himself, as on this occasion at the Green Dragon:

> and there we sang all sorts of things, and I ventured with good success upon things at first sight, and after that I played on my flageolet, and staid there till nine o'clock, very merry and drawn on with one song after another till it came to be so late. . . .[30]

And for many amateurs anxious to take part in performance the taverns were the natural gathering places. Friends met to sing the popular catches. Playford's edition of *Catch that Catch can* in 1667 was dedicated to the 'endeared friends of the late Musick Society and Meeting in the Old-Jury'. Other amateur instrumentalists met 'weekly or oftener, sometimes at private chambers, and not seldom at tavernes'. Roger North, who was likely to have been one of the gentlemen, wrote that 'their music was, of the Babtist [Lully] way, very good'. They met at the Castle, and their fame grew. The public crowded in until their importunity drove out the gentlemen, 'being under the *fastidium* of loosing the freedome of a private meeting', whereupon the 'masters of musick entered and filled the consort, which they carried on directly for mony collected as at other publik enterteinements'.[31] The keen eye of business had detected a virgin market. The amateurs' loss was the professionals' gain. The fully-fledged public concert before a paying audience had come into being. The credit for this event is usually given to the leader of the King's violins, John Banister

It seems that Banister's bold step came, as so often, from poverty. Banister had an unlucky hand with money; in former years his fellow violinist in the King's Musick had complained that their fees sometimes vanished under his stewardship. His concerts, the first most probably being at the end of December 1672, in his house in Whitefriars, was an attempt to lessen a musician's dependence on the insubstantial Privy Purse. Roger North called it a low attempt—'1s. a piece, call for what you please, pay the reckoning, and *Welcome gentlemen*. Here came most of the shack-performers in towne, and much company to hear; and divers musicall curiositys were presented.'[32] The concerts were given daily, with some periods of interruption, until 1678. Banister died in the next year.

Banister led an agitated life, and his concerts never quite settled down. The venue was changed rather frequently, from Whitefriars to Chandos Street to Lincoln's Inn Fields and finally to the Strand. But the public willingness to pay for musical performances had been demonstrated, and the practice was considered to be sound business. There now began to appear a number of rooms 'built express and equipt for musick', the first being in York Buildings, part of fashionable Villiers Street. Other concert rooms were set up in Freeman's Yard, Cornhill, in Charles Street and in Hickford's Dancing School, Panton Street.

After Banister's pioneering effort, further series of concerts were organized. In 1689, Robert King was granted a licence giving him sole right to fix 'such prices as shall be set down, and no person shall attempt rudely or by force to enter in or abide there during the time of performing the said music'.[33] Much more famous were the concerts of Thomas Britton, small-coal merchant of Clerkenwell, who began in 1678 to give weekly concerts in premises 'not much bigger than the Bunghole of a Cask',[34] and this series continued for almost forty years. The surroundings were intimate, though liable to produce what Ned Ward called 'a hearty sweat'; the concerts were at first free, and later very moderately priced, the music was in the hands of men of taste and anility. Handel gave some of the later performances. In fact, the enterprise prospered because Britton, though only a coal merchant, was both a scholar and an enthusiast. His qualities were soon recognized in the town; aristocrats were frequently in his audiences; the Earl of Oxford was counted among his friends. When Britton died, he left a large collection of books, manuscripts and instruments.

Concerts and public performances were not the only ways by which the London musician could increase his income and expand his interests.

After the Restoration, the new style of 'opera' gave musicians yet more opportunities for work. Opera then was not quite as we know it today; it had more in common with the court masques of the last age. The scenery, the machines, the spectacle and the direful improbabilities of the heroic tale competed with the music. The effect must have been closer to modern Palladium than modern Covent Garden. Dryden, in the preface to *Albion and Albanius*, describes the contemporary recipe:

> An Opera is a Poetical Tale, or Fiction, represented by Vocal and Instrumental Musick, adorn'd with Scenes, Machines and Dancing. The suppos'd Persons of this Musical Drama are generally Supernatural, as Gods, and Godesses, and Heroes, which at least are descended from them, and are in due time to be adopted into their number.

But music had its part to play in this cocktail, and that not the least important. The chief gainers from this new state of affairs were, of course, the composers. Most composers were members of the King's Musick and therefore, in the later Stuart years, liable to be impoverished by the royal finances. Composers, unlike performers, did not benefit much by public concerts; for them the theatre was the necessary alternative. And men like Locke, Grabu and especially Purcell gave the playhouse their devoted attention. Purcell began, in 1680, with some incidental music and a few songs for *Theodosius* at the Duke's Theatre. Over the next decade he gradually proved his genius for dramatic music with a number of songs and short scenes for various plays. The work, however, which finally displayed his fully developed operatic talent was *Dido and Aeneas* written around 1688, not for the commercial theatre, but for the amateur ladies of Josias Priest's school in Chelsea. He was now considered qualified for the mighty grandeur of 'opera', and in 1690 collaborated with Betterton at Dorset Garden in a piece called *Dioclesian*, confectioned out of Beaumont and Fletcher's *Prophetess*. This work, said Downes, 'gratified the expectation of Court and City, and got the author great reputation'. Purcell's music had caught the ear of Dryden, and over the next two years the two stars of their professions worked together on *Amphitryon*, and then on *King Arthur*, a work of lofty conception and plan, but in execution more impressive in the music than in the writing. And even the music suffers from an excess of high purpose. For the rest of his short life Purcell was a busy dramatic composer. In all, he provided music—often not very much —for forty-four plays. After *King Arthur*, he wrote three more 'operatic' works, *The Fairy Queen*, *The Indian Queen*, and *The Tempest*. He wrote music for plays by Dryden (eight times altogether), Shadwell, Settle, Lee, Crowne, Aphra Behn, D'Urfey and Southerne. When Congreve's first

play arrived on the stage, it did so accompanied by Purcell's incidental music.[35]

This activity, in public and in the theatre, helped both composers and performers to keep bouyant amid the rising waters of the royal insolvency. The public, in their turn, heard more music performed than ever before, and music's popularity remained high. Playford's publications were in demand; and he, like his brother booksellers, began to realize the force of advertising and promotion. At the turn of the century, Henry Playford tried to institute a sort of league of clubs, for which he drew up and framed articles and for which, of course, he printed tempting collections.[36] Though he was not successful, evidence of public interest abounded. Music groups prospered, concerts were well attended. Music was available not only in the raucous tavern, but also in the genteel coffee-house. There, on February 21, 1660, Pepys met Locke and the elder Purcells and spent an hour or two singing Italian and Spanish songs. In the nineties the coffee-houses also provided room for the first sales of music collections. This was the time, too, when Dutch picture dealers were finding a market in London for their art collections. The first music sale was held at Dewing's in 1691; Thomas Britton's important collection was sold at Tom's in 1694.[37]

In England, the meeting of art and the public took place in London. For a while London was expanding and lively, the countryside was quiet and empty. France had its regional cities, some of them quite large and assertive; in England, though Bristol and York were mildly populous, compared to the capital they were small indeed. The contrast was very striking; foreigners used to the bustling enormity of London found the country still, even static. Courtin, an emissary of Louis XIV, riding to Salisbury to avoid the Plague, travelled through fine land with the villages well scattered; it was reaping time, but there were not many labourers in the fields and hardly anyone in the roads.

> The common people [he wrote] live comfortably enough because they pay nothing when the state has no war, and because the land produces an abundance of food. But the inhabitants of the country and of the towns not by the sea-side have no cash. They are not numerous. . . .[38]

Without cash and with few people there can be no public patronage.

Though the countryside was wide and empty, it was by no means a desert of barbarism. The amelioration that comes from education and prosperity may not have embraced all, or even a majority, but it did spread well beyond London. The capital maintained its vitality partly because the hopeful crowds rallying towards the better life had already

received in their country or provincial birthplaces enough education to keep their minds lively and their curiosity extended. Adam Eyre, a yeoman farmer who lived in the Yorkshire dales during the Common-wealth, had a carpenter in to build special shelving for his books in the front room of his farm-house. There reposed his volumes—Lilly's work on prophecies; Raleigh's *History of the World*; Erasmus's *In Praise of Folly*; Dalton's solid *Country Justice*; Howell's exotic *Dendrologia*; and of course Foxe's *Book of Martyrs*. There were more besides, especially sermons and religious books. Adam Eyre was no doubt exceptional in that he actually possessed a library; but he noted in his rough diary that his fellow yeomen constantly came to him to borrow one volume or another.[39]

A serious reading public in the seclusion of the Yorkshire dales—how much larger and readier was the one in London! Amid the notorious religious dissensions, the litigious and brawling intellects were well supplied with the squibs of a paper war. Mercury brought the news post-haste from every quarter. Even the unsubstantial regions had their reporters; the *Mercurius Diabolicus* was otherwise known as *Hell's In-telligencer*, and *The Laughing Mercury* gave the 'genuine news' of the moon. The earthy *Mercurius Britannicus* was opposed by the watery *Mercurius Aquaticus*. The *Anti-Melancholicus* contended with the *Melancholicus*, the *Pragmaticus* with the *Anti-Pragmaticus*. There was even the ultimate Mercury, the schizophrenic *Mercurius Anti-Mercurius*.[40] The news was gathered fast and presented with prejudice and a lack of inhibition for all to read.

Polemics were bracing, and often fun. But a people becoming literate began to expect something more. They wanted discussion and instruction too. In 1665, the French, so much more polite than the English, had instituted in Paris a *Journal des Savans* dedicated to bringing the news from 'the Republick of Letters'. It gave as well a résumé of new books; obituaries of the great deceased; accounts of experiments in the natural sciences; and the latest words from the universities, whether theological or scholarly. Following after the French, Henry Oldenburg wrote a monthly account of the *Transactions of the Royal Society*, of which he was the secretary, covering much the same ground as the French *Journal*. The idea of periodicals giving learned or specialist information soon caught on. The London booksellers, in 1668, started the *Mercurius Librarius*, known generally as the *Term Catalogue*, setting out the current titles of the booksellers under various headings. The scientist Robert Hooke ran a series of *Philosophical Collections* in 1681–2, being 'a candid commendation of useful discoveries'. In January 1682, the first number of the *Weekly*

Memorials for the Ingenious came out admitting a debt to the *Journal des Savans*, Mr. Oldenburg and Mr. Hooke. In 1686, the scope of periodicals was extended by the *Universal Historical Bibliotheque* which claimed to give an account of the important books printed in *all* languages—a 'short description' of the 'design and scope of almost every book; and the quality of the author, if known'. The element of criticism had entered in.

The close connection between the life of the learned and social life ensured that these specialist periodicals had a rather wider effect than one would expect from similar publications today. Then, the men of the Royal Society, the philosophers, the experimenters, the authors were also playgoers, the amateur musicians, the wits and the great devotees of the coffee-house. They constituted a kind of 'society of gentlemen'. Since this society shared common experience and interests, there was obviously a place for a journal, unspecialized but having in mind the common outlook. By 1691, this thought had occurred to John Dunton, the energetic and wayward bookseller at the Black Raven. 'The human Mind,' he recalled with the endearing sententiousness which is his peculiar mark, 'though it has lost its innocence, and made shipwreck of the image of God; yet the desire for Knowledge is undestroyed.'[41] To cater for this desire, and to give the curious 'some glimmering apparition of Truth', on March 17, 1691, he brought out his *Athenian Gazette*.

This periodical (in 1696 it changed its name to the *Athenian Mercury*) demonstrated Truth particularly by attempting to resolve 'the nice and curious questions proposed by the Ingenious'. The response to this 'surprizing and unthought of' project was immediate; Dunton was over-loaded with letters: 'sometimes I have found several hundreds for me at Mr. Smith's Coffee-house in Stocks Market.'[42] And many of the queries were ingenious indeed. Why rats, toads, ravens, screech-owls etc., are ominous? When had angels their first existence? Is a public or private courtship better? Where best to find a husband? Was Adam a giant? Shall negroes arise at the last day? Where extinguished fire goes? and Where did the ten tribes go? All this the *Athenian* was competent to answer, sometimes painstakingly and sometimes with humour. The more sensible question as to which was the best poem ever made received an answer which considered Chaucer, Shakespeare, Ben Jonson, Spenser, Davenant and Cowley; the final opinion of the expert was that *Paradise Lost* would never be equalled, and that Waller was the most correct poet.[43]

Obviously the *Athenian* was as much entertainment as instruction. It was a step on the way from the high seriousness of the *Transactions* to later entertainments like Ned Ward's *London Spy* and Tom Brown's

Amusements Serious and Comical. But it would be wrong to underestimate it. The *Athenian* was a novel and valuable aid to a population growing in literacy. The fund of knowledge that ordinary people could draw on was then obscure and incomplete, and so their questions often had the charm of naïvety. But the *Athenian*—and its many followers—helped to make learning respectable and reading a popular enthusiasm. The *Athenian*, wrote Dunton proudly, received affectionate notice from Motteux, Defoe, Nahum Tate, Jonathan Swift, Sir William Temple, and even the great Marquis of Halifax himself.[44]

The burgeoning reading habits of the populace set the small pens busy in a hundred newspapers, periodicals and broadsheets; but the restrictions of the 1662 Licensing Act somewhat redressed this balance of enthusiasm, and made the business of author more tricky than it might have been. The powers of the royal prerogative were reasserted; the number of printers in London was reduced from about sixty to twenty; censorship, more or less efficient depending on the political climate, was in force from 1662 to 1695. Roger L'Estrange, the eyes of the royal prerogative throughout the Stuart period, was quick to spy out unorthodox opinions, though, as a typical Caroline courtier, he could be distracted by well-presented sex. He would, said Dunton, 'wink at unlicensed books if the printer's wife would but smile on him'. If beauty was not available, L'Estrange unappeased could be a deadly opponent. Once in office, he soon had the printer John Twyn hanged, drawn and quartered.

Other disasters hit the book trade. The Plague very obviously did it no good, and the Fire in the next year destroyed huge stocks in Stationers' Hall and St. Paul's Churchyard. Pepys put the value of the loss at about £150,000. Under these setbacks, the structure of the trade started to change. The printer shrank and the bookseller grew in importance. The bookseller became an entrepreneur, beginning to organize, in his own best interest, the literary talent. His business now was not just to sell books, but to foster authors, to commission and to promote their efforts. The caterpillar bookseller was transforming himself into the full glory of the publisher, that radiant butterfly. The process had been going on quietly for a number of years. The career of a man like Henry Herringman was demonstrating how important it was to recognize a viable literary property and to establish a sound stable of authors. Herringman started well with a share in the Shakespeare Third Folio, first editions of Cowley, Denham and Waller, panegyrics on Cromwell by Sprat, Marvell and the promising young Dryden. Soon he had also netted Davenant, Orrery, Howard, Katherine Philips (the matchless Orinda), most of the court wits

and a good share of the scientists from the Royal Society. Herringman's shop, at the sign of the Blue Anchor in the New Exchange, was the literary meeting-place of Restoration London.[45]

What Herringman did well, the famous Jacob Tonson did even better. He more than any other established the rules of publishing as they would appear to later ages. In 1678, Tonson set up shop at the Judge's Head in Chancery Lane and immediately set his sights on Dryden, the Poet Laureate. Though Dryden belonged to Herringman, within two years Tonson had snared him away with an offer of £20 for the play *Troilus and Cressida*. From 1679 onwards the careers of Dryden and Tonson were closely linked. Tonson handled his valuable poet most astutely, and Dryden, with a rather bad grace, recognized the advantages of the connection. In 1683 Tonson bought from Brabazon Aylmer a half-share in *Paradise Lost*, which had lain heavy and neglected on the booksellers' counter. Five years later Tonson brought out his sumptuous subscription edition in folio which was so successful that he gladly paid a greatly inflated price for the other half of the copyright. He said later that *Paradise Lost* eventually made him more money than any other poem he had published.[46] Tonson appraised future tastes imaginatively, conserved his resources well and was prepared to wait for his profits. That was the new formula for success. When Tonson first went after Dryden, the laureate was chiefly known as an industrious producer of puffed-out heroic plays. He was not the great, dominating literary figure of later years. And when Tonson took over *Paradise Lost* it was, to say the least, a slow mover. But he used excellent critical judgment, and backed his choices. Tonson, wrote Dunton, a fellow in the same trade, 'is himself a very good judge of Persons and Authors; and as there is nobody more competently qualified to give their opinion of another, so there is none who does it with a more severe exactness, or with less partiality.'[47]

Tonson with his stable of thoroughbreds was at the respectable end of the broad path opened up by a reading public. Down at the other end, in a good deal of mire and not too well housed against the weather, were the hacks of Grub Street. The hack of this time was a worn but lively beast, jumpy, nervous and as liable to kick friend as foe. He was usually talented; men like Ward and Brown are better writers—more in control, more striking, more daring—than many of the worthy figures who receive their few lines in the histories of literature. But the hack in general did not support the respectable aims that society and the state were beginning to expect from the arts. He preferred to be a gadfly rather than a propagandist. He was an iconoclast, a mocker, often idle

and often drunk. He and his companions, in their low way, mirrored the
society of the wits—the same exhilaration and the same despair, the same
refusal to accept the shams of contemporary polity. My Lord Rochester
was far closer to Tom Brown than he was to super-pliant Dryden or to
Bishop Burnet, the portentious cleric who dogged his dying days. And
the age was ripe for mockers; trimming was an endemic disease and
hypocrisy one of the badges of office. The age was ready to employ him,
too; newspapers and periodicals were spawning at a great rate, argument
was continuous, satire was a favourite mode of expression.

Tom Brown was the archetype of the Grub Street inhabitant. In 1688
he arrived in London, a twenty-five-year-old usher from Kingston school
'without any other Recommendation than a stock of Wit and Learning
sufficient to have advanc'd him to a much better Fortune than he ever
liv'd to see'.[48] To make himself known to the town he could not do better
than mount an attack on one of society's most famous whipping-boys.
In the previous year Dryden had published *The Hind and the Panther*,
giving Brown the fortunate chance to reply with *The Reason of Mr Bays
Changing his Religion*, an engaging and hilarious pamphlet which won
Brown a reputation even at court. But if King William, the Whig and the
Protestant cause thought they had found a new champion, they were
quite wrong. Brown was in fact an instinctive Tory; however, he disliked
trimmers and turncoats wherever he found them and attacked them, not
for reasons of political ideology, but out of his own indignation, and for
his own amusement and profit. At various times he let fly at Dryden, at
the odious Lord Sunderland, at even more odious Titus Oates and at
Dr. Sherlock, a clergyman who had opposed William on all grounds of
legality, morality and loyalty, but who in 1690 made a meek recantation
and was rewarded with the Deanery of St. Paul's. Another whose amenable
ways offended Brown was Tom D'Urfey. D'Urfey, though, was a pleasant,
sociable fellow, and a fine hand at light and tuneful verse, so Brown let
him off easily with a little verse of his own:

> Thou Cur, half *French*, half *English* Breed,
> Thou Mungrel of *Parnassus*,
> To think tall Lines, run up to Seed,
> Should ever tamely pass us.
>
>
>
> In t'other World expect dry Blows;
> No Tears can wash thy Stains out;
> *Horace* will pluck thee by the Nose.
> And *Pindar* beat thy Brains out.

Tom Brown was strong-minded and independent. His pen was for

sale but not his opinions; he went his own way, bent on pleasure and without too much thought for reputation or posterity. Work was an unfortunate necessity which should not be allowed to interrupt the serious business of tavern going. He was easily found in the company of Joe Haines and the like:

> and when the Drawer brings up the Reckoning, he sends a Porter to his Book-seller to redeem him; makes him great Promises that he will make him amends in the next Copy he writes; and by putting these Blinds so frequently upon him, he designs to make the Stationer as poor as himself.[49]

Luckily for Brown and his unquenchable thirst there was plenty of work around for a man of his undoubted ability. Periodicals eagerly embraced him. Peter Motteux,[50] in 1692, printed a Brown imitation of Horace in the opening number of *The Gentleman's Journal*, and over the next two years often included a piece of Brown's occasional verse. In 1692 also, Brown and others started *The London* (later *Lacedemonian*) *Mercury* as a rival to, and burlesque of, Dunton's *Athenian Gazette*. The Athenians were an easy target, more interested in 'Receipts for Fleas, &c. and such-like wise lectures', whereas they should be discussing 'witty and judicious Points, relating to History and Philosophy'. Brown's Lacedemonian queries, it may be said, were quite as giddy and nonsensical as Dunton's Athenian.

The other work readily available for the hack in the late seventeenth century was translation. Education extolled the superior virtues of the classics; criticism of the day recommended French, Spanish and Italian writers; it was a great convenience to ordinary men who liked to con-sider themselves well informed to have these paragons available in English. The stationers were eager to provide this service. Brown, who charac-terized himself as 'a very honest Fellow, who between a little *French* and less *Latin* makes a shift to get a sorry Livelihood', did his share of translation, and for this he was very well qualified. Despite his ironic view of himself, he was, like many another early Grub Street writer, a sound scholar. His Latin was good, his French very good, and his Greek, Spanish and Italian adequate. Dunton, who had no reason to like Brown, thought his morals 'wretchedly out of order', but admitted that Tom knew how 'to translate either the Latin or the French incomparably well'. Dunton is a notoriously unreliable witness, yet there is more than a little truth in the interesting remark which he then adds:

> He is enriched with a noble genius, and understands our own Tongue as well, if not better, than any man of the age.[51]

Tom Brown was a new phenomenon. Other writers before him, Roger

L'Estrange for example, had been popular pamphleteers, versifiers, journalists and satirists. But here was a scholarly and very talented writer choosing to be his own master entirely, living happily and idly in Grub Street on what an ingenious pen and fertile imagination could bring him. Only a greatly increased reading public made this possible.

The growing public patronage towards the end of the seventeenth century gave artists several advantages. They became less dependent on the whim and the favour of the court and aristocrats, and to that extent gained a little in human dignity. The 'little glittering Eloquence in a Dedication' to make a noble lord 'believe he's witty, and valiant, and every thing besides' was no longer necessary for Tom Brown, and he refused to use these gross forms of flattery. He avoided, too, the contagion of party propaganda. Though he was a strong Tory, the party managers could never rely on his pen. He was a hack, but not a party hack. A writer could now, perhaps for the first time, live solely on the receipts from his writings. In 1667, the contract between Milton and Samuel Simmons for the publication of *Paradise Lost* gave the poet £5 down, a further £5 at the end of the first edition, and similar sums at the end of the second and third editions, if the sales went that far. He received the first and second instalments and that was all—£10.[52] In 1694 Dryden signed a contract with Tonson for a translation of Virgil. The fees which Dryden received under this agreement finally amounted to some £1,400.[53] For the *Fables*, published by Tonson six months before Dryden's death, the poet received 250 guineas.

New advantages are only gained at a price. Brown paid for his independence. There was a living to be won from the public, but it was still very uncertain and hazardous. The toiler in Grub Street came to know only too well debts, summonses and gaol, the bailiff and the magistrate. The hack with duns after him was not always fastidious in his subject matter. In 1697, some mild pornography had helped Brown through a lean period. His *Marriage Ceremonies; as now Used in all Parts of the World. Very diverting, especially to the Ladies* was the only one of his works that received the compliment of translation, appearing in French at Geneva in 1750. As Brown had to pay for independence, so Dryden discovered the drawbacks of his new and later prosperity. He found that relations with Tonson were often as difficult as attendance at court. 'I told Mr. Congreve,' Dryden wrote to his publisher on October 29, 1695, 'that I knew you too well to believe you meant me any kindness.' Nagging perpetually about money, Dryden lost all patience with Tonson:

Some kind of intercourse must be carryed on betwixt us, while I am translateing

4

> Virgil. Therefore I give you notice that I have done the seventh Aeneid in the
> country; and intend, some few dayes hence, to go upon the eighth; when that
> is finished I expect fifty pounds in good silver; not such as I have had formerly.
> I am not obligd to take gold, neither will I; nor stay for it beyond four &
> twenty houres after it is due.[54]

The arrogant and impatient tone re-occurs in other letters to Tonson.
Though the total sums Dryden received from Tonson were large, they
came in at odd intervals, and slowly. By now Dryden had lost all his
income from the stage; Tonson was his only financial support. The old
poet, well aware of his fame and his ability, did not relish being in the
power of a bookseller.

> The inevitable consequence of poverty [wrote Dr Johnson] is dependence.
> Dryden had probably had no recourse in his exigences but to his bookseller.
> The particular character of Tonson I do not know; but the general conduct of
> traders was much less liberal in those times than in our own; their views were
> narrower, and their manners grosser. To the mercantile ruggedness of that race,
> the delicacy of the poet was sometimes exposed.[55]

Johnson was in fact less than fair to Tonson. The publisher did his best
to appease the irrascible poet; his letters are endlessly conciliatory. But a
publisher lived and prospered by a careful cultivation of the market, and
by paying close attention to an emerging public taste. In doing so, he
often condemned his writers to a drudgery which filled the pocket but
oppressed the spirit. The huge mass of verse translation, especially from
the classics, which appeared in the late seventeenth and early eighteenth
centuries is evidence that the publishers were eagerly attuned to the public
zeal for learning and improvement. But so many of the poets spending
long hours on these works, even the best of them now little honoured and
less read, were taking time out from the best years of their creativity.
Perhaps thoughts of this kind came to Dryden as he laboured on the
Epistles of Ovid, the *Satires* of Juvenal and Persius, the whole of Virgil,
and several lesser pieces of translation besides, all for Tonson. Tom Brown,
in his irreverent way, gave an entertaining picture of Dryden the univer-
sal translator at work:

> I encourage all the forward *Beaux* of the Nation, to take a voyage as far as
> *Greece* or *Italy*, to retrieve some Captive province of Poetry out of the hands of
> *Infidel-Invaders*, where besides the reputation which a person certainly gets,
> by being the leading Card of all the Company, that list themselves for such an
> adventure, I am sure of carrying away all the profit of the undertaking to my
> self.[56]

He could have saved his sneers. Soon he also was trekking through foreign
tongues, searching out the instructive pieces for the public education
and delight.

Musicians, as well, found that the service of the public had its own problems. They, most of all, needed the extra income that the public provided. Their wages from the King's Musick were already rather low; and after the accession of William and Mary, in 1688, the King's musical establishment was allowed to grow smaller and smaller. Yet outside engagements were not easy to come by, and their fees were not large. The records of the Inner Temple show a number of payments for music. In 1661, the musicians were paid £3.6s.8d. 'for their yearly fee and attendance on 5th November'. In 1671, the musicians received £2 for playing on Candlemas Day. The Christmas accounts for 1681 record £2 'for music in the hall'.[57] As these paltry amounts sufficed for musicians (in the plural), no one was likely to grow fat on this kind of work. Public concerts were a better source of income, but the concerts were few and could not hope to give work to more than a small fraction of London musicians.[58] Moreover, concerts sometimes clashed with opera, the other popular entertainment of the time, much to the disadvantage of the concerts. Indeed, the foolish hodge-podge known as opera was an artistic bane of the time; writers were poorly employed scribbling improbable scenarios; the composer's score was a patchy affair of songs and incidental passages which had to compete, none too well, with scenery, machinery, dancers and acrobats; and as if that were not enough, the leading singer, with exorbitant ego and higher fees, was even now beginning to command stage-centre, at the expense of all the rest of the production.

No one could see what appearance serious music would take under public patronage. A new audience in a new setting required some adaptation of forms and performance. The first attempts in the public concert room, though profitable, did not strike Roger North as an artistic success; though the 'best masters' played, the 'enterteinement' was not good:

> because it consisted of broken incoherent parts; now a consort, then a lutinist, then a *violino solo*, then flutes, then a song, and so peice after peice, the time sliding away, while the masters blundered and swore in shifting places, and one might perceive that they performed ill out of spight to one and other; whereas an enterteinement ought to proceed as a drama, firework, or indeed every publik delight, by judicious stepps, one setting off another, and the whole in a series connected and concluding in a perfect ackme, and then ceasing all at once.[59]

In the late seventeenth century, music in England was in a state of some uncertainty over new styles and new forms, Unsure gropings to meet new public demands did little to resolve this uncertainty. The continental developments in music, which swept into England after the Restoration,

were most easily assimilated in the King's Musick where profit and accountability were not all important. But the Musick was suffering the sickness of the Privy Purse, and later King William, by his lack of interest and his meanness, almost brought the royal Musick to an end. Public demand, keenly supported by the impresarios, caused a disproportionate expense and energy to go first on the jejune and tasteless musical dramas of the Restoration stage, and then on the Italian operas of the next century which were still oddities of dubious merit. Even in our twentieth century, an age of the widest musical curiosity, the operas of Handel—the greatest of masters—are rarely performed and sparsely attended; the names of his competitors are not worth remembering.

CHAPTER 5

RULES AND REFORM

The friends of antiquity are not few.
Dryden, *Preface to the Fables.*

A PLACE OF riches is a magnet for all men. Commercial nations are often attended by artists from countries old in sophistication but verging on bankruptcy, anxious to teach, for a healthy reward, the true ways of art. In the seventeenth century, except during the awkward years of the Civil Wars and the Commonwealth, foreign artists continually arrived in England, seeking profitable employment. After the Restoration a casual observer might have thought that foreign reputations and achievements were all-conquering throughout England.

Foreigners brought with them the skill of their hands, and their ideas, their theories. Skill of hand was more immediately of use, and painting in particular supplied rich opportunities to well-trained continentals from sound traditions. For painting in England had suffered from the Reformation. The old iconography had been rejected as too Roman and too Catholic; before native art could reassert itself a foreign priesthood had moved in, administering the mysteries of the art which had its inspiration and birth beyond the English shores. It seemed as if an Englishman could partake, but not officiate. After Holbein's first visit to England, in 1526, foreigners took over the lead in English painting—Gheeraerts, Vandyck, Lely, Kneller. But their contribution was mainly technical—the hand overshadowing the head. They avoided the problems of a perilous iconography by restricting themselves chiefly to portraits. Pictures of English faces delineating English character soon gave rise to a strong national school of portraiture under the curious successive leadership of Sir Anthony Vandyck, from Antwerp, Sir Peter Lely, from Holland, and Sir Godfrey Kneller, from Lübeck. At the Restoration there was a fresh influx of foreign painters keen to subdue their art to the English taste, and reap the appropriate rewards. Portrait painters such as Soest, Huysmans, Wissing, Kneller and Dahl came from northern Europe. Wall and ceiling painters such as Verrio, Laguerre, Pellegrini and the two Riccis came from France and Italy. Landscape and history painters came too, the van de Veldes, father and son, and Thomas and John Wyck. There was besides

a host of minor foreign painters more or less making a living in the prosperous London market.

Music in England, too, found employment for the accomplished fingers and tuneful voices of foreigners. The ideology of the Reformation had not disturbed music as much as it had the decorative arts, and musical influence had steadily flowed out of Italy throughout Renaissance times. Developments were perhaps slow to arrive in England, but did eventually wash British shores. And in the Jacobean age, when music here was blossoming so sweetly, England was able to confer reciprocal benefits on musical Europe. John Cooper might Italianize himself into Coprario, but the King of Denmark had Dowland as his lutenist, and English instrumentalists and their compositions were appreciated in Hamburg, Frankfort, Utrecht, Lübeck, Berlin, and throughout northern Europe in particular.[1] Troubling warfare, in the mid-seventeenth century, both on the continent and in England, slowed down English musical development. The new music of Monteverdi and his school was known in England before the Civil Wars, but the old style of madrigal composition lingered on. After the Wars there was room, even a need, for foreigners to demonstrate the virtues of the new kind of instrumental composition. In Charles's reign, Nicola Matteis, whom Evelyn called 'the stupendous violin', performed this function admirably. There was a need also to show the resources of the greatly improved Italian violin family of instruments. Violins and 'cellos had been used in England since the years of the early Stuarts, but they had not displaced the old 'chest of viols'. England was hardly aware of the full possibilities of the violin until the virtuoso Thomas Baltzar arrived from Lübeck in 1656. Anthony Wood and Evelyn, keen and intelligent music-lovers, were quite amazed at his prowess.[2] After the Restoration, the fiddle was very much the fashion. Charles had his string band in imitation of Louis XIV, and polite gentlemen, 'following also the humour of the Court, fell in *pesle mesle*, and soon thrust out the treble viol'.[3]

'And however England came to have the credit of musicall lovers, I know not, but am sure that there was a great flocking hither of forrein masters,' wrote Roger North about the post-Restoration years. 'And they found here good encouragement,' he went on, 'so that the nation (as I may terme it) of Musick was very well prepared for a revolution.'[4] In the van of the 'revolutionary' foreigners were the French. King Charles, by education and long residence, was naturally inclined to the French fashion. Music in France had lately been enlived by Baptiste Lully, and this manner was carried over to England. The *beau monde* especially took to the

sprightly French airs; but more serious musicians soon perceived that the Restoration court, with its usual instinct, was encouraging all that was frivolous and affected in the French modes. A few English musicians, like Pelham Humfrey, went to France with a serious intention to perfect their music, but French music was soon in disrepute, and the French performer a figure of scorn:

> In fine, he is the Mountebank of himself, and though he have nothing at all considerable to commend him, besides his own praises, and his being French (for which reason one may commend the Pox as well) yet there is such charm in this word, *à la mode*, and the English are so besotted with it, as the first Frenchman has their money, who proffers to teach it them.[5]

For a few years, however, French music held its own. Charles employed a number of Frenchmen in the King's Musick; in 1666 the thoroughly second-rate Louis Grabu was appointed Master of the Musick, much to the disgust of John Banister. In 1661, a Parisian operatic troupe performed *The Descent of Orpheus* in London, and French operatic companies continued to visit England from time to time. Then, gradually, sounder musical taste began to assert itself. The musical influence of Italy displaced that of France.

The discerning had always been convinced of Italian superiority, for even Lully, the great French master, was an Italian. Though the French captured the fashionable world, the Italians were not without their supporters and admirers in England. At the Restoration, one Guido Gentileschi had been granted a licence to maintain a band of Italian musicians. This establishment, the King's Italian music, remained in business, at a cost of about £1,700 a year, until the troubles of the Privy Purse, the differences in the kingdom, and the Catholicism of the Italians caused the group to languish after 1679.[6] By then, though life was made difficult for Italian (and French) Catholics, the reputation of Italian music was assured. Italian singing was particularly impressive. Evelyn commented on the 'rare Italian voices, 2 Eunuchs & one Woman' performing in 'his Majesties greene Chamber'.[7] Pietro Reggio, a singing teacher, prepared a collection of Italian vocal pieces which had a great success and introduced composers like Carissimi and Stradella to a wide public. Purcell had a long section on the Italian vocal style in his 1694 edition of Playford's *Introduction*. Equally influential was the Italian instrumental music, so ably promoted by Nicola Matteis—'a sort of precursor who made way for what was to follow'. Roger North, in his many notes on musical history, has much to say about Matteis, and his observations waver between real admiration for an outstanding musician and censure for the Italian's difficult ways.

Matteis, who arrived in England at some uncertain date before 1671, was at first poor and 'inexpugnably proud'; then he was much wooed, and by sharp and fast business-practice 'began to feel himself grow rich, and then of course luxurious'. He lived high and irregularly, 'contracted bad diseases', and 'dyed miserable'. But, according to the fair-minded North, his musical influence could hardly be overstated: 'this humour of learning in Italy is moderne, and sprang out of an ambition inspired by the musick of old Nichola;'

> As a gratefull legacy to the English nation, [he] left with them a generall favour for the Itallian manner of harmony, and after him the French was wholly layd aside, and nothing in towne had a relish without a spice of Italy. . . . But that which contributed much to an establishment of the Italian manner here, was the travelling of divers yong gentlemen into Italy, and after having learnt of the best violin masters, particularly Corelli, [they] returned with flourishing hands.[8]

Painting and music learnt technique from foreigners, and music especially was in debt to foreign developments. There was, too, another source of influence. All countries touched by the Renaissance paid homage to the example of classical antiquity, and in seventeenth-century England the rules of the ancients loomed very large in the minds of architects and poets.

Architecture, like painting, had suffered much from the Reformation. Churches ceased to be built; masons, carpenters and other craftsmen formerly employed by the Church were dispersed and unemployed. The prosperous building trade was reduced to something close to beggary,[9] and the art of design was neglected. The transition in England from a Gothic to a Renaissance style of building was slow and uncertain. The efforts of the Tudor Office of Works, which might have lightened this depression, were not impressive. Elizabeth was the only Tudor secure enough to encourage building, and she was rather tight-fisted and cautious in her personal expenditure, more eager to see others build than to build herself. Rich aristocrats were more enthusiastic builders, and for a time they were the chief patrons of architecture. But generally their architectural notions were insular and backward-looking, and they failed to discover within the neglected building trades men of breadth and scholarship. There were men competent to raise a structure, but no architects, no ideas. The aristocrat, therefore, who wanted to make some show of Renaissance modernity in his expensive new house was forced to become his own architect, studying the text-books and giving instructions to the craftsmen. The amateur architect started with first principles and took his patterns from antiquity. Sometimes he went straight to Vitruvius,

available in Barbaro's illustrated edition after 1556; and sometimes he relied on continental commentators—the Italian Serlio, the Frenchmen de l'Orme and Cerceau, or the Netherlanders de Vries and Dietterlin.

Armed with his manuals, the English amateur established himself as architect, beginning a polite tradition that continued up to the time of Pembroke and Burlington. At the end of the seventeenth century Roger North was still advising the enthusiast to build his own house:

> For a profest architect is proud, opiniative and troublesome, seldome at hand, and a head workman pretending to the designing part, is full of paultry vulgar contrivances; therefore be your own architect, or sitt still.[10]

An amateur tradition is usually a learned tradition, based on study not practice. One who undertook the 'designing part' provided the ideas only; he did not burden himself with the problems of construction, which were left to some competent workman. And when architecture began to re-acquire a measure of professionalism, it still based itself on this learned tradition. Inigo Jones, our first professional in the modern sense, at last gave England a mature Renaissance style truly founded on the classical principles as set out in Palladio and Scamozzi. Among Jones's books preserved at Worcester College, Oxford, are the works of Alberti, Cataneo's *Architettura*, Rusconi's *Dell'architettura*, Palladio's *I quattro libri dell' architettura*, Scamozzi's *L'idea dell'architettura universale*, and de l'Orme's *Premier tome de l'architecture*—all annotated with Jones's comments and sketches.[11]

The example of the few foreign architects practising in England merely helped give authority to the continental patterns. Balthazar Gerbier from Antwerp, who died in 1667 after many years' residence in England, pro-moted the Dutch style in his two little books on architecture and in the few buildings he designed. By the time the enigmatic and impecunious Captain Winde, from Bergen-op-Zoom, started to design at the end of the seventeenth century, Anglo-Dutch style was fairly well settled and Winde followed the prevailing manner.

Respect for antiquity was a part of the common heritage of the Renais-sance, and writers were particularly well-aware of the heavy burden imposed by the classical past. All the modes of literature had their proper classical models. Historical writing, the drama, the heroic poem, the lyric, all were inspected under a dim light thrown from a Greek and Roman past long dead and gone. In the seventeenth century, as classical scholar-ship improved, so too did the acrimony and pedantry of the commentators. Throughout Europe, but most particularly in Italy and France, rules for following classical composition were laid down with a strictness that would

4 *

have surprised the ancients. Authors were called upon to re-enslave themselves to a past from which they were receding inexorably, day by day. And many authors, out of respect for propriety and learning, willingly bound their inspiration according to the rules. The hold of the ancients remained remarkably strong through the eighteenth century and beyond. Sir Charles Sedley was a fair example of a late seventeenth-century man of culture; he had taste and ability without being too serious, and he was learned without being a pedant or a systematic scholar. Among the books from his library, sold by auction at Tom's Coffee-house on March 23, 1703, the classical authors are very well represented. He had the works of Livy, Virgil, Juvenal, Terence, Plutarch, Seneca, Suetonius, Sophocles, Martial, Pulatus, Cicero and Lucan—whose *Pharsalia* in duodecimo went for 4d. Many classical authors he also possessed in translation, or in French editions.[12]

The contents of Sedley's library, rich in the classics, almost as rich in French literature, also containing several Italian volumes and a couple in Spanish, are testimony to the interest Englishmen took in the state of art outside England, both in the past and in Sedley's own age. In a period respectful to theories, the arts in England owed large debts to foreign practice and theories. One can hardly regret that history writers looked back to Livy and Tacitus, and beyond them to Plutarch and Thucydides; for by keeping his eye on these masters, with some side glances to contemporary continentals like Davila and Bentivoglio,[13] Clarendon was able to plan and execute his great *History*. The time and energy which the seventeenth century put into the discussion of the 'heroic poem' may seem like wasted talent. Hobbes and Davenant had little to show for their ingenuity on this theme; Davenant's *Gondibert* was not a success, and likewise, in France Chapelain's *Pucelle* is as easily forgotten. But this tireless search for the pure form of the epic and the pure form of tragedy finally justified itself in Milton's *Paradise Lost* and *Samson Agonistes*. The reforms that Waller and Denham introduced into English prosody, though neither poet ranks as high today as he did in his own age, helped to discipline the wilder thickets of the metaphysical language. Molière became known to authors of English comedies, and Corneille was known to authors of tragedies, with less happy results.

English painting, a domain ruled by the portrait-painters, slumbered hardly disturbed by ideas foreign or native. The excellent skill of foreign hands was welcomed in England, but discussion on the principles of painting did not make much headway until the very end of the century. 'For some Gentlemen Vertuosoes and Painters', in 1694 Dryden agreed

to translate 'a little French Booke of Painting'; this was Du Fresnoy's *Art of Painting*. Early in the next century Jonathan Richardson wrote his *Essay on the Theory of Painting*, then, with the coming of Reynolds, the theory of painting became a popular eighteenth-century theme.

Painting was the exception. The other English arts in the seventeenth century were all disturbed by echoes from antiquity, or from across the Channel. Architects still ardently stole their designs from abroad. In the opinion of Sir Roger Pratt, the foremost architect at the Restoration, the best buildings were liable to come from those who had studied the best in Italy. 'Get some ingenious gentleman,' he advised, 'who has seen much of that kind abroad and been somewhat versed in the best authors of Architecture: viz. Palladio, Scamozzi, Serlio, etc. to do it for you.'[14] Wren, when he came to the practice of architecture, was a true student of the ancients. 'The Principles of Architecture,' he noted, 'are now rather the Study of Antiquity than Fancy.'[15] The books for his study were those listed by Pratt, with the addition of Barbaro's Vitruvius, Vignola, Alberti, de l'Orme and Bullant. In the summer of 1665 Wren went abroad for his first and only time. He went to Paris to study the buildings, 'surveying the most esteemed Fabricks of Paris and the Country round'. Italy was the fount of architectural style—the high point of Wren's French visit was a short meeting with 'old reserv'd' Bernini—but France, resolutely pursuing grandeur under the guidance of Colbert and Louis XIV, was a good enough place for the seeker after true merit. Visits to the Louvre— where Bernini was in attendance—were especially worthwhile; for there, with 'a thousand hands' working on the construction and decoration of the great building, Wren discovered a 'school of Architecture the best probably at this Day in Europe'. He saw, and was impressed with, several of the designs of François Mansart. He saw the Palais Mazarin, commended for its 'masculine furniture', and Versailles whose 'little Curiosities of Ornaments' he did not like—a womanish sort of architecture, he thought it.[16] He saw several châteaux and liked Vaux-le-Vicomte, Maisons and Le Raincy. In his few months in France he had seen much and assimilated much. He had followed the classic prescription for the training of an English architect; when he returned to England he felt competent to set himself up as a full professional man.

Purcell was another into whose mind Italy insinuated herself. As he came to maturity, in the late seventies, the Italians had made London their own musical province. The Albricis and Draghi were with the King's Italian music, and Vincenzo Albrici had been a student of Carissimi. Reggio was training voices and Matteis was beginning to make

a reputation as a violinist. The regard for Italian music was enormous. To improve her music at St. James's, the Queen drafted Italians into her chapel. Evelyn very naturally sent his daughter to learn singing from Reggio and the harpsichord from Bartolomeo Albrici. The popularity of the opera increased the demand for Italian and Italian-trained singers. The appearance of castrati was another Italian manifestation to wonder at. In the eighties Siface sang at James II's chapel, and even deigned to give a private concert at Pepys's. In the King's Musick, where Purcell received his training, Italian ways were known and admired. Captain Cooke, the master of the Children, sang after the Italian manner, and little Pelham Humfrey, tutor to Purcell, had visited both Italy and France. In 1683, the young Purcell openly admitted his debt, in the preface to his *Sonatas of III Parts*—he had 'faithfully endeavour'd just imitation of the most fam'd Italian Masters'. And his admiration remained constant. Eight years later, preparing his music from *Dioclesian* for the press, he commented:

> Musick is yet but in its Nonage, a forward Child, which gives hope of what it may be hereafter in *England*, when the Masters of it shall find more Encouragement. 'Tis now learning *Italian*, which is its best Master, and studying a little of the *French* Air, to give it somewhat more of Gayety and Fashion.[17]

Roger North, in his account of musical history written after Purcell's death, noted the Italian imitation 'in his noble set of sonnatas', though he thought the imitation did not go quite far enough. 'Mr. H. Purcell,' he wrote, 'began to show his great skill before the reforme of musick *al'Italliana*, and while he was warm in the persuit of it, dyed.' But this was the reflection of an old man. The short tribute he put in his notebook soon after the composer's death is probably a sounder judgment:

> He was a match for all sorts of designes in musick. Nothing came amiss to him. He imitated the Itallian sonnata and (bating a litle too much of the labour) outdid them. And raised up operas and musick in the theaters, to a credit, even of fame as farr as Italy, where *Sigr Purcell* was courted no less than at home.[18]

The Renaissance ideal saw a common European culture whose profound springs went deep to Greece and Rome and watered all lands touched by the mind of the former or the empire of the latter. The good influence of other places and times appeared in the English arts of the seventeenth century, and the ideal was partly realized. Then, after the Restoration, the ideas and theories that had exerted a beneficent influence were slowly transformed into a set of constricting rules. Old artists had handled foreign theories more or less with native inspiration, now the formula attempted to become more important than the living art. This was the

work of the age of rationalism. The complaint of Rymer, that *Othello* was not to be taken seriously as a tragedy because it turned on the loss of a handkerchief, appeared admirable criticism according to the 'rules'. And Shakespeare's portrait of Iago was obviously incompetent and bungling, for Horace had said that a soldier should be '*impiger, iracundus, inexorabilis, acer*', where as Iago was shifty, subtle, devious. Reason is always invoked at the expense of imagination, and the appearance of 'rules' was yet another sign of the late seventeenth-century flight from imagination. Rules call forth the censor, and he arrived, pat on cue, as Dryden angrily complained:

> They [the critics] were defenders of poets, and commentators on their works; to illustrate obscure beauties; to place some passage in a better light; to redeem others from malicious interpretations; to help out an author's modesty, who is not ostentatious of his wit; and, in short, to shield him from the ill-nature of those fellows, who were then called *Zoili* and *Momi*, and now take upon themselves the venerable name of censors.[19]

Dryden had reason to complain, for as usual he was pinched by his conflicting interests. He was, in the manner of the times, a respectful student of antiquity. He spent the early years of his writing life putting together heroic plays, a task he was unsuited for, as he had little talent for the dramatic and no instinctive feeling for the theatre. Since playwriting was an unnatural business to him, he needed all the help he could get; he paid close attention to the views of the authorities—to Corneille in particular—hoping that a protagonist sufficiently heroic, and an action that nearly preserved the unities, would enable his plays to get by. Alas, they did not, for there was little genius in them. This he realized, and gave up the labour of playwriting as soon as a decent profit could be made elsewhere. Despite the practice of his own plays, Dryden was not sympathetic to the strict 'rules' of the drama. His chief piece of writing on the drama, the *Essay of Dramatic Poesy*, was in part a defence of the moderns against the ancients and in part a vindication of the loose and irregular English drama of Shakespeare and Jonson against the strict and 'correct' drama of the French, planned according to the very best Aristotelian and Horatian usage.

For the truth about Dryden was that he remained always a servant of the imagination. As a man of the age of reason, he respected the fashionable thought, and the classical poets were dear to him; but he had the artist's instinctive appreciation of what was great and required no 'rules' to approve his choice. The soundness of his appreciation strikes through everywhere in his criticism. The great and just praise of Shakespeare is

well known; other passages are equally revealing. At the time, though it was customary to pay lip-service to Homer, Virgil was better liked, better understood and even considered a greater poet. Dryden sees the difference between them; he hints at the superiority of Homer, for the Greek poet was free, bold and inventive whereas 'the chief talent of Virgil was propriety of thoughts, and ornaments of words'.[20] A man who prefers Greek 'violence' and 'impetuosity' to Roman 'propriety' can be no real advocate of 'correct' writing. And much as he loved the classical poets, he found some moderns no less admirable. He thought that 'our old English poet, Chaucer'—a neglected name in that period—resembled Ovid in many ways, 'and that with no disadvantage on the side of the modern author.'[21]

'Rules' were not suddenly invented. The theories had existed and been commented on for a long time. The rules were quarried out of these hoary and respectable theories by a generation that had discovered a new perspective, what Dryden called a 'mechanic' way of looking at things. The term mechanic was very apt, for the new way was thoroughly scientific, empirical and rational. There was a conviction shared by natural scientists, philosophers, and artists too, that the 'laws' of a rational universe were discoverable. And the 'laws' of rational art must lie in the only profound body of theory that existed—the speculation of the classical ages and its Renaissance commentary. That mysterious thing called sympathy was no longer needed for the just evaluation of art; now that the true models were at last generally recognized, reason could judge the conformity between a work and its exemplar; what reason could not accord with classical principles, for example gothic art, it abused and neglected. When artists themselves took up this point of view—and very many of them did after the Restoration—the arts were in some danger.

Christopher Wren was such an artist, and his little troubles have been well analysed by Sir John Summerson.[22] Inigo Jones and Wren both started from the study of antiquity, and both founded their architecture on the classical principles of the five orders. Jones interpreted his principles imaginatively, with the artist's eye, Wren empirically, with the reason of the mathematician he so emphatically was. This distinction was not lost even to Wren's contemporaries. Roger North, who had sensible views on most artistic matters, wrote:

> Inigo Jones was one who did all things well and great. But since then has bin, Pratt for Clarendon, hous, Webb for Greenwich Gallery, and Gonnersbury, and at present Sir Christopher Wren, dexterous men: especially the latter, as to accounts and computation, but have not the Grand Maniere of Jones.[23]

'Accounts and computation'—that put the matter very neatly. The results of this approach were buildings worked out according to sound principles, and well-expressed, but chiefly notable for their correctness. Pembroke College Chapel, says Summerson, 'is constructed with a great deal of thought and expressed in sound Latin; but in conception it is totally unimaginative.' And Sir John is no more enthusiastic about the Sheldonian, which he calls 'an academic Latin essay'.[24] Such criticisms might not have worried Wren; for imagination did not appear in his aesthetic. Beauty, to him, was a rational proposition. 'Natural [beauty] is from Geometry, consisting in Uniformity (that is Equality) and Proportion.'[25] On this ground he thought the equilateral triangle more 'beautiful' than the scaline. Wren designed his buildings in accordance with classical principles and geometric beauty. If a building were criticized from the point of view of the imagination (as indeed Pratt criticized the First Model of St. Paul's), it could easily be changed, and so by empirical means a satisfactory solution come to. St. Paul's went through the various stages of the First Model, the Great Model, the Warrant Design, and so to the final plan.

No doubt Wren had the greatest architectural talent. His faults were the faults of the age, for the views he expressed were the common *artistic* views of the time. Architecture, wrote Evelyn, was 'the flower and crown as it were of all the sciences mathematical', and the task of the architect in the late seventeenth century—again according to Evelyn—was to prevent 'a busie and Gothick trifling in the compositions of the Five Orders'. These notions were not universally held, but as the eighteenth century dawned they became more and more conventional. Old-fashioned Captain Winde, for example, might still allow his craftsmen to play their part in the detailed design of a building. At Combe Abbey and Castle Bromwich, Pierce, the carver, and Goudge, the plasterer, designed and carried out the decorative features—ceilings, pediments and gateways. But soon, under the Palladian dictatorship of Burlington, all was done according to the book. The craftsman working with imagination and responsibility was no longer needed; his status fell. The appearance of another carver like Grinling Gibbons, another plasterer like Goudge, another ironworker like Tijou was hardly possible. Roger North, an old man in the Augustan age, generally approved of the rules embodied in the 'doctrine of the 5 orders'. But he had lived long enough, having been born before the Restoration, to feel a sense of glories departed. The Gothic, he wrote, 'bears not onely an air of Grandeur, but hath a strength and reasonableness beyond the other [Romanesque][26].'

The 'mechanic' view was widely cultivated. Led by the Royal Society, the age regarded its attainment as a triumph and a mark of rationality. Thomas Sprat hoped there would arise 'a race of young men', classically trained and empirically minded, 'invicibly arm'd against all the enchantments of enthusiasm'.[27] They rose up with a vengeance, these severe young men, and left their dispassionate mark on all the arts. The dissectors and the measuring-rods were used with great acclaim. Architecture and music, which have obvious kinship with mathematics, were especially susceptible. Francis, brother of Roger North, started many puzzling lines of inquiry with his *Philosophical Essay of Musick* in 1677. He thought that harmony and discord could be represented diagrammatically, according to the 'coincidences' of various 'pulses', and he 'made a foundation upon paper by a perpetual order of parallel lines'; and those were to signify the flux of time equally—

> And when a pulse happened, it was marked by a point upon one of those lines, and if continued so as to sound a base tone, it was marked upon every eighth line; and that might be termed the base.[28]

The various divisions of sound, the octave, 5th, 4th, major and minor 3rd, were marked off, until there appeared (on paper) 'a beautiful and uniform aspect in the composition of these accords when drawn together'. The virtuosos of the Royal Society were delighted with this obscure, but elegant, speculation. Sir Isaac Newton was canvassed for an opinion —he declined to comment on the musical import, but thought the scientific method doubtful. None the less, Robert Hooke made a machine to demonstrate Lord Guilford's thesis. Dr. Wallis, in a long Appendix to Ptolemy's *Harmonics*, had further comments on his lordship's scheme, and in 1694 Dr. William Holder brought out *A Treatise of the Natural Grounds and Principles of Harmony*, a work 'so puzzled with numbers', commented Roger North, 'that it is uneasy to read.' Not all this effort was wasted. Something was done for the science of acoustics. Attempts were also made to put musical notation into more rational order. In 1672, young Thomas Salmon had an idea to do away with clefs, a notion which involved him in an acrimonious war with eminent Matthew Locke. But in general this sort of speculation was indicative of the wrong way to think about music. The ingredients were well analysed and stirred in the laboratory of the mind, but no imaginative heat was applied to the retort; hence the essential artistic fusion did not take place. Roger North, as usual, was both drawn and repelled by the contemporary musical thinking. He was fascinated by some of the harmonic problems that his brother had

Writers at a favourite coffee-house in 1720. From early drawings in Indian ink

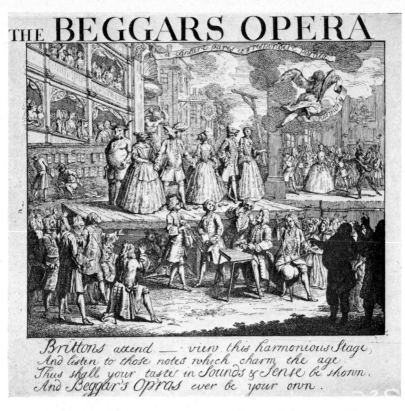

Two of Hogarth's commentaries on the English stage. The *Just View* is a satire on the popular farces of Cibber

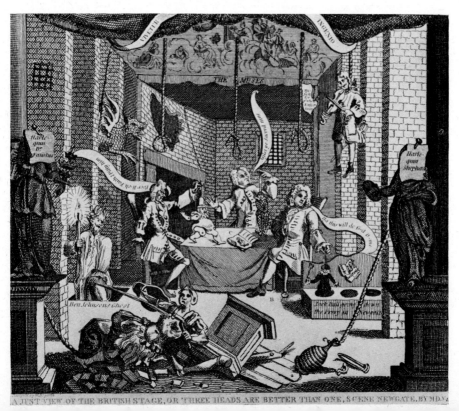

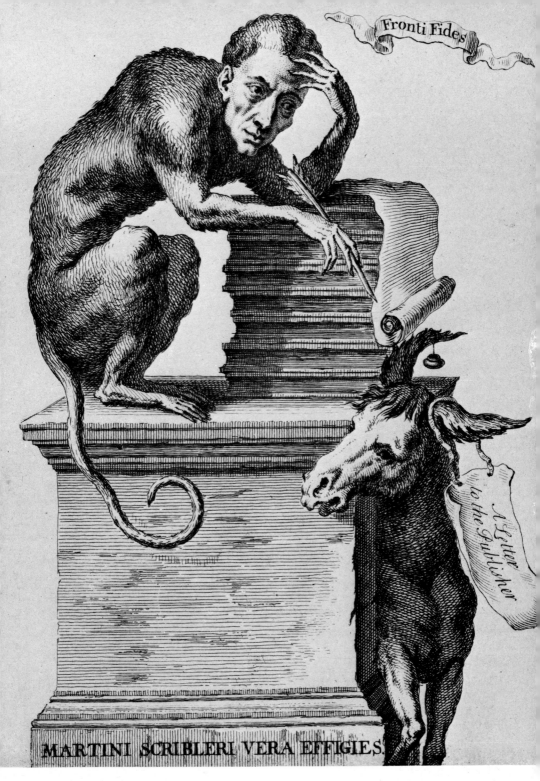

Fronti Fides

A Letter to the Publisher

MARTINI SCRIBLERI VERA EFFIGIES

A satire on Pope, provoked by the *Dunciad*. Pope's small, de-
formed shape and his abbreviated signature 'A. P—e' suggested
the figure of the monkey

Typical performers in the farces, pantomimes and intermezzi of
the London stage

investigated; but he saw that mechanical principles in the arts were an illusion—'the mind likes and dislikes, upon principles no sagacity of sence can discerne.'[29]

As one had learnt to expect, with the 'mechanic' view came the rules, the establishment of an orthodoxy. In the case of music, contemporary Italy provided the basis for right composition. Conformity to Italian instrumental practice—the *sonata da camera* and the *sonata da chiesa*—especially as these forms were exemplified in the work of Corelli, was what one looked for in the new music. Purcell, however, understood influence in much the same sense as Inigo Jones had before him. He came to be refreshed by Italian music, not commanded by it. For he was an English composer and had behind him a strong line of English composition. Consequently, his harmonic treatment was often rather free and loose, in the manner of the English madrigal composers, unchained from the doctrine of diatonic tonality; there was also in his work a degree of chromaticism which offended later critics like Burney; for Burney, though an intelligent and knowledgeable music-lover, was a true son of reason and thus a great supporter of correctness. Something of the changing attitude to Purcell may be traced again in the comments of North. North always admired Purcell greatly (and so did Burney); but as he grew older, and Augustan rationality secured its hold, he began to worry about Purcell's incorrectness, his deviation from the pure Italian. First, Purcell was the 'Orfeus Brittanicus' equal to any, even those from Italy; then North considered that the English composer had not quite reformed his music *al'Italiana*, though he had been 'warm in the persuit of it' when he died; then on final thought North could not help but admit that there was something regressive, something unauthorized in the trio sonates, still 'clog'd with somewhat of an English vein'. Fortunately North's good artistic sense once again rescued him from his principles; he regretted that the taint of Englishness made the sonatas 'unworthily despised' as they were 'very artificiall and good musick'.[30]

An age of rising orthodoxies is inevitably an age of academies, for the academy is a sure sign of petrification, if not of death, in the arts. But if there were 'laws' to be discovered, then there must be professors for the teaching of them; France had her academies and England naturally insisted on hers too. Soon after the Restoration, when the enthusiasm for French ways was still strong, the movement for the establishment of a British Academy got under way. In 1664, Dryden's Dedication to the *Rival Ladies* lamented our English lack;

I am sorry, that (speaking so noble a language as we do) we have not a more

certain measure of it, as they have in France, where they have an Academy erected for that purpose, and endowed with large privileges by the present king.

Dryden returned to this theme throughout his life. The Dedication to *Troilus and Cressida*, addressed to Lord Sunderland in 1679, hoped that his lordship would take the idea of an Academy under his patronage and so bring English to that 'purity of phrase to which the Italians first arrived, and after them the French'. In 1664, the Royal Society set up a committee to examine the possibility of an Academy, but nothing was achieved. Later, the Earl of Roscommon, with the help of Dryden, did form a Society 'for the refining and fixing the standard of our language'. The religious troubles ended this scheme; on the accession of James, Roscommon determined to emigrate to Rome, but contracting gout he fell into the hands of a sharp physician, took 'a repelling medicine' and soon died. And with him, for the time being, the idea of a British Academy died also.[31]

Architects, so many of whom had a connection with the Royal Office of Works, did not need an academy; the Royal Works was their school and their training ground. Those outside the Works were so few, an academy would have languished for lack of supporters. But music and painting both chased the fashion. In 1673, a Royal Academy of Musick was founded in Covent Garden by Robert Cambert, a Frenchman; almost nothing is known about his venture. Some twenty years later, in 1695, it was proposed to set up a lottery, the proceeds from which would go towards 'The Royal Academies', an institution capable of teaching all accomplishments, including languages, mathematics, writing, dancing, fencing and music. The advertisement claimed a strong line-up in its music faculty, including Purcell and Draghi to teach organ and harpsichord, and Banister and Matteis to teach violin.[32] This project also came to nothing. In 1710 a much more successful venture began at the Crown & Anchor Tavern in the Strand. The Academy of Antient Music provided a school for singing under well-known men like Pepusch and Galliard. The scheme was supported by subscription and flourished for eighty years. Very soon after the start of this music academy, the first English painting academy was founded in 1711, by Godfrey Kneller, in Great Queen Street. Despite the participation of Thornhill, Richardson and Dahl, it did not last. Others followed, to lead a fleeting existence, until in December 1768, the Royal Academy was constituted under the presidency of Sir Joshua Reynolds.

The connection between rules and reform is very well known. The attack which Jeremy Collier launched upon the English stage, with *A*

Short View in 1698, was thoroughly expected. Much presented on the London stage was ripe for reform. Too many plays relied on some of the more unpleasant aspects of post-Restoration conduct—a foppish affectation, an over-indulgence in obscenity, and a wilful desire to offend bourgeois susceptibilities. As early as 1665, Evelyn, who admitted to being sometimes 'a scurvy poet' and 'far from Puritanism', objected to the lamentable dramatic fare served in London:

> where there are more wretched and obscene plays permitted than in all the world besides. At Paris three days, at Rome two weekly, and at the other cities of Florence, Venice, etc., but at certain jolly periods of the year, and that not without some considerable emolument to the public; whiles our interludes here are very day alike; so as the ladies and gallants come reeking from the play late on Saturday night, to their Sunday devotions.[33]

While Charles was on the throne, an outright attack on the stage carried an element of risk, for the theatres were under the royal patronage; but once dull William had manifest his almost complete indifference to the arts, the accumulated outrage of men like Blackmore and Collier burst forth.

Excessive severity, carping criticism and the stupid formality of the rules greatly irritated the freer and more creative minds. 'The corruption of the poet,' Dryden observed very exactly, 'is the generation of a critic;'[34] Swift, in the *Battle of the Books*, saw criticism as the child of ignorance and pride, with the voice of an ass and the claws of a cat. Pope preserved a lofty disdain:

> Yet then did Dennis rave in furious fret;
> I never answer'd, I was not in debt:[35]

Yet by giving way to the rationalist temper of the age, men of the arts, and the best among them, had prepared the critical lashes for their own backs. The notion of 'propriety', so dear to antiquity and to the formulators of the rules, was capable of various interpretations. An aesthetic theory might perhaps have defined propriety as acting in conformity with the promptings of the imagination. But in the Augustan world of 'laws', the imagination—the 'fancy'—was suspect, and so propriety came to mean decorum; questions of morality were introduced as an essential element in aesthetic theory. Once this had happened the differences between what was artistically justified and what was socially acceptable were no longer clear. The position of Collier and his kind came to be that the justification of the arts was social acceptability. Yet, with certain reservations which demanded for the artist rather more freedom than Collier would give

them, this was also the view accepted by the major talents of the late seven-teenth and early eighteenth centuries. Dryden in the *Preface to the Fables*, which was his last and best-considered piece of critical writing, defended poets against Collier's foolish application of propriety—that corrupt clergymen should not be shown, for a corrupt clergyman was 'untypical' in the same way that Iago was an 'untypical' soldier. But Dryden did accept a moral responsibility for the arts. 'I have endeavoured,' he wrote of his *Fables*, 'to choose such fables, both ancient and modern, as contain in each of them some instructive moral;' and he apologized for some moral shortcomings in his earlier writings:

> for it must be owned, that supposing verses are never so beautiful or pleasing, yet, if they contain anything which shocks religion or good manners, they are at best what Horace says of good numbers without good sense, *Versus inopes rerum, nugaeque canorae.*[36]

The aim, then, of the arts was to instruct, following 'Nature' (in some sense) for their patterns. Most artists agreed on the benefits to rationality and sound order—that is to 'Nature'—offered by the arts, and thought that the arts had a responsibility to deploy themselves virtuously. The glory of the line, the beauty of the picture, the loveliness of the melody had no necessary justification in themselves; what mattered was the way they operated on the affections and passions; and these effects were to be judged from a moral point of view. Roger North, like Dryden, was enough a man of the past to take this line of argument gently, without too much stress on the moral imperatives. But he was sufficiently impressed with current ideas to draw the very common comparison between the arts, and insist on their similar aim:

> A composer of Musick ought to look upon himself to be in a parallel state with painters or poets, and as they frame in their minds some reall designe, to which as to a generall scope he is to direct his aimes.[37]

Poets, painters, composers, all alike, should excite 'proper ideas' in the public, 'whether lofty, serious, or jocular, as the subject proposed de-mands'.[38] North was no censorious pedant and realized that there are many kinds of perfection in music; but even he gave the highest award to the most earnest:

> And it must be granted that musick which excites the best, most important and sane thinking and acting is, in true judgment, the best musick.

And yet more confidently:

> So I conclude, setting aside the singular humor of men and times, that musick which agrees most with the best actions of civilised humanity is the best musick.
>
> ('Judgment of Musick')[39]

As literature and music agreed on the main points, painting in England, which set out on the business of theorizing rather late, could hardly do other than follow along. And Jonathan Richardson, the first English painter-theorist of the age of reason, influenced no doubt by the *Art of Painting* that Dryden had translated from the French, found his mind in perfect conformity to the conventional artistic thinking of the age. He recommended the 'mechanic' view:

> A Painter must not only be a Poet, an Historian, a Mathematician, &c. he must be a Mechanick, his Hand, and Eye, must be as Expert as his Head is Clear, and Lively, and well stored with Science:[40]

And he took the moral responsibilities of painting very seriously. 'Next to Genius and Industry,' he declared, 'Virtue is the best Qualification a Painter can have.' He expected the 'Ancient Great, and Beautiful Taste' in painting to revive in England:

> But not till *English* Painters, Conscious of the Dignity of their Countrey, and of their Possession, resolve to do Honour to Both by Piety, Virtue, Magnaminity, Benevolence, and Industry.[41]

'Conscious of the dignity of their country'—how very curious that a theory of aesthetics should make such a demand of an artist. Yet once morality and social acceptibility are allowed to be justification for art, how logical is that progress! In secular societies the state is the guardian of social values. In a Reformed country, boasting a state Church, the government is the real arbiter of morality; in a country where Parliament legislates on rights of worship, and where Toleration is a party issue between Whig and Tory, morality has been subsumed under the heading of politics. Good morality is merely proper government; art which teaches sound morality is merely an exaltation of the state. Artistic theory, in the name of morality, demanded reform, but reform is the business of government. The attack on the licence and lewdness of Restoration art ran parallel with the attack on the conduct and manners of late seventeenth-century society. Sound art would not come until there was sound government, and sound government could not come until the house of Stuart was undone. Artists with their theories turned themselves into minor participants in the grand design of the age of reason—the overthrow of arbitrary government. The artist, in the exercise of his gifts, ensnared himself in the battles of politics.

This forlorn pilgrimage of the arts, in retreat from the imagination, took time to reach its melancholy goal. By 1700 the journey was done; reason was enthroned, reform was afoot, and artists were parading their

social consciousness and their political abilities. Some relics from a former
intellectual age made their protests, but not effectively. Cringing Dryden
wavered, following sometimes the secret intimations of the imagination
and sometimes the solid respectability of reason, sometimes a poet and
sometimes only an Augustan man of letters. Age, experience showed him
the illusions of the rational paradise:

> Dim as the borrow'd beams of moon and stars
> To lonely, weary, wand'ring travelers
> Is Reason to the soul; and, as on high
> Those rolling fires discover but the sky,
> Not light us here, so Reason's glimmering ray
> Was lent, not to assure our doubtful way,
> But guide us upward to a better day.[42]

He looked 'upward', settled into Catholicism and in the last twelve years
of his life seemed to find a better day. His mind was fresher and keener
than ever; he was done with politics and intent upon a poet's business.
Rochester was another who, at the end of a short, wilful and scandalous
life, secured his mind with religion. He became the aristocrat in despair.
Reason was an *ignis fatuus* to the mind of men who tried to govern
themselves without the consent of the senses:

> His wisdom did his happiness destroy,
> Aiming to know that World he shou'd enjoy.[43]

But pleasures come gradually less sweet to a delicate constitution under-
mined by syphilis. In the winter of 1679, Bishop Burnet called on the
sick poet, 'in the Milk-Diet, and apt to fall into Hectical-Fits,' and the
two men began the great theological debate at Whitehall and at High
Lodge in Woodstock Park which led finally to the conversion of Rochester
in the summer of 1680. Two men, the stern, honest Scottish clergyman
and the rake dying from a burst ulcer and other bodily malfunctions
debating the way to death—the scene is fantastic enough for a Jacobean or
metaphysical pen. Rochester, the imaginative man, found his rest in the
mysteries of religion. Whatever his own reconciliation, he left the world
his unqualified condemnation:

> Tir'd with the noysom Follies of the Age,
> And weary of my Part, I quit the Stage;
> For who in Life's dull Farce a Part would bear,
> Where Rogues, Whores, Bawds, all the head Actors are?[44]

The maledictions of Rochester sounded fainter and fainter as society
captured the allegiance of the arts. The fall of absolutism and the rise of
parliamentary government, the collapse of royal patronage and the

growth (in power and wealth) of political lords, the discovery of a rational world by the arts, science and philosophy, and the appearance of a numerous, vocal and expectant public—all silently conspired to make the arts obedient to social and political ends. Even the remnant of the Court Wits, whose desperate ways had made the first years of the Restoration so lively, grew old and sombre in public or political service. Waller and Sedley, two gaudy butterflies in their young days, became known in old age for the sobriety and sense of their parliamentary speeches. Dorset, the Restoration Maecenas, was Lord Chamberlain from 1689 to 1697 and three times a regent for the absent King. He became, says Swift, fat and very dull. Sir Carr Scroop was an active member of the Whig Green Ribbon Club; in 1694 Fleetwood Shepherd was rewarded with the modest sinecure of Black Rod. Writers of lesser social rank conducted espionage and other diplomatic business for the government.

The new arbiters in artistic matters were responsible men, government men. George Savile, Marquis of Halifax, was a pattern for the new style, a combination of writer and statesman of whom Dryden wrote:

> Jotham of piercing wit and pregnant thought,
> Endued by nature, and by learning taught
> To move assemblies, who but only tried
> The worse awhile, then chose the better side;
> Nor chose alone, but turned the balance too;
> So much the weight of one brave man can do.[45]

In the new age, under Tories like Bolingbroke and Oxford, and Whigs like Somers and Charles Montague, Earl of Halifax—all dabblers in the arts, all patrons and all politicians; in clubs like the Kit-Cat Club and the Brothers Club, the arts did their modest bit towards the realization of the perfect society.

CHAPTER 6

NEW PROSPECTS

The Enquiry in England is not whether a Man has Talents & Genius, But whether he is Passive & Polite & a Virtuous Ass & obedient to Noblemen's Opinions in Art & Science. If he is, he is a Good Man. If not, he must be Starved.

Blake, Annotations to Reynold's *Discourses*.

WHEN CHRISTOPHER WREN designed at Winchester a modest rival to Versailles, for the old age of King Charles, he placed a Council Chamber at the centre of his plan. Versailles itself has the King's Bedroom as the chief and dominating chamber. In former years Charles had attempted to rule in the French manner, maturing his hidden schemes in private apartments and at the bedside of his mistresses. But the struggles of his long reign had tutored the monarchy, and the plan of Winchester showed the lesson learnt; the English way was government unmixed with private delight, and consultation rather then caprice.

The gain to parliamentary government was the artist's loss. The signs for a future court patronage of the arts were not good. A generous royal patronage springs chiefly from the private delight of the King; it is an expression of his grandeur and his taste. A monarchy subject to the control of Parliament lacks grandeur, and a King constrained to business and limited in his Privy Purse has neither the time nor the money to indulge his taste. In English history, until the reign of Charles II, the crown had done very little for the arts; after Charles, the course of politics ensured that his successors would do even less than before.

Even so, a monarch of taste and sensibility might have redressed, for the arts, the disadvantages of his limited position; but there was no hope for the arts in the characters of Charles's successors. The miserable reign of James II whirled out in conflict and confusion. The Glorious Revolution of 1688 brought in a Dutch King who 'understood little of the nation' and could not adapt to 'so peculiar a people as the English'. William's notions, said Dr. Johnson, were all military. He knew so little of poetry, he felt a captain of horse might be a fit position for Swift; he received St. Evremont very coldly, thinking him to be a French major-general. 'Reserved, unsociable, ill in his health, and soured by his situation,' Walpole wrote,

'he sought none of those amusements that make the hours of the happy much happier.'[1] Mary, his Queen, had a softer aspect and appreciated the arts a little; but neither her domestic nor her public life was easy, and she 'contented herself with praying to God that her husband might be a great hero, since he did not choose to be a fond husband'.[2] A Dutch soldier was penance enough for the arts to bear, but worse was to come. The reign of Anne was disrupted by the furies of party politics, from which artists gained some financial benefit; but of patronage in the sense of sympathetic understanding from this fat, dull and persevering lady, there was none. Then the house of Brunswick was imposed upon the unfortunate land. These Germans in England were most notable for a stolid egotism often bordering on stupidity, and for the violence of their family hatreds. 'No reign,' wrote Horace Walpole of painting under George I, 'since the arts have been in any esteem, produced fewer works that will deserve the attention of posterity.'[3] Painting, which at this time particularly depended on court patronage, suffered most from the indifference of the first two Georges, but none of the other arts gained from royal attention. Not even music, which both George I and George II enjoyed, could stir them into sympathetic action.

Old traditions do not die in a day, and the institutions of the King's Musick and the Royal Office of Works went on into the eighteenth century, though gradually sinking as the royal brutishness increased and the royal funds stopped flowing. An obvious mark for economies was the King's Musick, for the establishment in Charles's early years had been quite numerous. Charles himself had been forced to retrench as early as 1667. James, though a fair performer on the guitar, had continued to cut back; he had in his household music twenty-three counter-tenors, five basses, a flute, a bass-viol, a harpsichord, a composer and an instrument keeper.[4] William and Mary inherited roughly this number; a list of 1689 gives thirty-two musicians plus the Master and the Serjeant Trumpeter; by 1692 the number had been reduced to twenty-six in all.[5]

The martial mode of William's years went with a sterner court morality. In the country beyond the court the blithe ways of Charles's time were now odious; respectability was re-established as a virtue, and Collier and his kind were ready to pounce. Within the court 'swearing and cursing, prophaning the Lord's day, drunkenness, and such immoralities' were outlawed, and the third Wednesday in the month declared a fastday, to supplicate God for the success of William's wars.[6] Even music was not allowed to sully the purity of the court sacrifice:

Mr. Comptroller has complained to the Green Cloth against Mr. Story for

keeping music and revelling in his house on the fast-day; and 'tis believed he will be turned out.[7]

The court music, now slightly frowned upon by the new austerity, was very soon afflicted with a more familiar sickness—an empty Privy Purse. In May 1693, the singers belonging to the Musick complained to the Treasury that their yearly allowance of £40 had not been paid since Lady Day, 1690. In the summer of the same year, Nicholas Staggins, the Master of the Musick, petitioned the King to continue the salary of £200 per annum which Charles II had allowed him.[8] What with the reductions in the establishment, the censorious mood at court, and the old, familiar poverty, the King's Musick had little to look forward to.

Life in the Musick had always been hazardous, and for a time it may have seemed that the upsets of William's reign were merely a continuation of the many troubles suffered in Charles's time. Musical occasions went on as before. On New Year's Day, 1689, the King and Queen came to Whitehall to receive the greetings of their subjects; Shadwell, the laureate, had a song ready for the occasion which Blow set to music; there was, besides, 'a great consort of music, vocal and instrumental'.[9] And afterwards, scattered through the reign, music was heard at the usual and appropriate royal occasions—for a royal birthday, for a ball at Kensington palace, or for the Queen's entertainment when she took her barge on the river. The King himself took little interest in these proceedings, and permitted them perhaps because they were the convention. Bands, to him, were an adjunct of war, and martial noises from trumpet and drum were his only musical delight. When he crossed to Holland in January 1691, he took with him no less than forty-three musicians who played him into the Hague with fanfares and rousing marches. After the Peace of Ryswick, in 1697, William made a grand entry into London accompanied by the royal trumpets and the City trumpets, the drum major and the royal kettledrums. That was a noise to stir the King's heart.

The unspoken expectation at the Glorious Revolution was that music in every respect would go on much as before, the performers to entertain and the court composers to compose as in former years. And the main court composers—Staggins, Blow and Purcell—continued to produce offerings to royalty. Purcell's *Dido and Aeneas*, given at Josias Priest's school towards the end of 1689, has some scarcely hidden compliments to the new sovereigns:

> Look down ye orbs and see
> A new divinity

.

To Phoebus and Venus our homage we'll pay,
Her charms bless the night, as his beams bless the day.

But Purcell's intention was probably more political than courtly. In the
two previous reigns he had always been a strong Tory; he was also
suspected for financial misdealings over the sale of seats in the organ-loft
at the coronation of William and Mary; it was time to put himself right
with the new sovereigns and their Whiggish supporters. Thereafter,
Purcell wrote various pieces for royal celebrations—six birthday songs
for Queen Mary, some welcome anthems for the King returning from his
wars, the powerful *Te Deum* and *Jubilate* which, although written for the
Sons of the Clergy, the sovereigns heard in the Chapel Royal on December
9, 1694, and took as a fit tribute to the victor of the Boyne. Before the end
of the same month Queen Mary was dead of smallpox. Her body was
borne in solemn and magnificent procession from Whitehall to West-
minster Abbey to the sound of 'flat trumpets' and muffled drums in
Purcell's *Funeral March*, a piece previously used for a ghost scene in *The
Libertine* by Shadwell. Within nine months of the Queen's funeral Purcell
too was dead, expiring at about midnight on November 21, the day before
St. Cecilia's. The Chapter at Westminster unanimously voted him a free
burial, and laid him to rest to the music of his own *March* and *Canzona*. A
marble plaque, commissioned by Lady Elizabeth Howard, was set close
by the organ he had performed on so often.

The name of Purcell appears only twice in the official papers relating
to the Musick in the reign of William and Mary. The compositions
addressed to royalty are but few among the large number written by
Purcell in his last years. His Tory past perhaps caused him to be out of
favour at court; but he also felt the neglect of music under unsympathetic
sovereigns. Musicians now sought their livings beyond the circle of the
court, in the theatres and public concert-rooms.

In the reign of Charles portrait painters had been among the most
fortunate of artists, and in the changed and sterner times of William and
Mary their luck still held good. Godfrey Kneller, the successor to the fame
and business of Peter Lely, was as successful, as rich and as egotistical as
his predecessors. Ten sovereigns, says Walpole, sat for Kneller. From
Charles II to George I he was the King's Painter, knighted by William in
1692 and made a baronet by George in 1715. Kneller came to England
around 1676, youthful, well-trained, ambitious and extremely facile. Lely,
having saluted his young German rival, died in 1680, leaving Kneller to
be the portraitist of the next forty years. He harvested the rewards of an
exuberant, confident and acquisitive age, for he was very much a man of

his times. In 1695, King William granted him £200 a year and made him a
Gentleman of the Privy Chamber; succeeding monarchs merely confirmed
his honours and position. His success was so assured and his fees so high,
it seemed he did not bother to collect his official salary (any artist would
wish to spare himself dealings with the Treasury). In any case, £200 a
year was very little to a man who lost £20,000 in the South Sea Bubble
and still had sufficient capital left to raise an income of £2,000 per annum.
His prices, wrote Walpole, were 'fifteen guineas for a head, twenty if with
one hand, thirty for a half, and sixty for a whole length'.[10] Kneller was
amazingly prolific; a good authority reckons that he painted more
portraits than any painter in any age. He was a facile, careless, talented,
greedy painter; to him, portrait-painting was money-making. Walpole,
while recognizing his powers, was very severe on his character:

> he united the highest vanity with the most consummate negligence of character
> —at least, where he offered one picture to fame, he sacrificed twenty to lucre.[11]

He was a devotee of the cult of success, and in this he was at one with
most of his sitters. 'He met with customers of so little judgment,' Walpole
continued, 'that they were fond of being painted by a man who would
gladly have disowned his works the moment they were paid for.'[12] The
painter made an offering to their vanity; the sitters made a contribution
to his wealth. Neither considered overmuch questions of artistry; in a
material society the best painter is the richest and most fashionable
painter. To Kneller, the approval of the King, while naturally flattering
even in a country with only a tiny residuum of awe left in royalty, was
chiefly important as a mark of status and as an attraction to the would-be
fasionable. Kneller was not a court-painter in the old sense, for there was
no longer any court-ideal left to portray; and if there had been, Kneller
would not have been the man to paint it. Commissions from the court
were part of ordinary business—opportunities to make money. Lely's
Windsor Beauties, though not his best work, did at least perceive some-
thing of the nature of Charles's court; the wantonness, the insolence and
the grace were captured in part, though the humour and the wit escaped
the Dutch artist. But Kneller's *Hampton Court Beauties*, painted for
Queen Mary, reveal none of the secrets of court life. They are pleasant
pictures, but conventional and lacking in the distinction that famous
beauties are presumed to have. The large piece Kneller painted of William
triumphant on horseback is fitted out with the allegorical apparatus
suitable to the occasion, but it remains merely the picture of a glum
Dutchman on a demure and static horse.

The good fortune enjoyed by the portrait painters was to some extent

shared by the wall decorators and the history painters. The fashion, set in King Charles's day by men like Verrio, continued, and buildings projected in those former days—Greenwich and St. Paul's for example—became ready for painting only long after, in the reign of William, and even of Anne. Verrio, the first to grow rich from decorations, was working almost to the time of his death in 1707. Like Kneller, he had amassed enough wealth to be independent of royal favour. As a Catholic and a man much indebted to Charles and James, Verrio at first refused to work for the new sovereigns. He was at last persuaded by Lord Exeter to agree to paint at Hampton Court where he decorated the great staircase 'as ill as if he had spoiled it out of principle'.[13] Under Queen Anne he received a pension of £200 from the Crown and was preparing to undertake the painting at Blenheim when he died.

While Verrio was sulking, and after he died, such patronage as the Royal Works had to offer to painters was shared mainly between Louis Laguerre and James Thornhill. Laguerre, a modest, unassuming man, did well, but would have done better if he had possessed Thornhill's connections and power to intrigue. Laguerre worked for King William at Hampton Court and painted the saloon at Blenheim; he was employed to repair the cartoons of Mantegna, and designed a tapestry (never completed) for the Union of England and Scotland. But the decoration of the dome of St. Paul's, which should have been his great work and for which he was unanimously chosen by the commissioners, he never achieved, being set aside in favour of Thornhill.

The work of Thornhill was no better than that of Laguerre, but he was helped by the greatly influential Earl of Halifax, and he had the advantage of being English at a time when nationalism was running rather strongly.[14] Like many others, he had a hand in the decoration at Hampton Court; he also painted the hall at Blenheim. He had, however, the good fortune to be connected with two of the greatest buildings of the time. He painted the inside of the dome at St. Paul's and the ceiling of the great hall at Greenwich; the decoration of the walls at Greenwich was designed by him, but he left the execution to others. The painting at St. Paul's was a disappointing and mistaken business. Wren had not wanted any such scheme; painting viewed from 170 feet below is not likely to be successful. In the great hall at Greenwich Thornhill had a room and a theme—an allegorical representation of the glories of William and Mary—much better suited to his abilities. His work there was the best he ever did.

Although Thornhill bore the title of Historical Painter to the Crown, and was knighted by George I, the benefits to be gained from the royal

connection by now were perhaps outweighed by disadvantages. The monarchs were not very interested in the productions of their Historical Painter, and the Treasury was becoming meaner and meaner. While painters decorating the houses of the great nobles could expect a very handsome return, poor Thornhill, committed to a vast surface in St. Paul's and at Greenwich, worked away for a meagre allowance per square foot. And when the work was done there was the grave problem of extracting the money due. The work at Greenwich went on over nineteen years, continually interrupted by disputes and problems over payment. How much more pleasant for the artist to place Apollo, the Muses and the Liberal Arts on the saloon ceiling at Cannons and promptly receive £300 from the Duke of Chandos.[15]

Though William's lack of interest in the arts was clearly seen and felt very soon after his accession, some large undertakings which the Royal Office of Works had in hand from the time of Charles still carried on. Wren continued as Surveyor, and though he was now well into his middle age, he was still vigorous. St. Paul's was rising slowly, but with many years of building ahead. Chelsea Hospital and Greenwich were incomplete, and so too were the palaces at Whitehall and Winchester. Work stopped at Winchester, never to be resumed. William showed more interest in Whitehall, and Wren was busy here through most of the reign; he built a long block towards the river, a chapel and a Council Chamber, all of brick and in a quiet style but expensively decorated. Grinling Gibbons was employed to carve, and the whole project cost £35,000. In 1698, a maid left some linen too close to a fire; the material caught, and the palace was burnt down. Wren's first thought, as he rushed to the fire, was to save the Banqueting House, not caring about his own work but determined to rescue Inigo Jones's beautiful building which occupied such an important place in the history of English architecture. The Banqueting House, 'though much damnified and shattered', was preserved largely thanks to the courage of one John Evans who tackled the flames at great danger to his own life. Whitehall was not rebuilt. Some plans from Wren's office were drawn up, showing a bold and Baroque conception. But William had lost all passion for building. Instead of a grand palace, there arose on the site the small and peculiar Goose Pie House which Vanbrugh built for himself by permission of the King.

Though Whitehall had been conveniently placed in London, neither William nor Mary liked it. Hampton Court alone of the royal residences took the fancy of the sovereigns. One of the first decisions of the new reign was to adapt and extend Wolsey's old house, and in June 1689 the

foundations for the new works were already being prepared. Building went on quickly until Mary's death in 1694; then it ceased, and only started again after the destruction of Whitehall. In the usual manner of a Wren building, the plans for Hampton Court went through many modifications. The first design was grandiose and extensive, and seemed to have the Louvre in mind. Perhaps this was not to the taste of sovereigns who preferred the unexciting and domestic. The small part of the original great scheme which was actually built shows a plainer conception with unbroken lines and a uniformity that borders on dullness.

As the old projects were completed, few new designs were called for from the Royal Works. Chelsea Hospital opened its doors in 1692, and Wren received his £1,000 fee in the next year. St. Paul's went on steadily. Apart from Hampton Court, the construction of the Royal Naval Hospital at Greenwich was the only great piece of building undertaken by the crown after the Glorious Revolution. Greenwich Hospital was the Queen's idea. What Chelsea provided for soldiers, Greenwich would do for sailors; the Queen gave up the buildings and land of Greenwich Palace, including the incomplete work of John Webb, and she intended that the new architecture would far outshine Chelsea. In 1694 a Commission was appointed with Wren as Surveyor, Evelyn as Treasurer and (in the next year) Vanbrugh as Secretary. The basis of the design was Wren's, but the execution of the buildings—since construction continued over many years—owed more to Vanbrugh and Hawksmoor.

Though the Royal Office of Works was already declining in the reign of William, the last years of the seventeenth century were something of a golden age for craftsmen employed on the royal works. The embellishment of buildings such as St. Paul's, Hampton Court and Greenwich brought out the best artistry in a number of exceptional workmen. At Hampton Court, Morris Emmett was the master bricklayer; Caius Gabriel Cibber carved the great pediment and the cartouches on the garden front, and William Emmett carved the *œils-de-bœuf*; Gibbons provided some wood-carving, and Jean Tijou some iron gates in the park; John Grove was the plasterer, Verrio and Laguerre painted the decorations. Many of the same craftsmen were also at work on St. Paul's. Among the masons were Joshua Marshall, Thomas and Edward Strong; the master bricklayer was Richard Billinghurst. Grinling Gibbons worked on the Cathedral for a few years after 1694, carving in both stone and wood. Other sculptors were Jonathan Maine, Cibber and Francis Bird. Gibbons received £128 for ornaments on each spandrel in the legs of the dome, and £13 for each festoon he did under the windows. Maine was paid £189. 9s. for 681 feet

of a decorative band with 'caparole and flowers, husks and leaves, etc., 8 in. high and 1¼ in. imbost'. In 1706, Bird was paid £300 for 'the large Pannel in Bass Relivo over the Marble Dore at the W. End'; for the 'Pedament representing the Conversion of St. Paul'—54 feet long and 17 feet high—he received £650, and for the final touch, the statue of Queen Anne in front of the church, he earned the considerable sum of £1,700. Besides Gibbons and his staff, woodcarving was undertaken by several joiners, notably Charles Hopson. The work was as expensive as stone-carving. In 1696, Hopson and his firm received £1,638. 14s. 11d, and in the next year Gibbons' account came to £1, 561. 4s. 6d. Most of the impressive ironwork in the Cathedral was by Tijou; the chief plasterers were Henry Doogood and Chrysostom Wilkins.[16]

This prosperity gave a false impression of liveliness in the Royal Works. Wren was entering into his old age; more and more of the Surveyor's tasks were now shared with his colleagues Vanbrugh and Hawksmoor. This, indeed, was for the best since both Vanbrugh and Hawksmoor had considerable and unusual talent. But their best efforts were for clients outside the Royal Works. In 1702, Vanbrugh had the Comptrollership procured for him by Lord Carlisle, for whom Vanbrugh had designed Castle Howard. But Hawksmoor, with no aristocratic connections, never held high office in the Works. He was Clerk of Works at Kensington and Hampton Court, Deputy Surveyor at Greenwich, and Clerk to the Palaces of St. James, Whitehall and Westminster. He appeared, in fact, wherever a loyal, efficient and self-reliant overseer was needed. But the chief offices escaped him. It did not matter very much, for the positions in the Royal Works were becoming the architecturally insignificant gifts of the prevalent political patronage. Vanbrugh, who was jobbed into his post in 1702, was jobbed out in 1713, and returned with a knighthood in the next year. Hawksmoor lost his Clerkship at the Royal Palaces in 1718, but became Deputy-Comptroller to Vanbrugh in 1726. Saddest of all, in 1718 the great and gentle Christopher Wren (though now practically retired) was deprived of his Surveyorship for the sake of one William Benson, a miserable poet and almost completely ignorant of architectural knowledge. Until the death of Vanbrugh in 1726 the Works still retained some of its old prestige and influence, but the habits of party politics, and a moribund monarchy, were weakening it year by year. Queen Mary was the last of the Stuart builders; after her death in 1694 the inspiration for architecture passed from the crown to rich aristocrats, and the places in the Office of Works, from Surveyor to minor clerk, became the rewards for good political connections.

At the very beginning of the eighteenth century, in a final upsurge of intellectual energy, the Royal Office of Works gave birth to one very curious triumph—the English Baroque. The buildings of this school were mostly put up for private or ecclesiastical patrons, but it was the conjunction of Wren, Vanbrugh and Hawksmoor in the Royal Works that gave rise to this vigorous and unexpected development. The indications of the new style first began to emerge around 1692, as Nicholas Hawksmoor took over more and more of Wren's duties in the Works. In June 1692, the treasurer of Christ's Hospital commended 'the great pains and industry that Mr Hawksmoor Sr Christopher Wrens gentleman hath taken in makeing the draughts of the new intended Writing School and severall other matters relating to that affaire'.[17] After this date, the distinctive touch of Hawksmoor was quite recognizable in designs coming from the Works, for example in the very bold plans for the rebuilding of Whitehall after the 1698 fire. When John Vanbrugh joined the Works as Comptroller in the place of Talman, the famous collaboration was established. How much of houses like Castle Howard and Blenheim was the work of Hawksmoor is not very clear; Vanbrugh had the greater fame and greater credit. But their talents were both individual and complementary, and they deserve equal appreciation as the masters of English Baroque.

The new style was unexpected—an outpouring of prodigality in an age beginning to be excessively disciplined. 'Mass, sheer mass, became their passion,' writes a sympathetic critic; they rediscovered 'those intrinsic architectural values which Jones had disciplined away and Wren had not been the man to recall'.[18] The monumentality, the superhuman scale, offended against what was taken to be good order. Vanbrugh 'wanted eyes', said Walpole; he lacked 'all ideas of proportion, convenience, propriety'. The rules as laid down in the Palladian doctrine of Lord Burlington were disregarded, and respectable opinion was scandalized:

> He undertook vast designs, and composed heaps of littleness. The style of no age, no country, appears in his works; he broke through all rule, and compensated for it by no imagination.[19]

In 1732 Burlington looked over Hawksmoor's design for the Mausoleum at Castle Howard and declared it bad; to place columns only a diameter and a half apart in a circular Doric building was unlicensed by ancient practice. Hawksmoor had his reasons, which he set out for Carlisle. He hinted that the Palladian objection was merely pedantry:

> If your Lordship doubts of what I have said; then we must to please the inclinations of the Virtuosi; quit our Reasons and intentions, and by adding another diameter make the Colonade Corinthian.[20]

5

When Walpole said that Vanbrugh's Baroque lacked imagination he attacked as a critic whose rules have been slighted. But his own wonder at the view of Castle Howard gave the lie to his judgment. It was, he said, 'the grandest scene of real magnificence I ever saw'.[21]

Hawksmoor was no enemy of the ancients. His foundation came from the familiar Vitruvius, known to him in Perrault's annotated edition published in 1684. But he and Vanbrugh were not blind worshippers of reason; 'fancy' had a large part in the development of their ideas. Consequently they laid hold of and stressed certain purely architectural notions which, having nothing to do with the rational ideals of 'convenience and propriety'—as Walpole put it—surprised and perhaps alarmed the formalists. The true 'Rules of the Ancients', wrote Hawksmoor to Lord Carlisle, defending Vanbrugh's design for the Belvedere Temple, meant following 'Strong Reason and good fancy, Joyn'd with experience and tryalls',[22] and it was just this conjunction of sound architectural principles, fresh imagination and practical experience gained in the Royal Works that made the Baroque so singular and distinctive in the England of this time. The Baroque was, like Restoration comedy, a last fling of anti-rationalism, of a dominant imagination, before the darkness of rules and propriety closed in; and it is entirely fitting that the dramatist, Vanbrugh, should be a master of the Baroque, for he was one of the last writers to show a true understanding of the nature of comedy as the great wits of the Restoration conceived it. It would be hard to make any sort of parallel between the plays and the buildings— between *The Relapse* and *The Provok'd Wife* and Castle Howard and Blenheim—but they do have something in common. Each showed a strong artistic imagination at work, the plays realizing the possibilities of the stage and the buildings asserting purely architectural values, unhindered by pre-conceived notions of good order or propriety.

The Royal Works made the development of the Baroque possible. It provided a school of architecture relatively undisturbed by the upheavals of politics where artistic ideas could be fashioned and adapted amid helpful surroundings. But the enterprise needed the encouragement and protection of the King; when monarchs ceased to build, the places in the Works became the small coinage in the currency of political rewards.

With the transfer of power from King to Parliament, the patronage once dispensed by the King and his court was now given out by the ministry. A King had many selfish and political reasons for rewarding artists, but taste and a desire for future fame encouraged him to look for excellence wherever it could be found. Though ministers themselves

might be men of discrimination with a love for art, the rewards from a ministry were in the main recognitions of partisanship. Dryden had been pulled into politics and gave his service to the King's party, but his laureateship was more than a political payment; it was a gift from the King to the greatest poet of the age. To the procession of insignificants who followed Dryden—Shadwell, Tate, Rowe, Eusden—the appointment was a mark of political bondage. Words are the stuff of propaganda; the writer was becoming a valuable party property.

After the Glorious Revolution, as the Crown lost the power to foster the arts, it appeared also to lose the desire. Even music, while it still delighted, failed to inspire the Crown to generous action. Pepys noted that Queen Mary had a good ear as a child. Anne played the harpsichord and possessed a spinet which Hawkins thought 'the finest that was ever heard'.[23] George I, in his days as Elector before he came to England, had the sense to listen to Baron Kielmansegg and appoint Handel *Kapell- meister* in 1710 with a salary of 1,000 thaler. Caroline, wife of George II, had been taught by the castrato Pistocchi, and was quite accomplished. Haym complimented her on a *perfetta e giudiziosa conoscenza della musica*,[24] and Handel had dedicated to her the *Chamber Duets* of 1711. Yet when the Georges came to England, though they were still kindly disposed towards music, their encouragement was casual and not very active. Handel in England had to make do with a minimum of help from the crown. On his first visit in 1711 he had merely prepared the way with the successful opera *Rinaldo*. When he returned in the next year he set about wooing the court and the nobility. On February 6, 1713, he produced a *Birthday Ode* for the Queen. A few months later he had a *Te Deum* ready for the Peace of Utrecht; for the official performance on July 7 he added a *Jubilate*. But musical offerings were not enough; a petition to Anne from Handel's noble patrons had to be added before the Queen would grant the composer a pension of £200 a year. Thereafter Anne took no interest in her composer and demanded nothing from him. She was, wrote the Duke of Manchester, 'too busy or too careless to listen to her own band, and had no thought of hearing and paying new players however great their genius or vast their skill'.[25]

With the coming of George I, Handel was in some embarrassment, being absent without leave from the Electoral court. But the King was as little bothered to condemn as he was to encourage. For the rest of his life Handel had only the slightest recognition from the music-loving mon- archy. In 1727 he was listed as Composer of Musick for the Chapel Royal, a post that apparently lasted for the period of the Coronation only.[26]

In 1728 he became music master to the three eldest princesses; he never had any other official position in the Musick. When Handel came to England, long-serving John Eccles was the Master of the Musick. After him came Greene, in 1735, and Boyce in 1755. The Musick, under inattentive monarchs, was losing all vitality. Official music in England passed after Boyce into the hands of church organists, and remains to this day in their unillumined control.

Handel never ceased to address the indolent royalty. He wrote a *Wedding Anthem* and *Parnasso in Festa* for the marriage of his pupil the Princess Royal in 1734. His opera *Atalanta* saluted the wedding of the Prince of Wales with grand fireworks and a large transparency bearing the words FRIDERICUS and AUGUSTA. The battle of Dettingen called forth a *Te Deum* in 1743; *Judas Maccabaeus* celebrated the suppression of the '45 rebellion, and the *Royal Fireworks Music* was written to mark the Peace of Aix-la-Chapelle. Sometimes Handel resorted to gross flattery; *Riccardo Primo* was a rather obvious compliment to George II on his accession. And sometimes his offerings were unfortunately maladroit. The plot of *Floridante*, dedicated to the Prince of Wales in 1721, had an unhappy parallel with the royal troubles between the prince and his father.

The rewards for all this work were not large. George I confirmed the pension granted by Queen Anne. The Georges were fond of opera, and Handel's in particular. The King subscribed £1,000 to the Royal Academy of Music, founded in 1719 expressly to promote opera. But the Academy was a venture of the nobility and Handel merely happened to be the chosen composer; at least three lords—Newcastle, Chandos and Burlington[27]—subscribed an amount equal to the King's. And the King's careless interest did not prevent the opera from having a stormy political course. In 1728 the Academy collapsed. Handel and the impresario Heidegger set up at the Haymarket, and the King renewed his subscription. In 1734, after fresh quarrels with the nobility, Handel was forced out to Covent Garden. The nobility now had Farinelli at the Haymarket while Handel struggled on in unfashionable Covent Garden. In 1737 Handel's venture went bankrupt and Handel turned from opera to oratorio. The royal circle regarded these goings-on with equanimity. In 1734 the Prince of Wales gave £250 to Handel's company, but in the next two years he gave the same amount to the company of the nobility only. In 1737 he gave £250 to each—Handel had just presented him with *Atalanta*—but both companies went bankrupt none the less. No doubt it was not the task of the Crown to save the opera, which was a business undertaking run on

thoroughly commercial principles. But the King's Musick provided no work to supplement Handel's income from the opera, and when that income failed there was nothing at court to fall back on. Handel the composer worked for the public. He was promoted by his own efforts and by rich aristocrats, and he received support and encouragement mainly from these same aristocrats, not from the royal circle.

As the authority and wealth of the monarchy diminished, rich nobles began to take up the duty of supporting the arts. There had always been a few lords who blended discrimination with generosity; Buckingham and Dorset were notable patrons after the Restoraton. But now that lords were richer and more powerful than ever, many more took on the responsibilities of grandeur. Having diminished the power of the King, the greater lords began to surpass him in wealth. And in the excellent commercial climate of the early eighteenth century the opportunities for amassing fortunes were very many. Sometimes wealth was the fruit of political office; the Duke of Chandos is thought to have made £600,000 from the post of paymaster to Marlborough's army; a man was considered a fool if he did not leave an office richer than when he started. Some grew rich in business and speculation. The Earl of Halifax combined political position with financial wizardry; Chandos had dealings with the South Sea, the East India and the Africa companies; the Duchess of Marlborough, cunningly, and Sir Robert Walpole, luckily, took their profit from the South Sea stock before the Bubble burst in 1720. Newcastle had an advantageous business contract to supply timber for the rebuilding of St. Paul's, and Chandos had a financial interest in York Buildings and in life insurance. Others were fortunate in marriage, or in their inheritance. The wife of the second Earl of Oxford, a Cavendish heiress, brought her husband an estate of over £500,000. And many noble families had large properties in London and the country, providing ever-increasing incomes.

Development of their properties steered the rich inevitably towards an interest in architecture. Barbon and the other speculative builders who were so active after the Fire had quickly used up most of the available freehold land within easy reach of the City. If London was to keep growing, especially in the fashionable westward direction, it would have to do so on the estates of certain great families. In the seventeenth century, aristocrats such as Bedford, St. Albans, Buckingham, Salisbury and Southampton had shown that capitalist development of ancestral lands was a highly profitable affair. In the early years of the next century, when the creep of London arrived at the boundaries of the Harley, Grosvenor

and Burlington estates, the estate-owners welcomed the opportunity to profit.

Around 1719, Edward Harley, second Earl of Oxford, began to develop the Harley-Cavendish lands which lay to the north of the Oxford road. The development was put in the hands of John Prince, and though the buildings were by various architects to different designs the estate was planned as a unified whole. Cavendish Square would be for aristocrats, very grand, with gardens laid out by Bridgman, the King's Gardener. James Gibbs built the estate church, now known as St. Peter's, Vere Street. The scheme started hopefully. On the west side of Cavendish Square, Archer built a house for Lord Bingley; on the north side John Price began a veritable palace for Chandos. Gibbs, very much in Harley's confidence, was generally busy about the estate. After 1720 the speedy growth slowed considerably. The crash of the South Sea stock, which left so many ruined, made men more prudent and cautious with their money. The leaseholds became harder to sell, and the estate was not filled up for some fifteen or twenty years. Houses might have gone up more quickly if the regulations had been eased. But fortunately for the architecture, the estate steadily preserved the character of the development and refused to relax the conditions. A building agreement of 1729 allowed red or grey stock bricks, window arches were to be 'straight or compass' and the jambs rubbed brick or stone.[28]

While Harley was building to the north of the Oxford road, a little south and further west Sir Richard Grosvenor was beginning the square that still bears his name. Robert Andrews was made responsible for the development; the east side of the square was designed as a unit by John Simmons. The other sides were let off in small lots which made it hard to achieve uniformity, though even there the houses were 'all sashed and pretty near of an equal height'.[29] The policy here, as in the Harley estate, was to make one architect-surveyor a supervisor for the whole scheme. His job was to insure, if not uniformity, at least a harmony in the parts and a similarity in scale. On the Burlington land, north of Piccadilly, developed also at this time, Lord Burlington himself supervised the building, and he was able to insist that Palladian features were applied to town houses, a very successful application which remained the standard for the London house for over a century. Queensberry House in Burlington Gardens, designed by Leoni in 1721, was the first of these Palladian town houses. When Clifford Street and Savile Row were constructed soon afterwards, the Palladian scheme was expressed once more and the architecture of the street was more carefully controlled than on the other

estates. The influence of Burlington's Palladianism was soon felt in most large English towns which gained, as a result, in order and dignity.

Town houses were by no means the only kind of architecture to benefit from the attention of the landowners. The new-found confidence of the aristocracy was expressed in an almost universal passion for great country houses. Every architect of worth, whatever his political persuasion, seemed to find patrons eager to raise monuments of grand inconvenience. At the turn of the century, when with the carelessness of a gentlemen Vanbrugh decided to turn his hand to architecture, he found among his Whig colleagues of the Kit-Cat Club the patrons daring enough to employ him. He began by designing Castle Howard for the Earl of Carlisle. On the strength of this house, his Whig opinions, and his connections, he was next chosen by Marlborough to design the great house granted by a grateful country to the victor of Blenheim. The building of this Baroque triumph caused Vanbrugh pain and frustration over twenty years. Whatever the difficulties with the Duchess of Marlborough and Harley's Tory administration, he never lost the support of his Whig friends. He recast Kimbolton Castle for Lord Manchester. He built Kings Weston for Sir Edward Southwell, Claremont for Newcastle, Eastbury for Bubb Dodington, Seaton Delaval for Admiral Delaval, and began Grimsthorpe for the Duke of Ancaster.

Vanbrugh had good grounds to expect patronage; he was a Whig, a fashionable man and a wit, and he built houses that would have done honour to a megalomaniac. James Gibbs was a Tory, a Scotsman, a suspected Catholic, and a highly individual talent. No doubt, as a Scottish Tory, he preferred to work for Tories such as the Duke of Bolton, the Earl of Oxford, Lord Bolingbroke and Lord Mar. Harley was especially kind to him, and he valued his connection with the generous and imprudent earl. 'I was with Mr. Witton last night,' he wrote in 1714, 'with whom I did drink your Lordships health and ladys & all the familys, I am heartily glade to heare by him that all is weel in the family;' and he found himself 'infinity obliged' to the earl 'for doing me so great ane honor as remembring me so frequently'.[30] He had reason for gratitude, as Harley was employing him on the London estate and also at Wimpole Hall in Cambridgeshire. But a plain architect took work where he found it, and though the Whigs removed Gibbs from his surveyorship to the church-building commission he built Sudbrooke Lodge for the Whig Duke of Argyll.

To be a Whig was very helpful, as the Baroque architects Vanbrugh and Archer discovered; but to be a Palladian (and preferably a Whig too) was even better. The Palladian house, as devised by Colen Campbell out

of Palladio's *I quattro libri dell'architettura* and the works of Inigo Jones, and promoted by the authority of Lord Burlington, seemed to reflect exactly the ideals of the Whig theorists, concerned with the true ancient rules, rationality and a plain but serious style. The publication of Campbell's *Vitruvius Britannicus*, in 1715, showed what Campbell took to be the pure examples of English architecture. At the same time Campbell was putting his theories to effect, building a Palladian house for Earl Tylney at Wanstead. 'Campbell's influence was very great,' comments Sir John Summerson, 'partly because it required no inordinate skill to imitate him and partly, no doubt, because of the circulation of his designs in *Vitruvius Britannicus*.'[31] When Burlington took up the Palladian enthusiasm its success was ensured. Campbell, well-recommended by Burlington, built more than a dozen country houses before his death in 1729. Burlington himself was a considerable architect, erecting houses for his friends, or public buildings which he paid for himself. He designed his own villa at Chiswick and the Assembly Room at York. And his support of Palladianism did not stop there. He took William Kent under his wing, gave him lodgings, advice and encouragement, and turned a history painter into the architect whose Holkham Hall, begun in 1734, was the grandest of Palladian houses. Kent was insinuated by Burlington into the Royal Works, and ended as Deputy Surveyor, designing the Treasury and the Horse Guards in his official capacity and even putting forward a Palladian scheme for the Houses of Parliament. All Kent's success grew out of the kind interest of Lord Burlington.

'Was it not for Prodigality,' Mandeville wrote, 'nothing could make us amends for the Rapine and Extortion of Avarice in Power.'[32] The aristocracy took up the patronage of the arts, not only as one of the responsibilities of wealth, but also as a salve to pricking consciences guilty of a thousand irregularities in pursuit of fortune. The career of James Brydges, Duke of Chandos, was a perfect illustration of Mandeville's maxim. In 1703, Brydges found a place on the Admiralty Council, admitting he had no talent for the position; sixteen years later he was a duke, retired from politics, with a huge fortune intact. In 1705, Godolphin and Marlborough helped him to the post of paymaster to the foreign forces, and with this advantage and a great deal of sharp practice he rose to be one of the richest men in England. The outcry that brought Marlborough down left Brydges untouched. He covered his tracks well and acknowledged both his gratitude for Marlborough and his respect for the opposition. In 1713 he gave up the paymaster's account-books and retired from public office. George I made him a duke in 1719; he was by now only forty-five

with high social position, immense wealth and leisure to enjoy it. He turned his attention to his many business interests, to his West Country properties, and to the establishment of a life of aristocratic grandeur at Cannons, his house in Middlesex.

Chandos had bought Cannons in 1713 from the uncle of his first wife.[33] It was an old Elizabethan house, hardly fitting to the dignity of a nobleman in the age of reason, and Chandos immediately employed William Talman, the architect of Chatsworth, to alter it. But Chandos thought Talman expensive and negligent; when the architect demanded his fee of £100, Chandos dismissed him in an indignant letter:

> As I cannot believe anyone who has the character of a gentleman can make so ridiculous & extravagant a demand, I must believe Mr Zollicoffe must have mistaken your answer, & therefore I give you the trouble of this, to desire you will more fully explain yourself.[34]

Thus began the long story of the refashioning of Cannons. John James was next commissioned, and between August 1714 and December 1715 some £6,000 was spent on the works. Again the results were not satisfactory, so Vanbrugh was appointed to supervise James's work. By the end of 1715 James had done his worst: rooms were unfinished since the summer, floors were unpaved, and all the new chimneys smoked. James was sent on his way and Gibbs called in. In nearly three years under Gibbs another £5,500 was spent. Although Chandos appeared to be in residence for some of the time, progress towards a habitable mansion was slow. In September 1716, Chandos explained his difficulties to his nephew: 'one half of my house being to be pulled down & the other half already so full as disables me from making you an invitation for a longer time.'[35] The nephew had to be content with dinner only. By 1720, the dining room, chapel and music room were finished, but the saloon and the main apartments were not ready. By 1721 yet another architect— John Price who had designed the duke's house in Cavendish Square— was working at Cannons, and Thomas Fort, a master joiner, was also listed as 'Surveyor' for the years 1720–23. He had a salary of £300 a year, and by the end of 1723 had paid out on the duke's behalf no less than £12,460.

While the house was so long in preparation, the duke and his agents were collecting the furnishings and fittings: marble tables, *verde antico* and *giallo di Porto Venere*; Genoese damask furniture and Gobelin tapestry; large pictures for the gallery. Staff, too, was accumulating. Theophilus Shelton was appointed chaplain in January 1715, though he had as yet no chapel. A small body of Chelsea pensioners was taken on as

5*

watchmen at a salary of £12 a man and an allowance for coal and strong beer. Before the music room was complete, the orchestra was formed.[36] In April 1718 Chandos dismissed Haynes, the bass, and tried to steal a hautboy player from Baron Keilmansegg. In that same year, though the house was unfinished, the domestic establishment numbered eighty-three.

Nor were the park and the gardens forgotten. Richard Bradley, a botanist, had charge of a hot-house and a medicinal garden. Grass seed was ordered from Aleppo, lucerne seed from France, and evergreen oaks from Hammersmith. From Jamaica came the exotic fruits—pawpaw, star apples, guavas and tamarinds; cherry trees were brought from Barbados. And suitable fauna were introduced to decorate the park: ducks and sea-birds from the West Country: storks, pheasants and quail from Holland; tortoises from Minorca; wild geese and flamingoes from the West Indies. Later came greater rarities—ostriches, parakeets, macaws, an eagle and a small Whydah deer. No wonder that the view of Cannons pleased Defoe so much; he thought it equal to the finest house in England:

> so Beautiful in its Situation, so Lofty, so Majestick the Appearance of it, that a Pen can but ill describe it, and Pencil not much better; 'tis only fit to be talk'd of upon the very Spot, when the Building is under View, to be consider'd in all its Parts.[37]

The inventory of 1725 valued the ornamental parts of the grounds—the ironwork, the *jet d'eau*, the avenues, lodges, pleasure gardens, etc.—at £28,000.

The park and gardens at Cannons were impressive; but the real pride of the house was the embellishment of the interior where ceilings were painted by Thornhill, Symms and Kent, Bellucci, Laguerre, Francisco, Roberto and Grisoni. When Chandos chose Apollo and the Muses as the theme for Thornhill's painting in the saloon, he claimed no more than his due. His generosity to the arts had proved Cannons to be under the rule of Apollo. And to bring home the point, Chandos had Apollo and the Arts painted in other rooms as well—by Bellucci in the library and by Grisoni in a dressing room. Bellucci painted besides, a *Judgment of Paris*, *Time and Fortune*, both in dressing rooms, and the *Ascension* and *Nativity* in the chapel. Six apartments were painted by Laguerre, one by Roberto, two by Francisco,[38] including *Love and Marriage* in the best bedroom; Francisco also designed the stained glass in the chapel. And when his apartments were decorated, Chandos filled them with treasures. The Inventory of 1725 listed, in the saloon, 'Four fine chartoons representing the Creation by Raphel', valued at £700. 'Stephen Stoned'—Grinling Gibbons' carving of St. Stephen—was valued at £200. With St. Stephen in

the library were paintings by Andrea del Sarto, Luca Giordano, Fiamingo, Rubens, Vandyck, Van de Velde, Lely and Kneller.[39] The library itself was well and comprehensively stocked, for Chandos's agents sought him out books as well as paintings, and he paid generously for both.

For most rich men, to be a patron of architects, painters and authors would be enough. But Chandos was always thorough, and Cannons, famous for its decoration and its art, was even more famous for its music. The band numbered perhaps thirty; Swift thought that his 'friend the D. of Chandos' employed at least twenty-four.[40] Dr. Johann Pepusch was the director, at a salary of £100 a year; this was rather more than Chandos paid Dr. Baxter, his librarian and chaplain in 1720. The director's duties were exacting. He was copyist, repairer, music librarian and teacher, besides composer and performer. But Cannons had such excellent facilities and good players, Pepusch was content to stay there for about fifteen years.[41]

Chandos, despite his vast expenses, was a naturally prudent man, and he expected value from his musicians. They performed both in the house and in chapel, and some of them combined playing an instrument with attendance on the duke. Chandos sent Gherardo—'one of my Musick'— abroad with his son in 1721. 'He shaves very well & hath an excellent hand on the violin, & all necessary languages.'[42] Tetlow, the duke's personal valet, was also a violinist; in 1736 Chandos recommended him to the Chamberlain for a place in the King's Musick. At other times, young boys were taken into service and their voices carefully prepared for future employment in the music. The Cannons establishment was in fact a small musical academy. The performers had the very best instruments. There were two organs—one in the chapel and one at St. Lawrence's. In 1720 J. C. Bach was paid £572 for a harpsichord, and another small one was bought from Holland for £52. Pepusch's Catalogue of Instruments for the same year gives harpsichords by Ruckers and Hermanus Tabel, a spinet, a bass, a cello and several violins. On these instruments the masters in the music gave their lessons. Pepusch was a master; Francesco Scarlatti, brother of Alessandro, possibly was another and Handel was a third. Chandos noted the extraordinarily good progress made by George Monroe, one of his pages, under the finest instruction in London:

> he hath been so successful in his improvement under Mr Handell & Dr. Pepusch that he is become, though young, a perfect master both for composition & performance on the organ & harpsichord.[43]

Cannon's music is best known for the connection with Handel. Sometime in 1717 Handel took up residence at Cannons, for by September of that year Chandos was writing to Dr. Arbuthnot that 'Mr Handle has

made me two new Anthems very noble ones & most think they far exceed the two first. He is at work for 2 more & some Overtures to be plaied before the first lesson.'[44] Handel was employed at Cannons as a composer, for Pepusch was still director of the music. The chief fruits of his two quiet years at Cannons were the *Chandos Anthems*; he also composed during this period the *Suite de Pièces pour le Clavecin*. To a man of Handel's ambition and powers, the years at Cannons were perhaps too quiet. He was an independent soul and the position of domestic musician was not to his taste. When the Royal Academy of Music beckoned from London Handel hurried back to the risks and triumphs of an operatic composer. But he was not without honour at Cannons. In the list of music compiled in 1720, which shows the wide range of performance available at Cannons, Handel's works are well represented. There were by him fourteen anthems, a cantata, the masque *O the pleasure of the plain*, the score of the opera *Amadigi*, songs from *Rinaldo*, birthday music for Queen Anne, a sonata, a *Te Deum* and *Jubilate*.[45] Tradition has it that the music for the opening of Cannons chapel, on September 29, 1720, was *Haman and Mordecai*, later altered into the oratorio *Esther*, with a text partly prepared by Pope.

Cannons has received a bad reputation. Word went round that Pope used it as the model for Timon's Villa in the *Epistle to Burlington*. Though Pope claimed, and opinion now agrees, that Timon's Villa was a composite portrait with a large part of Blenheim in it, there was enough similarity between Cannons and Pope's example of a 'false Taste of Magnificence' to give life to the rumours. For Chandos's taste was uncertain, and his profuse outpouring of money achieved not very much of artistic value.

> Not for himself he sees, or hears, or eats;
> Artists must choose his Pictures, Music, Meats:[46]

His agents found him pictures, sometimes of dubious quality, and he paid dearly for them. With his habitual easy generosity, he was kind to authors, and nearly always subscribed to the editions of his acquaintances. He took five sets of Burnet's *History*, and four of Theobald's *Shakespeare* on royal paper. He treated Gay very handsomely, taking in 1720 no less than fifty copies of *Poems on Several Occasions*. Yet such was the reputation of Chandos, Gay was sure the town would misconstrue the act:

> If *Chandois* with a lib'ral hand bestow,
> Censure imputes it all to pomp and show.[47]

Despite the attention of so many famous architects, Cannons, the house,

was not a great success. The drawing of the east front made by Price in 1720 shows a careful composition of the type that Pope satirized:

> Conscious they act a true Palladian part.
> And, if they starve, they starve by rules of art.[48]

The park, the gardens, the house, the decoration, were all grand enough, as Defoe testified; but the magnificence was disappointing, the quality often not the best.

The prodigious expenditure of a Chandos, or a Bubb Dodington at Eastbury, guaranteed no triumphs. To be supported without sympathy becomes a servitude for the artist as bad as any other. James Thomson found life with Dodington at Eastbury 'far from that divine freedom, that independent life that the Muses love'. It was not for this that he had left off the study of divinity in Scotland. The age was a commercial one; the patronage followed after the profits:

> I look upon Avarice and Prodigality in the Society as I do upon two contrary Poisons in Physick, of which it is certain that the noxious Qualities being by mutual Mischief corrected in both, they may assist each other, and often make a good Medicine between them.[49]

But riches have 'in effect/ No grace of Heav'n or token of th'Elect'.[50] Sharing the ideals of the society that he had helped to form, by political service and propaganda, the artist had raised himself up to a man of affairs and business. He now watched anxiously to see if men of affairs and business would condescend to become true lovers of art rather than purchasers of magnificence. Fortunately, the first half of the eighteenth century produced a few aristocrats who combined prodigality with discrimination.

For a long time the ruling passion of the aristocracy had been politics; for too long political motives had governed a large part of artistic patronage. After the accession of the Hanoverians, and the beginning of Sir Robert Walpole's long ministry, the Whigs were secure in office, and nobles whose political ambitions were now finally realized or shattered could turn at last to the arts with a disinterested appreciation. The great patrons of the first half of the eighteenth century were men for whom politics had little to offer. Tories like Bathurst and Edward, Earl of Oxford, were excluded from office by the long Whig reign. Pembroke was a Whig, but his ancient lineage and rugged eccentricity made him unamenable to party discipline; and Burlington, though in general a supporter of Whig ideals, was completely indifferent to politics.

Following the age's enthusiasm, all these lords were great builders.

Pembroke and Burlington were themselves architects, the influence of the latter being very widespread; and even Bathurst may have designed his house at Cirencester. A large part of a patron's fortune was likely to be devoured by building ventures. Saws and hammers, Bathurst wrote to Pope from Cirencester, were 'apt to melt money sometimes'. Burlington spent £18,749. 8s. 8d. in 1720 merely for alterations to his old house at Chiswick. Swift commented on the financial difficulties of Henrietta Howard, for whom Pembroke built Marble Hill:

> My house was built but for a show
> My lady's empty pockets know;[51]

Edward Harley, Earl of Oxford, was so generally improvident, it is hard to know whether books or architecture consumed the most. Pope wrote of the 'mad good-nature' and 'bounty misapply'd'[52] at Wimpole Hall. Harley's expenditure on his Cambridgeshire home surely helped him towards the bankruptcy he suffered in 1738.

This enthusiastic expenditure was very encouraging for poor architects. William Kent had first met Lord Burlington in Rome at the end of 1714. In 1719 they went off together on a Palladian pilgrimage to Italy, with a missionary zeal to find for England the true taste and introduce 'a better gusto, than that damned gusto that's been for this sixty years past'.[53] When they returned to England Kent was installed in his own apartments at Burlington House and there he stayed for the rest of his life, a jovial, irreverent, hard-drinking appendage to the delicate and sophisticated earl. He was the beloved 'Kentino' whose pranks were nearly always forgiven, and whose career the earl promoted remorselessly. Before Kent became an architect, he was the society decorator, the darling of the *beau monde*:

> so impetuous was fashion, that two great ladies prevailed on him to make designs for their birthday-gowns. The one dressed in a petticoat decorated with columns of the five orders; the other like a bronze in a copper-coloured satin with ornaments of gold.[54]

Roger Morris was another whose career was intimately linked with that of his architect-patron. The buildings on which he and Lord Pembroke worked are sometimes credited to one and sometimes to the other; perhaps it is impossible to say where one left off and the other started. Morris began as a carpenter and ended as surveyor and architect. He was Pembroke's clerk of works and provided, no doubt, the practical building knowledge that the lordly amateur lacked.

As a love of painting often goes with a love of architecture, it is not surprising to find that the aristocrats who built were also collectors of

pictures and friends to painters. Pembroke and his friend, Sir Andrew
Fountaine, published a small book on the paintings and statues at Wilton.
Pembroke took an interest in the Academy of Painting run by Vander-
bank; he gave work to Vertue, Ellis, Foudrinier and 'the little French
painter' Clermont. He commissioned a bust in marble of Fountaine from
Roubiliac for £30, and a statue of Shakespeare from Scheemakers, which
cost £100. 18s. 4½d. Harley, the ever-generous, delighted in the company
of Thornhill, Dahl, the portrait painter, and Wootton, the painter of
animals. Thornhill decorated the chapel that Gibbs had built for Harley
at Wimpole; Dahl painted the earl and his wife, and Wootton painted
their horses. Vertue was so much a friend he was invited more than once
to accompany Harley on a country tour. Between them there was a
touching relationship. When the earl gave Vertue an onyx seal with the
head of Socrates on it, the humble engraver, not to be outdone in friend-
ship, replied with a gift of candlesticks and a silver coffee-pot. Vertue was
anxious that Harley's favours to artists should not go unrecorded. In his
valuable notes on painters he mentions the help given to Dahl and
Wootton, to Rysbrack, Bird, Seal and Zincke. Burlington was an even
more dedicated friend to painters. Vertue called him the 'noble Maecenas
of Arts', a title which he well deserved. Charles Jervas, portrait painter,
friend and teacher of Pope, accompanied Burlington on the first foreign
tour, and William Kent accompanied the second. On the first journey to
Italy, the rich young nobleman had bought well and expensively. In Rome
he paid 300 crowns for a *Temptation of St Anthony* after Carracci, 75
crowns for a Madonna by Pascoline and 210 for another by Maratta. He
bought the *Madonna della Rosa* by Domenichino from the nuns of
S. Maria della Vittoria for no less than 1,500 crowns. He also presented
the convent church with a set of marble columns. When he came back to
London, he bought with him the Italian sculptor Giovanni Guelfi who
was given rooms at Burlington House.

There was at the time another important guest living in Burlington
House. Handel had moved in within a year of his return to England,
and stayed for some three years. In 1714 Handel's opera *Silla* was per-
formed on the private stage at Burlington House. In May of the next year
Heidegger, in the dedication to *Amadigi di Gaula*, recalled the special
debt both opera and Handel owed to Burlington:

> My Duty and Gratitude oblige me to give this Publick Testimony of that
> Generous Concern Your Lordship has always shown for the promoting of
> Theatrical Musick, but this Opera more immediately claims Your Protection,
> as it is compos'd in Your own Family. . . .[55]

Indeed, the earl's enthusiasm for opera was to cause Handel future trouble; for it was Burlington who invited Bononcini to England, and so indirectly began the bitter rivalry which lasted between the composers as long as Bononcini stayed in London. But Handel appeared to have nothing but respect and gratitude for the earl, even though he left for Cannons in 1717. In 1719, when he was visiting Dresden looking for singers for the Royal Academy of Music, Handel wrote in the most complimentary terms to Burlington (who was, of course, a heavy subscriber to the Academy):

> I have good hopes, and as soon as I have concluded something definite, I shall inform you of it, my Lord, as my benefactor and patron. Pray continue, my Lord, your favours; they will be precious to me, and shall always exert myself in your service to carry out you commands with zeal and fidelity.[56]

Burlington supported music all his life. On his first foreign tour he had purchased two harpsichords and a bass viol in Paris. He brought back not only the sculptor Guelfi, but also Pietro Castrucci, a violinist, who became the leader of Handel's operatic band. Burlington's wife, Dorothy Savile, was as keen on music as was her husband. She was a neat caricaturist, and left some sharp drawings of the soprano Cuzzoni, fat and wide, and the castrato Farinelli, elongated and haughty. She gave a dowry to the dancer Violetti who married Garrick in 1749, and entered energetically into the rivalry between Cuzzoni and Faustina. She hissed Cuzzoni, Lady Pembroke jeered at Faustina; the two noblewomen insulted each other across the theatre while the singers pulled each other's hair on stage.

John Gay has left a pleasant picture of Lord Burlington as a universal provider:

> Yet *Burlington's* fair Palace still remains;
> Beauty within, without Proportion reigns.
> Beneath his Eye declining Art revives,
> The Wall with animated Picture lives;
> There *Hendel* strikes the Strings, the melting Strain
> Transports the Soul, and thrills through ev'ry Vein;
> There oft' I enter (but with cleaner Shoes)
> For *Burlington's* belov'd by ev'ry Muse.[57]

Gay, who for a time lived as one of Burlington's several artistic pensioners, had every reason for gratitude. And many other writers of the age received both help and flattering attention from the aristocrats. But there was between noble and writer an undefined relationship. 'He began in the Queen's time to be my patron,' Swift wrote of Lord Bolingbroke, 'and then condescended to be my friend.' By their political service and their

Choral and instrumental members of the King's musical establishment in a coronation procession

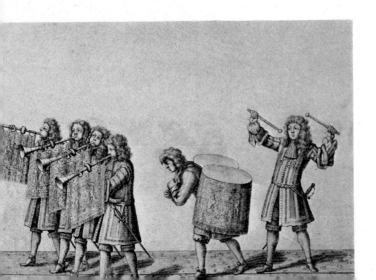

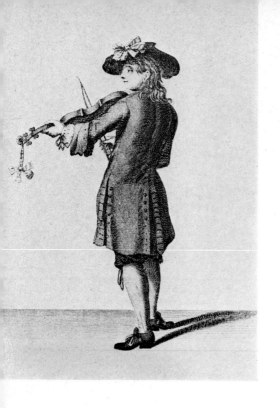

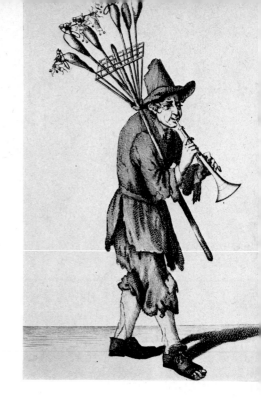

London street musicians

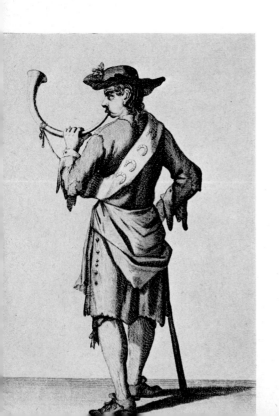

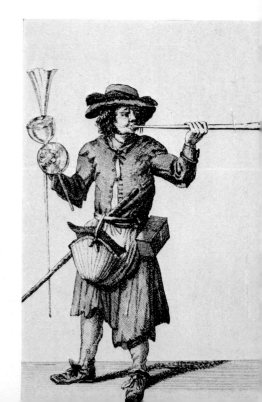

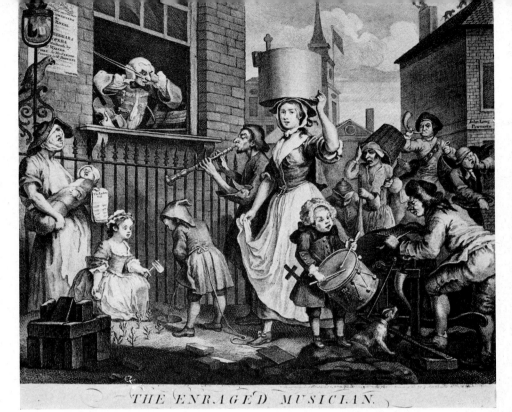

THE ENRAGED MUSICIAN.

The distraught musician is Castrucci, first violin of Handel's operatic band. The *Oratorio* was the subscription ticket for *A Midnight Modern Conversation* and represents the chorus rehearsing Handel's *Judith*

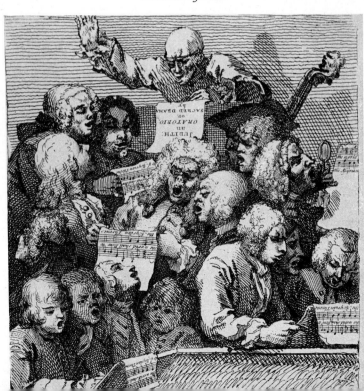

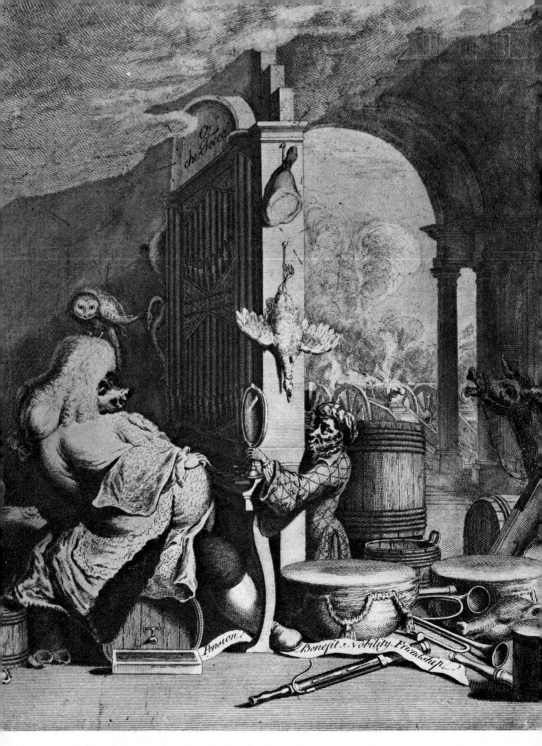

Handel was notoriously fond of good living. The scroll *Pension,*
etc. alludes to the patronage the composer enjoyed

sense of social responsibility authors had won the attention of the great; but differences in rank and wealth had the inevitable unsettling effect. An author aspired to the friendship of the great, but very often he also needed their support. The poet who was amenable, giddy, carefree and a buffoon, like John Gay, could rely on the aristocracy to set him back on his feet after every stumble. But if a man had a sense of the dignity and independence of the poet, as Pope had, he took a little gall with every act of aristocratic condescension. No artist received more attention from the great than Pope; yet none worried more about money. This was the penalty for trying to keep both his aristocratic friends and his own self-respect.

Authors less fastidious than Pope found the help of the aristocracy invaluable; a weak vessel like Gay might not have survived without it. He started in the service of the Duchess of Monmouth, and from there he was passed hand to hand until he ended his days in the household of the Duke and Duchess of Queensberry. 'The duke,' wrote Johnson, 'considering his want of economy, undertook the management of his money, and gave it to him as he wanted it.'[58] When Gay was sick, his noble protectors sent him to the country; when he was despondent, they made him cheerful; when he had nowhere to stay, he was given room at Burlington House, at Marble Hill with Lady Suffolk, or at Lord Lincoln's in Whitehall; when he was poor, his friends saw him provided for. The subscription for his *Poems*, in 1720, was quickly taken up and raised him £1,000. In the same year he received as a present some South Sea stock. At the thought of his potential riches he had delusions of grandeur, and consequently when the stock crashed he was so miserably dejected he had to be nursed back to physical and financial health once more by his solicitous friends. When *The Beggar's Opera* annoyed both the court and Walpole's ministry, Lady Suffolk and the Duchess of Queensberry shielded him from official displeasure. At his death, he left £6,000, the results of Queensberry's prudent economic management. 'Your head is your best friend,' the Countess of Suffolk once wrote to him; 'it would clothe, lodge and wash you; but you neglect it, and follow that false friend, your heart.'[59] But as distinguished ladies were attracted to this soft and wayward heart, there was no reason for Gay to bother his head unduly.

Matthew Prior was another whose worldly misfortunes were eased by aristocratic kindness. He had made a career in diplomacy until he was unseated by the brutality of party politics. For his share in arranging the Treaty of Utrecht he was made to suffer; when Robert Harley fell, Prior

fell too, and spent some time in prison. On his release, his friends, with Lord Edward Harley chief among them, looked after his welfare. A folio edition of his poems was brought out, with Harley, Bathurst, Arbuthnot and Swift actively chasing subscriptions. The profit came to over £3,000, which Lord Bathurst invested for the poet, and to which Harley added an equal sum allowing Prior to buy Down Hall for his old age. He died at Wimpole, in 1721, at the Earl of Oxford's house.

The noble patrons of the first half of the eighteenth century served literature generously. Their liberality and interest appeared unending. 'This Nobleman,' Pope noted of the second Earl of Oxford, 'died regretted by all men of letters, great numbers of whom had experienc'd his benefits.'[60] Gay, frank and open-hearted, cordially approved of Harley's similar nature:

> *Harley*, whose goodness opens in his Face,
> And shows his Heart the Seat where Virtue stays.[61]

In a letter to Lord Bathurst, Pope admitted his debt:

> You cannot know how much I love you and how gratefully I recollect all the good and obligation I owe to you for so many years. I really depend on no man so much in all my little distresses, or wish to live and share with no man so much in any joys or pleasures. I think myself a poor unsupported, weak individual, without you.[62]

Pope had for Harley an almost equal affection, looking on him as 'my way to moral virtue'. Burlington's library, under the gallery at Chiswick, contained the works of his literary friends. He left standing orders with Tonson and Lintot to send new volumes as soon as they were published. The library of Harley was justly famous, for book collecting was the passion of his life on which he squandered most of his huge fortune. Pope called it 'one of the most noble Libraries in Europe'.[63]

With the decline of royal patronage—only Queen Caroline retained a sense of the duty owed by the Crown to the arts—artists found some consolation in the attentions of the aristocracy. But the more thoughtful men, like Pope, were worried for the future. Pope saw, and pointed out in the two Epistles *To Bathurst* and *To Burlington* on the Use of Riches, that an enduring patronage depended on a community of interest between artist and aristocrat. Pope did all he could to encourage the formation of taste in rich men; but to find this taste in nobles was not a normal expectation; men of wealth and power have many claims on their attention, and the artist, once a friend and colleague, soon sinks to the position of sycophant or beggar:

Who starves by Nobles, or with Nobles eats?
The Wretch that trusts them, and the Rogue that cheats.
Is there a Lord, who knows a cheerful noon
Without a Fiddler, Flatt'rer, or Buffoon?[64]

Aristocratic ambitions veer with the wind, but what remains constant in them is the wish for influence and reputation. A King may continue to support the arts, though he has no interest in them, because patronage was a role the monarchy traditionally undertook. But unless an aristocrat had a passion for the arts, he gave nothing, especially if artistic talents and friends carried no social weight and added nothing to reputation. Artistic aptitudes may even appear disfiguring to high personages. Lord Chesterfield thought 'the minute and mechanical parts' of architecture best left to masons, bricklayers, and Lord Burlington, 'who has to a certain degree, lessened himself by knowing them too well'.[65] If patronage persisted among the aristocrats, it did so chiefly for fashion's sake; they 'keep a bard, just as they keep a whore'.[66]

The poor arts laid their service at the heavy and oppressive feet of an aristocracy dulled by power and pride and wealth; and inevitably dulled also by attendance at the leaden Hanoverian Court. 'Great Patron of Mankind!' Pope wrote with irony of George II, 'born to bring Saturnian times', who allowed Cibber to be made laureate while Gay died unpensioned, Swift languished in Ireland, and Pope drudged ten years at commentary and translation. Britannia slept under the Sovereign of Dulness—'Still Dunce the second reigns like Dunce the first'.[67]

POLITICS AND THE STATE

The Moral Virtues are the Political Offspring which Flattery begot upon Pride.

Mandeville, *Fable of the Bees*: *An Enquiry into the Origin of Moral Virtue.*

IN THE REIGN of Charles II artists had become recruits to the wars of politics. By the time of the Glorious Revolution the arts had their recognized place in the political scheme; for twenty-five years and more after 1688, as in no other period, any enquiry into a man's art must take some account of his relation to the party struggles of the Whigs and Tories.

No party compelled the allegiance of the arts, but some strong considerations persuaded artists to invest themselves in the plain drugget of political and public service. After the Revolution there was a good income to be gained from political patronage. But money, though important, was not the main cause, for artists then were hardly more venal than in other ages. What weighed most with them was a sense of their own importance as rational and articulate men—the epithet *articulate* being in this context exactly right—which drove them to speak out: rhetoric in the service of reason to establish right government. 'I saw a Parcel of People,' Defoe wrote in the *Review*, 'caballing together to ruin Property, corrupt the Laws, invade the Government, debauch the People, and in short, enslave and embroil the Nation; and *I cry'd Fire.*'[1] Affairs of state were a general pre-occupation. The opposing principles concerned all ranks of society, and those with similar views came together in a loose confederation including the professional politicians and various groups of fellow-travellers among whom the artists found a place. The political philosophies of Hobbes and Locke had assured the citizens of England that they were parties to a social contract; they had a right to consider the terms and conditions of their participation. If politicians took the arts into employment, and if artists took good money for their political service, both were merely declaring a common interest and doing their best for their principles. Such at least was the ideal theory as set out by Steele in a dedication to the great Whig patron, Charles Montague, Earl of Halifax:

Your patronage has produced those arts, which before shunned the commerce of the world, into the service of life; and 'tis to you we owe that the man of wit has turned himself to be a man of business.[2]

The material rewards for the wit turned man of business appeared to be very satisfactory. Positions were found for him, most being sinecures, though a few demanded administrative talent; the salaries and pensions were paid reasonably promptly. Montague himself had first come to notice through the poem he wrote with Prior satirizing Dryden's *The Hind and the Panther*. Montague deserted poetry for the prosperous deities of politics and finance, but Prior combined the serious vocation of a poet with a career in affairs. In 1690 he was appointed Secretary to the Ambassador at the Hague; in 1697 he was Secretary to the Embassy at the Treaty of Ryswick, and in the next year Secretary to Lord Portland in Paris. In 1700 he became a Commissioner for Trade and Plantations, and in 1701 entered Parliament representing East Grinstead. He undertook the preliminary arrangements for the Treaty of Utrecht, and received in 1712, to crown his diplomacy, the Embassy to France. He returned in 1715, was impeached by the new administration and sent to the Tower for two years.

Men of the arts were soon jostling in the ante-rooms to preferment. Addison was sought out by Montague, now Baron Halifax and still ascending, and enrolled for the Whig cause. A pension of £300 persuaded Addison to leave his Oxford Fellowship and travel in Europe for his political education. After a leisurely four years abroad, he returned to find his patron temporarily eclipsed and out of office. But the grand victory at Blenheim allowed both poet and patron to re-establish their political credit. For his panegyric *The Campaign* Addison was made a Commissioner of Appeals in the Excise; soon he became Under Secretary of State, first to Hedges, a Tory, and then to Sunderland, a Whig. When Sunderland went, Addison moved easily on. He was appointed Secretary to the Earl of Wharton, Lord-Lieutenant of Ireland; he became also Keeper of the Irish Records and a Member in the Irish Parliament. Steele was more agressively Whig than mild Addison and had appropriate rewards. He collected a profitable rag-bag of positions—editor of the official *Gazette*, Commissioner of Stamps, Governor of the Royal Comedians, Deputy Lieutenant of Middlesex, Surveyor of the Royal Stables, and Commissioner for Forfeited Estates. He was also knighted. In the early days of political patronage, active propaganda was not demanded. Congreve was pre-eminently a gentleman who might rise to a small panegyric; but he had talent and was respectful to Whiggish views. In 1693, *The Old*

Bachelor recommended him to Montague who 'putt him into the Commission for hackney coaches'.[3] He then became in succession Customer at Poole, a Wine Licenser, Undersearcher of Customs at the Port of London, Secretary to Jamaica, and held a post in the Pipe Office.

The Tories, less frequently in office than the Whigs, had fewer opportunities to give out sinecures. But Harley and Bolingbroke were as eager to promote artists to the Tory cause as Halifax and Somers were to the Whig. Minor poets such as John Philips and Granville were smiled on. Granville, emulating the Whig Halifax, became more politician than poet, rising from M.P. to Secretary at War, being elevated to the peerage as Lord Lansdowne, becoming Comptroller and then Treasurer to the Queen's Household and finally a Privy Counseller. Arbuthnot, doctor and man of letters, was the Physician to Queen Anne.[4] Defoe, in his varied political career, was for a time taken up and employed by Harley. In 1703, Harley found him in gaol, as a consequence of writing *The Shortest Way with Dissenters*, 'much oppress'd in his mind with his usage' but 'willing to serve the Queen'.[5] Harley had him released from Newgate, helped to set him up as editor of the *Review*, and ran him as a government agent in the north. When Harley headed the ministry in 1710, Defoe's previous service was remembered. He was employed once more on discreet business, preparing the evidence, for example, which would unseat Steele in the House of Commons; he was an invaluable deviser of party tactics and strategems. He was also—to be on the safe side—in correspondence with the Whigs.

Of all the Tory writers, Swift deserved most, though his irreverent and intractable character prevented him from receiving most. In the *Examiner* he was the foremost Tory propagandist. He was also a kind of Tory impresario, searching out talent and mediating between the ministry and the writers, even the dejected Whigs. 'I have now had almost all the Whig poets my solicitors,' he wrote to Stella in June 1711; 'and I have been useful to Congreve, Steele and Harrison.'[6] Eighteen months later he related the services he had given:

> Steele I have kept in his place, Congreve I have got used kindly, and secured. Rowe I have recommended and got a promise of a place. Philips I could certainly have provided for, if he had not run party mad, and made me withdraw my recommendation; and I set Addison so right at first that he might have been employed, and have partly secured him the place he has.[7]

Swift helped Parnell to see his way to joining the Tories. He saw to it that Mrs. Manley, whose anti-Whig *New Atalantis* had pleased him in 1709, took over as editor of the *Examiner* in 1711. He even secured a brief

appointment for his hopelessly impractical friend John Gay, appointed for a short summer Secretary to Lord Clarendon.

These were some of the greater writers in political employment. But political parties are not known to be the most discriminating or fastidious judges of art; the rolls of placeholders contained many lesser names where loyalty or importunity outweighed talent. Among these ranks may be numbered such men as the laureates Tate, Rowe and Eusden, also the well-forgotten names of Hughes, Maynwaring, Tickell, Edmund Smith, Budgell and Ambrose Philips.

A ministry's first interest was in writers, for words make the best propaganda; as the writers were the most useful they made the most profit. The ideal, however, was to incorporate all arts and sciences into rational government. John Locke became a Commissioner for Trade, a tactful recognition for his part in formulating the Whig philosophy, insisting on the importance of commerce. Isaac Newton was made Director of the Mint. And party patronage naturally extended to architecture and the places in the Office of Works. Having designed Castle Howard for the Earl of Carlisle, Vanbrugh had the Comptrollership secured for him by the same Whig patron in 1702; 'Van's genius, without thought or lecture,' wrote Swift, 'Is hugely turn'd to architecture.'[8] Carlisle had other favours to grant; in 1703, against the serious protests of old Gregory King, Lancaster Herald and statistician, Carlisle appointed Vanbrugh the Clarenceux King of Arms, though the playwright still regarded heraldry as the ridiculous science that he had mocked six years before in his play *Aesop*. But the profits were attractive and the badge was a pretty thing to be worn on formal occasions; he wears it in the portrait by Kneller painted for the Kit-Cat club. After Blenheim, Marlborough selected Vanbrugh as the architect for his great house. Vanbrugh was doubly recommended by his feeling for the monumental and by his Whig connections. Later, Vanbrugh felt the vagaries of political fortune; for what one party could do, the other could undo. In 1713 the Tories deprived him of his office, though he came back with the Whigs in the next year. In 1718, by which time he had proved himself the logical man to take over from Wren, he was passed over for the Surveyorship. William Benson, a minor Whig man of letters and M.P. for Shaftesbury, had put former connections with the Electoral Court of Hanover to good use. When Wren was deprived of his post, George I was pleased to let Benson succeed him.

The income provided by official positions allowed the artist to live in a very decent style. The career of Congreve, who did little for the Whigs

except lend them his name and reputation, illustrates the kind of financial benefit to be won by men of wit. From 1694 to 1705 he was Commissioner for Hackney Coaches at £100 per annum. From 1700 to 1703, the Customs at Poole brought him £48 a year—or £28 if he used a deputy, which he naturally did. The post of Wine Licenser, which he held from 1705 to 1714, paid £200 a year, and when that ceased he stepped immediately into the much more valuable post of Secretary to Jamaica, which paid no less than £780 a year, and which he held (by deputy) from December 1714 until his death. In this last period of his life he also had a small payment of £12 per annum from the London Customs, and possibly a minor salary from the Pipe Office, though there are no records of payments.[9] For those more actively engaged in politics, the rewards were greater. Steele, though often short of money and sometimes in debt, received in his lifetime large sums for political service. A contemporary computed Steele's income to be about £2,000 a year, which seems a close estimate.[10] In 1714 he made £2,000 for *The Crisis*, received £1,000 as his annual share due to a Governor of the Theatre, and had various payments from the secret service money.[11] Addison did even better. At the height of his prosperity, after he became Secretary of State in 1717, he had an income of some £10,000 a year, which included a salary of £1,850, a secret service payment of £3,000, board wages of £730, and an allowance of 1,013 ounces of silver plate valued at £337. 17s. On March 19, 1718, he was given a retirement pension of £1,600 a year.[12] That other writers received pleasantly large amounts is certain, though a virulent partisanship makes some of the estimates unlikely. Defoe was said to be 'adored and caress'd' by Harley, 'who gave him, as that Mercenary said himself, to the value of £1,000 in one year.'[13] The usually unreliable John Dunton asserted that Swift had £1,000 a year for the *Examiner* from Harley's ministry.[14]

The wooing of the writers, dubious from the start, soon lost any purity of motive it had once possessed. Walpole put the matter into perspective; when he laid out money on a writer he expected, and got, a hack propagandist. Between 1731 and 1741 he spent £50,000 from the secret service funds on writers and printers, and had, said Swift, 'none but beasts and blockheads for his penmen'. Arnall, one of the chief among them, is said to have received £11,000 in four years, and retired on £400 a year. What had begun hopefully as the patronage of literature finally succeeded in promoting nothing more than the grey, stale productions of a ministry of information.

The expectation of what men were supposed to perform for their money varied. A few, like Congreve or Vanbrugh, merely lent the prestige

of their names and reputations; others, like Defoe or Swift, earned their incomes by hard labour. In general, the requirements became stricter and more narrow as the eighteenth century advanced. A gentlemanly adhesion to the correct political philosophy and good social and artistic connections had been sufficient in King William's time; workers for the party were welcome, but the occasional small panegyric kept one in good official standing. Gradually the parties demanded more drudgery, more lip-service more sycophancy; by the time of Walpole the pretence that the artist had a place in rational government, as the creator of order, was quietly abandoned.

Politics proposed a marriage to the arts, but could not keep the terms. What should have been a partnership became an enslavement. The ideal dreamt of disinterested men pursuing a rational society; the practice saw parties paying to preserve their power, artists being only hirelings to their ambitions. Numerous subtle inducements drew the men of the arts into this bondage. Many became place-hunters in the hope of money and success. Having gained their easy and profitable berths, they were apprehensive of hard times and trimmed accordingly. Cases like that of Edward Young were not rare. In 1713 he wrote an *Epistle* to the Tory Lord Lansdowne, full of the sweetest flattery; in the next year, with the coming of George I, Young discovered that he was a confirmed Whig and the good servant of the Whig Duke of Wharton, from whom he later received £2,000 for his *Universal Passion*. Swift has related how Whigs such as Congreve and Steele were quite anxious to come to terms with Harley's Tory ministry in 1710. Self interest was recognized as a very natural element in the make-up of a rational man; the tincture of Hobbes coloured Augustan thought. 'Nature directs every one of us,' Swift began his sermon *On Doing Good*, 'and God permits us, to consult our own private Good before the private Good of any other person whatsoever.' Moreover, the man of wit was now become the man of business; he made a kind of contract with his patron to grant the benefits of his muse; when the patron could no longer pay, the muse was withdrawn. Swift certainly felt that he was under no debt to Sir William Temple for the years he spent at Moor Park;

> But I hope you will not charge my living in his family as an obligation, for I was educated to little purpose, if I retired to his house, on any other motives than the benefit of his conversation and advice, and the opportunity of pursuing my studies. For, being born to no fortune, I was at his death as far to seek as ever, and perhaps you will allow that I was of some use to him.[15]

Many well-known names changed, or sought to change, their political

allegiance. Among the notable, or notorious, who succeeded are Prior, Defoe, Swift, Parnell and Young. All were ambitious men. Prior saw Montague, his collaborator in *City Mouse and Country Mouse*, getting on while he stagnated:

> My friend Charles Montague's preferred,
> Nor would I have it long observed,
> That one mouse eats while t'other's starved.[16]

The self-seeking element appeared in him as it did, more obviously, in Young. Swift made a sudden jump for reasons that are not easily decipherable. In 1710 he brought out an edition of *A Tale of a Tub* dedicated to Lord Somers, the great Whig. Before the end of the year he published *A Short Character* of Lord Wharton, a brutal attack on one of Somer's colleagues in the Whig Junto. The barren honour of a sinecure will not explain these shifts; nor, entirely, will venality. Something was looked for which had to do with politics, in so far as politics concerns government and social order, but which lay beyond party squabbles. They sought a truth which seemed at times to be partly in the Whigs and at other times partly in the Tories, but which neither perceived very steadily or for long. 'I remember a curious piece written on the character of a Trimmer,' wrote Defoe of his much admired Marquis of Halifax, 'in which a Trimmer was justly proved to be much better than either Whig or Tory, since he was biased by nothing but the public good, and inclined either to the Whigs or to the Tories as they pursued that end.'[17]

Defoe desired a superman, victorious but upright, to safeguard the 'public good'. He thought he had found his hero in William III, 'the late Glorious Monarch', who was not only a soldier but also 'of serious Piety and Religion, as few Kings in the World in these latter Ages of Time can come up to'.[18] William was thrown from his horse and died within two weeks, leaving Defoe heroless. He later thought he saw great qualities reflected in Harley, and even, later still, in that surprising duo George II and Walpole; but William was his first and best hero. Others had a certain vision of England, strong, beneficent, disinterested in war, but ardent for peace; and they addressed their panegyrics to the party that seemed to bring England closest to their ideal. William, and afterwards Anne, were much praised by the Whig writers as the champions of liberty, whose arms crushed tyrants and established impartial justice in Europe. William, said Prior, was 'the hero perfect in the king';

> Imperious arms by manly reason swayed,
> And power supreme by free consent obeyed.
> With how much haste his mercy meets his foes,
> And how unbounded his forgiveness flows;[19]

In Congreve's *Pindarique Ode* of 1706, the Queen—

> Has all her peace and downy rest resign'd
> To wake for common good, and succour human kind.
> Fly, Tyranny; no more be known
> Within Europe's blissful bound.
>
>
>
> Again Astraea reigns!
> Anna her equal scale maintains,
> And Marlborough wields her sure-deciding sword.

And Addison's *Campaign* is equally effusive on the supposed benevolence of Marlborough's victories:

> Marlborough's exploits appear divinely bright,
> And proudly shine in their own borrowed light:

All this martial ardour was in the cause of liberty; the service of this goddess distinguished England from other European nations superficially more attractive:

> Thee, goddess, thee Britannia's isle adores,
> How has she oft exhausted all her stores,
> How oft in fields of death thy presence sought,
> Nor thinks the mighty prize too dearly bought.
>
>
>
> 'Tis Liberty that crowns Britannia's isle,
> And makes her barren rocks and her bleak mountains smile.[20]

The virtue of war was the prerogative of the Whigs; the Tories were more inclined to sing the blessings of peace. Even Pope, the careful non-partisan, was persuaded by Lord Lansdowne to celebrate the coming peace. In 1713, he recast *Windsor Forest* into a poem in praise of the Treaty of Utrecht, the Tories and Queen Anne, and against the war, the Whigs and foreign dynasties:

> And peace and plenty tell, a Stuart reigns.

Party hatreds soured human relations, caused much rancour and spite. But England's well-being and her rising importance in Europe was the leavening of life which the poets celebrated. And since England's new strength grew out of the political struggles after the Restoration, political thought was the natural study for all who wished to see England maintain her prosperity and place. All society, in the early eighteenth century, concerned itself with the alternatives of policy. Though a man might have no strong allegiance to the Whig or Tory party, he often found that he was making friends and spending his leisure with men of similar

'political' views. Clubs, coffee-houses, associations—institutions with interests far removed from party politics—were known to be Whig or Tory inclined, and attracted members accordingly. Whig or Tory was more than a party label; it denoted a social and philosophical brotherhood, loose and open perhaps, but permeating the life of the time. As the artist was a man in society, he could not avoid society's favourite preoccupation. As he was a man with a living to earn, he found himself inevitably affected by 'political' views; for the predominating political philosophies had their opinions on art too, and artistic ventures were frequently begun or supported by Whig and Tory associations. Whiggism and Toryism, in the large and general sense, had become important elements in artistic patronage.

The most famous social and political group of the early eighteenth century was the Kit-Cat Club, a collection of eminent Whigs, who first met in the tavern of Christopher Cat, near Temple Bar, and took the name of their club from mutton pies baked by the landlord and called 'Kit-Cats' in his honour. The club was formed shortly before the turn of the century, and seemed to have grown out of the literary group which surrounded Jacob Tonson, the well-known publisher. An early mention of the club was in connection with the funeral of John Dryden, Tonson's chief poet. When Dryden died in May 1700, the club was 'at the charge of his funeral which was not great'[21]—£45. 17s. to be exact. Tonson was the guiding spirit of the club through all the quarter century of its influence; at his house in Barn Elms he set aside a special room for the Kit-Cats. If in its early days the association had been a casual meeting of literary men in which a notorious Tory like Dryden had a place, it soon became a much grander affair devoted to Whig principles, and included among its members the greatest Whigs in the land—the Dukes of Newcastle, Somerset, Devonshire, Manchester, Dorset and Montagu; the Earls of Lincoln, Bath, Wilmington, Carbery, Carlisle, Berkeley and Halifax; Stanhope, Godolphin, Cornwallis and Somers; Viscount Cobham and Sir Robert Walpole; even the great Duke of Marlborough entered into the deliberations of the club. Here, in the words of a satiric attack, was 'A Club that gave Direction to the State'.[22] If a young man of artistic ability could summon up the slightest Whig sympathies, the Kit-Cat Club was his goal; for here were his patrons ready provided, well-disposed, influential and often prodigal.

The connection between the club and the arts existed from the first. The club began, says a poem attributed to Blackmore, as an astute venture by Tonson who gathered up the writers made poor by William's lack

of concern for the arts, soothed them and put them to work in the interests of his publishing house:

> He still caress'd the unregarded Tribe
> And did to all their various Tasks prescribe
> From whence to both great Acquisition came,
> To him the Profit, and to them the Fame.[23]

When Ned Ward published his *Secret History of the Clubs* in 1709, he confirmed that Tonson, 'Chief Merchant to the Muses', had 'a sharp eye towards his own interest, having riggled himself into the company of a parcel of Poetical young sprigs, who had just wean'd themselves from their Mother University'. 'Finding that Pies to Poets were as agreeable Food as Ambrosia to the Gods', Tonson supported them:

> provided they would do him the Honour to let him have the Refusal of all their Juvenile Products, which generous proposal was readily agreed to by the whole Poetick clan.[24]

The association of writers and publisher in the club was of mutual benefit. Tonson's presses were available for the works of his fellow Kit-Cats; Congreve, Addison, Steele, Vanbrugh, Walsh, Garth and Stepney all had their pieces published by Tonson. And Tonson had the benefit of his friends' discrimination in artistic matters, and trusted them to search out new talent for him:

> For Men of Wit do Men of Wit inspire,
> And emulation strikes out nobler Fire.[25]

Seeing a pastoral of Pope's in the hands of Mr. Walsh and Mr. Congreve, Tonson hastily approached the rising star:

> If you design your poem for the press, no person shall be more careful in printing it, nor no one can give a greater encouragement to it than, sir, your, &c/Jacob Tonson.[26]

Ovid's Epistles, brought out by Tonson in 1712, contained Pope's version of *Sappho to Phaon*. Other works followed; the relationship prospered, then ran into difficulties over the *Iliad*, which Tonson did not publish, and came to a more fortunate culmination in the edition of Shakespeare which Tonson brought out in six quarto volumes in 1725.

The unfriendly satire, *Faction Display'd*, sneered at Tonson's tyrannous position:

> 'I am the Touchstone of all Modern Wit,
> Without my Stamp in vain your Poets write.
> Those only purchase ever-living Fame,
> That in my Miscellany plant their name.'

Though the great publisher was a Whig, and the fortunate authors in the Kit-Cat Club got every consideration, he was too much a man of business, and too concerned with literary matters, to be over-persuaded by politics. He eagerly took up Pope who was Tory by inclination and apolitical by conviction. He continued to publish works by Prior long after the poet turned Tory.[27] And Tonson's fellow club-members did not allow their fundamental Whiggishness to interrupt their steady support of art of every kind. The theatre was a favourite interest, as one would expect of a group that included Congreve, Vanbrugh, Addison and Steele. 'Tomorrow night Betterton acts Falstaff,' Prior wrote in January 1700, 'and to encourage that poor house the Kit-Katters have taken one side box, and the Knights of the Toast have taken the other.'[28] Pope told Spence that in 1709 he had seen a memorandum in Halifax's own writing, stating that the Kit-Cats had subscribed 400 guineas to encourage good comedies. Their enthusiasm even went so far, it had persuaded them to build a theatre of their own. The Queen's Theatre, which opened in the Haymarket on April 9, 1705, was designed and built by Vanbrugh, and paid for by the contributions of his fellow club-members. The Tory press, no doubt shaken by this bold incursion into artistic patronage, attempted to undermine the Whig venture by suggesting devious political connections:

> The KIT-CAT *Clubb* is now grown *Famous* and *Notorious* all over the *Kingdom* And they have Built a *Temple* for their *Dagon*, the new *Play-House* in the *Hay-Market*. The *Foundation* was laid with great *Solemnity*, by a *Noble* Babe of *Grace*. And over or under the *Foundation Stone* is a *Plate* of *Silver*, on which is Graven *Kit Cat* on the one side, and *Little Whigg* on the other.[29]

The patentees of the theatre were Congreve and Vanbrugh—the obvious choices from the Kit-Cat Club; in January 1706 Vanbrugh's *Mistake* was playing with Betterton and Booth in the company. Soon, however, the management decided to go over to Italian opera, recently made popular by Clayton's efforts at Drury Lane. The *Temple of Love* was the first and unsuccessful attempt. The music by the German, Greber, was not very Italian, and it had to compete with the atrocious acoustics of Vanbrugh's building. But the management persevered and even won the applause of the opposition. D'Urfey, a changeable fellow but generally a Tory, in 1706 dedicated his comic opera, *The Kingdom of the Birds*:

> To the Right Noble, Honourable and Ingenious Patrons of *Poetry*, *Musick* &c., The *Celebrated* Society of the *Kit-Cat-Club*.

The theatre built by the Kit-Cats in the Haymarket became the cradle and forcing-ground for the Italian opera in England. The success of this

music was not immediately ensured. For some years the actors and the singers took turn and turn about in the theatre. The operas were at first given in English, with English singers; but the arrival of the castrato Nicolini in 1708, to sing in Scarlatti's *Pyrrhus and Demetrius*, paved the way for the final triumph of Italian words and foreign singers. That triumph was not long delayed. Aaron Hill, the new manager at the Haymarket, had planned improvements in his theatre designed to show off the opera to spectacular advantage. When the renowned composer George Frederic Handel arrived in England at the end of 1710, Hill at once invited him to compose an opera for his theatre. The result was *Rinaldo*, knocked together with impressive speed with a libretto by Rossi out of Tasso, and first presented on February 24, 1711. The reception was enthusiastic; the opera remained in the run until the end of the season, being repeated fifteen times in all. Handel's reputation was made as a dramatic composer, and the Haymarket was established as the home of opera.

The genius of Handel, the voices of Nicolini, Valentini and Boschi, and the business sense of Hill and Heidegger made the Italian opera successful. But the taste which the opera served was fostered in clubs like the Kit-Cat, and the club members provided the subscriptions on which the opera lived. Not all the Kit-Catters liked the new fashion. Addison and Steele both attacked the Italian opera in the *Spectator*. But it was known that Addison was piqued by the failure of *Rosamond*, his English opera set to Clayton's dull tunes; and Steele's financial interests suffered from the opera; he was a patentee of an acting company, and had let the York Buildings concert room to Handel's rival musicians.[30] The attitude of Addison and Steele was not typical of the Kit-Cats. When, later, the opera floundered through jealousies and muddle, the Kit-Cat lords subscribed heavily to set it up again. Though the Royal Academy of Music, the body formed in 1719 to promote opera, drew on a general aristocratic support that went beyond party affiliations, the Whig lords of the Kit-Cat Club were very prominent in the affairs of the Academy. The Duke of Newcastle, the Lord Chamberlain, was the Governor, and Grafton, Manchester, Berkeley, Burlington and Lincoln were among the subscribers.[31] And the Kit-Cat members still kept their connection with the Haymarket. Tom Brown had portrayed Tonson satirically as the doorkeeper to the theatre. Vanbrugh, the designer, builder and patentee, received the rent from the management; as late as 1719 he was complaining to Tonson of 'hard labour' and 'cruel difficultys' caused by the theatre.[32]

The interests of an educated gentleman were presumed to extend to all

the arts. The patronage of the Kit-Cat Club embraced painting and architecture as well as literature and music. Sir Godfrey Kneller, the chief painter of the age, was a foreigner, and thus excused from party warfare; at his town-house in Great Queen Street and at Whitton in the country he was on genial terms with all men of wit, with the Whigs Congreve, Addison and Steele and with the Tories Swift, Arbuthnot, Gay and Pope. But as a German he naturally inclined towards the supporters of the Hanoverians, and as an inordinately ambitious and over-proud painter he naturally liked the Whigs, for they were the men most often in power. He soon came to the attention of the Kit-Cat Club. Early in the eighteenth century, Tonson, encouraged by the Duke of Somerset, engaged Kneller to paint the members of the club, the portraits to hang in the meeting room at Barn Elms. The execution of this order occupied Kneller, on and off, for the next fifteen years. Although he was never elected a member, his commission kept him always close, and the club had an unrivalled opportunity to see what a fantastical, vain, talented, slap-dash painter he was. 'In short, the Kit-Cat wants you much more than you ever can do them,' Vanbrugh wrote to Tonson:

> Those who remain in towne, are in great desire of waiting on you at Barne-Elmes; not that they have finished their pictures neither; tho' to excuse them (as well as myself), Sr Godfrey has been most in fault. The fool has got a country house near Hampton Court, and is so busy about fitting it up (to receive nobody), that there is no getting him to work.[33].

Later, Tonson tried to hasten things along with gifts of wine and venison; then there were stories of the publisher withholding payment, and the painter turning the work over to assistants in retaliation. But the completed series ranks among Kneller's best work and gives an exceptional glimpse into the character of the age. The great Whig lords stare out of their canvases—a stock size, 36 × 28 inches, since known as a 'kit-cat'—with the easy confidence of their position and wealth, notwithstanding the brutal ugliness of some of them. The literary gentlemen strike negligent poses, Vanbrugh rather casual, Congreve very elegant, and Steele hefty and four-square with a touch of humour in his face. The whole presents an image of the ruling oligarchy, cheerful and self-satisfied, with a little coarseness in the lips and insensitivity behind the eyes.

The Kit-Cat Club employed Kneller; the rich painter returned the compliment by commissioning Vanbrugh to design Whitton Hall, his house at Hounslow. For with Vanbrugh in the club, the members could not forget architecture. Nicholas Rowe, in his pleasant imitation of Horace, has Tonson addressing Congreve:

I'm in with captain Vanburgh, at the present,
A most *sweet-natur'd* gentleman, and pleasant;
He writes your comedies, draws schemes, and models,
And builds dukes' homes upon very odd hills:'[34]

In the club Vanbrugh found the best advocates for his design, and his best patrons. Carlisle and Halifax helped him into the Office of Works, stood by him when the Tories evicted him, and brought him back triumphantly with George I, with the added title of Surveyor of the Gardens and Waters. For the members of the club he executed some of his best projects—Castle Howard for Carlisle, Kimbolton remodelled for Manchester, Claremont vastly expanded for Newcastle, and the gardens at Stowe laid out for Lord Cobham. Vanbrugh was lucky to find in the Kit-Cat Club men who admired the monumental grandeur of his buildings. The great Whig lords in the club were men of an older generation, supporters of the Glorious Revolution, with a robust appreciation for a massive style. The Palladian taste of the younger Whigs of the eighteenth century found Vanbrugh's designs over-bearing and vulgar. He was forgotten as the fame of Burlington and Kent grew. Vanbrugh seized the fortunate moment. His unlikely genius hit off exactly the aspirations of successful revolutionaries. The support of the Kit-Cat Club was an essential element in the strange, alchemical transformation of dramatist into architect.

The Kit-Cat, though the most famous of the clubs, had no monopoly among the wits. The Tories came together in the Brothers Club, founded in 1711, where lords such as Harley and Bolingbroke met, dined, and planned perdition to the Whigs with writers like Swift, Arbuthnot, Gay and Pope. The political aims of the Brothers were frankly recognized; the club specialized in pamphlets and political squibs; contributions were collected from the members for the support of struggling writers likely to be useful to the Tory party. But Tory hopes were already lost in the labyrinthine uncertainties of their policy. Before the death of Queen Anne, the wits of the Brothers Club were driven to disgust or dispair by active politics; they turned their attention to literary matters, satiric and critical, and formed the Scriblerus Club out of the older association of the Brothers.

> The design of the Memoirs of Scriblerus was to have ridiculed all the false tastes in learning, under the character of a man of capacity enough; that had dipped into every art and science, but injudiciously in each.[35]

Such was Pope's account of the club to Spence, set down many years after. The leaders now were Swift, Arbuthnot, Gay and Pope, with the the addition of Parnell, a late recruit from the Whigs. The Scriblerus

meetings lasted two years only, the club dying with the Queen in 1714. The light-hearted mood and witty irreverence were hard to carry on after the fall of the Tory ministry, Harley's imprisonment, the flight of Bolingbroke and Swift's return to Ireland. But the association between the Scriblereans had remarkable fruit. The club confirmed and encouraged the satiric talents of its members, and gave birth to such sprightly pieces as *Three Hours after Marriage, God's Revenge against Punning,* and Pope's *Peri Bathous: or the Art of Sinking in Poetry.* These, however, were the delightful shafts of the hour; the profound influence of the club only appeared years later, in *Gulliver's Travels* (1726), the *Dunciad* (1728), and the *Memoirs of Martinus Scriblerus* (1741).

Whatever services the clubs gave to the arts, their patronage was never disinterested, for no one could forget their political bias. The Kit-Cats were Whigs, the Brothers were Tories. Button's coffee-house was Whig, and there Addison presided over his 'little Senate'; Will's coffee-house was Tory. The rancour of partisanship entered into the life of the clubs. The Tory *Examiner,* damning Garth's panegyric *To the Earl of Godolphin,* saw it as a typical and poisonous effusion from the Kit-Cat Club:

> The Collective Body of the Whigs have already engrossed our Riches; and their Representatives, the *Kit-Cat* have pretended to make a Monopoly of our sense. Thus it happens, that Mr. P[rior], by being expelled the Club, ceases to be a Poet; and Sir Harry F[urness] becomes one, by being admitted into it. 'Tis here that Wit and Beauty are decided by Plurality of Voices.[36]

The considerations of an artist's politics affected judgments on his performance. Writers allied themselves with the parties out of conviction, pride and greed. But painters and architects also wore political labels. Jervas was a fervent Whig, Kneller was a Whig favourite; Thornhill and Dahl consorted chiefly with the Tories. Vanbrugh and Archer, Burlington and Kent, were Whig designers; James Gibbs was a Tory.[37] The accepted intimacy between politics and the arts appears very clearly in a letter from Bolingbroke, outlining to Lord Orrery the intentions of the Brothers:

> We shall begin to meet in a small number, and that will be composed of some who have wit and learning to recommend them; of others who, from their own situations, or from their relations, have power and influence. . . . The improvement of friendship, and the encouragement of letters, are to be the two great ends of our society. A number of valuable people will be kept in the same mind, and others will be made converts to their opinions.
>
> Mr. Fenton, and those who, like him, have genius, will have a corporation of patrons to protect and advance them in the world. The folly of our party will be ridiculed and checked; the opposition of another will be better resisted.[38]

Nearly every man of the arts, eager to find himself in Mr. Fenton's advantageous position, looked for notice and help from the political

parties. The great exception was Pope, who, always priding himself on his independence, wrote towards the end of his life:

> I take myself to be the only scribbler of my time, of any degree of distinction, who never received any places from the Establishment, any pension from the Court, or any presents from a Ministry. I desire to preserve this honour untainted to my grave.[39]

His Catholicism and his friendships with Swift and Arbuthnot, Harley and Bolingbroke, Bathurst and Edward Harley, inclined him to a moderate Toryism; but he asserted the right to stand apart from politics, earning his living in the public market, and 'ambitious of nothing but the good opinion of all good men on both sides'. How difficult it was to earn this good opinion! He encountered:

> much malignity on the score of religion, some calling me a papist and a tory, the latter because the heads of the party have been distinguishingly favourable to me. ... Others have styled me a whig, because I have been honoured with Mr. Addison's good word and Mr. Jervas' good deed, and of late with my Lord Halifax's patronage.[40]

He continued with a lament that was soon echoed by other men of, first-rate abilities:

> This miserable age is so sunk between animosities of party and those of religion that I begin to fear most men have politics enough to make the best scheme of government a bad one, through their extremity of violence, and faith enough to hinder their salvation.[41]

In the *Essay on Man* he gave his opinion on party politics:

> For Forms of Government let fools contest;
> Whate'er is best administer'd is best:[42]

and he condemned the expense of talent for political ends as a waste of ability, and irrelevant to art. 'Let us,' he told Swift, 'write for truth, for honour, and for posterity.'[43]

To add to an artist's disgust, the practical disadvantages of political patronage soon appeared. 'I thank God,' Pope wrote at the death of Queen Anne, 'that, as for myself, I am below all the accidents of state changes by my circumstances, and above them by my philosophy.'[44] Others however had to look to their posts. Swift noted the distress of Whigs like Congreve, Steele and Rowe when the Tories came to office in 1711. No doubt he had an ironic appreciation, for he had been chasing political favour ever since the appearance of his *Discourse of the Contests and Dissensions between the Nobles and the Commons in Athens and Rome* in 1701. The Whigs Somers and Halifax had taken notice and promised certain rewards; the years passed, Swift remained in his quiet Irish parish awaiting a preferment

which never came. With customary indignation he wrote in a book borrowed from Halifax:

> Given me by my Lord Halifax, May 3, 1709. I begged it of him, and desired him to remember, *it was the only favour I ever received from him or his party.*[45]

The *Tale of a Tub* had hurt his chances of ecclesiastical preferment; the Whigs, relying on the support of the Dissenters, were not disposed to worry too much about Church of England affairs. With the change of government his prospects improved; and so it happened generally with other men of the arts, some falling from positions and others rising into them. The commission to build Blenheim should, by right and reputation, have gone to Wren, the Queen's Surveyor; it went to the almost untried Vanbrugh. 'I suppose my Lord you made choice of him because he is a professed Whig,' said Lord Ailesbury, who perceived exactly the principle of artistic judgment at work; and he added the pleasant comment: 'It was at my tongue's end for to add that he ought as well to have made Sir Christopher Wren, Poet Laureate.'[46] Wren suffered further for his inoffensive, mild Tory views. In 1718 he was deprived of his place for the incompetent Whig, Benson. In the business of place-hunting, the Whigs had a great advantage: in the business of artistic production, the Tories were the gainers. Since the Tories were so long out of office, the Tory artist could forget the party jungle and concentrate on the artistic task in hand. The superiority of Tories such as Swift, Pope and Gay over Whigs such as Addison, Steele and Rowe is partly a matter of talent, and partly a matter of greater attention to artistic ends and less diffusion of energy on politics and affairs.

For the twists of political favour very often governed what was produced. In 1711, the new Tory ministry, to accommodate their many High Church supporters, introduced an Act for the building of fifty new churches, chiefly in the spreading suburbs of London. Only twelve of these churches were built, as the Tories did not remain long in power, and the Whigs, when they returned, once more failed to press forward Church affairs. But the Commission began briskly with a report from Wren, clear and concise, on the type of church to be built, and another from Vanbrugh arguing, characteristically, for impressive sites, for grand and massive construction. Hawksmoor was appointed Surveyor to the Commission at a salary of £200; a little later he was joined by James Gibbs. Hawksmoor continued in his post until his death, twenty-five years later, and built his churches at a leisurely pace; the first two, St. Anne, Limehouse, and St. Alphege, Greenwich, were begun in 1712, and the last, Christ Church, Spitalfields, was finished in 1729. But Gibbs, the

unfashionable student of Fontana and a Scots Tory, had time only for the highly interesting St. Mary-le-Strand before the Whigs were back in power and he was dismissed from his Surveyorship.

The troubles of Gibbs were not unexpected. His ability could not overcome his Toryism. But Vanbrugh, fortune's darling and a Whig, ran into unusual political difficulties at Blenheim. First of all, he engaged in a long feud with the Duchess of Marlborough, an implacable and wearying opponent who did not at all like his designs. Then, the initial warrant to build had been extremely vague as to the cost and the responsibility for payments. Sums were to be handed to the duke from time to time, as expenses were incurred. This seemed satisfactory, for who could believe, in 1705, that the duke might fall from favour, or that the country would stint the gift to him? In 1705 the estimate for the building had been £100,000; by 1711, twice this sum was already spent.[47] Vanbrugh's extravagance was another prick to the duchess's anger. He defended himself manfully:

> There is not one part of it, that I don't weight and Consider a hundred times, before 'tis put in Execution, And this with two ends, one of trying to do it better, And tother of giving it some other turn that may be as well and yet Come Cheaper.[48]

He daily 'hit upon things, that have Spar'd great Sums of Money', for he regarded Blenheim 'with ye tenderness of a sort of Child of my Owne'. But the inconceivable had happened; the duke had fallen from grace, the duchess had lost her influence with the Queen, and the Tories had come to power. On June 1, 1712, by the Queen's command, work on Blenheim stopped indefinitely.

It commenced again, of course, on the accession of George I. Marlborough, the old hero, came back, and Vanbrugh, who idolized the general, was the first man knighted by the new king. The architect was back at Blenheim, still under the suspicions of the duchess who could never forgive his designs, his expenditure, and his failure to complete the house in good time. The final rupture came in 1716. Vanbrugh had acted the unsuccessful go-between in the marriage plans that the duchess had hatched for her granddaughter. The duchess drew up an indictment of her architect, blaming him for all the ills at Blenheim for the last eleven years. Unprotected by the sick and paralysed duke, Vanbrugh turned his back on his greatest building, resigned his commission. He recognized his defeat as a political one. The afflictions that battered the duke, his house and his architect rose out of political causes, though the duchess would not see it. He enlightened her with bitter and unusual insolence:

I shall in the mean time have only this Concern on his account (for whom I shall ever retain the greatest Veneration) That your Grace having like the Queen thought fit to get rid of a faithfull servant, The Torys will have the pleasure to see your Glassmaker, Moor, make just such an end of the Dukes Building as her Minister Harley did of his Victories for which it was erected.[49]

She had just engineered a Tory victory.

Even music, the most amiable and impartial of the arts, suffered from the baleful influence of party dissension. Handel was the acknowledged master throughout the first half of the eighteenth century. A foreigner, awkward and rough, struggling with English all his life, he was quite without political passion. His interests were his music and his own prosperity. But he was an opera composer, and opera was the toy of an aristocracy split by party feeling. When the Royal Academy of Music was formed in 1719, it seemed as if all enmities were reconciled by the love of opera. The King was at the head of the list of subscribers. The Whigs, as the dominant party, provided the largest sums; Newcastle, Chandos and Burlington each contributed £1,000; but not for party ostentation, for Chandos was done with politics and Burlington was never interested. In the list of subscribers a ferocious Whig such as the Earl of Sunderland appeared alongside strong Tories like Bathurst and Lansdowne. The amity was short-lived. Soon factions grew up within the Academy, not always developing on strict party lines, but having to do with intrigues at court and the aristocratic pursuit of reputation and power. In 1720, Bononcini arrived in England at Burlington's invitation. The winter season opened on November 19 with Bononcini's *Astarto*. Handel's *Radamisto* was then revived, but the popular vote went to Bononcini's easy and unremarkable talent.

The academy was divided between the rival composers. Bononcini was taken up by Marlborough's daughter, the new duchess, who gave him a pension of £500 a year, and used him to entertain the fashionable world. Worse troubles were ahead. The jealousies of the singers Faustina and Cuzzoni completely split the already estranged members of the Academy. On June 6, 1727, urged on by hissing and shouting admirers, the *prima donnas* came to blows in Bononcini's *Astyanax*, before an audience that included the Princess of Wales. The old party divisions were forgotten, said one satire; the question was, are you for Faustina or Cuzzoni, Handel or Bononcini? In the winter, Mrs. Pendarves, Handel's friend, feared the opera would die.[50] She was right; on June 1, 1728, the Royal Academy of Music came to an end. The death was hastened by the first performance of *The Beggar's Opera* on January 29, 1728, which thrust the sharp knife of satire into the expiring body of the academy.

The accession of George II and his musical Queen Caroline gave some hope for a re-organized opera. Towards the end of 1728 Handel formed a new company with Heidegger, leasing the Haymarket for five years. The new venture opened on December 2, 1729, with Handel's *Lothario*. For some time matters ran hardly more smoothly than they had before. Then, in 1733, a dangerous opposition developed. The aristocrats, offended by Handel's tactics and perhaps angry that he should still be operating while their own Academy had failed, began a rival Opera of the Nobility at Lincoln's Inn Fields. And at once party faction entered into this rivalry. The King and Queen remained faithful to Handel. The Prince of Wales, the inveterate enemy of his father, gave some support to the Nobility. The political opponents of Walpole hoped to use the Prince to come to power, and the opera was a means to keep the royal family apart. The next three years were trying and ruinous for Handel. Rich London still could not bear the expense of two operas. Handel wooed the Prince with the flattering *Atalanta*, won him over, and offended the King. There was little that Handel could do. He needed peace and the patronage of the aristocracy for the success of his operas. Political forces beyond his control had determined that he should have neither. He was a victim of a game whose rules he could not understand. The end of this game could only be the ruin of Handel's company, and the end to opera. On June 1, 1737, Handel's opera closed in Covent Garden; ten days later the Opera of the Nobility, then at the Haymarket, also closed.

The alliance between politics and the arts appeared to some to have dazzling advantages. Voltaire, always conscious of the proper dignity of art, and beset by priests and cliques in France, admired the sense of importance enjoyed by his English colleagues. In France, Addison might have matured into a worthy Academy, with a seat in some woman's literary *salon*; in England he became a Secretary of State. Newton controlled the Mint; Prior was a Plenipotentiary, and Swift 'is a Dean in Ireland and is there accounted a much more important person than the Primate'.[51] Englishmen of the late eighteenth century, looking back on the earlier age, saw matters otherwise. Considering music, Dr. Burney thought that disaster came in with the Glorious Revolution:

> During the reign of King William and Queen Mary, the different parties in politics were too much on the *qui vive*? too jealous and apprehensive of the machinations of each other, to bestow much meditation on the arts of peace. And both these sovereigns were personally too indifferent about Music to contribute to its refinement or corruption.[52]

Horace Walpole, writing about English painting in the reign of Queen

Anne, was equally sure of politics' bad effects. 'Party,' he said, 'that sharpened the genius of the age, dishonoured it too—a halfpenny print of Sacheverel would have been preferred to a sketch of Raphael.'[53] Even the well-being, which Voltaire envied, was precarious. He forgot to add that Prior was sent to prison for his work as a Plenipotentiary, and Swift regarded his days in Ireland as an exile almost as sad as Ovid's by the bleak Euxine sea.

Whether an artist is rich or poor, in prison or the king's ante-chamber, are not the most important questions in the history of art. The judgment of the good or evil influence of politics depends on the effects political patronage had on the man, his thoughts, his desires, and the art he produced. When the political employment was responsible, a man had little time to practice his art. 'I had enough to do,' Prior wrote of his early diplomatic days, 'in studying French and Dutch and altering my Terentian and original style into articles and conventions.'[54] He later complained to Swift of his Commission of the Customs because it spoilt his wit—'He says he dreams of nothing but cockets, and dockets, and drawbacks, and other jargon . . .' At this time, when Harley was in office, Swift himself laboured as a drudge of business: 'I toil like a horse,' he wrote to Stella, 'and have hundreds of letters still to read.'[55] Addison blamed 'multiplicity of Businesse' and his asthma for the delay in answering his letters. Projects of the imagination gave way before the press of affairs. Addison began work on *Cato* before the turn of the century; he did not complete it until 1713, when his Whig patrons were out of office. At the same time, being without political employment, he was able to collaborate with Steele and give birth to the *Spectator*. But as soon as the Whigs returned, Addison abandoned literature from business once more. Between Swift's *Tale of a Tub* and his *Gulliver's Travels* lie twenty-four years; a time spent chiefly in politics, intrigue, and pursuit of the wraith of preferment. What would literature come to, with writers penning more memoranda than verses?

> As for *Comedies*, ther's not great Expectation of any thing of that kind, since Mr. *Farquhar's* Death. The two Gentlemen, who would probably always succeed in the *comick* vein, Mr. *Congreve* and Captain *Steele* having Affairs of much greater Importance to take up their Time and Thoughts.[56]

This lament was true of Steele, as politically busy as Addison. But Congreve presents another case, revealing a different view of the political trap. Though Congreve was a Whig, he was a genial, much-loved person, quite undisturbed by party rancour. The posts he held were sinecures, given out of friendship and appreciation of his wit. The richer he grew, the more indolent he became. As he advanced in esteem, he slowly

stopped writing. Between 1693 and 1695, being as yet unrewarded, he wrote three plays; between 1695 and 1700, and now in possession of one post, he wrote two more; between 1700 and 1714, with the comfortable income from two posts, he wrote two masques and a few occasional pieces; and from 1714 to his death, while enjoying the large salary of Secretary to Jamaica, he wrote nothing of any value at all. Prosperity kept him silent.[57]

An attempt will be made in the final chapter to assess the artistic value of works produced in this political era; to see what reins were placed on the imagination by a variety of social and political considerations; to see how artists, with the applause of society, set themselves to uphold certain moral and social standards, and judged their artistic success according to whether they met these standards or not. But certain other aspects of political patronage may be mentioned here.

The results of political patronage could not be all bad. Besides enriching certain men of the arts, and inducing self-respect—even self-importance —in certain others, this patronage had several respectable triumphs. Baroque architecture, though it grew out of the Royal Office of Works, was promoted and financed chiefly by a small band of the older Whigs whose sense of their historical importance, as the architects of the new English State, was ideally expressed in the powerful grandeur of Vanbrugh's and Hawksmoor's buildings. Indeed, the furious activity in country house construction which possessed the aristocracy at the turn of the century was a manifestation of their confidence and new-found political importance. Political feeling lay behind nearly all the writings of Swift. *The Conduct of the Allies, The Public Spirit of the Whigs, The last Four Years of the Queen* and other powerful works from the troubled years of unsatisfied ambition are clearly political. But the *Tale of a Tub* and *Gulliver's Travels* rehearse his usual political pre-occupations, though his imagination was here freed from the immediate needs of the party. The continuous political argument led also to some admirably clear and forceful prose. 'Plainness,' wrote Defoe, is 'the Perfection of Language.' 'I could give you Similes and Allegories to represent the Case to you,' he went on, 'But I have chose a down-right Plainness, and to speak home both in Fact and in Stile.'[58] Swift, of course, is the master of the style; and an easy plainness marks to some degree works as diverse as Locke's philosophical writings, Shaftesbury's *Characteristics*, the *Tatler* and the *Spectator*, Hervey's *Memoirs of George II*, and William Law's *Serious Call*. The poetic equivalent of the prose plainness was the use of the heroic couplet, which Pope made the perfect vehicle for his thought and his manner.

6*

But a political pre-occupation also expressed itself in less happy ways. Panegyric had always been part of a writer's business, the small coin whereby he pays for favours received or hoped for. William and Mary were naturally quite effusively greeted by many anxious poets after the Revolution; in the following years a normal number of works celebrated a variety of virtues in the sovereign. Important events in contemporary history also received attention, rather more so than they had in the past, for the artist was now very aware of his country's policy and her hopes in the world. Farquhar, Addison and Edmund Smith celebrated the battle of the Boyne. Congreve, Rowe, Addison, Garth, Blackmore, Dennis and John Philips all found something to sing in Marlborough's victories. Hughes and Congreve wrote on the Peace of Ryswick, and Parnell, Pope and Arbuthnot celebrated the Peace of Utrecht. In former ages, panegyrics had relied on outrageous flattery, airy flights of the imagination that were intended to deceive no one; their main purpose was to remind illustrious persons of the existence of a humble writer. Examples of this type were still written, but now, more and more, the writer bound his inspiration to policy, and wrote didactic, prosaic works (though usually in verse) supporting the aims of the state. This was particularly so in the case of the Whigs, for they had clearer aims than the Tories, whose 'policies' were merely collections of conservatism, nostalgia and prejudice.

> Britannia, rise! awake, O fairest Isle,
> From iron sleep! again thy fortunes smile.
> Once more look up, the mighty man behold,
> Whose reign renews the former age of gold.[59]

So Congreve sang at the Peace of Ryswick in 1697, mixing adroitly the old flattery of the King with the new eulogy of state policy. Soon the dull verse of policy was in full flow. Addison's *Campaign*, written at Godolphin's suggestion, was called 'a Gazette in rhyme', and the poet's dogged intention to rehearse 'Britannia's wars' 'In the smooth records of a faithful verse' justified the criticism. Worse was to come. When the wars were finished, the Whig writers let their muse loose on the party's peacetime interests—free trade and commercial prosperity:

> Fearless our merchant now pursues his gain,
> And roams securely o'er the boundless main;[60]

And:

> While I survey the blessings of our isle,
> Her arts triumphant in the royal smile,
> Her public wounds bound up, her credit high,
> Her commerce spreading sails in every sky,[61]

And even more imbecile:

> Is 'merchant' an inglorious name?
> No; fit for Pindar such a theme.[62]

England was 'Great nurse of fruits, of flocks, of commerce', and 'Nurse of merchants, who can purchase crowns! Supreme in commerce'.[63]

The poet as economic and political commentator is a dull and ridiculous fellow. He may even be a danger. Whig and Tory writers alike pressed for war with Spain in 1738. Akenside, Johnson, even Pope, arrayed themselves as men of affairs—the livery they had won many years before—and demanded an end to Walpole's peace. Burke testified to their influence:

> Sir Robert Walpole was forced into the war by the people, who were influenced to this measure by the most leading politicians, by the first orators, and the greatest poets of the time.[64]

At the end, political patronage and the alliance between the arts and politics appeared a destructive chimera—an invitation to bad work for the artist, a cause of unjustifiable pride in the political patron. The presumed community of interest did not exist. The patron congratulated himself on his generosity and urbanity, and judged the art he received on its value as propaganda; the artist, striving to make his work socially responsible, put such weights on his imagination it could hardly rise from the prosaic ground. The best wits perceived this and, angry at their prison that they helped to build, struck out at their gaolers. Charles Montague, Earl of Halifax, most representative (and some would say the best) of political patrons, received bitter strokes from both Swift and Pope. Swift thought his patronage a hollow pretence:

> ... Montague, who claimed the station
> To be Maecenas of the nation,
> For poets open table kept,
> But ne'er considered where they slept:
> Himself as rich as fifty Jews,
> Was easy, though they wanted shoes.[65]

Pope, going deeper, saw an indifference to real artistic values covered by pride and conceit:

> Proud as Apollo on his forked hill,
> Sate full-blown Bufo, puff'd by ev'ry quill;
> Fed with soft Dedication all day long,
> Horace and he went hand in hand in song,
> His library, where busts of Poets dead
> And a true Pindar stood without a head,
> Receiv'd of wits an undistinguished race,
> Who first his judgment ask'd, and then a place.[66]

CHAPTER 8

THE POWER OF THE PEOPLE

That a genius must write for a bookseller or paint for an alderman!
Walpole, *Anecdotes*: Kneller.

THE SIZE, the successes, the despairs of London in the first half of the eighteenth century arose out of trade. According to the conduct of merchants, 'Cities, rise out of nothing, and decay again into Villages'.[1] London swelled so greatly that one observer feared it would not 'feel any want of recruits till there are no people in the country'.[2] The riches that the crowd searched for existed in the capital, and many found them. 'How ordinary is it,' Defoe wrote, 'to see a tradesman go off of the stage, even but from mere shop-keeping, with, from ten to forty thousand pounds estate, to divide among his family?'[3] The poor and the labourer also, did they but realize it, were partakers at the affluent feast. Defoe, unwearied advocate of the virtues of trade, thought that the English poor were 'enabled to live in a posture equal to the middling tradesman in other countries',[4] and that 'the working manufacturing people' made 'better wages of their work, and spend more of the money on their backs and bellies, than in any other country'.[5] Wealth was the true life-blood of kingdoms and towns. It was naturally the 'Support of their People'; it was also, Defoe added, the 'Test of their Power'.[6]

Sudden wealth diffused throughout society creates unusual problems. It became very clear that money by itself does not banish dirt, disease and crime. The poor in London, though often well paid, were still as drunken, as feckless and as exploited as they had ever been. The paradoxical advice of Mandeville, that luxury and expenditure could and should be made to work for the public benefit, was listened to with horror by the conventional moralists. They would rather have cut wages to the bone, so that the working man would not have the means for vice; they thought it better that he should starve rather than be an idle or criminal nuisance. But as the understanding of the economy was beyond most people, so too was the control of it. As long as trade prospered the benefit was felt not only by the great merchants, the bankers and the brokers, but also by the worker and the small tradesman. The middle and the lower ranks of society found an

insistent and imperative voice that was capable of drowning the finer cadences of the gentry. Defoe, who perceived best the workings of the people in the commercial state, in his *Hymn to the Mob* (1715), saluted the appearance of the brazen monster:

> Thou are supream in Peace as well as War,
> All Human Powers thy Great superior Self revere.
> *Princes* make *Speeches, Commons vote,*
> The *Priest* extends his *double-sounding* Throat;
> From the *Leud Press* tis labour'd o're again,
> THY mighty Approbation to obtain.
> When *Froward Lords* make *Long Harangues* of State,
> From thy *Great Suffrage* they receive their *Fate*;
> To they *Great Sentence* they submit,
> And recognise *thy Right* to *Censure* or *Acquit.*

The mob was something the arts could not afford to neglect.

As the feelings of the people were difficult to gauge, and their intervention was sometimes brutal and overwhelming, the first task was to inform, cajole and correct them. After the lapse of the old Licensing Laws, in 1695, extraordinary efforts were made to persuade the public, sometimes for political ends, sometimes in the interest of morality, and often merely for profit. The writers and the presses of England were extremely busy. The legislation of Charles II had limited the number of presses in London to twenty. By 1724 London had no less than seventy printing-houses, and there were another twenty-six in towns outside London.[7] Many of these works were large establishments. In 1725, when Benjamin Franklin was an apprentice printer in London, his master, Watts, employed over forty men in his works near Lincoln's Inn Fields. The mass of paper put out by the presses, much of it political and nearly all of it polemical, was quite the despair of reading men. 'Meantime the pamphlets and half-sheets grow so upon our hands,' Swift wrote in 1710, 'it will very well employ a man every day from morning till night to read them.'[8] His solution, he added, was never to read any. In 1724 London was served by sixteen newspapers—three dailies, seven thrice-weeklies, and six weeklies. Estimates of newspaper circulation varied greatly. An official report to the Treasury in 1705 gave the combined weekly figure of 43,800, with the official *Gazette* having the largest circulation. Six years later, Defoe, writing against a tax on newspapers, estimated the total circulation throughout the country to be some 200,000 a week, though Defoe included in his estimate popular periodicals, like the *Spectator*, the *Examiner* and the *Medley*, which had not existed at an earlier date.[9] The Stamp Tax, introduced in 1712, failed to stop the flow

of reading matter. The circulations remained large; and the number of copies sold gave no real indication of the size of the audience. Newspapers and periodicals were taken in by the coffee-houses and taverns, and were there seen by all the curious. Addison noted the success of the *Spectator*:

> My Publisher tells me, that there are already three thousand of them distributed every day; so that if I allow twenty Readers to every Paper which I look upon as a modest Computation, I may reckon about three-score thousand Disciples in London and Westminster.[10]

In 1729 the coffee-house owners claimed that a single issue of a paper, available on their premises, would be seen by some 20,000 people. They also complained that papers were so numerous they could not possibly take them all in.

The public appetite for print did not stop at newspapers and periodicals. The squibs of controversy, the passionate outcries of prejudice and hate, the calls to honour and justice, the satires and the lampoons, all were furiously devoured. Defoe's *True-Born Englishman*, in defence of William's Dutch standing army, in 1701 went through ten genuine editions and as many pirated ones. The mischievous sermon of Dr. Sacheverell, the famous High Flyer—High Churchman—who helped bring down Queen Anne's Whigs, sold 40,000 copies within a week; and the first sermon after his impeachment and three years' silence sold another 40,000. The Whigs answered in kind. *A Letter to Sir J—— B——*, a pamphlet against Sacheverell, sold 60,000 copies, and *The Modern Fanatick*, a similar effort, went to twelve editions. A more solid polemical work, Swift's *Conduct of the Allies*, sold 2,000 in two days and some 11,000 in two months.[11] To feed this large and not very discriminating consumption was the delight of those 'demi-booksellers' so despised by Roger North. Before the end of the seventeenth century he discovered them at their 'pickpocket work':

> They crack their brains to find out selling subjects, and keep hirelings in garrets, at hard meat, to write and correct by the great; and so puff up an octavo to a sufficient thickness, and there is six shillings current for an hour and a half's reading, and perhaps never to be read or looked upon after.[12]

In the early eighteenth century, with an ever-growing public strongly divided by politics and religion, the tricks and wiles of the demi-booksellers became still more fantastic.

Despite improvements in the education of the poor, a large number among the labourers, servants and small shopmen could not read. At the turn of the century, the Society for the Promotion of Christian Knowledge had set up a number of charity schools; these, and similar

ventures in the country, spread a little light into the working-man's darkness. By the middle of the century Dr. Johnson thought there had been good progress. 'All foreigners remark,' he wrote in the *Idler*, 'that the knowledge of the common people in England is greater than that of any other vulgar.'[13] But reading was never the favourite diversion of the mob. Driven from their lodgings by fearsome overcrowding, and in search of strong and simple pleasures, they swarmed in the public places and settled in the taverns, which they made the centre of their social life:

> Until lately, all the amusements of the working people of the metropolis were immediately connected with drinking—chair-clubs, chanting-clubs, lottery-clubs, and every variety of club, intended for amusement were always held at public-houses. In these clubs every possible excitement to produce excess was contrived.[14]

Music, dancing and spectacle were naturally popular to those whose working days were unremitting toil amid the bleakest surroundings. Their taste in these matters was something to take account of; for as they had money to spend, there was a profit to be made from their pleasures.

The stage had always been the particular mirror of society.

> The stage but echoes back the public voice;
> The drama's laws, the drama's patrons give;
> For we that live to please, must please to live.[15]

The Restoration drama of the wits, which reflected the licentious ways of Charles's courtiers, gradually gave way before the attacks on 'immorality and profaneness' instituted by Collier, Defoe, Addison and Steele, and there rose up instead a drama full of middle-class virtues, respectable and sentimental. There also came into the London theatres, pressed on by the newly-assertive public voice, a succession of farces, pantomimes, dumb-shows and other simple representations. The number of London theatres increased from two to five within a few years, subsisting largely on this diet of nonsense. In 1729, Goodman's Fields Theatre opened in East London, in the heart of the working-man's town. The simple fare put on to attract the common people did not please the higher intelligences, and they attacked it both morally and aesthetically.

The connection between theatres and vice had been a favourite demonstration for over a hundred years. Theatres breed brothels and drinking-dens. The conjunction of a playhouse with the popular and well-established Goodman's Fields New Wells was considered an extreme danger to the labourer's sobriety and industry. 'Plays, interludes, and other disorders,' the justices found, 'were open to all persons to enter gratis;' and once in, 'wine, punch, ale, and spirituous liquors' were sold

'at exorbitant prices'.[16] Sir John Hawkins wondered how it was 'that no sooner is a play-house opened in any part of the kingdom, than it at once becomes surrounded by a halo of brothels'; and he cited the evidence of Goodman's Fields where, to his own knowledge, a certain parish spent £1,300 in prosecutions to remove the whores and other undesirables drawn by the playhouse 'for instruction in human life'.[17] These moralists among the gentry were over-severe on the working-men in Goodman's Fields; for the more respectable theatre of Cibber and Booth, in Drury Lane, was also wreathed by brothels. At the opening of Vanbrugh's Theatre in the Haymarket, in 1705, Defoe saluted it as a monument to vice raised upon filth:

> A *Lay-stall* this, *Apollo* spoke the Word,
> And straight arose a *Playhouse* from a T – – –.
> Here *Whores* in *Hogstyes*, Vilely blended lay,
> Just as in *Boxes*, at our *Lewder Play*;[18]

The aesthetic criticism, which came from all sides—from Dennis, Fielding and Pope, to name the most articulate—condemned these stage-shows as barren affairs of roaring sound and irrelevant spectacle. The demands of a new and vulgar audience, wrote Dennis, had been 'Instrumental in introducing Sound and Show, where the business of the Theatre does not require it'; the result was a delight 'independent of Reason, a delight that has gone a very great way towards the enervating and dissolving their minds'.[19] Pope launched his satire in the *Dunciad* against Cibber, the actor-manager of Drury Lane, who brought 'The Smithfield Muses to the ear of Kings'. Pope's footnote explained the grounds for his contempt:

> *Smithfield* is the place where Bartholomew Fair was kept, whose shews, machines and dramatical entertainments, formerly agreeable only to the taste of the Rabble, were, by the Hero of this poem and others of equal genius, brought to the Theatres of Covent-garden, Lincolns-inn-fields, and the Hay-market, to be the reigning pleasures of the Court and Town. This happened in the Reigns of King George I. and II.[20]

The Author's Farce by Fielding, taking suggestions from the first versions of the *Dunciad*, gave the two Cibbers, Colley and Theophilus, some hard satiric knocks. And Pope, when he recast the *Dunciad* making Cibber the hero, no doubt had Fielding's play in mind. Luckless, the Author in Fielding's *Farce*, having had his proper drama repulsed by both theatrical manager and bookseller, decides to present a puppet-show, for 'what have been all the playhouses a long while but puppet-shows?'[21] Jack-Pudding announces the author's intention to the Mob:

This is to give notice to all gentlemen, ladies, and others, that at the Theatre Royal in Drury Lane, this evening, will be performed the whole puppet-show called the Pleasures of the Town; in which will be shown the whole court of nonsense, with abundance of singing, dancing, and several other entertainments: —Also the comical and diverting humours of Somebody and Nobody; Punch and his wife Joan, to be performed by figures; some of them six foot high. God save the King.[22]

If only he had added tumbling, fire-eating and vaulting on the horse he would have had the complete entertainment; for truly, as the Poet explains in the 'Pleasures of the Town', the fashionable had taken over the common man's past-times: 'My lord mayor has shortened the time of Bartholomew Fair in Smithfield, and so they are resolved to keep it all the year round at the other end of the town.'[23] The appetite for this farcical stuff explains the success of the French acting-company which came to London regularly between 1718 and 1727, and less regularly between 1727 and the Licensing Act of ten years later. The company brought Molière and Corneille, but that was only to give their acting some credit; for their staple they wisely relied on acrobatics and dancing, mimes and farces and pieces from the *Commedia dell' Arte*.[24]

The effect of the mob on music is harder to judge. Music in the tavern seemed as popular as ever; and music was to be heard in public and open spaces—at the pleasure gardens of Vauxhall, Ranelagh, Marylebone and Cupers, at the Wells of Richmond, Hampstead, Sadler's and Goodman's Fields. Musical societies attached themselves to taverns; one of the most famous, the Academy of Antient Musick, met at the Crown & Anchor in the Strand from 1710 to 1792. Other societies met at the Castle in Paternoster Row, the Swan in Cornhill, the Globe, and the Greyhound, in Fleet Street, and the Devil Tavern at Temple Bar. These were merely grand examples of the working-man's 'chant-club', mentioned by Francis Place, which met in local and unrecorded taverns throughout London.

Details of the performance at these obscure musical occasions are hard to find. But it appears that the taste for novelty and knockabout variety seen in the contemporary theatre was also felt in the musical offerings. The theatres themselves presented musical intermezzi, along with the tight-rope walkers, dancers and acrobats. And many of the recitals in the respectable concert-rooms were in the nature of musical stunts. Performances on extraordinary instruments were advertised. The dubious qualities of the Great Theorbo, the Violetta Marina, the Decachordon, the Corno Chromatico, and the 'musical glasses' were demonstrated.[25] The glasses were performed upon by no less a master than Gluck, who in 1746 offered a 'Concerto upon Twenty-six Drinking Glasses tuned with

Spring-Water, accompanied with the whole Band'.[26] A quite typical programme from the early years of the century ran as follows:

Never Perform'd Before.

At the Great Musick Room in *York Buildings* on *Friday* the Fifth of February will be an Entertainment, in which will be a Consort of Instrumental Musick and Variety of New Dancing, both Comick and Serious, by Mr. *Weaver*, Mr. *Essex*, and others. And singing by a little Girl. Likewise an Entertainment of Vaulting on the Horse.[27]

Later, the variety became stranger and the stunts more grotesque. Signor Castrucci, 'first Violin of the Opera', threatened to 'make you hear two trumpets on the violin'; and a Miss Robinson offered to play the harpsichord with her feet.[28]

The presence of the common people was hard to ignore in the London of the early eighteenth century. Their forthright desires influenced the course of public entertainment. But their misery was as obvious as their power, and many an artist, in sympathy with the poor, put his talent to the benefit of charities. The establishment of the Foundling Hospital by Captain Thomas Coram, in 1739, was well supported by artists. Their interest showed their admiration for the good Captain, whose resolute and benign character shines out so strongly in Hogarth's portrait. But they no doubt recognized as well the inability of a burgeoning commercial economy to put right the social distress it caused; and men of the arts, being sensitive, are often compassionate. Hogarth, a man of the people, was a particular friend of the Foundling. He is listed in the Charter as a Governor and Guardian and was very active in his help. He executed a print of *The Foundlings*, designed a shield to go over the door of the first home in Hatton Garden, and presented the portrait of the founder in 1740. This portrait, he said, was the one he painted 'with most pleasure, and in which I particularly wished to excel'.[29] The lead taken by Hogarth was followed by other painters. Coram was painted by Hudson, Reynolds, Highmore, Ramsay and Wilson, among others, and a committee of painters formed to give their free services for the decoration of the new hospital buildings in Lamb's Conduit Fields. In the course of a few years the Foundling possessed a respectable collection of art, which, though it might not have helped the children who died off at a remarkable rate,[30] at least made the hospital a place for the fashionable to visit, and perhaps incidentally take note of the suffering. Hogarth never lost his concern for the Foundling. When he sold the *March to Finchley* by lottery in 1750, he donated 167 tickets to the Foundling, and one of these tickets was the winning draw.[31]

Concerts were also given for charity and, of the many musicians who took part, few were as generous with time and talent as Handel. Like Dr. Johnson, he had a great kindness for children and the unfortunate concealed beneath his gruff exterior. The first performance of *Messiah* on April 13, 1742, in the New Musick Hall, Fishamble Street, Dublin, raised about £400 to be divided between Mercer's Hospital, the Charitable Infirmary, and the Relief of Prisoners. Towards the end of the forties Handel also began a long-standing connection with the Foundling Hospital. Having offered a concert to raise money for the chapel, he was, on May 7, 1749, elected a Governor. On the 27th he directed, in the chapel, his *Fireworks Music*, selections from *Solomon*, and a new piece now known as the *Foundling Anthem*. In the next year, he presented the Foundling chapel with an organ and inaugurated it on May 1 with a performance of *Messiah*. The concert was something of an occasion. The invitation was decorated with Hogarth's design for the hospital arms; such a press attended that many without tickets slipped in, and some 'Persons of Distinction' with tickets had to be turned away.[32] The performance raised £728 3s. 6d. for the hospital, and began the custom of the annual performance of *Messiah* at the hospital which did so much for the work's popularity.

The condition of the poor and the mob, though it brought out the kindness in the artist, only rarely informed his art. In an age when the common man was becoming rather obtrusive, art, in the main, still dealt with a select and fashionable subject-matter. Changes in patronage and social organization gradually alter the subjects of art, but the process is slow. Very often a new audience is paying for and watching art which treats the lives and interests of former patrons. Urban and ordinary life began to appear, especially in prose fiction; Defoe, Richardson and Fielding were laying the foundation for the novel which was soon to win popularity over most other forms of art. But the rise and the development of the novel, though starting in the early eighteenth century, take us well beyond the period and the aim of this study. Few of the other forms of art received any lively infusion from the workings of common humanity. The foolishness of the contemporary theatre inspired Fielding to write a large number of farces and burlesques in the ten years after 1728; though marvellously humorous and pointed, these were but the hits of the moment. *The Beggar's Opera*, in 1728, taking the subject of low life, did manage to make some moral and political points, and, being extraordinarily popular, was much imitated. Gay's own *Polly* appeared in the next year; plays like *The Lottery*, *The Beggar's Wedding*, and *The*

Death of Queen Gin announced their social themes in their titles. A few plays struck the pastoral note, contrasting country honesty and simplicity with urban deceit. Lillo's *Sylvia*, Dodsley's *King and the Miller*, and Dorman's *Sir Roger de Coverley* are of this type. Comedies, farces, burlesques, ballad-operas and pastorals were all produced. Most were very undistinguished, hovering uncertainly between the picaresque and slapstick, between moral earnestness and social satire, between sentimentality and dullness.

Two men however, both original and powerful talents, did realize the artistic possibilities of the working world. Defoe and Hogarth were both Londoners, born and raised among petty tradesmen and labourers, and took their material from the world they knew so well. Defoe's achievement in the novel is not our concern here, but how exactly he observed the current of daily events! *Crusoe*, among other things, is a triumphant accumulation of small domestic affairs; and the *Journal of the Plague Year* is the anatomy of a diseased city.

Hogarth shared with Defoe the observer's eye; both had the command of the small but telling detail. For an artist, he advanced along a hard road, being apprenticed to an engraver and set to work at first on tradesmen's cards and other trifles. But he seemed to understand instinctively that his intimate knowledge of public life in London was the basis of his strength. For a while he was tempted by history painting and portraiture, the fashionable avocations of the early eighteenth-century painter: he even produced some biblical figures more than seven feet high for a staircase at St. Bartholomew's Hospital. But he found himself 'unwilling to sink into a *portrait manufacturer*':

> and still ambitious of being singular, dropped all expectations of advantage from that source, and returned to the pursuit of my former dealings with the public at large.[33]

'The public at large' gave him his income and his subject-matter. His prints and his paintings recount, more clearly than any book or document, the social history of his contemporary world. The power of the crowd, vital, confused, sometimes violent, is expressed in such prints as the *Burning of Rumps* from the illustrations to *Hudibras*, *Southwark Fair*, and the *March to Finchley*. The terrors and joys of London living are inimitably touched upon: the Distressed Poet in his garret, the Harlot in Bridewell, the Rake in the Fleet and in Bedlam; the degrees of drunkenness in the *Midnight Modern Conversation*, the furious city cacophony of the *Enraged Musician*, the vignettes of urban life from the *Four Times of the Day*. Nor were the common people his only concern. His view was comprehensive,

and dissects a nobleman's dining-room and the Fleet Prison with equal authority.

> He gives us reception rooms in Arlington Street, counting-houses in St. Mary Axe, sky-parlours in Porridge Island, and night cellars in Blood-Bowl Alley. He reproduces the decorations of the Rose Tavern or of the Turk's Head Bagnio as scrupulously as the monsters at Dr. Misaubin's museum in St. Martin's Lane, or the cobweb over the poor-box in Mary-le-bone Old Church.[34]

He recorded with the fidelity of the camera, and with the pointed relevance of the artist.

Hogarth considered his works to be 'dramatic', in which lay their 'singularity'. He himself made the comparison between his prints and the theatre. His intention was often moral and critical, and his effect was profound. His prints were everywhere; the petty clerk's furnished room, 2s. 6d. a week, 'two pair of stairs forwards in Grub Street, Golden Lane, Moor Lane, Fee Lane, Rag Fair or the Mint', had its Hogarth print 'cut in wood and coloured, framed with deal but not glazed'.[35] 'I esteem the ingenious Mr. Hogarth,' wrote his friend Henry Fielding, 'as one of the most useful Satyrists any Age hath produced.' His works had done more 'for the Preservation of Mankind, than all the Folios of Morality which have ever been written'.[36] And the great Swift recognized the painter as an equal:

> Were but you and I acquainted,
> Every monster should be painted;
> You should try your graving tools
> On this odious group of fools;[37]

But *saeva indignatio* was no part of Hogarth's business. His great and original contribution was to record vice with the commentator's eye. He recorded it exactly, without the savage heightening for effect that Swift employed. The Dean, aristocratic by temperament, was something of a prophet; Hogarth, a common man, did not regard any group of the people as 'odious fools'.

The poorer citizens of the town did not concern themselves with art. Unless an event was free, in the open air, or in the tavern, they passed it by for lack of time and money. Their influence on eighteenth-century art was indirect; their pleasures were reflected because they were now an important group in the trading State. As trade was now England's religion —indeed, the Dissenters almost made it a formal tenet of their faith— the merchant and the tradesman came to have great authority in society. The merchant philosophy became the fashionable wisdom. With growing wealth and secure position, the merchant began to take over the burdens

of patronage from the gentry and the aristocracy. '*Power*', wrote Swift in a bitter defence of the principles of the Tory landowners, 'which, according to the old Maxim, was used to follow *Land*, is now gone over to *Money*.'[38] The trading men were a large part of the new public audience, and they imposed their conditions, both consciously and unconsciously, on the art.

The wit of the Restoration had not been kind to trade. The merchant had a place on the scale of contempt very close to the cuckold and the country oaf. And as long as the patterns and preconceptions of Restoration art lasted, the merchant remained a butt for ridicule. Even in the first years of the eighteenth century, in the days of Whig dominance, Congreve, Vanbrugh and Farquhar still treated the merchant very severely. These playwrights were Whigs, but they were working in the old tradition, and were more interested in their art than in Whig theory. Evidence of social changes, however, cannot be kept out of the theatre. The drama grew full of characters in pursuit of wealth, even in the plays of the wits; in Congreve's *Way of the World*, in Vanbrugh's *Relapse*, in Farquhar's *Beaux' Stratagem* and *Constant Couple*, and in many other plays, questions of income and inheritance pre-occupy the characters.[39] And this natural drift towards a reflection of society's interests was hastened by the attacks on the theatre at the turn of the century.

When Blackmore and Collier instituted their campaign against the immorality and profaneness of the stage, part of their complaint was that the wits portrayed merchants as mean, skulking, dishonest rogues, often with pretensions above their station, whereas in truth, said the critics, the merchant was an important citizen and an ornament in the state. Since the duty of the stage, in the opinion of these critics, was to teach morality, the merchant should be cast as the 'virtuous man' he was. Blackmore put the case most clearly:

> The Labours of the meanest Persons, that conduce to the Welfare and Benefit of the Publick, are more valuable, because more useful, than the Employments of those, who apply themselves only, or principally, to divert and entertain the Fancy; and therefore must be as much preferable to the Occupation or Profession of a Wit, as the Improvement and Happiness of Men is to be regarded above their Mirth and Recreation.[40]

This hint, so obviously inimical to the work of the imagination, was quickly picked up by the admirers of England's trading prosperity— chiefly the Whigs—and the merchant suddenly emerged as a man of radiant parts.

> A True-Bred Merchant [Defoe wrote] is a Universal Scholar, his Learning

> Excells the meer Scholar in Greek and Latin, as much as that does the Illiterate Person, that cannot Write or Read: He Understands Languages without Books, Geography without Maps; his Journals and Trading-Voyages delineate the World; his Foreign Exchanges, Protests and Procurations, speak all Tongues.[41]

Defoe, himself a trading-man, was a notorious enthusiast; but his view became so much the conventional Whig opinion that it finally received the accolade of a melodious endorsement from the ultimate Whig spokesman, Joseph Addison:

> There are not more useful Members in a Commonwealth than Merchants. They knit Mankind together in a mutual Intercourse of good Offices, distribute the Gifts of Nature, find Work for the Poor, add Wealth to the Rich, and Magnificence to the Great.[42]

Stamped with the approval of Addison, the merchant's eminence was assured; after 1711 the sanctity of trade and the sterling virtue of the merchant were accepted by all but the most recalcitrant Tory.

The contemptible merchant of Vanbrugh and Farquhar gave way, in the twenties, to the admirable merchant of Steele and Susannah Centlivre. But the triumph of commercial respectability did the stage no good. From the moment the principles of Blackmore and Collier were put into effect the drama began to decline; between the last play of Farquhar and the first play of Sheridan—a period of over sixty years—there was very little worthy of attention on the London stage. The reasons for the decline were various; for a quarter century, between 1711 and 1737, the Italian opera enjoyed a glamorous reign, leaving the drama dispirited and impoverished. But much of the failure in the theatre came from the attempt to follow the prescriptions of middle-class morality, to bind the imagination with social responsibility. Johnson, no friend to affectation or vice, saw the essential difference between the live Restoration theatre and the dead, portentous productions of his own middle years. 'They pleas'd their Age,' he wrote of the Restoration dramatists, 'and did not aim to mend.' But in his time the theatre was given over to considerations that had little to do with the dramatist's art:

> Then crush'd by Rules, and weaken'd as refin'd,
> For Years the Pow'r of Tragedy declin'd;
> From Bard to Bard, the frigid Caution crept,
> Till Declamation roar'd, while Passion slept.
> Yet still Virtue deign the Stage to tread,
> Philosophy remain'd, though Nature fled.[43]

The rule of money had arrived. The commercial spirit diffused through the upper and middle ranks of society so successfully that soon the gentry and the aristocrats were as keen on stock-jobbing, as hot after

wealth, as the City merchants. The artists had a large and prosperous public eager to be amused and instructed, and eager to display the ostentation of their wealth. The theatre was in decline, but musical events were flourishing in the public interest.

The most magnificent entertainment available to the London audience in the first half of the eighteenth century was the Italian opera. It is to be expected that an affluent era should subscribe to expansive gestures, and the opera was smart and inordinately expensive. It appealed not to 'the Taste of the Rabble, but of Persons of the greatest Politeness, which has established it'.[44] Successful Italian opera began with the arrival of Handel in England. The works he composed to Italian libretti for Italian singers were so much superior to the English operas put together by Clayton and others some six or seven years previously, he soon caught the cultivated ear. To the lover of the arts, the opera offered 'the *completest concert* to which they can go':

> to the most perfect singing, and effects of a powerful and well-disciplined band, are frequently added excellent acting, splendid scenes and decorations, with such dancing as a playhouse, from its inferior prices, is seldom able to furnish.[45]

The synthesis of the arts had been attempted before in the lamentable musical dramas of the Restoration times, to which Dryden and Purcell had contributed; but never before had the parts blended into an acceptable whole. The unique qualities of the new entertainment, and the favour of high persons, gave expectations of artistic and financial success. Roger North, writing his *Musicall Gramarian* around 1728, felt the expectations had been fulfilled:

> But now the subscriptions with a Royall encouragement [the Royal Academy of Musick] hath brought the operas to be performed in their native idiom and up to such a sufficiency that many have sayd, Rome & venice, where they heard them, have not exceeded.

Money was the constant concern of the Italian opera. Though it was promoted and heavily underwritten by the aristocracy, the expenses of the productions were so great, it needed the support of the whole monied community to remain healthy. To ensure this support, the opera had to keep in the wayward eye of fashion. When musical quality alone lost its hold, the managements resorted to the desperate artifices of publicity. More ingenious machines, yet more astounding spectacles were created. The egos, and the bitter rivalries, of the leading singers were puffed out by extraordinary fees. When Senesino, Cuzzoni and Faustina appeared together for the first time on the London stage, in Handel's *Alessandro* (1726), each had contracted for 2,000 guineas for the season. Boschi,

Carestini, Farinelli, Durastanti, Strada, and several others, all commanded very large amounts. Yet famous names were necessary to bring in the audience. The opera season of 1729–30, though it contained two new works by Handel—*Lothario* and *Partenope*—failed for lack of a great name. For the next season Handel was glad to lure Senesino back from Italy for a fee of 1,400 guineas. The necessity to write for the leading voice, remarkable voice though it may be, stinted the artistry of the whole. Roger North noted the dismal result:

> One thing I dislike is the laying too much stress upon some one voice, which is purchased at a dear rate. Were it not as well, if somewhat of that was abated & added to the rest to bring the orchestra to neerer equality? Many persons come to hear that single voice, who care not for all the rest, especially If it be a fair Lady; And observing the discours of the Quallity-crittiques, I found it runs most upon the point, who sings best?[46]

The Italian opera was an over-ambitious commercial enterprise. The wish to meet the demands of a careless public—and the blows of political partisanship—reduced the hopeful art that Handel had introduced in 1711 to the 'tawdry, expensive, and meretricious lady' that Dr. Burney discovered in 1740, 'who had been accustomed to high keeping, was now reduced to a very humble state, and unable to support her former extravagance'.[47]

Despite the limping course of opera, which led at last to the bankruptcy of both Heidegger's company and the Opera of the Nobility in 1737, it was kind enough to the English musicians of the time. The bands maintained by the three play-houses in the Haymarket, Covent Garden and Drury Lane gave the work that the Royal Musick no longer provided. And the standard of performance, notwithstanding North's opinion, was often good. Quantz, on his visit to London in 1727, commented on the 'extremely fine effect' Handel drew from his cosmopolitan group of Englishmen, Italians and Germans, under the leadership of Castrucci.[48] Handel himself, whatever the poverty of the opera, only grew richer. After the collapse of the Royal Academy of Musick, he set up in partnership with Heidegger, contributing £10,000 of his own money. The failure of this venture still left him financially sound; when he died in 1759 his credit in the Bank of England stood at £17,500.[49]

Not all Handel's riches came from opera. He was a prudent and astute businessman, and his income came from many sources—from investments, from concerts of his works, from his own superlative performance on organ or harpsichord, from teaching, from his court pension, and especially from profitable association with Walsh, his music-publisher.

Many of his printed scores were sold by the then popular method of subscription; and Handel's name, backed by the energetic Walsh, drew subscribers from all ranks and all places. The list for *Alexander's Feast* in 1738 included seven members of the royal family, aristocrats like Lord Cowper, Lady Burlington, Lord Shaftesbury, his wife and mother; the Master of the Musick and the Master of the Children; musical societies in Dublin, Exeter, Oxford and Windsor; the Academy of Antient Musick and the Philharmonic Society; the organists at Durham, Oxford, Windsor and Newbury; Festing, the violinist, John Harris, the organ-builder, and Zincke, the painter; and a great number of private gentlemen.[50] The public was eager and Handel was there to serve them, as Pope testified:

> Strong in new Arms, lo! Giant Handel stands,
> Like bold Briareus, with a hundred hands;
> To stir, to rouze, to shake the Soul he comes,
> And Jove's own Thunders follow Mar's Drums.[51]

For public music, building on the success of men like Banister and Thomas Britton in the last part of the seventeenth century, was very widely available in the next century. Hickford's Music Room, first in Panton Street and after 1738 in Brewer Street, was endlessly busy with subscription and benefit concerts. York Buildings was used for music until 1734, being hired for private concerts by the King and the Prince of Wales. The flow of music in the taverns was still in full spate. The theatres were available for special concerts, such as the benefit for Handel at the Haymarket, on March 28, 1738, where the Earl of Egmont counted 'near 1,300 persons besides the gallery and upper gallery',[52] and which raised some £800 for the composer. The pleasure gardens, too, as they came into being after 1730, were great users of music and musicians. The fine violinist, Michael Festing, was the soloist at Ranelagh; William Defesch played at Marylebone, and Richard Collet at Vauxhall. Jonathan Tyers, the impresario at Vauxhall, felt he owed such a debt to Handel's music, he commissioned, by way of 'apotheosis, or laudable idolatry',[53] the well-known statue of the composer by Roubiliac. The grand celebrations to mark the Peace of Aix-la-Chapelle took place at Vauxhall in April 1749. The rehearsal for Handel's *Fireworks Music*, performed by a band of a hundred, was attended by a crowd of 12,000 people paying half a crown each; the jammed traffic closed London Bridge for three hours.

The prices paid by the public for concerts in London were not cheap. Charges went from 2s. 6d. to 15s., though on exceptional occasions a

guinea might be asked. These prices remained quite stable for the first
half of the eighteenth century: in 1716 a Handel concert at the King's
Theatre charged 'Boxes on the Stage 15s., Tickets Half a Guinea, Gallery
4s.'; for Gluck's performance on musical-glasses, in 1746, the seats were
still 10s. 6d.[54] That these high prices were paid is a tribute to public
wealth, and music's power, in England. And foreign musicians were
quick to notice the advantages of musical London. Singers naturally
came in strength for the opera. But there was also in London a succession
of fine instrumentalists. Violinists were especially favoured, and London
gave employment to Castrucci, Carbonelli, Pepusch, Saggioni, Gasparini,
Veracini, Dubourg and Geminiani; Caporale, Pasquale and Mattei were
well-known cellists; Loeillet and Ballicourt played the flute; Kytsch,
San Martini and Galliard the oboe; Barbandt and Weichsel the clarinet;
Karba played the bassoon, and 'Mr. Charles, the Hungarian' the horn.[55]

The cheerful state of the London market now encouraged the arts to
abandon some of the old forms of private patronage, and put their
works at the mercy of the general public. Men like Handel and Hogarth
were their own masters. Hogarth especially worked for the public favour.
Until his time portrait-painting for the gentry and aristocracy, or wall
and ceiling painting in the great buildings, had been the chief employ-
ment of painting in England. Hogarth determined to break out of these
restrictions. He wanted more freedom for his hand; he also found that
conscientious portraiture, giving proper time and attention to each sitter,
did not pay enough to support his family. 'I therefore turned my thoughts,'
he wrote, 'to a still more novel mode, viz., painting and engraving modern
moral subjects, a field not broken up in any country or any age.'[56] And
he sold these new wares in a number of novel ways—by subscription, by
auction, by lottery and the like. Some of these methods worked well, and
some did not. Subscription was perhaps the most successful method, and
had the advantage that it allowed the artist to design an entertaining trifle
to go on the subscription-ticket. The six plates of the *Harlot's Progress*,
engraved by Hogarth himself, were sold by this method in 1732. 1,200
sets were printed and the subscription was sold out; at the price of a
guinea a set, Hogarth made the tidy sum of £1,260. As his fame grew he
also did well on a few individual pieces. An eccentric lady of Kensington,
who dressed very strangely, paid sixty guineas for the *Taste in High Life*,
a painting satirizing the popular fashion of 1742. The engraving of
Garrick as Richard III, in 1746, sold to a Yorkshire gentleman for £200,
'more', as Hogarth proudly recalled, 'than any English artist ever received
for a single portrait.'[57] For his auctions, Hogarth devised most peculiar

conditions, which successfully prevented high prices. In 1745 he auctioned the six paintings of the *Harlot's Progress*, the eight of the *Rake's Progress*, the four of the *Times of the Day*, and the *Strolling Players*, for all of which he received £427 7s., a much smaller sum than he might have achieved. The *Marriage-à-la-Mode* pictures, auctioned at the Golden Head in 1750 by sealed bid, with no dealers permitted to bid, went for a mere 120 guineas; forty-seven years later they were sold at Christie's for £1,050.[58]

The public that paid so eagerly for Hogarth's prints was just as ready, and even more so, to buy the productions of the booksellers. And the booksellers, energetically devising a thousand projects to catch the public eye, grew fat on their profits. Thomas Guy, the benefactor of Guy's Hospital, died in 1724 leaving an estate of over £200,000. Old Jacob Tonson, Dryden's publisher in the seventeenth century and secretary of the Kit-Cat Club in the eighteenth, lived on intimate terms with the greatest Whigs in the land. To fulfil the designs of the booksellers, and to help them towards their fortunes, writers were needed, and these came forth in great numbers. Swift computed the number in London to be several thousand, and Johnson, writing in 1751, thought 'there is not any reason for suspecting that their number has decreased'.[59] And why not? Authors were in demand, living was cheap—Johnson recalled an Irish painter who lived on £30 around 1730—and few qualifications were required; Savage, wrote Johnson, 'having no profession, came by necessity an author';[60] and Fielding thought his choice lay between hackney writer and hackney coachman.

The demand for successful work was enormous. The clamour for the first part of *Robinson Crusoe*, published by William Taylor in April 1719, was so great the publisher was forced to keep several printers at work on it. Three editions were run through in under four months, and Taylor made a profit of over £1,000. The first impression of *Gulliver's Travels*, published in November 1726, sold out in a week. *The Beggar's Opera* reached the fourth edition within six years; the sequel, *Polly*, was so eagerly awaited that Bowyer was able to issue two quarto editions, totalling 10,500 copies, in 1729 alone. For the first collected edition of the *Spectator* in 1712, 9,000 copies were printed; in the next seventeen years no less than nine more editions were needed.

And the author's rewards from the bookseller grew correspondingly. The career of John Gay demonstrated the happy expectations of a popular author. In 1713 Bernard Lintot paid him £25 for the *Wife of Bath*; two years later he paid the author £43 for *Trivia*, and in 1717 £43 2s. 6d. for

Three Hours before Marriage. In 1720 the subscription edition of Gay's poems, with his aristocratic and literary friends actively drumming up sales, raised £1,000. A few years later he received another £1,000 for *The Captives*; *The Beggar's Opera* earned him £788 3s. 6d., and *Polly* around £1,200. Writers were being paid larger and larger sums for their copyrights. Rowe received £50 15s. for *Jane Shore* and £75 5s. for *Lady Jane Grey*. Cibber had £105 for his *Non-Juror* in 1718, and Southerne £120 for the *Spartan Dame* in the next year. Motte paid Swift £200 for *Gulliver*, though that was one of the only two books for which Swift ever received payment. In 1712 Addison and Steele sold the copyright to the first four volumes of the *Spectator* for no less than £1,150, which gives an idea of the great popularity of the work; Samuel Buckley paid half and Jacob Tonson junior, the old man's nephew and partner, contributed the rest.

One man, however, stood out as the complete literary man of the age. Pope by his example and his effort proved irrevocably that a writer of talent could entrust himself to the public and come out of the liaison with honour and profit. Pope was well-suited to the pioneer way he chose to follow. He had, of course, the necessary genius. And his Catholic birth, his deformity, his delicacy and his pride made him the odd man out, in-eligible for political patronage and unable and unwilling to endure the ardours that the hunting of the great imposed. Both necessity and pre-ference made him seek out the public. From the first, his ability brought him to the attention of the booksellers. Astute old Tonson had cast his net for young Pope, but the poet was not to be rushed. 'Jacob creates poets,' he wrote to Wycherley, 'as kings do knights, not for their honour, but for their money.'[61] Concerned for his own honour and riches, cold and clear-headed young Pope soon left Tonson and entered into his famous association with Bernard Lintot.[62] *The Rape of the Lock* appeared in Lintot's *Miscellany* in 1712. In the next three years Lintot purchased other works—*Windsor Forest* for £32 5s., *Ode on St. Cecilia's Day* for £15, *The Temple of Fame* for another £32 5s., and some others. In 1714 poet and publisher drew up the contract which was to make Pope's fortune and reputation, and also cause him endless trouble and drudgery. He intended to translate the *Iliad*, being driven to this plan purely by 'want of money. I had then none; not even to buy books'.[63] The transla-tion was in six quarto volumes to be sold by subscription at a guinea each.[64] Lintot paid the poet £200 for each volume, and provided free the copies for the subscribers. The first volume appeared in 1715, and the last five years later. Pope received over £4,000 for his labours, but poor Lintot

was done out of much of his profit by a pirated duodecimo, printed in Holland and 'imported clandestinely for the gratification of those who were impatient to read what they could not yet afford to buy'.[65] Consequently, in 1725 Lintot felt he could pay for the copyright of the *Odyssey* only half the sum he had given for the *Iliad*. Moreover, he would not provide free copies for the subscribers of Broome, one of Pope's collaborators in the *Odyssey*. Lintot and Pope quarrelled; Pope returned once more to Tonson, and met more disappointment. He received £217 12s. to edit Shakespeare, out of which he had to pay his helpers, Gay and Fenton. Yet, to his chagrin, Theobald's *Shakespeare*, for which Pope had so much contempt, went through many editions and earned the editor £652. The echoes of these quarrels and defeats reverberate through the *Dunciad*. But in ten years of translating Homer Pope had received some £8,500;[66] Dryden, at the end of the seventeenth century, had earned £1,400 for his translation of Virgil; the author's gain in a quarter century was very considerable. No wonder the poet's friends, Gay and Swift, saluted Pope on his 'Safe Return from Troy'.[67] He had proved the existence of a public rich enough and cultivated enough to secure the independence of the writer. The public was now the concern of every great writer. Swift, who had chased political favour so earnestly in his early days, wrote in his old age to Pope: 'My popularity is wholly confined to the common people.'[68] And Dr. Johnson was able to say, 'No man who ever lived by literature, has lived more independently than I have done.'[69]

Now that the public audience was so important, artists began to consider the protection of their works; the question of copyright, a minor worry in the days of private patronage, suddenly concerned all the arts. The lapse of the old Licensing Laws in 1695 left book-publishing in a fine lawless state. The regulations of the Stationers' Company were completely disregarded—between 1701 and 1708 only twenty-six books appeared on the Register—and piracy flourished. Application to Parliament in 1709 produced the Copyright Act, which, for the first time in England, gave a statutory protection to authors and publishers. Books already in print were given a copyright of twenty-one years from April 10, 1710; the copyright in a new book was to last for fourteen years, and if the author was still living then, was to be renewed for a further fourteen years. Prints were as easily stolen as books, and Hogarth in particular suffered from this trade; his very first published print, *Masquerades and Operas*, was pirated. Painters and engravers, like the authors and publishers before them, began an agitation for copyright which gave rise, in 1735, to a bill sometimes known as Hogarth's Act.

Although these Acts were well-intentioned, they gave few benefits. Before the Act of 1709 there had been a Common Law presumption of a perpetual copyright in a book; now this perpetuity—though admittedly very uncertain—was exchanged for a statutory term of twenty-eight years at the most.[70] More important, these Acts quite failed to prevent piracy. In the book-trade men like 'Mr. Lee of Lombard Street' were not uncommon. John Dunton described him thus:

> Such a Pirate, such a Cormorant, was never before. Copies, Books, Men, Shops, all was one; he held no propriety, right or wrong, good or bad, till at last he began to be known; and the Booksellers, not enduring so ill a man to disgrace them, spewed him out, and off he marched for Ireland, where he acted as *felonious-Lee*, as he did in London.[71]

Designers and engravers were still exploited. Within a month of the Act in 1735, Hogarth was complaining in the *Post Boy* that *The Rake's Progress* was being illegally reproduced by several other print sellers.[72] Composers, too, were poorly protected. A published score no doubt had the benefit of the Copyright Act, but there was no such thing as performing rights. Handel was frequently annoyed by rival concerts of his own music. Two weeks after the first public performance of *Esther*, in the King's Theatre, Haymarket, Thomas Arne advertised an unauthorized concert of the same work in the New Theatre in the Haymarket.

Cast adrift from the King's Musick, and needing to play as often as possible in order to live, musicians (and the music they performed) were very sensitive to public taste. Italian opera had risen in answer to fashion; fashion also caused its eclipse. When opera became distasteful, and so unprofitable, Handel luckily shifted to oratorio, which fitted the changing mood. The excesses in the operas of expense, vulgarity and nonsense, that Addison had complained of from the first,[73] at last revolted the people who had formerly applauded these excesses. Other weighty persons added their criticisms to the *Spectator*'s. By 1729, Law's *Serious Call* had condemned opera morally, the first version of the *Dunciad* had condemned it artistically, and *The Beggar's Opera* had condemned it satirically. The outstanding success of *The Beggar's Opera* gave the best indication of the public's state of mind. A letter attributed to Dr. Arbuthnot, after lamenting the decline of the opera which he put down to 'the fickle and inconstant temper of the English nation', declared *The Beggar's Opera* 'to be a touch-stone to try the British taste on':

> and it has accordingly proved effectual in discovering our true inclinations; which, how artfully soever they may have been disguised for a while, will one time or other start up and disclose themselves.[74]

The public wanted works in English, simpler than the formal and artificial Italian opera, and perhaps with a moral or satirical point. In 1732, Bernard Gates, the Master of the Children, gave a private performance of Handel's long-neglected *Esther*, composed at Cannons some twelve years before. The same singers then twice repeated the work for the Antient Academy of Musick at the Crown & Anchor. On April 20 another group of players and singers performed the oratorio in the York Buildings Room. The attraction of this 'Oratorio or Sacred Drama', a curiosity new to England, spread. Princess Anne desired to see it in the theatre, but the Bishop of London refused to allow a 'dramatic' performance on the stage. Therefore, when *Esther* came to the Haymarket 'By His Majesty's Command' on May 2, 1732, a note explained the nature of the performance:

> There will be no Action on the Stage, but the House will be fitted up in a decent Manner, for the Audience. The Musick to be disposed after the Manner of the Coronation Service.[75]

The text in English, the biblical subject, the simplicity and impressive dignity of the performance, and Handel's music, met the prevailing taste. Coincidence, a bishop's injunction, and the public appetite for what was new and severe rescued Handel from the toils of opera and set him after the financial and artistic rewards of oratorio.

The service of the public brought in great trials and problems for the arts. The new audience conferred some benefits. Some moves were made to improve the security, and independence of the artist. A few men of the arts grew rich, and several made a sufficiency. The conditions of the market encouraged the unique genius of Hogarth; changing public taste established first Italian opera and then Handelian oratorio. But the advantages were paid for at a great rate. When the arts become dependent on the public, the artist shares the conditions of the public. London life was brutal as ever; men of the arts, unprotected by private patronage, felt the common dangers. Violence, poverty, and the severity of the law were the common expectations and very often these became the artist's lot as well. Those who relied on the public rage for politics to win them profit often found the pillory—which Defoe called 'the *State-Trap* of the Law'[76] —awaiting them. Defoe himself stood there for his *Shortest Way*. Ned Ward, one of the liveliest of the Grub Street sparks, was there on several occasions. In 1713 George Ridpath, Whig editor of the *Flying Post*, fled the country; Bolingbroke had posted a £100 reward for his arrest. Luttrell and Abel Boyer have many accounts of the prosecutions and machinations of the government against writers.[77] The Tory Stamp Act

of 1712 failed to stop adverse criticism, but it made publication more expensive and cut down the writer's opportunities.

And the business of a Grub Street author was hazardous in any case. Hot after the public favour, the booksellers had a thousand dishonest stratagems, in which they were ably abetted by their hackney writers. For every respectable Tonson or Lintot there were two reprobates like Roper, Hills or Curll. Dunton, a man who had tried his hand at the tricks of the trade, complained of piracy, forgery, false claims, downright lies, unauthorized abridgements and editions, 'so that I am really afraid that a *Bookseller and a Good Conscience* will shortly grow some *Strange* Thing in the Earth'.[78] With huge industry and inventiveness, the low publishers pandered to the eternal weaknesses of the public—its salacious taste, its love of famous names, and its undying snobbery. Works like *The Art of Cuckoldom, The Auction of Ladies*—'prefixed to it the picture of a black ram'—*The Nun in her Smock*, and *The Treatise of Flogging* sneaked from the presses of Roper and Curll.[79] Books appeared bearing the name M. Prior or J. Gay on the title-page, who were quite other than the famous Matthew or John of the same surname. A mean twopenny pamphlet would be expanded, padded and puffed into a bold four shilling volume:

> Give me a good handsome large volume, with a full promising title-page at the head of it, printed on a good paper and letter, the whole well bound and gilt, and I'll warrant its selling—You have the common error of authors, who think people buy books to read—No, no, books are only bought to furnish libraries, as pictures and glasses, and beds and chairs, are for other rooms.[80]

These tactics naturally earned the enmity of the more reputable authors. Pope suffered from Curll's unwanted attention, and the brisk, flaring contest that resulted between the proud, touchy author and the brazen bookseller has given the name of Edmund Curll its dubious fame. In 1716 Curll had acquired and published some verses that did no credit to Lady Mary Wortley Montagu, Gay and Pope; Pope replied by inducing Curll to take a strong emetic; accusation and counter-attack continued over a number of years; in 1728 Curll was given his prominent place among the Dunces of the *Dunciad*, and Curll led the offensive of the Dunces against Pope. It is even possible that Curll, combining malice with good business, put out a pirated edition of the *Dunciad*.

Pope had pride and reputation to preserve, but there were a hundred hackney writers with neither of these burdensome commodities anxious to assist every questionable practice of the booksellers. John Dunton relates how they plied him for business 'as earnestly, and with as much passion and concern, as the *Watermen* do *Passengers* with *Oars* and

7

Scullers'.[81] Their talents were various, their word was unreliable. When in funds they were often drunken and riotous, when poor 'they'll sneak, fawn, and cringe, like a dog that has worried sheep, and dreads the halter'.[82] But, having the tatters of a university education still hanging about them, they were useful to the booksellers. Curll kept his translators 'three in a bed, at the *Pewter-Platter* Inn in Holborn'.[83] In *The Author's Farce*, the bookseller welcomes a new recruit to his labouring flock:

> no one can want bread with me who will earn it; therefore, sir, if you please to take your seat at my table, here will be everything necessary provided for you: good milk-porridge, very often twice a day, which is good wholesome food, and proper for students: a translator too is what I want at present; my last being in Newgate for shop-lifting.[84]

The young man regrets he is not qualified, as he translated Virgil out of Dryden. The bookseller is delighted: 'Not qualified! thou art as well versed in thy trade, as if thou hadst laboured in my garret these ten years.' Unfortunate Richard Savage pictured the life of a Curll drudge in *An Author to be Lett*, supposedly a satiric portrait of his fellow-hack, Charles Gildon:

> 'Twas in his [Curll's] service that I wrote obscenity and profaneness, under the names of Pope and Swift. Sometimes I was Mr. Joseph Gay, and at others Theory Burnet,[85] or Addison. I abridged histories and travels, translated from the French, what they never wrote, and was expert at finding out new titles for old books. When a notorious thief was hanged, I was the Plutarch to preserve his memory; and when a great man died, mine were his remains, and mine the account of his last will and testament.

'For poets ought to be poor,' wrote Tom Brown with his usual cheery fortitude, 'and those that disdain the station, can have no true title to the honour.'[86] Poverty and duns were familiar companions, as we see in Hogarth's *Distressed Poet*; and too often the sponging house and the gaol also waited:

> And has this Bitch, my Muse, trepanned me:
> Then I'm as much undone as can be;
> I knew the jilt would never leave me
> 'Til to a prison she'd deceive me;
> Cursed be the wretch, and sure he's cursed
> That taught the trade of rhyming first.[87]

The poor, dark alleys of the Grub Street life were pierced with some shafts of humour, uproar and satisfaction. The earlier generation of hacks, living in expansive days at the turn of the century, were still defeated by their profession. L'Estrange, Pittis, Tutchin, King, all declined into obscurity, poverty or ill health. Tom Brown died at forty-one, overcome by sickness and poverty; Ned Ward bought an ale-house and retired

from literature. For the later generation of hacks, circumstances were
even more severe. The aristocracy, seduced by politics at the Revolution,
never rediscovered a passion for the arts. Walpole's ministry brought an
end to the political patronage of the previous quarter century. A few
writers of remarkable ability or character, such as Pope at first, and then
Johnson, won independence with a fair livelihood. Others such as Gay,
Thomson and Young still put their faith in private patronage, seeking
the favours of the rich. But many—some unlucky, some careless and idle,
some too fond of freedom, some without talent—served the public and
felt the vicissitudes of the market. Dennis, Oldmixon, Gildon, Savage,
Mallet were all able men in their various ways: they were beaten down
by Grub Street. Dr. Johnson, during his early years in London, knew
what it was to wander all night for lack of a lodging, to keep a weather
eye on the look out for the bailiff, and to restrict himself to fourpence a
day for food.

'Oh let me live my own, and die so too!' Pope sighed for blessed
independence:

> Maintain a Poet's dignity and ease,
> And see what friends, and read what books I please:[88]

That end was not beyond reach and Pope himself came closest to it.
Favoured by influential friends—Bolingbroke, Marchmont, Bathurst,
Queensberry—and the champion heavyweight of the booksellers' lists,
he secured his reputation and his well-being. The first half of the eight-
eenth century was an age of 'commerce and computation', and prosperity
in the nation bore up the independent poet. There were penalties to be
paid for this advantage. Dignity and ease are the children of wealth, and
the man who pursues wealth in a greedy age receives the infection from
his quarry. 'Commerce,' wrote Johnson, 'has kindled an universal emula-
tion of wealth . . . money receives all the honours which are the proper
right of knowledge and of virtue.'[89] The court, the lords, the government,
the great merchant, the small tradesman were all votaries of wealth, united
by affluence into the great public. 'See Britain sunk in lucre's sordid
charms,' Pope cried out:

> Statesman and Patriot ply alike the stocks,
> Peeress and Butler share alike the Box
> And Judges job, and Bishops bite the town,
> And mighty Dukes pack cards for half a crown.[90]

Under the pressure of this potent coalition the arts entered into the reign

of commerce. Against this reign and coalition Pope struck with anger and despair in the *Dunciad*.[91]

When the arts become business they are naturally governed by the balance-sheet. The itch for easy profit dictated the desperate practices of an Edmund Curll. But respectable Bernard Lintot was equally bound by the state of the public market. 'Thanks to Homer,' Pope said, 'I live and thrive;'[92] yet only at the cost of ten years of labour on translation, not the fittest work for an original poet. The man of business found his place in all the arts—the theatrical managers, the musical impresarios, the picture-dealers—and became (as Pope observed ironically of Heidegger) arbiters of elegance. Strange arbiters, strange notions of elegance! To spirit the coin from the public pocket, they instituted fashions, blew up the ridiculous passing fad, and attempted to make art into a hackney to transport money from the audience to the bank. Hogarth, like Pope, thought the business of art hateful. He spoke contemptuously of the 'standard of judgment, so righteously and laudably established by Picture-dealers, Picture-cleaners, Picture-frame-makers, and other Connoisseurs'[93] which devalued his own work because it was plentiful and puffed into fashion dismal, foreign pieces by Italian names. He has a sharp satire (that Pope might not have been ashamed of) describing a dealer unloading one of these 'sham virtuoso-pieces' on an English dupe:

> 'O Sir, I find that you are no connoisseur—that picture, I assure you, is in Alesso Baldovinetto's second and best manner, boldly painted, and truely sublime; the contour gracious; the air of the head in the high Greek taste, and a most divine idea it is.' Then spitting on an obscure place, and rubbing it with a dirty handkerchief, takes a skip to the other end of the room, and screams out in raptures, 'There is an amazing touch! a man should have this picture a twelve-month in his collection before he can discover half its beauties.' The gentleman (though naturally a judge of what is beautiful, yet ashamed to be out of the fashion in judging for himself) with this cant is struck dumb, gives a vast sum for the picture, very modestly confesses he is indeed quite ignorant of Painting, and bestows a frame worth fifty pounds on a frightful thing, without the hard name on it not worth as many farthings.[94]

The arts began to suffer the booms and depressions of the business cycle; even opera, the pre-eminent artistic business, could not retain its appeal. Incomes falsely inflated by the accidents of fashion, were as capriciously cut off by the falling out of fashion. A large part of art was at the mercy of a monied society that had lost the ideal of intelligent patronage, and the foundation on which to base a just taste.

This was the chief cause for the animus of men like Pope and Hogarth against commercial exploitation in the arts. Most of the great public, from lords to traders, were sensation-seekers, materialistic and insensitive.

Their demands prevented the growth of art under its own quiet laws; to pander to them was aesthetic death. Roger North put forward the paradox 'that the late improvements of Musick have bin the ruin, and almost the banishment of it from the nation'. Nothing less than perfect facility was now acceptable, and music was no longer alive in the home; 'even masters, unless of the prime, cannot enterteine us.' As the public wanted flashy demonstrations rather than the good order of art, the gain in technique did not make up for the loss in the home:

> And in the performance, each takes his parts according as his opinion is of his owne excellence. The master violin must have its solo, then joined with a lute, then a fuge, or sonnata, then a song, then the trumpet and haut-bois, and so other variety, as it happens.[95]

This was written soon after the death of Purcell. The history of the Italian opera in the next fifty years confirmed North's opinion. This chronicle of conspicuous waste was only slightly redeemed by the genius of Handel; by 1740 even sympathetic Burney had to regard the opera as an artistic failure, and Pope in the expanded version of the *Dunciad*, three years later, wholeheartedly agreed.

As in music, so in the other arts. The 'many-headed beast', the people, were 'Alike in nothing but one Lust of Gold'; the taste of mobs had become the taste of lords, a taste that guaranteed the despicable in every art:[96]

> See, see, our own true Phoebus wears the bays!
> Our Midas sits Lord Chancellor of Plays!
> On Poets Tombs see Benson's titles writ!
> Lo! Ambrose Philips is prefer'd for Wit!
> See under Ripley rise a new White-hall,
> While Jones' and Boyle's united labours fall:
> While Wren with sorrow to the grave descends,
> Gay dies unpension'd with a hundred friends.
> Hibernian Politics, O Swift! thy fate;
> And Pope's, ten years to comment and translate.[97]

Dullness descends upon the land: '*Art* after *Art* goes out, and all is Night.'[98]

FAILURE

Art is not life, and cannot be
A midwife to society.
 Auden, *New Year Letter*.

AT THE END of his life, in the sombre last lines of the *Dunciad*, Pope saw the artist's work undone, the careful pastures given over to disorder:

Lo! thy dread Empire, CHAOS! is restor'd;
Light dies before they uncreating word:
Thy hand, great Anarch! lets the curtain fall;
And Universal Darkness buries All.

His own career, which progressed so fortunately, had seemed to prove the good chances of art. He gained fame, influence, wealth and independence. Yet Pope had hard words for the people and conditions that supported him. The aristocrats and the rich, whose help he had enjoyed so often, were, with a few exceptions, condemned in the Epistles *To Bathurst* and *To Burlington*; their tastes derided, their motives impugned, their achievements dismissed. The public and the merchants of the arts received, in the *Dunciad*, vast measures of the poet's contempt and anger.

The young Pope had set a course to take him into the blessed company of the wits. Here he had expected to make some reputation—

All that we feel of it begins and ends
In the small circle of our foes or friends;[1]

and here he expected to find the stirring, cultivated minds that would give his ideas form and his efforts encouragement. Isolation was now considered no advantage for the artist. The community that grew up around the Royal Society after the Restoration had brought the pursuit of learning, the practice of art, and the Roman ideal of friendship within the limits of a loose, but small association. The habitual presence of the playwright in the best company of his age, Dryden wrote, produced the distinctive successes of Restoration drama.[2] In the early eighteenth century this company had become an essential university for the aspiring artist.

Friendship was more than a private pleasure; conversation among intimates was the initiation into the mysteries of art. Old Dryden and

young Congreve, touchingly sincere in their mutual regard, had shown the value of a true sympathy between the artistic generations. The experience of the old was the tutor of youth: some small revisions by Dryden had helped *The Old Bachelor*, Congreve's first play, to its deserved success. And the young were the interpreters and defenders of the excellencies of a former age: 'no man,' Congreve wrote generously of Dryden's works, 'hath written in our language so much, and so various matter, and in so various manners so well.'[3] When Pope entered the London literary society he no doubt hoped for an artistic education such as Congreve had received. Addison was the reigning power; in December 1711 a favourable review in the *Spectator* of the *Essay on Criticism* had brought young Pope into Addison's circle. But the proceedings of Addison's 'little Senate' at Button's Coffee-house were not to Pope's taste. After a few years Pope broke with Addison and later, with the usual asperity of his wounded self, attacked the old writer as 'Atticus' in the *Epistle to Dr. Arbuthnot*. Reasons for this severe, but telling portrait were not hard to see. Pope was vain and ardent; Addison cold and polite. Pope thought Addison was behind the contract Tickell drew up with Tonson to translate Homer, which naturally seemed to Pope likely to undermine his own *Iliad* and thus deprive him of his long-sought independence. But Pope had reasons beyond pique and jealousy for the truthful harshness of the Atticus portrait. He saw that the Whigs of the 'little Senate' served politics better than literature and allowed party matters to subvert their judgment. And he thought that Addison had failed in the important role of artistic counsellor, demanding precedence without giving guidance. Pope, said Warburton, came to Addison with his plans for improving *The Rape of the Lock*; Addison received them coldly and advised against alteration. 'Mr. Pope,' Warburton added, 'was shocked for his friend; and then first began to open his eyes to his Character.'[4] In the school of friendship Addison was not performing his artistic duty.

The practice of art had become a kind of communal activity. Men of the arts had raised their status so that they could take their place with ease in the best company. In an age respectful to theory and authority, the future of art was often planned by deliberation among cultivated friends. 'In Proportion,' Addison wrote, 'as Conversation gets into Clubs and Knots of Friends, it descends into Particulars, and grows more free and communicative.'[5] Steele's happy notion in the *Tatler*, to date accounts of entertainment from White's Chocolate-house, literature from Will's, politics from St. James's, and learning from the Grecian, reflected the real influence of these gathering-places. The purpose of the *Tatler* and the *Spectator* was,

in a sense, to make the deliberations of the best company known to a wider public, so that, with an increased sensibility, the general public might enter into the making of a well-ordered society. Friends incited a man to work at his art, and when he had finished they looked at the results in the light of a common ideal. Pope drew all his life on the artistic and moral support of his friends. He was introduced to London society under the eye of Wycherley, and the two exchanged the artificial letters that a vain young writer and a fantastic old courtier thought fitting to the dignity of poetry. Later, in the company of Swift, Bolingbroke, Arbuthnot, Gay and a few others, Pope found the friendly spur to poetic plans that the 'little Senate' had failed to provide. Whether he and his companions were discussing gardens with Bathurst at Cirencester, looking out books in Harley's magnificent library at Dover Street, inciting Lady Burlington to new flights of operatic caricature, or acting the butler and pantryman to Lady Suffolk at Marble Hill, new work was always going on, rising out of their intimacy. Marble Hill, Swift's poem claimed, cast its good influence on Pope's muse:

> My groves, my echoes, and my birds
> Have taught him his poetic words.[6]

Out of the satisfactions of their friendship and the similarity of their ideals this company of wits gave birth to the Scriblerus Club, joining together to ridicule 'all the false tastes in learning'[7] and sowing the harvest that time would reap as *Gulliver* and the *Dunciad*. And the same company, in the great houses of Burlington and Chandos, in the years when Handel was a resident in the first and then the composer for the second, fortuitously arranged the beginnings of English oratorio. *Haman and Mordecai*, Handel's ceremonial piece for the opening of Cannons chapel, composed to a text devised by the wits, later reappeared as *Esther*, the first of the English oratorios.

Besides these happy results of association, friends joined together in more formal groups to press forward many of the artistic changes of the age. A club such as the Kit-Cat was a patron in two senses; an employer of the arts, but also a developer of taste and a promoter of styles. Acting in the second sense, it left the greater mark. The paintings by Kneller of the Kit-Cat members were a commission won by the most fashionable portraitist, who, being an outsider to the club, was not inspired by the ideals of the members to a particular style of painting. But Vanbrugh was no mere artistic servant of the Kit-Cats. He was a club member sharing thoughts among equals, and the buildings he put up for the members and

their friends expressed not only his own distinctive genius but also, in a
certain way, the communal will of the club. The English Baroque took its
architecture from Vitruvius and Wren, but its emotion from the sense of
grandeur and confidence enjoyed by the old Whigs of the 1688 revolution.
And when the Baroque in its turn gave way before the Palladians, the new
style grew out of the social consciousness of a younger Whig generation.
Lord Burlington and his friends supported the new architecture with a
missionary zeal as a severe, decent, patriotic kind of building worthy of a
virtuous Whig country. It was no surprise that the Whigs and the
Palladians finally triumphed together. The preaching of Colen Campbell
and Burlington had its greatest effect just as Sir Robert Walpole began his
long reign. No less than fifty major houses were begun in the years 1720–
1724, and this despite the bursting of the financial bubble in 1720.[8] Not all
these houses were built on the Palladian plan. But the successful and
cultivated Whig was likely to have something of the Palladian in him, and
the Whig domination was an encouragement to building:

> Every man now, be his fortune what it will, is to be doing something at his
> place, as the fashionable phrase is, and you hardly meet anybody who, after the
> first compliments, does not inform you that he is in mortar and heaving of
> earth, the modest term for building and gardening.[9]

Respectability came to the arts with social conscience. Those who keep
the best company will find in time that they have the best incomes, the
best houses, and the greatest say in society. By a journey whose twists were
not always foreseen, the arts, which had committed themselves to public
issues in the passionate times after the Restoration, slid by degrees into
political service, and took as their business the moral problems of the
state, saw their followers in the early eighteenth century in the confidence
of the great and busy about affairs. Steele, Kneller, Vanbrugh and
Thornhill were knighted. Addison, on the great stage of the nation, was
Secretary of State, while even Kneller did his best for his adopted
country, becoming a J.P. for Middlesex, a kindly but eccentric interpreter
of English law. Swift, Prior, Addison, Steele had the ear of great ministers;
Congreve and Vanbrugh sat down to supper at Barn Elms with the most
important Whigs in the land; Kent was almost another self to Lord
Burlington; Gay was the intimate of Lady Suffolk and the Queensberrys,
and Congreve was the lover of Henrietta, Duchess of Marlborough. The
cares and advantages of the artist's social position gave much of the work
of the early eighteenth century a new tone, brilliant, easy and worldly, and
a new subject-matter that reflected the contemporary problems of polity
and society. Pope's recommendation to find 'a real beauty in an easy, pure,

7*

perspicuous description'[10] was the counsel of a well-bred man. Whether touching on religion, politics, manners or business, the same pure and easy style prevailed. Reason and clarity served as well for the satire of Swift's *Tale of a Tub* and *Modest Proposal* as for Pope's *Rape of the Lock* and *Dunciad*.

An art that limits itself in the main to social commentary avoids a large part of the individual's experience. Many causes have been put forward for the restrictions that the Augustans imposed upon themselves; they had, some say, too great a respect for the models of antiquity; they burdened themselves with unnecessary rules and authority; and they set up reason at the expense of the imagination. Yet though these things happened, the greater men of the early eighteenth century were not the slaves of their theories. The severity with which Sprat, of the Royal Society, had attacked 'fancy' after the Restoration was considered twenty-five years later too extreme and positive; and nagging according to the strict 'rules', such as the worst efforts of Rymer, Collier and Blackmore, was condemned as blind pedantry. Pope, a great servant of reason, very sensibly allowed the force of imagination in poetry:

> Music resembles Poetry, in each
> Are nameless graces which no methods teach,
> And which a master-hand alone can reach.[11]

And in another well-known passage he exempted the imaginative man from the carping 'rules':

> Great Wits sometimes may gloriously offend,
> And rife to faults true Critics dare not mend;
> From vulgar bounds with brave disorder part,
> And snatch a grace beyond the reach of art,
> Which without passing thro' the judgment, gains
> The heart, and all its end at once attains.[12]

Swift, authoritarian and uneasily rationalist, in a typical black passage gave two occasions when the passions must triumph over the superior force of reason:

> The first is, the propagation of the species, since no wise man ever married from the dictates of reason. The other is, the love of life, which, from the dictates of reason, every man would despise, and wish it at an end, or that it never had a beginning.[13]

Neither Addison nor Steele was a narrow rationalist. The old English writings, much neglected when the Restoration brought in the age of reason, were reviewed sympathetically in the *Tatler* and the *Spectator*. Spenser, Bacon, Shakespeare, Ben Jonson, and Milton most of all, were

recommended to the eighteenth-century reader; Addison also had a fine essay on the beauties of the ballad *Chevy Chase*.

The age no doubt had a grave respect for reason, and its mark can be seen in such different places as the poetry of Pope, the moral preoccupation of Addison, the architecture of the Palladians, the music of Handel, and Reynolds' aesthetic theory. The empirical philosophy of Locke saturated the age, and one must agree with him or attack him. In the first blush of the new dawn after Locke, Blackmore proclaimed the new creed:

> Turn on it self thy Godlike Reason's Ray
> Thy Mind contemplate, and its Power survey.[14]

A few years later Pope found the smart lady of his youth reading 'Malbranche, Boyle, and Locke';[15] at the mid-century Locke, said Warburton, was universal. But however respectful art was to the fashionable thought, it was not overborne by it. If William Kent had acted always according to theory, his life's work would appear to present a most irrational and puzzling division. In his character as architect, he was a great advocate of the rational, chaste, classical virtues of Palladian building; yet in his other character as landscape gardener, he was a discoverer of the serpentine line of beauty, the informal art of the picturesque. Horace Walpole gave this account of Kent's achievement:

> He was a painter, an architect, and the father of modern gardening. In the first character, he was below mediocrity; in the second, he was a restorer of the science; in the last, an original, and the inventor of an art that realizes painting and improves nature.[16]

Discounting the extreme Palladian enthusiasm of Walpole, one may interpret this shrewd comment as follows: Kent was a formal antiquarian in architecture whose achievements were diminished by too much dependence on the 'rules'; but he was a gardener of the first rank, an imaginative artist to the highest degree. Kent managed the two sides of his art very well because he was in fact no rational theorist. He was governed by men more than principles. He was caught in a certain society, of which Lord Burlington was the centre, and he responded, in life and in art, to the communal will of that group. As he was a man with a social position, Kent in his art respected the social responsibilities of that post. It so happened that Burlington and his friends had made architecture a matter of morality and patriotic duty, and Kent was naturally tied by that; but fortunately gardening had no social dogma attached to it, serving only for delight, and Kent was able to approach it with an unfettered imagination. The artist had risen to the dignity of a commission within society, and like

a good soldier he could not allow himself to upset the order for which he
held himself partly responsible. Social considerations became the test of
artistic performance. Both the artist and his work were expected to be
useful and respectable.

A reader once wrote to the *Spectator* wishing to know 'what you esteem
to be the chief qualification of a good poet'. And the authority replied:
'To be a very well-bred man.'[17] W. B. Yeats saw the age of reason in
England working towards 'intelligible laws planned out upon a great
blackboard, a capacity for horizontal lines, for rigid shapes'.[18] The
business of art became to expound the laws, extend the horizontal lines,
frame the rigid shapes. The great purpose of art was to establish a
virtuous commonwealth. After the Restoration morals and manners had
remained corrupted for a long time, and Restoration art had shown itself
indifferent to this corruption. The reformation that swept in at the end of
the seventeenth century condemned any art that would not set itself
against the offences in society. Blackmore, a leader of the reform, wrote
in 1695:

> Our poets seem engaged in a general *Confederacy* to ruin the End of their own
> Art, to expose *Religion* and *Virtue*, and bring *Vice* and *Corruption of Manners*,
> into Esteem and Reputation.[19]

The assumption so hastily accepted by the moralist, that virtue is the end
of art, soon went almost without question. The tincture of morality began
to colour all art. Ned Ward and Tom Brown, those protean Grub-
streeters of the turn of the century, took their readers on a pleasant
excursion round Westminster Abbey, with an eye for the beauties and the
oddities. When Addison follows them not many years later, the journey
is an occasion for vast solemnizations, for reflection on morality.[20] The
founding of the *Tatler* in 1709, and the *Spectator* two years later, brought
the union of art and morality boldly to the public notice, and the great
success of the periodicals blessed the union with popular approval, making
him a rash man who would try to separate them in the future.

The reforming spirit of the *Tatler* was soon noted. John Gay wrote in
1711:

> Instead of complying with the false Sentiments, or Vicious tastes of the Age,
> either in Morality, Criticism, or Good Breeding, he has boldly assur'd them,
> that they were altogether in the wrong, and commanded them, with an
> Authority, which perfectly well became him, to surrender themselves to his
> Arguments for Virtue and Good Sense.[21]

When the *Spectator* came out in March 1711, within two months of the
demise of the *Tatler*, the joint authors set out their moral purpose in

plain writing. The *Spectator* was a work, they told Lord Somers, 'which endeavours to Cultivate and Polish Human Life, by promoting Virtue and Knowledge, and by recommending whatsoever may be either Useful or Ornamental to Society'.[22] The tenth number of the paper amplified this proposal in a small manifesto. Emulating Socrates, Addison promised to make the world a school; he informed his readers that he would try 'to enliven Morality with Wit, and to temper Wit with Morality':

> And to the End that their Virtue and Discretion may not be short, transient, intermitting Starts of Thought, I have recovered to refresh their Memories from Day to Day, till I have recovered them out of that desperate State of Vice and Folly into which the Age is fallen.

The reforming character of the time, in society and in government, particularly among the Whigs, determined the moralizing temper of Addison's writing, and the same spirit soon worked its way into other arts. In 1712 Shaftesbury thought the post-Restoration architecture as wretched as the drama, and condemned the long dictatorship of Wren:

> Thro' several reigns we have patiently seen the noblest publick Buildings perish (if I may say so) under the Hand of one single Court-Architect; who, if he had been able to profit by Experience, wou'd long since, at our expence, have prov'd the greatest Master in the World.[23]

The 'Experience' that Wren had failed to assimilate was political experience, not artistic. In this *Letter concerning Design* Shaftesbury gave no account of the reformed architecture he wished to see; he only insisted that building, and indeed all the arts, should reflect the new England, reformed by the Revolution of 1688:

> Every thing co-operates, in such a *State*, towards the Improvement of *Art* and *Science*. And for the *designing Arts* in particular, such as *Architecture, Painting,* and *Statuary,* they are in a manner link'd together. The Taste of one kind brings necessarily that of the others along with it. When the *free* Spirit of a Nation turns it-self this way, Judgments are form'd; Criticks arise; the publick Eye and Ear improve; a right Taste prevails, and in a manner forces its way.[24]

As Shaftesbury wrote, a style was slowly growing that would meet all his conditions for a reformed architecture. The Palladian taste was plain and severe, based on noble antiquity, and introduced under the impeccable Whig patronage of Colen Campbell and Lord Burlington. When William Benson, Whig M.P., colleague of Campbell and the builder of the first Palladian house,[25] displaced Wren as Surveyor in 1718, it seemed that Shaftesbury's architectural paradise had been realized in England.

At this same time writers on the other 'designing art', painting, were expressing its moral nature. 'The way to be an Excellent Painter,'

Jonathan Richardson wrote in 1715, 'is to be an Excellent Man.' Richardson regarded good portraiture as a lesson in morality: ''tis rational to believe that Pictures of this kind are subservient to Virtue;' and he thought that the best work was always from the hands of the best men: 'Those Works we so highly esteem were Men of Solid Sence, and Virtue.'[26] Fifty years later Sir Joshua Reynolds still holds to this line of thought in his *Discourses*. The painter's struggle to express beauty brings 'refinement of taste', which conducts 'the thoughts through successive stages of excellence, till that contemplation of universal rectitude and harmony which began by Taste, may, as it is exalted and refined, conclude in Virtue'.[27] The moralists also turned their attention to music, for music had the traditional ability to raise or quell the passions more quickly and effectively than any art. Addison, who insisted that good rules come 'from the general Sense and Taste of Mankind, and not from the Principles of those Arts themselves', naturally thought that music should look to its social task:

> Musick is not designed to please only Chromatick Ears, but all that are capable of distinguishing harsh from agreeable Notes.[28]

Addison, like Pope, was possible without 'chromatick ears' himself. But Roger North, a far greater musical authority, after allowing that the pleasures of the senses are beyond rational argument, agreed that music had a moral duty:

> And it must be granted that musick which excites the best, most important and sane thinking and acting is, in true judgment, the best musick.[29]

For this reason he gave the prize to 'the ecclesiastical style' which Addison had also commended, and on the same grounds. Church music, he wrote, 'raises noble Hints in the Mind of the Hearer, and fills it with great Conceptions'.[30] The high moral tone of Handel's oratorio pleased the polite audience who, finding it much superior to the pagan excesses of opera, encouraged Handel to concentrate his resources in the new form.

Pope, the pre-eminent example of the artist fixed in the constellations of society, naturally wrote under the eye of the moral censor. Though in most matters he differed from Addison, Pope also attempted to bring philosophy out of the schools and into the drawing-room. His intention in the *Essay on Man* was to form 'a *temperate* yet not *inconsistent*, and a *short* yet not *imperfect* system of Ethics'.[31] This was a curious task for Pope to set himself. He was no systematic thinker, the philosophizing in his poem being only the clichés of common experience leavened with a plentiful sprinkling of Bolingbroke. Moreover, he was at best a reluctant rationalist,

and the structure of the poem shows his divided mind. The first Epistle sings of divine perfection and human incomprehension. Man's reason is limited; he cannot look beyond his powers into the order of the universe:

> Presumptuous Man! the reason wouldst thou find,
> Why form'd so weak, so little, and so blind![32]

In the last three Epistles, however, the poet himself acts the 'presumptuous man', pointing out just how the world is arranged providentially for the benefit of mankind, and how reason necessarily directs man and society towards certain ends.[33] One may guess that the first part of the poem was the instinctive thought of an imaginative sceptic. The last part was merely a tract for the times on the advantages of 'cosmic Toryism', written as part of a poet's duty to the society he lived in.

When artists work with propriety and social acceptance in mind, they have agreed, at least unconsciously, with Addison's proposition, that the best rules come 'from the general Sense and Taste of Mankind, and not from the Principles of those Arts themselves'. This state of mind encouraged men to take up certain attitudes and develop certain tendencies in their art. Grandeur gave way before convenience. Appreciation of Vanbrugh's imaginative structures, which aimed (in his own words) at a 'Noble and Masculine Shew', did not survive the change of taste. When Vanbrugh began Castle Howard in 1699, enough of the old robust taste survived for him to make his reputation. By the time he was well started on Blenheim, the reformation in manners was already recasting taste and thus making his style out of date and despised. The Duchess of Marlborough, a hard-headed, practical woman, criticized Blenheim from the beginning:

> I never liked any building so much for the show and vanity of it as for its usefulness and convenience, and therefore I was always against the whole design of Blenheim, as too big and unwieldy.[34]

The feelings of the duchess, who had run the gigantic apartments, are understandable. But soon the monumental scale of the building was considered an artistic failing as well as an inconvenience. A satire by Abel Evans, in which Swift and Pope may have had a hand, makes the puzzled inquiry:

> But where d'ye sleep, or where dy'e dine?
> I find by all you have been telling,
> That 'tis a House, but not a Dwelling.[35]

Pope 'never saw so great a thing with so much littleness in it', and thought it a reflection of the owner's arrogance: 'I think the architect built it

entirely in complaisance to the taste of its owners; for it is the most inhospitable thing imaginable, and the most selfish.'[36] And Blenheim, identified to some degree with Timon's Villa, received another blast of condemnation in the *Epistle to Burlington*:

> Lo! what huge heaps of littleness around!
> The whole, a labour'd Quarry above ground.

The epithet 'selfish' gives the clue to Pope's mind; Blenheim was criticized on moral grounds. The vast expenditure on Blenheim, on the Eastbury of Dodington, the Moor Park of Styles, and the Cannons of Chandos, was condemned as an excess that upset the ideal balance of society. In his society, Pope looked for, and did not find, the essential harmony beloved of the Augustans. Therefore, in the Epistles on the Use of Riches, he expected aristocratic patronage to strike a mean between avarice and prodigality, so that great wealth would lead to the general good of the community:

> Who then shall grace, or who improve the Soil?
> Who plants like BATHURST, or who builds like BOYLE.
> 'Tis Use alone that sanctifies Expence,
> And Splendor borrows all her rays from Sense.[37]

'Never was protection and great wealth,' Horace Walpole wrote of Burlington, 'more generously and judiciously diffused than by this great person.'[38] Judicious diffusion was exactly what Pope had in mind when he proposed that Burlington should restore the arts of England:

> You too proceed! make falling Arts your care,
> Erect new wonders, and the old repair;
> Jones and Palladio to themselves restore,
> And be whate'er Vitruvius was before.[39]

Artistic endeavour was nothing without virtue and social conscience. The Epistles *To Bathurst* and *To Burlington* exemplify the fundamental text given to the eighteenth century by the Earl of Shaftesbury:

> Thus are the Arts and Virtues mutually friends; and thus the Science of Vir-tuosos and that of Virtue itself, become, in a manner, one and the same.[40]

The reformation of manners and morals had been called for in the cause of England's future greatness. Once art had put on the modest gown of morality, it was well on the way to patriotic utterance and nationalistic fervour. Shaftesbury, once more the fount of respectable wisdom, saw improvements in the arts as the direct consequence of national power:

> From what I have observed of the rising Generation of our Nation, if we live to see a Peace any way answerable to that generous Spirit with which this War [Marlborough's] was begun and carried on for our own Liberty and that of

Europe, the Figure we are like to make Abroad and the Increase of Knowledge, Industry, and Sense at Home will render united *Britain* the Principal Seat of Arts.[41]

Shaftesbury called the popular habit of the gentry, to travel abroad at an impressionable age, 'a Mistake in Education' which made the rich Englishman overvalue foreign works and despise British. These words heartened English pride. Campbell brought out his *Vitruvius Britannicus* in 1715 to demonstrate that the great buildings of Britain provided a worthy basis for national taste. The Palladian style, forced on by the works of Campbell and his friends, raised up Inigo Jones as the great English master. Palladians claimed to take their principles from Jones as much as from Palladio, and this patriotic gesture helped to make the movement so successful.

Since Addison and Shaftesbury echoed each other in so many of their views, Addison recommended Englishmen to keep not only their bodies at home, but also their minds, and cultivate their virtue rather than devour the small tattle of the news-sheets:

At least, I believe every one will allow me, it is of more importance to an Englishman to know the history of his ancestors than that of his contemporaries, who live upon the banks of the Danube or the Borythenes.[42]

These sentiments, coming from influential men and coinciding with England's successful intervention in the affairs of Europe, pleased the confident spirit of the nation. At this time Handel was just beginning his career as an English composer. He had arrived with a reputation for Italian music, but the feeling he met in England no doubt encouraged him to look back to Purcell for models likely to please English ears. The *Birthday Ode* for Queen Anne in 1713 follows the happy example of Purcell's Welcome Odes in the last reign, and the Utrecht *Te Deum* and *Jubilate* are indebted to Purcell's settings of 1694. As the respect for classical models and foreign criticism had fostered much ill-starred work after the Restoration, the praise for English sources was hopeful indeed. Yet despite the renewed fame of Inigo Jones, despite essays by Addison on the English poets and editions of Shakespeare by Pope and Theobald, and despite Handel's deference to Purcell, the return to English sources did not go very far. This patriotic movement exalted the England of the present, not the glories of the past. Eighteenth-century art was rooted in social and political conditions, not the practice of the past. A country growing in power, responsibility and virtue demanded the recognition of the arts. The names of the past were talismans to encourage the pride in the present. At best, art would embellish and serve the country:

> Bid Harbors open, public Ways extend,
> Bid Temples, worthier of the God, ascend,
> These Honours, Peace to happy Britain brings,
> These are Imperial Works, and worthy Kings.[43]

At worst, art expressed an extreme nationalism, a narrow patriotism abjectly singing the praises of that overbearing colossus, the state. Here is Richardson, in a book on painting:

> There is a Haughty Courage, an Elevation of Thought, a Greatness of Taste, a Love of Liberty, a Simplicity, and Honesty among us, which we inherit from our Ancestors, and which belong to us as *Englishmen*. ... I will venture to pronounce (as exceedingly Probable) That if ever the Ancient Great, and Beautiful Taste in Painting revives it will be in *England*: But not till *English* Painters, Conscious of the Dignity of their Countrey, and of their Profession, resolve to do Honour to Both by Piety, Virtue, Magnaminity, Benevolence, and Industry.[44]

Whatever Richardson might have thought, this blind fervour of patriotic feeling did the arts no good. It soon induced a suspicion and even a contempt for foreigners and their works, and foreign artists resident in England began to suffer. In the first years of the century Laguerre had been prevented from painting the interior of St. Paul's because he was foreign; Halifax had insisted that the commission went to Thornhill. Blessed by ministerial approval, the feeling against foreigners grew. Hogarth had good reason to suspect the foreign picture-dealers, but allowed this animosity to carry over to foreigners in general. He condemned most foreign painters out of hand, and he enjoyed placing ridiculous foreigners in his prints. The fiddle player in the *Enraged Musician*, driven to distraction by the noises of the town, is certainly foreign, most probably Castrucci, the leader of Handel's operatic band. And the 'Toilet Scene' in *Marriage-à-la-Mode* includes a sharp satire on Carestini, the castrato, and Weideman, a German flute-player. The excesses of opera were worth satirizing; but the fault lay in the taste of the audience, not in the interpreters, many of whom were extremely gifted performers. The indignation at the trash of opera, which should have been impartially visited on the heads of the impresarios, the aristocracy and the public, fell instead on the unfortunate foreign performers. Even a judge as sober as Roger North was inclined to see greedy foreigners behind the problems of English music:

> Anciently musick was in some sort pastorall, that is plain, practical, and good. Now it is set up drest in superlatives brought from I know not whence, at imense charges in profuse salarys, pensions, subscriptions, and promiscuous courtship and flatterys into the bargain. These farr fetcht and dear bought gentlemen returne home rich, buy fine houses and gardens, and live in admiration of English wealth and profusion.[45]

The service of national prejudice also licensed much vulgar thumping and empty rodomontade. The unworthy panegyrics of state policy have been mentioned in another chapter. Handel had discovered in Purcell a pure spring of musical ideas. Yet whenever he took some glory of the English nation as a starting point, his music limped. Works like the Dettingen *Te Deum* bore on, dull and repetitious. The flawed masterpiece *Solomon*, a celebration of the golden age of George II, sets great beauties amidst weary passages and conventional pieties. To suit the fervent nationalism of the people after the defeat of the '45 rebellion, Handel, in the least vital period of his prodigious career, wrote the *Occasional Oratorio*, and then *Judas Maccabaeus*, the first a perfunctory piece of propaganda, and the second marrying some lovely music to a ranting story of national glorification.

The road to nationalism led the arts into the house of party politics. Once art undertook to instruct and improve the people, and to glorify the image of the nation, it stained itself with party colour. All men, and not only the active propagandists, acknowledged their political attachments. Addison, seeing the destructive rage of party feeling, promised to keep the *Spectator* free of politics, 'as I am very sensible my Paper would lose its whole Effect, should it run into the Outrages of a Party'.[46] Later, he congratulated himself on his neutrality: 'my Paper has not in it a single Word of News, a Reflection in Politicks, nor a Stroke of Party.'[47] He deceived himself, for he could not hide his essential Whiggishness. Within three numbers he was supporting Whig fiscal policy, and thereafter he always praised the trading state and the virtues of merchants. The *Spectator* came out for Marlborough just before his fall, and resolutely called for a Hanoverian succession, much to the anger of the Tories. The members of the *Spectator* Club also wore their party labels. Sir Roger de Coverley and Will Honeycomb were Tories, both kindly satires of Tory attitudes; Sir Roger was the eccentric squire, and Will a harmless relic from the unreformed days before the cleansing effect of the 1688 revolution. Set against them, and the corrector of their foibles, was Sir Andrew Freeport, the prosperous Whig merchant, full of prudence, sense and self-satisfaction. Even the innocent pursuit of architecture became a party matter. The desire of the Lords and the Commons to gain stature and influence in the country encouraged the construction of new houses:

> One large room, a serpentine river, and a wood are become the absolute necessities of life, without which a gentleman of the smallest fortune thinks he makes no figure in his country.[48]

It has been calculated that seventy-one per cent of the new country

houses begun between 1710 and 1725 were built by peers or Members of Parliament.[49] And the predominance of the Whig party caused the predominance of the Palladian taste. It is a curious matter how political was the Palladian enthusiasm. Shaftesbury, who proposed the patriotic style of building, was a Whig. The disciples, Campbell and Benson, who gave the basis for the new taste, were Whigs, the first supported by Halifax and Argyll, and the second a Member of Parliament. *Vitruvius Britannicus* and the translation of Palladio's *I quattro libri dell' architettura* by Dubois with plates by Leoni, the two books which inaugurated the Palladian era, were both dedicated to George I. A Palladian house became a 'flaunting symbol in architecture of territorial Whiggery'.[50]

To make art speak in party accents, to govern it by party opinion, was an unnatural business that did little good. A man in the grip of vehement opinions on society and policy, could make these issues inform his work with powerful results. Swift had a great suspicion of human motives, and saw a limit to man's good intentions:

> It is the mistake of wise and good men that they expect more Reason and Virtue from human nature than taking it in the bulk, it is in any sort capable of.[51]

This conviction made him hold fast to established authority wherever he found it, in the Church, in state, in ethics, in social organization. The Whig notion of progress, which threatened to subvert the Anglican Church and shift power from the landowners to the merchants, became hateful to him. 'Whatever be the Designs of innovating men,' he wrote, 'they usually end in a Tyranny.'[52] As he was entirely possessed by his own ideals of Justice and Freedom, he threw his talent in a mighty onslaught against the tyranny he saw implicit in the England of his day. His politics were the making of his art. But in too many other cases politics were a hindrance to performance. Perhaps politics were slipped in to assure the public that the artist had his social responsibility in mind, perhaps they were a salute to propriety. Even Pope, the confirmed apolitical man, fell in the attempt to govern poetry by politics. The badness of the *Essay on Man*, its disjointed structure and its paltry thought, was caused by a desire to instruct his readers with a poetic version of Tory philosophy.

Men who presume to direct public morality must attempt 'to trace the passions to their sources, to unfold the seminal principles of vice and virtue'.[53] Since art struggled to implant virtue and responsibility in the commonwealth, it worried excessively about the relation of reason to the passions. The fear of what the disreputable passions might do to the good order of society made the arts watch carefully lest they raise up these demons. The problem was most acute in music, traditionally thought

able to go behind reason and stir the passions. To move the passions, Hawkins wrote, was 'the most excellent attitude'[54] of music, and most eighteenth-century writers agreed with him. Roger North made the ordinary observation that major keys were appropriate for joy, and minor for sorrow. Allowing, then, the affective power of music, the theorists were anxious to prevent to abuse of this power. The purpose of music was to fix 'the Heart in a rational, benevolent, and happy tranquillity',[55] and music which failed to do this, which disordered the emotions, was bad music. Church music and other 'pathetic' music was socially right, while 'violent' music, even that of the great master Handel, was wrong.[56] No man was expected to deny his passions; Pope, Swift, North and Richardson all agreed that the passions well-ordered had their proper place in the making of the virtuous man:

> Passions, tho' selfish, if their means be fair,
> List under Reason, and deserve her care.[57]

Passion was to be governed by Reason which itself could not go wrong so long as it followed Nature: 'Suffice that Reason keep to Nature's road.'[58] This golden rule was easily proclaimed; it was much more difficult to decide just what 'Nature' expected of the arts.

This doubt made the arts wary and liable to choke themselves with rules not so much designed for the creation of great work, but rather for the prevention of offences against decorum. Antiquity was much admired because the contemporary world saw there the example of great men, and the practice of the great carried natural authority. 'The sound rules of Grecian Architecture,' said Reynolds of Vanbrugh's buildings, 'are not to be lightly sacrificed.'[59] Richardson recommended a painter to follow the Italians on the grounds that they were the true successors to the Romans: 'No wonder then that as Ancient *Rome*, so Modern *Italy*, has carry'd Painting to such a Height.'[60] And architecture looked through Palladio and Inigo Jones to the Roman Vitruvius. The string of observations that Pope ran together in his *Essay on Criticism* were all taken from the ancients, and though many of his points are sensible they can hardly be called fresh or unusual. Pope's own practice, both in his technique and in his subject matter, was a model of decorous control. He limited himself to the heroic couplet and shaped it into his own instrument with the greatest art, using surprising variation within the formal bounds of his couplet, and making it capable of all the kinds of wit. Yet despite his absolute mastery of form and his quite marvellous command of language he delivered nothing but the consensus opinion of his age, presenting it beautifully expressed with lucid ease, but displaying after a very short

acquaintance its perfect banality and lack of imaginative fire. Contempt, as in *The Rape of the Lock*, or anger and hatred, as in the *Dunciad*, sometimes forced real emotion into his work, but most often passions were well under the control of a complacent reason. The two satires that Hogarth did of *Burlington Gate*, in 1724 and 1731, were complaints of a young unbound imagination against the dead hand of artistic conformity imposed by Burlington, Pope and Kent.

Pope was blind to the real condition of art in England. He saw the formation of taste as the prerogative of a select band of wits, supported by aristocrats, all under the great patronage of the monarchy. He urged Bathurst and Burlington to recall the aristocracy to its artistic duty:

> To balance Fortune by a just expence,
> Join with Oeconomy, Magnificence;
> With Splendor, Charity; with Plenty, Health;
> Oh teach us, BATHURST! yet unspoil'd by wealth!
> That secret rare, between th' extremes to move
> Of mad Good-nature, and of mean Self-love.[61]

He assured Burlington that his efforts would have the applause of the monarchy; for the just and intelligent uses of art, to the benefit of the land, are 'Imperial Works, and worthy Kings'.[62] This was a grand but illusory vision. Bathurst and Burlington were rare indeed, their fellow peers being busy about the affairs of a commercial state with increasing international power. And the monarchy, the supposed founthead of taste, had abandoned the arts almost entirely. Pope's little band of arbiters, men of position, wealth, intelligence, and above all responsibility, no longer existed. The public had begun to call the tune.

'We cannot vie with these Italian and Gothic theatres of art,' Hogarth said, 'and to enter into competition with them is ridiculous; we are a commercial people, and can purchase their curiosities ready-made, as in fact we do.'[63] Hogarth understood that the European traditions of the Renaissance, dependent on aristocratic patronage, could not apply in the modern commercial state. The artist must reconcile himself to a new society and a new audience and not pine away in regret for a departed era. Hogarth's determination to respect reality made him very out of step with the polite opinion of his age. He was no worshipper of the past. 'I grew so profane,' he wrote, 'as to admire Nature beyond the finest pictures and I confess sometimes objected to the devinity of even Raphael Urbin Corregio and Michael Angelo for which I have been severely treated.'[64] He saw classical theory as the destroyer of native tradition; the first print of *Burlington Gate* has an old woman wheeling Shakespeare, Ben Jonson,

Dryden, Otway and Congreve to the wastepaper shop while Burlington, Kent, the impresario Heidegger, and the singer Cuzzoni debauch the public taste with their importations. Discovering the 'serpentine line of beauty', Hogarth paid attention to nothing but 'nature', and though he never defined nature it is certain he found there a loose order, a subtle variety beyond the reach of the formalists and the rules. Symmetry, uniformity, regularity, he rejected. He understood well that they served social purposes, but daringly asserted, contrary to the whole respectable opinion of his age, that social convenience is not a sufficient law for art:

> [Symmetry] may indeed have properties of greater consequence, such as priopriety, fitness, and use; and yet but little serve the purposes of pleasing the eye, merely on the score of beauty.[65]

Since Hogarth was his own master, aiming only to please himself and to sell his paintings and prints, he could attack the connoisseurs with impunity. He shared nothing with them; he did not need their patronage, and took nothing from their theories. Public favour and commercial success secured Hogarth's imaginative freedom.

The signs were clear that the arts were in the morning of a new and commercial age. The *Spectator* only survived after the Stamp Act of 1712 by doubling its price and seeking out more advertising. Addison was the grand director of morality, but his efforts would have been in vain without the astute business sense of Steele who attracted to the paper's columns every kind of advertisement, from the reputable and the charlatan alike. Addison's attempt to revive the *Spectator* in 1714, without Steele's help, failed because he could not secure the volume of advertising required.[66] Even Richardson, an uncompromising idealist, had to admit that a painter was a professional man with talents for hire. But he hoped that the unfortunate necessity to make money would not lower the high standard of the painter:

> What Rank a Painter (as such) is to hold amongst these *Money-Takers* I submit to Judgment, after what I have said has been consider'd; and I hope it will appear that they may be placed amongst those whom all the World allow to be Gentlemen, or of Honourable Employments, or Professions.[67]

But art was as yet uneasy in the presence of the public. Having lost the patronage of the few, it stumbled under the rule of the many. The change of patrons very nearly killed English music. Purcell, who spent a working life in the King's Musick, had been able to assimilate Italian elements into the native English tradition. The King's Musick, cast adrift by the monarchy, ceased to be a force in English music at about the time Purcell died. When Handel arrived he had only the public to please,

and he gave them Italian opera unadulterated; for the public cared only for the latest fashion, and had no interest in preserving the English tradition. At the same time, as Roger North tells us, public concerts, by professional musicians with fine techniques, were driving music out of the home. It was serious enough that a foreign style played by foreign performers should be the rule; but the fact that the fashionable music was vocal music made the state even more disastrous. For the music was set to Italian words, and so English music lost touch with the language. When the public finally revolted against the excesses of opera, the condition of music was not improved. The new demands of the public took music two ways. *The Beggar's Opera* pointed one direction, and oratorio the other. Dr. Arbuthnot had called John Gay's work the 'touchstone to try British taste on', and a thoroughly dull and conventional musical taste it revealed. Pepusch had arranged for Gay a number of old English songs; but he dressed the folk-tunes in the fashionable square, diatonic shape, and obscured the traditional beauties of the old modal melodies married so marvellously to their ballad words. *The Beggar's Opera*, a patriotic work satirizing the foreign silliness, did not prevent the Italian opera from plodding on for many a year, though its prosperous days were over by 1737. By a great irony, it did prevent the growth of a proper English opera, for the English audience was perfectly satisfied with the rum-ti-tum ballad operas of Gay and his many imitators, and saw no need for serious opera in English.

The influence of oratorio was even more lamentable. Here was another Italian import introduced by Handel without any thought of the English tradition. The first performances were given by Italian singers straight from the opera house, and Handel never quite got to grips with the English language, which he always spoke imperfectly. But his desire to please popular sentiment was a startling success. His oratorios were by no means all on religious subjects, nor did they all express moral thoughts and noble actions. His audience, however, was determined to see in them these qualities. Even a critic as acute as Burney, who was living at the time, wrote that after 1740 Handel 'never set any other words than English and those wholly confined to sacred subjects'.[68] Despite Handel, the public imposed upon oratorio a sham religiosity that reflected the respectable opinion of the period. The people came to oratorio, seeking not the life and beauty of the music, but pious sentiment and uplifting emotion. Once again art was undermined by social and moral expectations. An intelligent lady, after hearing *Belshazzar*, typically commented on an impressive moment 'where the name, Jehovah, is introduced first with a

moment's silence, and then with a full swell of music so solemn, that I think it is the most striking lesson against common genteel swearing I ever met with'.[69] Music had no chance against this approach.

Whichever way Pope looked at the end of his life, he could see reasons for depression. In the public market, literature was at the mercy of the Curlls, the theatre in the hands of the Cibbers, and music governed by the Heideggers. In the world of the private patron, matters were as bad, though Pope did not say so. Gross monarchs neglected art, and aristo-crats had turned to trade and politics. The Palladians had stamped on architecture an unimaginative propriety. The long and prolific course of Stuart portrait-painting was coming to a tired end. Kneller died in 1723, and Michael Dahl, the last of the school, died in 1743, the year before Pope. To Pope it seemed as if the chances had not been taken. The wide social and political changes at the end of the seventeenth century had persuaded him, and many others, that art had an important place in the new dispensation; that art was no longer anybody's servant, but a guide to kings and governments, and the teacher of the people. And in achieving this, art also became its own master, free from the wretched pulls of a patron. Pope was wrong. The artist as a public figure did not survive. He put his imagination under the discipline of an official tutelage, and then found that government took little notice of him anyway. And the ignorant public was soon instructing its teacher, for a decent income could only be won by giving way to public demand. There were hard lessons to learn. Artists had to give up all hope of making the rules of society, and become servants once more. The old patronage of the king, the court and the lords had fallen away; the new patron, the problematic public, was waiting to take over. But to be a servant again was a relief. A legislator shares in, and is bound by, the aims of his society. The servant takes his master's money, and keeps his mind his own. He is free to make what noises he likes in the servant's hall.

NOTES

Chapter 1

1. John Walker, *Sufferings of the Clergy* (1714), ii, 63.
2. Ibid., i, 253.
3. See H. C. De Lafontaine, *The King's Musick* (1909).
4. C. H. Collins Baker, *Lely and the Stuart Portrait Painters* (1912), i, 91.
5. *Athenae Oxoniensis*: ed. Bliss (1817), iii, 462.
6. Cowley, *Works* (1668), Preface.
7. HMC 6th Rep: see Baker, *Lely &c.*, i, 142.
8. *Nat. Hist. of Wiltshire* (1847), 84.
9. J. Lees-Milne, *Age of Inigo Jones* (1953), 211–2, 186–7.
10. *The Schoole of Abuse* (1579), Arguments and Sayings.
11. *Anatomie of Abuses* (1585), 200.
12. *Histrio-Mastix* (1633), 289.
13. SP Dom. 18 vol. 153: quoted P. Scholes, *Puritans and Music* (1934), 282–3.
14. *Diary*, 12 July 1654.
15. Jenkins's salary with the Norths at Kirtling was £1 a quarter.
16. Details of musical publications appear in F. Kidson, *British Music Publishers* (1900).
17. Wood, *Life and Times*: ed. Clark (1891–1900). Weekly clubs at Oxford, Oct. 1656, Sept. 1659; Wood's musical training, Feb. & Sept. 1653, Jan. 1657, July 1658.
18. *Roger North on Music*: ed. Wilson (1959), 34.
19. *Diary*, 13 June 1649, 30 Jan. 1654; 1 Aug. 1652, 4 Mar. 1656; 28 Oct. 1655.
20. *North on Music*, 294.
21. Dugdale to Langley: quoted Scholes, *Puritans and Music*, 144.
22. See A. Harbage, *Annals of Eng. Drama* (1964), 136.
23. See H. E. Rollins, 'A contribution to the history of the English Commonwealth drama', *SP*, XVIII (1921), 267–333, and *SP*, XX (1923), 52–69.
24. T. Forde, *Faenestra in Pectore* (1660), 56: in Rollins, *SP*, XX (1923), 53.
25. Aubrey, *Brief Lives*: Davenant.
26. *Areopagitica* (1644), 30.
27. *Catch that Catch can* (1652), Introduction.
28. Wood, 'Notes on Musicians', quoted Scholes, *Puritans and Music*, 135.
29. Letter to Cromwell, 17 Dec. 1710.
30. *The Flaming Heart: Upon the Book and Picture of the seraphical Saint Teresa* (1652).
31. *Religio Medici*, ii, sec. xi.
32. SP Dom. Charles II, vol. 5, 74, 1.
33. *Poems by J. C.* (1657).
34. Shirley fought for the King, and then became a schoolmaster in London. In 1653 he published *Six New Playes* (five in fact were old). On 26 March 1653 his masque *Cupid and Death* was performed for the Portuguese ambassador.

35. *Areopagitica*, 21.

36. The best account of Fuller's career is the anonymous *Life of Dr. Thomas Fuller* (1661).

37. See Lees-Milne, *Age of Inigo Jones*, 170–76.

38. BM Add. MSS. 23069.

39. For Jones's Will, see P. Cunningham, *Life* (1848), App. E.

40. Collins Baker, *Lely and Stuart Painters*, i, 147, 154.

41. Ibid., i, 106–7.

42. J. Pulver, *Biog. Dict. of Old Eng. Music* (1927), 284.

43. M. Whinney, 'John Webb's drawings for Whitehall Palace', *Walpole Soc.* XXXI (1942–3).

44. Collins Baker, *Lely &c.*, ii, 132, App. I.

45. *Works* (1668), Preface.

46. *Human Nature: Eng. Works* (1839–45), iv, 32–3.

47. See C. V. Wedgwood, 'The Last Masque', in *Truth and Opinion* (1960), 139–56.

Chapter 2

1. Aubrey, *Brief Lives*: Monk.

2. 'When his famous poem first came out in the year 1660,' says Eugenius in the *Essay of Dramatic Poesy*, 'I have seen them reading it in the midst of 'Change time; nay so vehement they were at it, that they lost their bargain by the candles' ends.'

3. *Iter Boreale* (1660).

4. A. Bryant, *Charles II* (1931), 81.

5. *A Character of King Charles II* (1750), 7–8.

6. Pepys, *Diary*, 8 June 1660; 22 Nov. 1663; 31 Dec. 1662.

7. Aubrey, *Brief Lives*: Hobbes.

8. *North on Music*, 300.

9. *Character*, 5–6·

10. *To his sacred Majesty, a Panegyric on his Coronation* (1661).

11. See Lafontaine, *King's Musick*, entries between Aug. 1660 and Feb. 1664.

12. Webb's comment on Denham's appointment.

13. Cibber, Dedication to *Ximena, or the Heroic Daughter* (1719).

14. See E. S. de Beer, 'Later life of Samuel Butler', *RES*, IV (1928), 159–66.

15. *Paradise Lost*, vii, 27–28.

16. 'Some Observations concerning the People of this Nation': quoted by C. H. Firth, *Hist. Review*, XVIII, 319..

17. Burnet, *History* (1897), i, 127.

18. Hamilton, *Memoirs of the Count de Gramont* (1889), i, 123.

19. Cominges to Lionne, 2 Oct. 1664: in J. J. Jusserand, *A French Ambassador at the Court of Charles II* (1892), 91.

20. Cominges to Louis XIV, 5 July 1663: Jusserand, 89.

21. *A Character of England as it was presented to a Nobleman of France* (1659).

22. *Gramont*, i, 190.

23. *Character*, 32–3.

24. Ibid., 23.

25. Cominges to Lionne, 23 June 1664: Jusserand, 116–7.

26. *Character*, 45.

27. Horace Walpole, *Anecdotes of Painting*: ed. Dallaway and Wornum (1888), ii, 92–3. The verse is from Pope, *Imit. of Horace*, i, 150.

28. *Essays of John Dryden*: ed. Ker (1900), i, 29.

29. A. Beljame, *Men of Letters in the 18th Cent*: ed. B. Dobrée (1949), 79–83.

30. Ibid., 81–2.

31. *Diary*, 1 Oct. 1661.

32. Walpole, *Anecdotes*, ii, 98 (n).

33. Aubrey, *Brief Lives*: Hobbes.

34. *Diary*, 18 Jan. 1671.

35. Aubrey, *Brief Lives*: Wilkins.

36. *Essays of Dryden*, i, 124.

37. Dedication to *The Rival Ladies*.

38. Shadwell, *A True Widow*, Act 3.

39. *Gramont*, ii, 21–2.

40. Ibid., i, 190–1.

41. *Diary*, 5 May 1664.

42. *Diary*, 25 Feb. 1666.

43. Pepys, 6 Jan. 1668.

44. Pepys, *Private Corres* (1926), 110–11: *Diary*, 9 Nov. 1660.

45. Evelyn, 14 Aug. 1661.

46. 10 Jan. 1684; 13 June 1684; 19 Apr. 1687.

47. J. Harley, *Music in Purcell's London* (1968), 25–6.

48. *Diary*, 30 July 1666.

49. Pepys, *Diary*, 28 July 1666.

50. 2 Sept. 1666.

51. Evelyn, *Diary*, 13 Mar. 1687; 18 Dec. 1691.

52. Harley, *Purcell's London*, 37.

53. Ibid., 24.

54. C. E. Ward, *John Dryden* (1961), 249–51. See also R. G. Ham, 'Dryden's Dedication for the *Music of the Prophetesse*', *PMLA*, L (1935), 1065–75.

55. *Diary*, 20 Oct. 1662.

56. Ibid., 11 Apr. 1669.

57. A Powell, *John Aubrey and his Friends* (1963), 100–1.

58. *Diary*, 10 Feb. 1671.

59. *Lives of the Poets*: Dryden. The comment on Anne Killigrew's death is by Anthony Wood.

60. J. Summerson, *Architecture in Britain* (1953), 117.

61. *To My Lord Chancellor* (1662).

62. Dedication to *Marriage à la Mode*.

63. Walpole, *Anecdotes*, ii, 99–100.

64. *Satire on the Poets* (1694). See B. Harris, *Charles Sackville, 6th Earl of Dorset* (1940), Pt. IV, for an account of Dorset's patronage.

65. Prior, *Poems* (1733), 111, ii-iii.

66. *Works of Mr. John Oldham: Together with his Remains* (1770), 1, v.

67. *Satire on the Poets*.

68. V. Sackville-West, *Knole and the Sackvilles* (1922), 151: quoted in Harris, *Dorset*, 177.

69. S. Centlivre, Ded. to *Love's Contrivance*; Aphra Behn, *Pindarick Poem on Coronation of James II*.

70. *Miscellanies over Claret* (1697).

71. See V. de Sola Pinto, *Sir Charles Sedley* (1927), 94 (n).

72. Harris, *Dorset*, 196–7.

73. Ward, *Dryden*, 241.

74. Harris, *Dorset*, 201.

75. *History* (1897), i, 476.

76. *Letters of Wit, Politicks and Morality* (1701).
77. Ded. to *Essay of Dramatic Poesy*: Ker, i, 24.
78. Dryden, Ded. to *The Rival Ladies*: Ker, i, 7.
79. Collins Baker, *Lely and Stuart Painters*, i, 166.
80. *Anecdotes*, ii, 117.
81. BM Harl, MSS. 7338.
82. Roger North was not impressed with this experiment. See *North on Music*, 212.
83. *Diary*, 8 July 1660.
84. *Diary*, 21 Dec. 1662.
85. Shadwell, Epilogue to *The Lancashire Witches*.
86. Luttrell, *A Brief Relation* (1857), i, 311.
87. See E. N. Hooker, 'The purpose of Dryden's *Annus Mirabilis*', Huntington Lib. Quar., X (1946), 49–67.
88. *Life* (1843), 1004.
89. Dryden, Ded. to *Marriage à la Mode*.
90. *Gramont*, ii, 48.
91. *Poems on Affairs of State*: ed. Lord (1963), i, 424.
92. Powell, *Aubrey and his Friends*, 256(n).
93. *A Duel of the Crabs*.
94. Pepys, *Diary*, 23 Oct. 1668.
95. It was once thought that Rochester had something to do with this affair, but that now seems unlikely. See J. H. Wilson, 'Rochester, Dryden and the Rose Street Affair', *RES*, XV (1939), 294–301.
96. *Anecdotes*, ii, 102.
97. Collins Baker, *Lely and Stuart Painters*, i, 148.
98. *Camden Soc. Pub.*, Wills.
99. C. H. Collins Baker, 'Lely's financial arrangements with Charles II', *Burlington Mag.*, Oct. 1911, 43–45.
100. Dallaway in *Anecdotes*, ii, 161.
101. Pepys, *Diary*, 21 March 1669.
102. Lafontaine, *King's Musick*, 19 Aug. 1663.
103. Ibid., pp. 124, 208, 268.
104. Ibid., 13 Dec. 1679.
105. Ibid., 27 Jan. 1676. See also Henry Cooke's fees for teaching and looking after the Children (10 May 1669).
106. Ibid., 17 Apr. 1668.
107. Ibid., 5 June 1677; 21 Sept. 1686.
108. *Diary*, 19 Dec. 1666.
109. Ward, *Dryden*, 79, 85, 99.
110. Malone, *Life of Dryden* (1800), 444–48.
111. Beljame, *Men of Letters*, 112.
112. Buckingham, *Epistle to Captain Julian*.
113. Shadwell, Prologue to *The Squire of Alsatia*.
114. Downes, *Roscius Anglicanus* (1886), 35–36. Crowne's *Calisto*, a masque presented at Whitehall in 1675, cost a farthing short of £3,527, of which the musicians and dancers received only £234 5s. See E. Boswell, *Restoration Court Stage* (1932), 177–227.
115. Beljame, *Men of Letters*, 108 (n).
116. Buckingham, *Epistle to Captain Julian*.

Chapter 3
 Lives of the Poets: Waller.

2. *Lives of the Poets*: Dryden.

3. Ibid.: Waller.

4. *Jonson's Conversations with Drummond* (1842). 3.

5. *Essay on the Dramatic Poetry of the Last Age*: Ker, i, 172. See also J. Kinsley, 'Dryden and the Art of Praise', *Eng. Studies*, XXXIV (1953), 57–64.

6. Johnson, *Lives of the Poets*: Waller.

7. *Astraea Redux*, 296–99.

8. Hobbes, *Eng. Works*, IV. 413.

9. Jusserand, *French Ambassador*, 100.

10. Ibid., 144.

11. Ibid., 104, 106–7.

12. *Poems on Affairs of State*: ed. Lord, i, 52.

13. Ibid., i, 138.

14. Ibid., i, 165.

15. *Lives of the Poets*: Waller.

16. Ibid.: Dryden.

17. See R. F. Jones, 'The originality of *Absalom and Achitophel*', *Mod. Lang. Notes*, 46 (1931), 211–18.

18. 'On Mr. Edward Howard upon his *British Princes*', *POAS*, i, 339.

19. 'On the same Author upon his *New Utopia*', *POAS*, i, 341.

20. 'My Lord All-Pride', *POAS*, i, 414.

21. 'An Epistolary Essay from M.G. to O.B.', *POAS*, i, 340.

22. 'An Allusion to Horace', *POAS*, i, 358.

23. 'An Essay upon Satire', *POAS*, i, 412.

24. Beljame, *Men of Letters*, 142–43. Although the King's party had control of the stage, a number of Whig, or anti-Catholic plays, were written, i.e. Settle, *Pope Joan* (1680); Lee, *Lucius Junius Brutus* (1680 suppressed); Tate, *Richard II* (1680 suppressed but acted under title of *Sicilian Usurper*); Crowne, *Henry VI, Pt. 1* (1681 suppressed); Shadwell, *Lancashire Witches* (1681 heavily censored). After the death of Shaftesbury on 21 Jan. 1683 the number of political plays diminished.

25. Ded. to *Pope Joan*.

26. *Vindication of the Duke of Guise*.

27. Letter to Henry Savile, 21 Nov. 1679.

28. *Christianity not Mysterious* (1696), 25.

29. *Essay concerning Human Understanding*, 4, 18, 11.

30. *Second Treatise of Civil Government*, 8, 95.

31. Ibid., 9, 124.

32. *Religio Medici*, 1, 9. For this comparison see Basil Willey, *Seventeenth Century Background* (1934), 269.

33. *Origin of Honour* (1732), 31.

34. Bayle, *Hist. and Critical Dict.* (1710): art. on 'Pyrrho'.

35. *Parallel of Poetry and Painting*: Ker, ii, 127.

36. Johnson, *Lives of the Poets*: Dryden.

37. Ker, i, lx.

38. *Apology for Heroic Poetry*: Ker, i, 189.

39. Act II, scene 1.

40. Act I, scene 1.

41. Sir Fopling Flutter, *Man of Mode*, Act IV, scene 1. The sentiment was stolen by Crowne for Sir Courtly Nice (Act III, scene 2).

42. *A Defence of Sir Fopling Flutter* (1722), 8.

43. *The Country Wife*, Act III, scene 2.

44. *Ratisbon Letterbook*, 10/20 March 1686–7.

Chapter 4

1. *The Petty Papers*: quoted in N. G. Brett-James, *The Growth of Stuart London* (1936), 508.
2. Cominges to Lionne, 19 Apr. 1663: Jusserand, 119.
3. *Londinium Redivivum*. For the state of London at the Restoration, see W. G. Bell, *The Great Fire* (1923), Ch. 1.
4. Malcolm, *Londinium Redivivum*, iv, 73: quoted in Bell, *Great Fire*, 24.
5. *London Gazette*, 27 Sept.–1 Oct. Knight's plan is given in Bell, *Great Fire*, 241–42.
6. *Diary*, 31 Dec. 1666.
7. *Fables of the Bees*: ed. Kaye (1924), i, 359.
8. H. M. Colvin, *Biog. Dict. of Eng. Architects* (1954), 3. These increasing sums seem to indicate a real prosperity, and not just an inflation of wages and prices. In 1696 the contractor for the Earl of Nottingham at Burley was offering 'a good mason' 10s. to 12s. a week. At 2s. 6d. a day Fulkes in 1664 would earn 15s. for a six-day week. One would expect the London rate to be higher than that in Rutland. In other words, a mason's wages remained roughly the same for thirty-two years. See H. J. Habakkuk, 'Daniel Finch, 2nd Earl of Nottingham: His House and Estate', in *Studies in Social History*: ed. Plumb (1955).
9. *Lives of the Norths*: ed. Jessopp (1890), iii, 60.
10. Brett-James, *Stuart London*, 361.
11. Wren, *Parentalia* (1903), 135–7.
12. *An Apology for the Builder*.
13. Wren was also alive to the question of cost. St. Paul's, a national monument, was rebuilt without too much worry over expense. A schedule of Wren's, dated 1711, put the cost at £736,752 2s. 6d. Money for the City churches was not so easily available. The most expensive City church was St. Lawrence Jewry, at £11,870 1s. 9d. Only two others cost over £10,000, and a number cost less than £5,000. Very good value indeed.
14. Walpole, *Anecdotes*, ii, 202.
15. *Theory of Painting* (1725), 39–40.
16. Pepys, *Diary*, 1 Feb. 1669.
17. Whitehall, *Urania*, a poem in praise of Streeter's decorations in the Sheldonian.
18. Evelyn (10 Feb. 1671) commented on Streeter's impressive scenery for Dryden's *Conquest of Granada*.
19. Walpole, *Anecdotes*, ii, 191–92, 280 (n).
20. *Gilpin's Scot. Tour*, i, 6.
21. Rev. J. Dallaway: in Walpole, *Anecdotes*, ii, 83 (n).
22. Eric Halfpenny, 'The "Entertainment" of Charles II', *Music and Letters*, XXXVIII (1957), 32–45. Matthew Locke composed special music for the occasion.
23. Evelyn, *Diary*, 21 Sept. 1671.
24. *Diary*, 29 Oct. 1663.
25. Harley, *Music in Purcell's London*, 114.
26. Persons, *An Anatomical Lecture of Man* (1664): quoted in Harley, 135–36.
27. Ned Ward mentions rows of seats and a rail at Wapping. Roger North, describing Banister's concert-room, modelled on the taverns, mentions tables and chairs, and a curtained side-box: *North on Music*, 302.
28. Ward, *The London Spy*, Pt. XIV
29. Pepys, *Diary*, 21 Aug. 1663; 11 Feb. 1660; 19 Dec. 1666; 26 March 1668.
30. *Diary*, 16 Jan. 1660.
31. *North on Music*, 304 & (n).
32. Ibid., 302–3.

33. Harley, *Purcell's London*, 149.
34. Ned Ward, *Secret Hist. of Clubs* (1709): 'The Small-Coal-Man's Musick Club'.
35. For Purcell's dramatic music, see J. A. Westrup, *Purcell* (1937), 271–73.
36. Henry Playford, *Musical Companion* (1701), Preface.
37. Harley, *Purcell's London*, 144.
38. Courtin to Lionne, 15 Aug. 1665: Jusserand, 168–69.
39. W. Notestein, *English Folk* (1938), 250–51.
40. See Beljame, *Men of Letters*, 153–56.
41. Dunton, *Life and Errors* (1818), 187.
42. Ibid., 189.
43. W. Graham, *The Beginnings of English Literary Periodicals* (1926), 16–23.
44. Dunton, *Life and Errors*, 192–93.
45. For Herringman's career, see F. A. Mumby, *Publishing and Bookselling* (1949), 118–19.
46. Ibid., 122–26.
47. Dunton, *Life and Errors*, 216.
48. 'A Character of Mr. Tho. Brown': quoted in B. Boyce, *Tom Brown of Facetious Memory* (1939), 18.
49. *The Sessions of the Poets* (1696).
50. Dr. Boyce, Brown's modern biographer, feels that Brown may have contributed 'something of his wit and language' to Motteux's famous translation of Rabelais (1694).
51. *Life and Errors*, 179.
52. In 1667, Milton was perhaps lucky to find a publisher at all. His service to the Puritans was not forgotten, his controversial pamphlets still rankled; at the Restoration a work of his had been burnt by the hangman.
53. Ward, *Life of Dryden*, 273.
54. *Letters of John Dryden*: ed. Ward, 77–78.
55. *Lives of the Poets*: Dryden.
56. *The Late Converts Exposed*, 51: quoted in Boyce, *Tom Brown*, 72.
57. Harley, *Purcell's London*. 115.
58. Over 200 musicians passed through the King's Musick in the reigns of Charles II and James II.
59. *North on Music*, 305.

Chapter 5

1. See E. Walker, *Hist. of Music in England* (1952), 85.
2. Both Anthony Wood and Roger North expressed reservations on Baltzar's playing. They admired the speed and facility of his technique, especially in double-stops; but they did not like his tone—his sound was 'like his country rough and harsh'. It is good to see these old enthusiasts putting musicianship before mere technique.
3. *North on Music*, 301.
4. Ibid., 351.
5. Flecknoe, *Enigmatical Characters*: 'A petty French lutenist in England.'
6. SP Dom: quoted in Westrup, *Purcell*, 90.
7. *Diary*, 24 Jan. 1667.
8. *North on Music*, 310.
9. D. Knoop & D. G. Jones, 'Masons' wages in Medieval England', *Economic Journal*: *Hist. Supplement*, 11 (1930/3), 487.
10. *Of Buildings*: quoted in Colvin, 'Roger North and Wren' *Architectural Rev.*, Oct. 1951.

11. The contents of Inigo Jones's library are given in J. A. Gotch, *Inigo Jones* (1928) 248–52.

12. Pinto, *Sedley*, App. II.

13. Clarendon discussed the work of continental historians in his essay 'On an Active and on a Contemplative Life'.

14. *The Architecture of Sir Roger Pratt*: ed. Gunther (1928), 60.

15. Tract I: *Parentalia* (1903), 236.

16. Ibid., 105.

17. The Preface was probably written for Purcell by Dryden. See Ch. 2, n. 54.

18. *North on Music*, 310 (n), 307 & (n).

19. Ded. to *Examen Poeticum*: Ker, ii, 3.

20. *Preface to the Fables*: Ker, ii, 251

21. Ibid., Ker, ii, 247.

22. See his article 'The tyranny of intellect: Wren and the thought of his time', *Journ. of R.I.B.A.*, XLIV (1937), 373–90.

23. Quoted by Colvin, *Architectural Rev.*, Oct. 1951, 259.

24. 'Tyranny of intellect', 379, 380.

25. *Parentalia*, 236.

26. 'North and Wren.'

27. *History of Royal Society* (1702), 53.

28. *North on Music*, 44.

29. Ibid., 45 (n).

30. Ibid., 307 & (n), 310 (n). 'Artificiall' is here used in the sense of well-made.

31. See O. F. Emerson, 'John Dryden and a British Academy', *Proceedings of the Brit. Academy*, X (1921), 45–58.

32. See M. Tilmouth, 'The Royal Academies of 1695', *Music and Letters*, XXXVIII (1957), 327–34.

33. Letter to Lord Cornbury, 9 Feb. 1665: *Corres.* ed. Bray (1852), iii, 152.

34. Ded. to *Examen Poeticum*: Ker, ii, 2–3.

35. *Epistle to Dr Arbuthnot*, 153–54.

36. Ker, ii, 250–51.

37. *North on Music*, 118.

38. Ibid.; both North and Dryden considered the effect of music on the passions— North in the *Musicall Gramarian* and elsewhere, and Dryden in his St. Cecilia's Day poem, *Alexander's Feast*.

39. Ibid., 293. 'The Judgment of Musick' occurs in *Notes . . . of Elder and Later Musick and Somewhat Historicall of both*. In this late work (c. 1726) North's views have become rather more Augustan than formerly.

40. *Theory of Painting* (1725), 24.

41. Ibid., 225.

42. *Religio Laici*, 1–7.

43. *Satyr against Mankind*.

44. *Rochester's Farewell*. The authenticity of this poem is discussed in Pinto, *Enthusiast in Wit* (1962), 210.

45. *Absalom and Achitophel*, 882–87.

Chapter 6

1. *Anecdotes*, ii, 202.

2. Ibid.

3. Ibid., ii, 261.

4. *Cal. Treasury Books*, 31 Aug. 1685. Harley (p.61) thinks that the string band is disguised among the counter-tenors, taking the term to refer to instruments.

5. Lafontaine, *King's Musick*, 25 March 1689 & 27 Feb. 1692.
6. Luttrell, *A Brief Relation* (1857), ii, 263, 16.
7. Ibid., iii, 489.
8. *Cal. Treasury Books*, 24 May & 17 Aug. 1693.
9. Luttrell, ii, 1.
10. *Anecdotes*, ii, 211.
11. Ibid., ii, 202.
12. Ibid.
13. *Anecdotes*, ii, 121.
14. Walpole [ii, 280 (n)] notes that Halifax refused to endorse the choice of Ricci to decorate the Princess's apartment at Hampton Court. He insisted that the job go to Thornhill; if Ricci was chosen, Halifax, Commissioner of the Treasury, would not pay him.
15. C. H. & M. I. Collins Baker, *Life and Circumstance of James Brydges, 1st Duke of Chandos* (1949), 163 (n).
16. L. A. Turner & W. H. Ward, 'The Crafts at St. Paul's', in *Sir Christopher Wren, 1632–1723*, 83–115.
17. E. H. Pearce, *Annals of Christ's Hospital* (1908), 151.
18. Summerson, *Architecture in Britain*, 166.
19. *Anecdotes*, ii, 254.
20. K. Downes, *Hawksmoor* (1959), 40.
21. Quoted in L. Whistler, *Vanbrugh, Architect and Dramatist* (1938), 57.
22. Downes, *Hawksmoor*, 40.
23. Pepys, *Diary*, 2 Apr. 1669; Hawkins, *General History*, bk. XVI, ch. 150.
24. Ded. to *Giulio Cesare* (1724).
25. *Court and Society* (1864), ii, 337.
26. O. E. Deutsch, *Handel, A Documentary Biography* (1955), 219. See also A. Yorke-Long, 'George II and Handel', *History Today*, Oct. 1951, 33–39.
27. Deutsch, *Handel*, 91.
28. J. Summerson, 'Great landowners contribution to architecture', *Journ. of R.I.B.A.*, XLVI (1939), 433–54.
29. Ibid., 439.
30. Letter of 23 Nov. 1714: quoted in J. Lees-Milne, *Earls of Creation* (1962), 213.
31. *Architecture in Britain*, 201.
32. *Fable of the Bees*: ed. Kaye, i, 103.
33. For the building of Cannons, see Collins Baker, *Life and Circumstances of Chandos*, ch. VI. James Brydges became Earl of Carnarvon in 1714, and was made Duke of Chandos in 1719. For convenience he will be called Chandos throughout this work.
34. Collins Baker, *Life & Circumstance*, 115.
35. Ibid., 125.
36. The orchestra performed in the church of St. Lawrence, Whitchurch. See Collins Baker, 126.
37. Quoted Collins Baker, xvi.
38. The identity of this 'Francisco' is not certain. See Collins Baker, 171 (n).
39. The Cannons Inventory is given in Collins Baker, 162–72.
40. Letter of 9 Feb. 1719: Deutsch, *Handel*, 83.
41. Like most musicians, Pepusch was a good pluralist. A letter of 9 March 1732 indicates that he had recently left Cannons. See Collins Baker, 129–30.
42. Ibid., 139.
43. Ibid., 130.
44. Deutsch, *Handel*, 78.
45. Collins Baker, *Life & Circumstance*, 134–39.
8*

46. *Epistle to Burlington*, 5–6.
47. *Epistle to Paul Methuen Esq.* (1720).
48. *Epistle to Burlington*, 37–38. Cannons was such a strange hodge-podge it could hardly be called Palladian.
49. Mandeville, *Fable of the Bees*, i, 106.
50. Pope, *Epistle to Bathurst*, 17–18.
51. *Pastoral Dialogue bet. Richmond Lodge and Marble Hill* (1727).
52. *Ep. to Bathurst*. This was Warburton's version of a suppressed passage, see *Twickenham Edition of Pope's Poems* (1951), III, ii, 105 (n).
53. Quoted in Lees-Milne, *Earls of Creation*, 122.
54. Walpole, *Anecdotes*, iii, 58–59.
55. Deutsch, *Handel*, 67.
56. Ibid., 93–94.
57. *Trivia* (1716), bk. II, 493–500.
58. *Lives of the Poets*: Gay.
59. Oct. 1727: L. Melville, *Life and Letters of John Gay* (1921), 75.
60. *Ep. to Bathurst*, note to l. 243.
61. *Mr. Pope's Welcome from Greece* (1720), XV.
62. Letter of 6 Aug. 1735.
63. *Ep. to Bathurst*, note to l. 243.
64. Ibid., 237–40.
65. Letter to his son, 17 Oct. 1749.
66. Churchill, *Independence* (1764).
67. *Imit. of Horace*, II, i; *Dunciad*, iii, 320, 331; i, 6.

Chapter 7
1. *Review*, III, Preface.
2. Ded. to Vol. 4 of the *Tatler*.
3. Southerne, BM Add. MSS. 4221.
4. Blackmore and Garth, two Whig literary physicians, were also knighted.
5. Letter from Harley to Godolphin, 20 Sept. 1703.
6. *Journal to Stella*, 30 June 1711.
7. Ibid., 27 Dec. 1712.
8. *History of Vanbrugh's house* (1706).
9. See J. C. Hodges, 'Congreve in government service', *MP*, XXVII (1929), 183–92.
10. *A Letter to the Right Worshipful Sir R. S.* (1715).
11. G. A. Aitken, *Life of Richard Steele* (1889), ii, 6 (n).
12. P. Smithers, *Life of Joseph Addison* (1968), 382, 428.
13. Oldmixon, *History of England* (1735), iii, 519.
14. *Mordecai's Memorial* (1716).
15. *Corres*: ed. Ball (1910–14), iii, 301.
16. *Epistle to Fleetwood Shepherd*.
17. *Rogues on both Sides* (1711), 1.
18. *Review*, IV.
19. *Carmen Seculare*, IX.
20. Addison, *Letter from Italy* (1701).
21. Hinton to Cooper, 14 May 1700: *HMC* 5th Rep. App.
22. *Faction Display'd* (1704).
23. *The Kit-Cat* (1708).
24. Ned Ward, *Secret History*, 360.
25. *The Kit-Cat*.

26. 20 Apr. 1706: quoted in G. Sherburn, *Early Career of Alexander Pope* (1934), 51.

27. Tonson's publications are listed in G. F. Papali, *Jacob Tonson* (1968), App. II. See also ch. 5 on the Kit-Cat Club.

28. Longleat MSS. iii, 393. Prior was at this time a Whig and a member of the Club.

29. Leslie, *Rehearsal*, No. 41. The 'Babe of Grace' and the 'Little Whigg' was the Countess of Sunderland, Marlborough's daughter,. See R. J. Allen, 'The Kit-Cat Club and the Theatre', *RES*, VII (1931), 56–61.

30. See Burney, *Gen. Hist.*: ed. Mercer (1935), ii, 675.

31. For the list of subscribers, see Deutsch, *Handel*, 91.

32. 29 Nov. 1719: see Papali, *Tonson*, 100 (n).

33. 15 June 1703: quoted in Whistler, *Vanbrugh*, 77.

34. *Dialogue, bet. Tonson and Congreve* (1714).

35. Spence, *Anecdotes* (1820), 10.

36. No. 6 (7 Sept. 1710). This attack seems to be the work of Prior himself.

37. Happily, in the arts these categories were not exclusive. Jervas was always a friend to Pope; Kneller was on good terms with most, and would paint anyone with the money to pay; Thornhill received help from the Whig Halifax, and Gibbs built for Argyll, another Whig.

38. 12 June 1711: *Works* (1798), i, 246.

39. Letter to Lord Carteret, 16 Feb. 1723.

40. Letter to Caryll, 1 May 1714.

41. Ibid.

42. *Epistle* III, 303–4.

43. Letter to Swift, 16 Nov. 1726.

44. Letter to Caryll, 16 Aug. 1714.

45. The book was *Poésies Chrétiennes* by Jolivet.

46. Quoted in Whistler, *Vanbrugh*, 117–18.

47. The final cost of Blenheim was £300,000.

48. Quoted in Whistler, *Vanbrugh*, 155.

49. 8 Nov. 1716.

50. *The Devil to Pay at St. James's*: Mrs. Pendarves to her sister, 25 Nov. 1727. See Deutsch, *Handel*, 211, 218.

51. *Lettres philosophiques*, XXIII.

52. *A General History*: ed. Mercer (1935), ii, 379.

53. *Anecdotes*, ii, 243.

54. Quoted in W. J. Courthope, *History of Eng. Poetry* (1905), V., 109.

55. *Journal to Stella*, 13 March 1712 & 28 Oct. 1712.

56. *The Muses Mercury*, Sept. 1707. See also Beljame, *Men of Letters*, 336f.

57. Hodges, *MP*, XXVII (1929), 183–92.

58. *Review*, VII.

59. *Birth of the Muse.*

60. Tickell, *Prospect of Peace* (1713).

61. Young, *Universal Passion* (1728), Satire VII.

62. Young, *Imperium Pelagi* (1730).

63. Thomson, *Liberty* (1736), Pt. V; Young, *Reflections ... on the Kingdom* (1745). See C. A. Moore, 'Whig panegyric verse, 1700–1760', *PMLA*, XLI (1926), 362–401.

64. *First Letter on a Regicide Peace.*

65. *Libel on Dr. Delany.*

66. *Ep. to Dr. Arbuthnot.* The character of Bufo was first applied to Bubb Dodington, the Whig politician, for whom Vanbrugh built Eastbury.

Chapter 8

1. Defoe, *Review*, III, 3 Jan. 1706.
2. Morris, *Observations on the past Growth and present State of London* (1751), 106.
3. *The Complete English Tradesman* (1726), 373.
4. *Review*, II, 14 Apr. 1705.
5. *Complete Eng. Tradesman*, 317.
6. *Review*, III, 3 Jan. 1706.
7. J. Nichols, *Literary Anecdotes of the 18th Century* (1812), i, 288f.
8. Letter to Dean Sterne, 26 Sept. 1710.
9. See J. Sutherland, 'Circulation of newspapers, 1700–1730', *The Library*, XV (1934), 4th Series, 111; *Review*, VII, Preface.
10. *Spectator*, No. 10.
11. See Beljame, *Men of Letters*, 308–9.
12. *Lives of the Norths*: ed. Jessopp (1890), ii, 282.
13. No. 7.
14. Francis Place, *Improvement of the Working People* (1834), 19.
15. Johnson, *Prologue for the Opening of Drury-lane* (1747).
16. *Middlesex Records*, Order Book, 28 Feb. 1751: quoted in M. D. George, *London Life in 18th Cent* (1930), 288. Mrs. George points out that one of the justices was the landlord of the New Wells, and himself procured the licenses for the brothels. Goodman's Fields Theatre closed in the late forties, but it appears from this complaint that plays continued in the area.
17. *Life of Johnson* (1787), 75–76.
18. *Review*, II, 3 May 1705. A 'lay-stall' was a dung-heap.
19. *Critical Works* (1939–43), i, 293–94.
20. *Dunciad* (1743), i, 2 & footnote.
21. *The Author's Farce* (1734), II, vi.
22. Ibid, II, vii.
23. Ibid., III, i.
24. See E. L. Avery, 'Foreign performers in London theatres in the early 18th cent.', *PQ*, XVI (1937), 105–23.
25. See H. A. Scott, 'London concerts from 1700–1750', *Musical Quar.*, XXIV (1938), 194–209.
26. *General Advertiser*, 31 March 1746.
27. *Daily Courant*, 4 Feb. 1703.
28. *Daily Courant*, 17 March 1725; *Daily Post*, 17 Feb. 1733.
29. Ireland, *Hogarth Illustrated* (1791–8), iii, 51.
30. Between 1742 and 1756 the Hospital admitted 1,384 children, of whom 724 died. To keep some 50 per cent alive was considered a fair achievement. See George, *London Life*, 43–45.
31. *Gen. Advertiser*, 1 May 1750.
32. Deutsch, *Handel*, 688–89.
33. *Hogarth Illustrated*, iii, 31.
34. A. Dobson, *William Hogarth* (1898), 7.
35. *Considerations . . . on the Wages of Servants* (1767), quoted George, *London Life*, 92–93.
36. *Champion*, 10 June 1740.
37. *Legion Club* (1736)
38. *Examiner*, No. 13.
39. See J. Loftis, *Comedy and Society from Congreve to Fielding* (1959), ch. III.
40. *Essay upon Wit* (1716): Loftis, 28.

41. *Review*, III, 3 Jan. 1706
42. *Spectator*, No. 69.
43. *Prologue for the Opening of Drury-lane* (1747).
44. Addison, *Spectator*, No. 18.
45. Burney: ed. Mercer, ii, 676.
46. *North on Music*, 313.
47. Burney, ii, 827.
48. Quoted in A. Carse, *The Orchestra in the 18th Cent.* (1940), 78.
49. See Deutsch, *Handel*, 819 and 835f.
50. Deutsch, 453–54. Walsh usually paid 20 gns for an opera by Handel. *Alexander's Feast* went for the unusually high sum of £105.
51. *Dunciad*, iv, 65–68.
52. Deutsch, *Handel*, 455.
53. Burney, ii, 825.
54. See Scott, *Musical Quar.*, XXIV (1938), 194–209. To compare prices, the usual price for a furnished room in London at this time was 2s. 6d. a week.
55. Carse, *Orchestra in 18th cent.*, 78–81.
56. *Hogarth Illustrated*, iii, 27.
57. Ibid., iii, 56.
58. Dobson, *Hogarth*, 40.
59. *Rambler*, No. 145.
60. *Lives of the Poets*: Savage.
61. 20 May 1709.
62. Pope returned to Tonson in 1725 to edit Shakespeare. Works of his were also published by Gilliver and Dodsley. The latter was indebted to Pope for his start in business.
63. Spence, *Anecdotes*, 304.
64. For some time in the late 17th and early 18th cent., sale by subscription was the most profitable way. Even Voltaire gained £6,000 from the subscription edition of *Henriade*, published in London in 1727.
65. Johnson, *Lives of the Poets*: Pope. See also Nichols, *Literary Anecdotes*, i, 77–78.
66. Out of this sum Pope paid about £700 to Fenton and Broome, his collaborators on the *Odyssey*.
67. Gay, *Mr. Pope's Welcome from Greece*; Swift, *Libel on Dr. Delany*.
68. 9 Feb. 1736.
69. Boswell, *Life*, i, 443.
70. See A. Birrell, *Seven Lectures on Law and History of Copyright in Books* (1899).
71. *Life and Errors*, 214.
72. 14 June 1735.
73. *Spectator*, No. 5 (6 March 1711).
74. *London Journal*, 23 March 1728.
75. *Daily Journal*, 19 Apr. 1732: Deutsch, *Handel*, 288–89.
76. *A Hymn to the Pillory* (1703).
77. Luttrell, *Brief Relation*, v, 157f; Boyer, *History of the Reign of Q. Anne* (1735), 286f.
78. *Life and Errors*, 56.
79. Curll wrote the conventional defence: 'They cannot by the laws of nature and nations be termed *bawdy* books, since they treat only of matters of the greatest importance to society, conduce to the mutual happiness of the nuptial state, etc. . . .' (*Curlicism Display'd*).
80. Bookweight, the bookseller, in Fielding's *The Author's Farce*, II, v.
81. *Life and Errors*, 61.

82. Abel Roper on Tom Brown: quoted in P. Pinkus, *Grub St. stripped bare* (1968), 20.
83. T. Amory, *Life of John Buncle* (1756), 383.
84. II, v.
85. Thomas Burnet, author of the popular *Sacred Theory of the Earth* (1690).
86. 'Tom Brown's Last Letter': quoted in Pinkus, *Grub St.*, 119–20.
87. 'Recantation' supposedly by Brown, but probably by Fleetwood Shepherd.
88. *Ep. to Dr. Arbuthnot*, 261–64.
89. *Idler*, No. 73.
90. *Ep. to Bathurst*, 139–43.
91. See H. M. Reichard, 'Pope's social satire: belles-lettres and business', *PMLA*, LXVII (1952), 420–34.
92. *Imit. of Horace*, II, ii, 68.
93. *Daily Post*, 2 Apr. 1743.
94. Nichols, *Genuine Works of Hogarth* (1808), i, 101–2
95. *North on Music*, 11, 12, 13.
96. *Imit. of Horace*, I, i, 121, 124; II, i, 311.
97. *Dunciad*, iii, 323–32.
98. Ibid., iv, 640.

Chapter 9

1. *Essay on Man*, iv, 241–42.
2. *Dramatic Poetry of the Last Age*: Ker, i, 162–77.
3. Dryden, *Works*: ed. Scott (1808), ii, ii.
4. Pope, *Works* (1751), iv, 26 (n).
5. *Spectator*, No. 68.
6. *Pastoral Dialogue bet. Richmond Lodge and Marble Hill*.
7. Spence, *Anecdotes*, 10.
8. See J. Summerson, 'Classical country-house in the 18th cent.', *Journ. of the Royal Soc. of Arts*, CVII (1959), 540.
9. Quoted J. H. Plumb, 'Noble houses of 18th century England', *Horizon*, I, No. 2 (1958), 41.
10. Preface to the *Odyssey* (1725).
11. *Essay on Criticism*, i, 143–45.
12. Ibid., i, 152–57.
13. *Works*: ed. Davis, IX, 263.
14. *Creation*, vii, 202–3.
15. *Imit. of Eng. Poets*, VI: the Earl of Dorset.
16. *Anecdotes*, iii, 57.
17. No. 314.
18. Introduction to 'The Words upon the Window-Pane', in *Explorations* (1962), 347.
19. Preface to *Prince Arthur*.
20. See B. Boyce, 'Two debits for Tom Brown', *PQ*, XIV (1935), 255–69.
21. *The Present State of Wit*.
22. Ded. to Vol. I of the *Spectator*.
23. *Letter concerning Design* (1712).
24. Ibid.
25. Wilbury House, Wilts, built in 1710.
26 *Theory of Painting* (1725), 30–31, 14, 213.
27. *Discourses*: ed. Wark (1959), 171
28. *Spectator*, No. 29.
29. *North on Music*, 293.

30. *Spectator*, No. 405.
31. *Essay on Man*, 'The Design'.
32. Ibid., i, 35–36.
33. See J. M. Cameron, 'Doctrinal to an age: Pope's *Essay on Man*', *Dublin Review*, CCXXV (1951), 54–67.
34. Quoted in Whistler, *Vanbrugh*, 118.
35. 'Upon the D. of Marlborough's house', *Elzevir Miscellany* (1715).
36. See *Works*: ed. Elwin-Courthorpe, X, 264. In the opinion of Robert Adam, Vanbrugh planned better interiors than either Jones or Wren: 'Vanbrugh understood better than either the art of living among the great. A commodious arrangement of apartments was therefore his peculiar merit.'
37. *Ep. to Burlington*, 177–80. 'Boyle' is of course Richard Boyle, Earl of Burlington.
38. *Anecdotes*, iii, 53
39. *Ep. to Burlington*, 191–94.
40. *Advice to an Author*, Pt. III, sec. 3: in *Characteristics* (1732), vol. 1.
41. *Letter concerning Design* (1712).
42. *Spectator*, No. 452.
43. *Ep. to Burlington*, 197–98, 203–4.
44. *Theory of Painting*, 223–25.
45. *North on Music*, 250.
46. *Spectator*, No. 16.
47. Ibid., No. 262.
48. Quoted by Plumb, *Horizon*, I, No. 2 (1958), 41.
49. Summerson, *Journ. of Royal Soc. of Arts*, CVII (1959), 544.
50. Ibid., 542.
51. *Of Public Absurdities in England*: *Works* (Bohn), XI, 179.
52. *Examiner*, No. 39.
53. Johnson, Preface to *Plays of Shakespeare*.
54. *Gen. History* (1875), I, xxxvi.
55. R. Avison, *Essay of Musical Expression* (1753), 3.
56. See H. M. Schueller, 'Use and decorum of music, 1700–1780', *JHI*, XIII (1952), 73–93.
57. *Essay on Man*, ii, 97–98.
58. Ibid., ii, 115.
59. *Discourses*: ed. Wark, 242.
60. *Theory of Painting*, 222.
61. *Ep. to Bathurst*, 222–28
62. *Ep. to Burlington*, 195, 204.
63. Quoted in R. and S. Redgrave, *A Century of British Painters* (1947), 1–2. 'Gothic' here means northern.
64. *Analysis of Beauty*: ed. Burke (1955), 209.
65. Ibid., 36.
66. L. Lewis, *The Advertisements of the Spectator* (1909), 64.
67. *Theory of Painting*, 31.
68. *History*: ed. Mercer, ii, 831.
69. Mrs. Carter, 2 Apr. 1745: quoted in W. Dean, *Handel's Dramatic Oratorios and Masques* (1959), 137.

INDEX

Academy of Antient Music, 104, 167, 176, 182

Addison, Joseph, 17, 59, 139, 140, 142, 145, 147–49, 150, 152–54, 157, 158, 160, 164, 165, 173, 179, 181, 184, 189, 191–97, 199, 201, 205

Advancement of Music, Committee for the, 6, 15

Ailesbury, Lord, 154

Aix-la-Chapelle, Peace of, 122, 176

Akenside, Mark, 161

Alberti, Leon Battista, 95, 97

Albrici, Bartolomeo, 97, 98

Albrici, Vincenzo, 97

All Souls, Oxford, 72

Ancaster, Duke of, 125

Andrews, Robert, 124

Anne, Princess, 182

Anne, Queen, 73, 111, 115, 118, 121, 122, 140, 144, 145, 151, 152, 153, 155, 158, 164, 199

Arbuthnot, Dr. John, 129, 136, 140, 150, 151, 153, 160, 181, 190, 206

Archer, Thomas, 124, 125, 152

Argyll, Duke of, 125, 202

Arlington, Henry Bennet, Earl of, 42, 55, 67

Army Plot, 8

Arnall, William, 142

Arne, Thomas, 181

Arran, Earl of, 28

Arundell (organist), 77

Assembly Rooms, York, 126

Athenian Gazette (later *Mercury*), 82–83, 86

Aubrey, John, 4, 5, 19, 27, 30

Auden, W. H., 74

Aylmer, Brabazon, 84

Bach, J. C., 129

Bacon, Francis, 59, 192

Ballicourt (flautist), 177

Baltzar, Thomas, 7, 92

Banister, John, 29, 46, 77–78, 93, 104, 176

Banqueting House, 116

Barbandt, Charles, 177

Barbaro, Daniele, 95, 97

Barbon, Nicholas, 38, 68–70, 123

Barlow, Francis, 73

Basing House, 2

Bath, Earl of, 146

Bathurst, Allen Bathurst, 1st Earl, 131, 132, 136, 153, 156, 185, 190, 198, 204

Baxter, Dr. (librarian at Cannons), 129

Bayle, Pierre, 60

Beaumont, Francis, 16, 79

Bedel, Lady, 10

Bedford, Duke of, 123

Beggar's Wedding, The, 169

Behn, Aphra, 35, 79

Bellucci (painter at Cannons), 128

Bennet, 'Lady', 44

Bennet, Mrs., 28

Benson, William, 118, 141, 154, 187, 195, 202

Bentivoglio, 96

Berkeley, James, 3rd Earl, 146, 149

Berkeley House, 31

Berkeley, Lord, 14

Bernini, Giovanni Lorenzo, 97

Betterton, Thomas, 36, 79, 148

Bingley, Lord, 124

Bird, Francis, 117–18, 133

Blackfriars Theatre, 8

Blackmore, Sir Richard, 35, 105, 146, 160, 172–73, 192–94

Blake, William, 59

Blenheim, 72, 73, 115, 119, 120, 125, 130, 141, 154–55, 197–98

Blount, Sir Henry, 44

Blow, John, 39, 47, 112

Bludworth, Sir Thomas, 67

Bolingbroke, Henry St. John, Viscount, 109, 125, 135, 140, 151–53, 182, 185, 190, 196

Bolton, Duke of, 125

Bononcini, Giovanni, 134, 156